ART AND VISION IN THE INCA EMPIRE
ANDEANS AND EUROPEANS AT CAJAMARCA

In 1500 C.E., the Inca empire covered most of South America's Andean region. That empire's leaders first met Europeans on 15 November 1532 when a large Inca army confronted Francisco Pizarro's band of adventurers in the highland Andean valley of Cajamarca, Peru. At few other times in its history would the Inca royal leadership so aggressively showcase its moral authority and political power. Glittering and truculent, what Europeans witnessed at Inca Cajamarca compels revised understandings of pre-contact Inca visual art, spatial practice, and bodily expression. This book takes a fresh look at the encounter at Cajamarca, using the episode to offer a new, art-historical interpretation of pre-contact Inca culture and power. Adam Herring's study offers close readings of Inca and Andean art in a variety of media: architecture and landscape, geoglyphs, sculpture, textiles, ceramics, featherwork, and metalwork. The volume is richly illustrated with more than sixty color images.

Adam Herring is Associate Professor of Art History in the Meadows School of the Arts at Southern Methodist University. He is author of *Art and Writing in the Maya Cities, AD 600–800: A Poetics of Line* (Cambridge University Press, 2005).

ART AND VISION IN THE INCA EMPIRE

ANDEANS AND EUROPEANS AT CAJAMARCA

ADAM HERRING

Southern Methodist University

CAMBRIDGE
UNIVERSITY PRESS

CAMBRIDGE
UNIVERSITY PRESS

32 Avenue of the Americas, New York, NY 10013-2473, USA

Cambridge University Press is part of the University of Cambridge.

It furthers the University's mission by disseminating knowledge in the pursuit of education, learning, and research at the highest international levels of excellence.

www.cambridge.org
Information on this title: www.cambridge.org/9781107094369

First published 2015

Printed in the United States of America

A catalog record for this publication is available from the British Library.

Library of Congress Cataloging in Publication Data
Herring, Adam
Art and Vision in the Inca Empire / Adam Herring, Southern Methodist University.
 pages cm
Includes bibliographical references and index.
ISBN 978-1-107-09436-9 (hardback)
1. Inca art. 2. Art and society – Andes Region – History – 16th century.
3. Art – Political aspects – Andes Region – History – 16th century.
4. Art – Psychology. 5. Cajamarca, Battle of, Peru, 1532. I. Title.
F3429.3.A7H47 2015
704.03'098323–dc23 2014048689

ISBN 978-1-107-09436-9 Hardback

CONTENTS

LIST OF ILLUSTRATIONS

ACKNOWLEDGMENTS

FOR THEIR HELP OVER MANY YEARS, I THANK KENNETH ANDRIEN, PETER Bakewell, Amy Buono, Richard Burger, Rodolfo Cerrón Palomino, R. Alan Covey, Marco Curatola Petrocchi, Gudrun Dauner, Carolyn Dean, Derick Dreher, Amy Freund, Christopher Gales, Regan Huff, Giles R. M. Knox, George Lau, Dana Leibsohn, Guillermo Maafs Molina, Robert Maxwell, Colin McEwan, Mary Miller, Walton Muyumba, Jeffrey Quilter, Daniel Slive, Kurt Stache, Rebecca Stone, Roberto Tejada, Birgit Wendt-Stache, and Margaret Young-Sánchez. Two anonymous reviewers retained by Cambridge University Press provided valuable insight and commentary on the manuscript. All errors of fact or scholarly argument are my own.

For their assistance in assembling the images in this volume, I am grateful to Adrianna Stephenson of the Visual Resources Library of the Department of Art History at Southern Methodist University, and Joseph Hartman, Mariana von Hartenthal, Alice Heeren-Sabato, Elena Gittelman, and Rheagan Martin, all of the Department of Art History at Southern Methodist University. For her time and effort on my behalf I am particularly grateful to Chelsea Dacus of the Museum of Fine Arts Houston. For their generous permission to reproduce visual images from their publications, I thank Augustín Llagostera, Colin McEwan and Frank Meddens, Michael Moseley, Eduardo Peláez, Flora Vilches and Enrique Uribe, and Dwight Wallace. I also thank Mr. Bernard Selz of New York City.

Portions of this study were presented to attentive audiences at the Department of Art History of the University of Chicago; the Seminario de Estudios Andinos, Pontífica Universidad Católica del Perú, Lima; the Andean Archaeology Seminar of the Institute of Archaeology, University College London; the Kunsthistorisches Institut in Florenz/University of Tokyo; and the Scratchpad Series of the Department of Art History, Southern Methodist University, Dallas.

I thank Pamela Patton, who as chair of the Department of Art History provided generous support for my research; I also thank the University Research Council and the Faculty Development Fund of the Meadows School of the

Arts, Southern Methodist University. I wish also to acknowledge the life-long generosity of Clarence and Maret Herring, William D. Duthie, David and Eudora Bischoff, and Fredrick and Diana Herring. This work could not have been written without Annie Herring and Alexis McCrossen, ever bright-shining.

INTRODUCTION

In 1500 C.E. the Inca empire covered most of South America's Andean region – nearly all of coastal and highland Peru, as well as large portions of Ecuador, Bolivia, Chile, and Argentina. That empire's leaders first met Europeans on 15 November 1532, when a large Inca army confronted Francisco Pizarro's band of 168 soldiers at Cajamarca, Peru. There in the harsh daylight of the highland Andes, the Inca royal court was in the fullness of its powers, while the impulses of European expansionism were ascendant. At few other moments in its history would the Inca royal leadership so aggressively expound its claims to moral authority and political power. At no other point would European observers be as attentive to that cultural expression, or so assiduous in committing their impressions to writing. *Vision at Inca Cajamarca* takes a fresh look at the encounter at Cajamarca, using that episode to offer a new art-historical interpretation of Inca culture and power.

A day after their arrival at Cajamarca, Pizarro and his men ambushed and massacred the royal Inca entourage on the Inca settlement's central plaza. Not surprisingly, this action figures prominently in both triumphal and revisionist histories of the Americas. It is framed alternately as a defining chapter in the advent of the modern European *mentalité*, or the bloody induction of a native Andean society into the West's incipient global hegemony.[1] Either way, the meeting ushers the Inca into the grand narrative of the West: Cajamarca's events consign the pre-contact Inca cultural order to an irrecuperable, prelapsarian past. The Incas' heirs were now left to negotiate the myriad disenchantments of emergent global modernity. Such may be the case, though those narratives continue to push aside alternative accounts of power and cultural experience at Inca Cajamarca.

In examining the problem of vision at Inca Cajamarca, I hope to bring forward part of that other history. My analysis takes up five episodes of visual experience that took place over those twenty-four hours at Cajamarca: a sudden prospect onto animals grazing in a distant valley; the haze of a semitransparent cloth; the patterned resplendence of an oncoming army; sunlight off yellow metal; and the glint of a stray human hair. Pizarro's men reported all these as so many anecdotal asides, each one irreducible in its singularity. And so historians have since understood them: reduced to historical marginalia, these eccentric

details do not question or displace a narrative driven by European cultural trajectories, modes of signification, and aesthetic criteria. In the present study I consider them as more consequential forms of cultural expression and experience. Restored to inquiry, these spectatorial encounters vest the episode at Cajamarca with new historical and ethical dimensions. They also compel revised understandings of pre-contact Inca visual art, spatial practice, and bodily expression.

At Cajamarca, the Inca royal leadership confronted foreign enemies and technologies. They responded with their own array of technical aptitudes and social disciplines. Those native Andean technologies of power were many – and they invite further inquiry, whether the logistics of camelid pastoralism or the ballistics of Andean sling-stones. Prominent among them, and the guiding interest of this study, was a regime of perception, a coordination of bodily experience with the symbolic structures of myth and cosmology.[2] That order of culture was based on the sensory functions and cognitive mechanisms of the human organism. As a "regime" it was also a cultural construct, a politicized, complexly situational inflection of human perceptual faculties. The vision cited in this study's title thus gestures to a biological capacity of the human body, and to a cultural negotiation of ideology and power. Among the Inca leadership, seeing was cultural being: the sensory, moral, and social capacities of vision were staged across landscapes, in the confines of architectural spaces, and in performative tableaux of mass action.

This is to say that the Incas' actions at Cajamarca were not just visible to non-Inca observers: they were visually *discursive*. The Inca systematically enacted society and culture as visible fact, such that sight itself operated a means of argument and analytical reasoning. The Inca leadership's supremacy – military, political, mythic – was constituted as a set of visible encounters. In those bodily perceptions the Inca made their cultural system not just sensible, but incontrovertible.

THE SPANISH ARRIVED AT CAJAMARCA LATE ON A FRIDAY AFTERNOON. Francisco Pizarro's band had marched from the Pacific over the previous weeks, moving through coastal deserts and bitterly cold mountain passes.[3] They arrived at Cajamarca cold and wet. The scale and monumentality of the Inca settlement immediately impressed them, though they found the place nearly deserted. The Spanish seized and interrogated a lesser Inca official who came forward to meet them. The man informed the Spanish that a large Inca army was camped on the opposite side of the Cajamarca valley. In its midst, the Spanish were told, was the Inca monarch himself, lodged with his retinue at a complex of stone buildings near a prominent spur of rock (*peñol*). The

native king would be known to the Europeans as *Atabaliba*, or *Atabalipa* – and among specialists today as *Atawallpa*.

Pizarro and his soldiers regarded the Inca encampment. "For a league [five kilometers] around that building the fields were everywhere covered with white tents."[4] The Europeans estimated the Inca army's size to be at least 40,000; some accounts reported double that number. Two decades later, the Inca nobles of Cuzco recalled that it numbered around 87,000 fighting men, along with 30,000 male camp attendants – this not including wives and female servants, who probably numbered in the tens of thousands.[5] The Inca camp was made up of well over 100,000 people, as well as tens of thousands of pack animals. The Inca encampment outside of town was less an army than a fully constituted society unto itself: populous, organized, provisioned, governed.

Pizarro quickly sent ahead a party of horsemen to meet the native ruler. The bold move would show Spanish fearlessness – to their Andean antagonists, and to the European party itself, now badly outnumbered. The Spanish embassy also served another, more important purpose. The soldiers were to convince the Inca ruler to descend into town to meet with the Spanish captain. It was a ploy, of course, a stratagem employed for decades by European slavers and bush fighters in the Americas. Pizarro sought to lure Atawallpa into close quarters, then capture or kill him outright with a surprise attack. At a stroke, the Inca leadership would be decapitated: the small Spanish force would seize the initiative, and the Incas' vast armies would be left paralyzed, perhaps for weeks. Central Cajamarca was perfectly suited to the Spanish ruse: its confined spaces would restrict the Incas' ability to react and maneuver, and so render them doubly vulnerable to ambush.

About twenty soldiers made the trip to the palace east of town. Pizarro's emissaries took their measure of the Inca army camped there, before being admitted into the Inca palace. The riders were made to wait for some hours in the outer courtyards of the Inca complex. After this delay the Spanish were allowed to pass deeper into the structure, where they were led into the presence of the Inca ruler. They met with Atawallpa, and then they were allowed to return to central Cajamarca unharmed.

Whatever communication took place between the Inca king and the Spanish horsemen, the Inca ruler made the trip to Cajamarca's main plaza late the next afternoon. Borne on an elaborate palanquin, he entered the plaza with many thousands of guards and attendants – a retinue of as many as 6,000. The Spanish engaged in a scripted legal parley – the *requerimiento*.[6] By it, the native ruler was invited to submit to Spanish legal and religious authority. Predictably, the Inca king was impassive. The Europeans summarily deemed the offer rejected. Pizarro's men then attacked by surprise. Cannon were touched off, horsemen surged forward. An ugly scrum took place on the plaza

as Atawallpa's guards fought off the Europeans' attempt to pull the Inca ruler from his sedan chair. The Inca lost that struggle, and Atawallpa was seized alive. The wider fight gave way to a massacre. Atawallpa's entire retinue, some five or six thousand men and women, died on Cajamarca's plaza. Some members of the Inca entourage managed to elude the slaughter. Fleeing through the fields outside the settlement, they were chased down and killed by Pizarro's horsemen.

The Spanish would hold Atawallpa hostage for nine months, during which time the Spanish demanded a large ransom in precious metal. After many months of tension, the Inca delivered the stipulated amount of metal. At that point the Inca ruler was executed on pretext: Atawallpa was garroted on 26 July 1533. Pizarro's force left Cajamarca on 11 August 1533, moving along the highland Inca road that led south to the Inca capital of Cuzco. After several battles with Inca armies, Pizarro's force would capture the Inca capital about three months later, on 15 November 1533. The Incas' ancestral capital was looted. Pizarro would refound Cuzco as a royal Spanish town on 23 March 1534. Cuzco's finest properties – its palaces, residence compounds, and temples – were repartitioned among Pizarro's soldiers. Inca generals made concerted attempts to retake the city over a year of bitter fighting in and around Cuzco in 1536/7.[7] The city was severely damaged, though it did not fall back into the Inca leadership's hands. After that, the campaign entered a decades-long strategic phase that is widely underacknowledged by Western historians. In the southern highlands, Inca leaders pulled back into mountainous country and there retrenched; in the far north, Inca generals actively fought on, extracting a heavy toll from the Spanish and their native allies. The last Inca ruler capitulated to the Spanish viceregal administration only in 1572, by which time Inca nobility's political loyalties were complexly divided between the Inca and Habsburg dynasties. Throughout those decades, the ancestral capital of Inca dynastic authority never returned to the control of the independent Inca leadership.

THE BROAD HISTORICAL OUTLINES OF THE MEETING AT CAJAMARCA ARE WELL known to history, though the episode's particulars are less well understood than generally acknowledged. Those details significantly reshape the narrative of the encounter: they lend this study its overall structure.

The four main chapters of my analysis move chronologically through the events of 15–16 November. They begin with the Europeans' arrival in the Cajamarca valley late in the afternoon of Friday 15 November (Chapter 1). Chapter 2 addresses the Spanish embassy to the Inca camp outside Cajamarca that same day. Chapters 3 and 4 treat the Incas' approach and entry to Cajamarca's central precincts the following day, 16 November. A concluding

chapter returns to Atawallpa's chambers on the afternoon before the Incas' defeat; there I offer final thoughts on Inca art and bodily experience. In the aggregate, the study reexamines the historical narrative of 15–16 November 1532; with it I hope to recuperate the sensory dimensions of Inca authority and political prestige.

Chapter 1, "Llamas and the Logic of the Gaze," takes up the Europeans' first impression of Cajamarca from the northern rim of the valley. "There we were given to find many pastors and llamas," commented Cristóbal de Mena (*y hallamos muchos pastores y carneros*). Mena and his companions brought with them so many naturalized cultural conventions of landscape and power. At Cajamarca they confronted an altogether alien landscape: a valley overrun by llamas. Those animals were not part of the Andes' natural environment. Ecologically intrusive, economically disruptive, and menacingly aggressive, Cajamarca's llamas were creatures of empire and instruments of cultural power. Offering a close look at Inca camelid pastoralism, Chapter 1 introduces landscape and the logic of the gaze at Inca Cajamarca.

Chapter 2, "Under Atawallpa's Eyes," examines the first meeting between Pizarro's men and the Inca leadership at the architectural complex outside Cajamarca later on the afternoon of 15 November. When the Europeans first saw the Inca ruler, they found him seated in a small courtyard among his retainers. "No one could see him directly," wrote one Spanish soldier later, "for he was completely obscured by a thin veil held up before him by two women." In Chapter 2 I consider the role of eyesight within Inca discourses of moral authority and political prestige. My analysis examines the veil as architectural element, as theatrical act, and as means of cultural production. At once seen and seen through, the raised cloth serves to introduce the cultural construction of sight among the Inca leadership. Chapter 2 brings forward the cultivated visualism of Inca courtly life.

On the day after the Europeans' arrival in Cajamarca, the Inca ruler and his entourage traversed the distance between their camp and town. "They wore costumes like chessboards," wrote several Spanish soldiers.[8] "So they began to march, blanketing the fields," wrote another.[9] Chapter 3, "Chessboard Landscape," considers the Incas' march to Cajamarca. That forward advance, I argue, paraded both the Inca leadership's fighting strength and its ideological assumptions. That movement demonstrated the Incas' military order and discipline – the native army's will to close with the enemy, and their resolve to fight hard once in striking distance. The royal Inca retinue's progress toward Cajamarca also offers a lesson in visual expression and the performative construction of space, temporality, and military power. As their enemies watched, the Inca sign-system – a body of cultural truth and a way of knowing – was enacted. Chapter 3 offers an analysis of Inca design patterns in motion and in the political moment.

The Inca ruler and his retinue entered Cajamarca in a blast of noise and reflected light: *rreluzia con el sol*, wrote one Spanish observer, "how all their gold gleamed in the sunlight." I examine the Incas' sensory energy in Chapter 4, "*Quri*: A Place in the Sun." My analysis interprets the Inca entry into Cajamarca as an elaborate ceremony of possession: Atawallpa and his entourage processed into the town's central plaza, and there went about the rituals of patronal authority and communal obeisance. The entry was a rite of sensory intensification, a staged performance of shining costumes and regalia, song and drumming. Glittering, loud, and kinesthetic, the entry generated the violently sensible energies of Inca sacral authority. Disorienting and alluring to Andean observers as well as European eyes, *quri*, "gold," was a defining signature of that triumphalism. My discussion explores the cultural phenomenology of light, color, and optical brilliance among the Inca leadership, bringing forward the performative and synesthetic dimensions of Inca metalwork. Chapter 4 engages the sensory materialism of Inca cultural experience.

The Inca ate Atawallpa's hair: while in Atawallpa's presence, Pizarro's men saw female attendants eat stray hairs they plucked off the Inca ruler's clothing. "Fount of Beauty" closes the study with a brief consideration of Inca materiality, memory, and embodied experience.

THE PEOPLE WHO MET THE EUROPEANS AT CAJAMARCA ARE DIFFICULT TO reckon as historical actors. The Incas' ethnic origins, sociological makeup, and political emergence all remain imperfectly understood. From the sixteenth century onward, native Andeans as well as European settlers, evangelizers, and administrators produced a rich corpus of writings on the pre-contact Inca past. Those reports and accounts may be discursively rich, but they are hardly the stuff of Rankean historical empiricism. In the aggregate they offer a narrative of divine (or politically deceptive) foundation, rapid rise, and, finally, teetering political instability, all of it unfolding over a span of perhaps a century. Recent archaeological work and historical interpretation offer a more plausible story than this. It is now clear that the Inca emerged in the highland Andean region of Cuzco, Peru, in the thirteenth century C.E.[10] They were a people of complex polyglot origins: the Inca leadership appear to have spoken some combination of the Quechua, Aymara, and Puquina languages. The Inca were just one of many groups active in the central Andes after the decline of the Wari empire around 1000 C.E. They went on to dominate Andean South America by about 1500, folding the Andes' diverse lands and ethnicities into a closely administered imperial order.

Scholars now recognize the Inca leader who met the Europeans at Cajamarca as *Atawallpa*, "Favored in Battle," or "The Victory-Destined." (Sixteenth- and seventeeth-century Quechua speakers also identified the name as *gallo*,

"fighting cock."[11]) To his subordinates he was *Sapa Inka*, "the one-and-only," or "peerless leader," or more directly from the Incas' Aymara- and Puquina-inflected Quechua language, "the pure-Inca" or "most-*Inka* Inca."[12] Atawallpa thus shared the defining identity of the broad Inca leadership under him; but he was the essence of the Inca state, its very pith. He was *the* Inca, *El Ynga*, as the Spanish would colloquially – and in fact properly – refer to him.

Atawallpa was no stranger to the northern highlands. He was Ecuadorian by birth, a product of the Inca expansion into Ecuador in the decades after 1450. Atawallpa had come to power after the death of his father, the previous Inca ruler Wayna Qhapaq. Both strident militarist and strong administrator, that king had been among the Incas' most successful monarchs. A succession conflict followed Wayna Qhapaq's death in the mid-1520s. A northern, Ecuadorian dynastic faction was pitted against another from Cuzco, the traditional center of Inca governance in the southern highlands. Atawallpa was the representative of the northern party; a half-brother, Waskhar, protagonized the Cuzco faction. Much of this civil war among the Inca leadership appears to have played out as a bloodless political contest. Both sides sought to enlist allies among the Inca nobility and regional client-leaderships across the Inca realm. The conflict seems to have lasted several years, escalating to outright warfare between large armies. Atawallpa and his advisors prevailed, ensuring their success with a military victory in the southern Peruvian valley of Abancay in early 1532.[13]

Pretender, rival, usurper: Atawallpa was all three before he became king. And king he may never have been in the strictest sense. Indeed, the case has long been made that Atwallpa was an illegitimate ruler. He had no right to the Inca kingship, this argument goes, nor had he undergone the ceremonies of accession by which that power was ceremonially invested. So claimed large portions of the Inca leadership in the colonial era. Those nobles had long-standing grievance with Atawallpa and his faction, having numbered among his opponents in the war of dynastic succession. Francisco Pizarro and his political allies also contended that Atawallpa was not the Incas' true king.[14] Their arguments are to be trusted even less. Francisco Pizarro had given the order to execute Atawallpa in July 1533, a move that even in the event appeared to many as hasty and altogether unprovoked. Pizarro's apologists were eager to cast Atawallpa as a usurper. Were Atawallpa not the rightful Inca monarch, Pizarro and his men would be absolved of regicide in the eyes of Spanish law; moreover, their peremptory act of execution would be recast as the delivery of justice.[15]

It is the case that Atawallpa gained the title of *Sapa Inka* only through prolonged factional conflict. It is also true that he had not been invested with the office of kingship in a ceremony in Cuzco. Even so, there is no evidence that such a succession crisis was out of the norm for the Inca high leadership.

Factional struggle among royal pretenders brought short-term upheaval, but it also forced the kind of consensus and compromise on the wider Inca leadership that might not otherwise be accomplished. The contest for power also tended to favor the most aggressive party. That kind of aggression was admired in seated Inca kings: ferocity was all but required of the leader of the Incas' militarized, expansionist state. Further, such admiration was reaffirmed in dynastic lore. Pachakuti Inka Yupanki, remembered by the Inca as their greatest commander and administrator, assumed power during a military crisis; born a lesser son, Pachakuti seized power from both the seated ruler and more likely dynastic successors to assume the kingship.[16] Atawallpa may not have been considered the legitimate Inca ruler by his rivals and enemies. Among his generals and retainers at Cajamarca, however, he was the Incas' rightful monarch, and so he is considered in the present analysis.

In important respects the biography of the Inca ruler is secondary to this study's analysis. This is not a study of "the behavior of Atahualpa" in the mode of traditional political or diplomatic history: my argument does not attempt historical biography, nor a study in comparative leadership, nor any consideration of the relative qualities of pre-contact Andean and early modern European mentalities.[17] My analysis seeks to frame the episode at Cajamarca less as a contest between leaders – Francisco Pizarro and Atawallpa – than as a historically situated encounter between two distinct social and cultural organizations. This does not deny the Inca cultural agency; it rather seeks to recast their actions in terms of cultural institutions, rather than individual subjectivities.

Throughout the study I employ the phrase "the Inca leadership." My use of the phrase corresponds roughly to what cultural anthropologists describe as "political society": that is, it gestures to a more or less cohesive subcategory of Inca society characterized by elevated social status and mythologically endowed authority.[18] But who, exactly, constituted "the Inca leadership"? That question is not easily answered. It included Atawallpa's inner circle of courtiers and retainers, certainly, as well as advisors, religious specialists and custodians, administrators, and military men. They were drawn from Atawallpa's royal kingroup, or *panaqa*, and they likely included many close blood relatives. Beyond Atawallpa's immediate retinue, the Inca leadership was constituted by leaders drawn from the Incas' traditional heartland in the Huatanay River Valley of the southern Peruvian highlands.[19] By the time of the Spanish invasion, Inca ethnic identity was not so easily tied to geographic origin: Atawallpa himself, very much an ethnic Inca, was born and raised 1,500 kilometers north of Cuzco, in an Inca-dominated province of Ecuador. Even as the social institutions of the Inca leadership took traditional ethnic Inca far afield, so too did they remake members of the Andes' non-Inca ethnicities into "Incas."

The Quechua word *Inka* was less an ethnic identity than a term of dynastic affiliation and political hegemony. *Inka*, "leader" or "noble," indicated

an ancestral tradition of ruling authority that was traced back to the mythic founder Manqo Qhapaq. In the ethnic heartland around Cuzco, friendly leaders of neighboring peoples were inducted into the Inca ruling hierarchy as "Incas-by-privilege." As the Incas' realm expanded, its leadership came to include nobles drawn from the Andes' various regional ethnicities. Inca political organization actively sought to bind provincial nobles to the higher Inca administrative apparatus. The Inca's far-flung clients submitted to and in turn replicated what one scholar of the Inca empire's provincial elites characterized as "the [Inca] state's largesse and civilizing influence, the teaching of Inca cults, and the establishment of idealized political structures in the likeness of Cuzco."[20]

The word *Inka* itself was the most junior rank in a flight of male titles that denoted relative degrees of prestige: *inka* ("ruler"), *pawllu* ("second"), and *qhapaq* ("royal").[21] It was thus the lowest common denominator among the "Inca" leadership, something like a privileged status rather than a degree of rank. The ruler's title, *Sapa Inka*, at once recognized this commonality among Cuzco's leadership and superseded its ascending degrees of rank: *Sapa Inka*, "unique," or "peerless ruler," or better, "Among all the Inca, first."[22] Inca, then, may be considered to refer to "a signifying system," that is, to a cultural order "through which necessarily (although not exclusively) a social order is communicated, reproduced, experienced, and explored."[23]

IF THE ART AND CULTURE OF THE INCA LEADERSHIP ARE THE SUBJECT OF THIS inquiry, sixteenth- and seventeenth-century European historical accounts are its backbone. The Pizarro expedition was manned by ambitious provincials, men who were resilient on campaign and, in time, also dogged litigants. They were not Renaissance figures of erudition and deep insight. Instead, they were men drawn from Europe's outlying regions – the dusty Castilian province of Estremadura, most of them, though also a few from such places as Crete and England.[24] They are called soldiers in this account – and in the field, soldiers they were – though they were of diverse social origins and professions. In joining Pizarro's risky, violent endeavor, they were intent on winning social privilege. In writing of their experiences, they were equally determined to protect the gains they had won. These men were knowing inhabitants – aspiring protagonists – of Spain's new administrative culture of writing and literacy. Many could themselves write, though hardly with eloquence; the illiterates employed professional notaries. Sharpened self-interest and sufficient technical competency among Pizarro's men combined to produce an unusually deep body of written reportage and commentary.

Seven members of Francisco Pizarro's company produced reports of the experiences at Cajamarca.[25] Those accounts were rough-hewn and maladroit,

all awkward diction and quarrelsome self-assertion. They participate in what Carlo Ginzburg has described as early modern Europe's "different culture" of literary production – the miller's sermons, witches' confessions, and thieves' argot against which so much humanist writing of the period would define itself.[26] It is no surprise then that from the 1550s onward, Peninsular humanists would write the soldiers' notices out of their finely spun histories of the New World.[27] The campaigners' clumsy reportage was deemed irrelevant to the grand literary project of European self-reckoning.

The soldiers' narratives do not offer "eye-witness testimony," nor do they "chronicle" the Peruvian campaign's events.[28] They cannot claim the historical authority such labels would bestow. The reports of Pizarro's soldiers are complicated documents – determined by the vagaries of memory and desire, and no small degree of polemical inflection. Produced over a span of forty years, they were written in very different circumstances, by men with very different motives. Some were set down soon after the events they describe: Cristóbal de Mena's sensationalized narrative circulated through Europe in several printed editions after 1534. The contemporary account of the notary Francisco de Xerez sought to emphasize the legal diligence of his employer Francisco Pizarro. A decade later, the soldier Juan Ruiz de Arce propounded the rectitude of his conduct in the Peruvian campaign; Ruiz never intended his account to be read by any but his descendants. Other reports were produced decades later, well after political struggles between and among Pizarro's soldiers and crown officials had been settled: Pedro Pizarro and Diego de Trujillo set down their accounts in the early 1570s, by which time they were old men settled into comfortable lives on the edges of the Habsburg empire.

There can be no doubt that all these accounts are unusual and in many ways suspect objects of historiographic rehabilitation. They present sharply distinct versions of the Peruvian campaign, so as to confront the reader with significant discrepancies of fact, timing, and responsibility. Real issues hang in the balance: was the massacre on Cajamarca's plaza triggered by Inca aggression or European deceitfulness? Was Atawallpa's execution a year later legally sanctioned? Was it morally justified? Those are questions that administrators and theologians grappled with in the sixteenth century; they remain unresolved to the present day. Any answers significantly shape the master narrative of European expansion into the New World and substantially affect more fine-grained assessment of sixteenth-century Habsburg politics. It is little wonder that the soldiers' accounts have been treated with suspicion, for they cannot be trusted to provide answers to the broad historical questions they themselves raise.

Those are problems for other scholars and other arenas of historical inquiry. The history told here is ostensibly smaller and more immediate in scope. It is a story built from signal turns of phrase and the telling non sequitur. Such is the nature of experience and recollection, and such is the nature of the

Europeans' incomprehension before the alien cultural practices they witnessed. My inquiry thus looks for consistency and corroboration across the soldiers' disparate narratives, though it reads those accounts precisely for their narrative eccentricities and arbitrary moments of close observation. Those curious incidentals and discursive textures point to another, less familiar order of state and cosmos, that of the Inca leadership.

Historian James Lockhart offered a frank description of one soldier's account: "untutored . . . and direct, magnificently unconcerned with larger issues, and able to see and depict what [he] experienced in vivid anecdotal fashion."[29] This characterization is apt, although the soldiers' narratives are as noteworthy for the uncertainties they profess as the facts they report. Pizarro's campaigners agonized over what they saw at Cajamarca, and how deeply these perceptions challenged understanding. Over and again, the accounts own up to their authors' limitations as observers: "he was completely obscured," "we could not see," "what a strange thing it was." Without doubt, these professions of perceptual frustration had some basis in early modern rhetorical conceit. In some measure they ventriloquize the lover's stammer of contemporary lyric poetry, and the renunciatory ideal of vernacular devotional literature. It would be equally easy to consider these passages as symptomatic of the emergent colonial system: we might read into them, that is, the narrative of the colonial gaze in the New World. Even so, little is achieved in such appeals to the specularity of literary artifice or to the recursiveness of colonial semiosis. For to the Incas' European witnesses, those instances of troubled vision and frank incomprehension were not just artful codes of period response or symptoms of the Hegelian narrative of modernity. They were facts on the ground, and as such they were as real-seeming as any other event, physical feature, or emotion these observers would experience in the Peruvian campaign. That alterity of sight and mind was itself a structure of Inca power. It remains among the least explored aspects of pre-contact Inca cultural practice.

THE STUDY'S ANALYSIS IS STAYED BY A NUMBER OF METHODOLOGICAL AND interpretative guy wires, of which specialized readers are owed some explanation. That audience is alerted already to the tension of "Inca visuality" versus the "regime of perception." The problem of Andean visual experience was emplaced in contemporary Inca studies by museum exhibitions in the era of high modernism, and the powerful, if also powerfully distortive, formalism advocated in that scholarship.[30] Vision returned in the 1990s in path-breaking research on the Inca body, and on Andean religion.[31] That scholarship has helped to reinstate scholarly attentiveness to the centrality of visual experience in native Andean cultural practice.[32] Even so, the cultural-historical scholarship of the 1990s used its insights to pursue thesis-driven arguments

concerning Western cultural narratives: the rise of non-figuration in art; the West's mind/body problem; the late-antique underpinnings of piety in early modern Peru.

Such interpretative redirection is understandable, given the richness of Western cultural narratives those arguments address, as well as the semantic austerity of Inca visual expression itself. The pre-contact Inca produced no written records, few visual images, and spare, starkly enigmatic visual iconography. Unlettered and largely aniconic, Inca visual expression eschewed the principal artistic devices by which the West judges agency and ambition in visual expression. The *philosophe* Alexander von Humboldt wrote in 1812: "I saw nothing . . . [of] grandeur and majesty [Inca] architecture . . . it is merely interesting, though highly so, in that it throws great light on the history of the primitive civilization of the inhabitants of the mountains of the continent." At mid-twentieth century the Inca visual tradition seemed only to confirm the dystopian orientalism of Kipling, Spengler, and Wittfogel. At best, the art offered a sociological object lesson, a deep-historical foreshadowing of twentieth-century totalitarianism, "bleak and monotonous," in historian Louis Boudin's words.[33]

For at least fifty years specialist scholarship has consigned pre-contact Inca visual work to two alternatives. There is the black square of Andean abstraction: the immediacy and finality of the individual object, its solipsism as visual expression. By this logic, Inca artworks constitute self-contained "expressive realities" that float free from society and history.[34] Then there is the black box of the archaic state: artwork (indeed, all work) as social document – "the concretization of history,"[35] and "the materialization of state power."[36] So considered, Inca artworks are mere conveyances for the ulterior, driving truths of society and culture. The two arguments are skeptical of each other's claims, being divided against each other despite mutual – and abiding – interest in the works as cultural artifacts. Even so, they are complexly interrelated. Both are constituted by Enlightenment criteria of aesthetic judgment (monumentalism, high arts, noble media). They share theoretical indebtedness to Modernist utopianism, such as it may be comprehended in universalized structures of formal expression (art history) or social complexity (archaeology). They are alike as abstract ideological constructions – each a totalizing, timeless intellectual formalism.

So it comes as no surprise that recent art-historical scholarship on the Inca sidesteps all-encompassing aesthetic narratives and philosophical antagonisms. This research instead favors questions of patronage and production technique. Even so, specialists in Andean art and archaeology acknowledge only a "decorative effect" in Inca buildings, or point to the visual work of other Andean civilizations as "arguably more interesting . . . than the abstract geometrical arts

of the Incas."[37] Other specialists warn – understandably – of the "deceptions of visibility" in Inca visual works entirely.[38]

Such responses in the literature of Andean studies rightly point out the deep record of misreading in the historiography of Inca art and architecture. They provide valuable correctives to primitivist aesthetic discourses that transpose European values onto cultural contexts where they do not apply. Still, Andean studies' critique of Western aesthetic judgment – of mid-twentieth-century Greenbergian formalism in particular – can shade into a broad, undifferentiated mistrust of visual expression as cultural discourse.[39] All too easily, it reaffirms familiar Western hierarchies of visual expression (the primacy of text and image), while draining Andean visual expression of its capacity to convey and carry cultural arguments. In turn Inca artworks are cast as proxies or bearers of ulterior verities – social, political, cosmological – rather than the means by which those propositions were negotiated as cultural knowledge. Without saying, the scholarship of Andean studies suggests how much is at stake in any close reading of Inca art.

Here my analysis seeks to break down the rival essentialisms of the black square (artwork as formalist monument) and the black box (artwork as socio-logical document). I seek to reconcile those two rival positions by way of a third term: visuality. My argument thus attends to visual work (cultural practice) as well as visual works (morphologically or technologically elaborate objects). Visuality addresses material things endowed with a social life of changing contexts and uses. And no less, it recognizes visual acts as themselves culturally prepared action – as habits of human apprehension and comprehension that unfold within particular social, temporal, and physical occasions. To address visuality is to consider human vision as a discursive construct of culture, at once an artifact and a determinant of social experience. Such an approach promises a deepened account of Inca visual works' formal intricacy. It also opens up the wider dimensions of those objects' discursiveness as social expression.

From this larger methodological position, three subsidiary strategies follow. The first addresses certain assumptions implicit in the tradition of art-historical interpretation since the mid-twentieth century. Modernist criticism cast Inca visual works as "a total geometric formality": it recognized in Inca visual expression both aesthetic self-sufficiency as visual composition, and the refu-tation of all artistic and historical precedent.[40] My argument counters that individual Inca works did not stand alone; nor did the wider Inca visual tradi-tion stand in opposition to Andean precedents and peers. My analysis addresses specifically Inca forms of art and visual experience, although my discussion encompasses works by the Incas' antecedents and contemporaries: works by the cultures of Cerro Sechín, Paracas, Tiwanaku, Wari, Chancay, and Chimú make significant appearances in the book's pages. Those works were produced

among disparate societies, in different historical eras, and for distinct cultural purposes. Even so, to consider Inca artworks in light of those non-Inca artistic precedents and peers hardly decontextualizes Inca art, nor does it argue for any sort of ahistorical Andean-ness among the region's cultural production. Instead, it is to reintegrate the Inca art into the broader Andean tradition whence the Inca works sprang, and to which they were addressed. Indeed, the public face of Inca power – the face that would be brandished before Spanish observers at the provincial Inca center of Cajamarca – was drawn from discourses of sensory experience and cosmological order that were widely shared among the Andes' disparate peoples.[41] As Inca imperial rhetoric spoke to the Incas' ancestral forebears and subaltern clients, so too do the works of the Andes' various regional traditions comment on Inca imperial rhetoric. "Do they have anything better to do?" Atawallpa would remark of an Ecuadorian community forced to weave the supple garment of bat hair he sometimes wore on his person.[42]

My second position addresses archaeological scholarship of Andean studies. Here I seek to put Inca visual expression into sustained engagement with the semantics of language generally, and with the semantic operation of native Andean languages in particular. Post-Enlightenment archaeology has done much to recuperate and interpret the pre-contact Andean cultural record. The Inca have assumed impressive historical concreteness in the scholarship of Andean studies, and no small degree of sophistication as cultural protagonists and agents. Though if empiricism is the foundation of that scholarship's great successes, it is also the source of certain of its limitations as cultural analysis.[43] In these pages I turn to scholarship on Andean-language sources in order to bring forward key aspects of the Inca cultural imaginary. The limitations of the Andean cultural record mean that some linguistic data I employ are drawn from sources separated by many years; I do so not to erase the contingency of context and the historical process, but to help recuperate a cultural and linguistic tradition otherwise so threatened by history's contingencies.

My analysis also considers the broader capacities of Andean languages as embodied expressive-sensorial practice. Inca visual experience was bound to language and its devices – to sound, to the interdependence of the speech act and the performative context, to the co-participation of social life. In language, the Inca articulated the engagement – the identity, even – of visual experience with other sensory stimuli, moral affects, and states of social being/becoming. This is to say that Inca visuality acceded to a discursiveness that was not properly visual in our sense – not, that is, a function of opticality alone. The Incas' culture of visual experience was something like a corporeal schema in which sensory and social energies "straddled the divide between mind and body, cognition and sensation."[44] In the Andean linguistic record, then, we are afforded an opportunity to explore the relationship of vision to the body,

and to test the engagement of sight with other, equally encultured faculties of sense perception.

Finally, my account of Inca art also seeks to position its analysis within the framework of the global historical process, as well as Andean prehistory. The larger history of contact between Europeans and Andean peoples is an old story, if one freshly informed by recent archival/historical research and postcolonial revisionism.[45] More, the problem of gaze has assumed a crucial position in postcolonial studies, particularly after Homi Bhabha's influential account of "the anomalous gaze of otherness" and "mimicry."[46] In that argument the chiasmic structure of vision organizes colonial subject-positions within a desta-bilizing anamorphosis – a configuration of seer, seeing, and seen-to-be-seeing. Bhabha's shrewd redeployment of Lacanian poetics has sharpened critical atten-tiveness to the trans- and intercultural operations of visuality in the early mod-ern Andes. Recent scholarship has pointed out the ways native Andean visual codes were inscribed into ostensibly European structures of pictorial com-position and fields of legibility, and conversely, how European iconographic and representational codes were incorporated into traditional Andean visual media.[47] This scholarship has unseated old verities concerning the dominance of a Eurocentric "art of the victor" in the Viceroyalty of Peru.[48] That com-plicated history began at Cajamarca. As early modern European witnesses looked on, the Incas' order of sensory experience unfurled in all its complex elaboration.

If a study of Inca visuality, this study retains the term "art" in its analysis of Inca visual experience and its correlate forms of spatial and material expression. This usage does not purport to identify any ancient Andean category of cultural production or period-term of experience.[49] Nor does it intend to recuperate or otherwise insist on the anthropological relevance of schemes of universalized aesthetic judgment. Instead, art is employed here as a term of critical awareness and historiographic self-identification: "Art" identifies a mode of humanistic interpretation and its attendant critical sensitivities. It offers acknowledgment not only of the works themselves, but of the complicated work those objects performed in Inca social experience. Art appears in these pages as a means to identify the intricacy of Inca visual expression as poetic form.

A NOTE ON ORTHOGRAPHY IS ALSO IN ORDER. IN GENERAL I HOPE TO TAKE A middle path between the early modern European orthographies and those proposed in more recent linguistic scholarship. The orthography inherited from the early modern period often misrepresents the Quechua language employed by the Inca, whereas recent scholarship has done much to recap-ture the linguistic and historical specificity of this and other native Andean languages. Even so, those spellings introduced in early modern lexica and

administrative writings have a long tradition in Latin American arts and letters, and they are to be respected for this reason alone. Contemporary linguistic orthographies offer increasingly nuanced renditions of the Incas' language: *Pachacuti/Pachakuti/Pachakutiq*. Even so, they are best understood as working notes among linguistic specialists. These newer systems are themselves subject to significant, ongoing emendation: the most up-to-date orthography may contain − and so conceal − significant linguistic errors, as Rodolfo Cerrón-Palomino has long argued in the instance of the mid-twentieth-century's revisionist spelling of "Cuzco."[50]

In general, I employ the orthographic conventions employed by archaeologist Terrence N. D'Altroy in his recent authoritative survey of Inca archaeology and prehistory. In the instance of indigenous-language terms and proper names, I follow the spellings in his "Glossary of Foreign Terms."[51] In many instances, particularly those involving wordplay and polysemy, I retain the spellings of early modern literary sources: *aucay camayoc*. If plagued by linguistic inaccuracies, elisions, and conflations, that traditional orthography also preserves meaningful ambiguities ("paranomasia") in the language.

CHAPTER ONE

LLAMAS AND THE LOGIC OF THE GAZE

Antes de hora de bisperas llegamos a vista del pueblo que es muy grande: y hallamos muchos pastores y carneros . . . [1]

Late in the afternoon we caught sight of the town, which is very grand; and we were given to see many shepherds and llamas . . .

Cristóbal de Mena, 1534

We are taught to identify Andean South America's Inca visual tradition in certain artistic media and morphologies of form: in regular, geometric compositions, for instance, and in intricate though anonymous production techniques. We are also given to understand Inca art by its refusals – by what it does not employ: no texts and very few visual images, principally, and only a narrow lexicon of iconographic signs.[2] Those judgments beg revision, though not for any connoisseurial lapse or mischaracterization. The problem is one of analytic perspective. In that scholarly understanding of the Inca visual tradition is founded on the objects now housed in the world's storehouses and museums, we take too narrow a view. So suggests Cristóbal de Mena's report of the long, broad vista from the road above Cajamarca, Peru.

In early modern Peru, the Castilian word *carnero*, "animal" or "sheep," referred to Andean camelids.[3] "Llamas – they are this country's sheep" (*llamas, que son los carneros de la tierra*) wrote a Spanish Jesuit in Cuzco in the mid-seventeenth century.[4] Iberian administrators and settlers used the word *carnero*

to refer to several species, the llama (*lama glama*), guanaco (*lama glanicoe*), and alpaca (*vicugna pacos*). Guanacos are wild animals, whereas alpacas are smaller, more delicate lamoids raised for their fine wool. The llama was the principal species in Inca herds, and those are the animals that Mena and his fellow soldiers witnessed grazing in the Cajamarca valley. The llama was first bred from guanacos around the second millennium B.C.E.[5] By the sixteenth century C.E., thousands of years of selective breeding had yielded an animal that was tall and sturdy. Stray llamas do not form wild herds, for they do not survive outside captivity. Now as when Mena saw them, llamas exist only as a domesticated species. In broadest ontological terms, llamas were part of the Andes' indigenous social practice, not its natural environment. They are to be read as Andeans understood them, as creatures of empire and instruments of cultural power.

Of course, as its history is traditionally told, the meeting at Cajamarca turns on horses, not llamas. *Mi tierra se ganó á la gineta*, wrote Cuzco-born Garcilaso de la Vega in the early seventeenth century: "My country was won by horsemen."[6] Pizarro's horsemen were impetuous fighters, men disposed to risky battlefield lunges. They were masters of tactical feints and gambits, as well as the "fierce and unnatural cruelty" of sudden violence.[7] "Once he got close enough," it was recalled of one of Pizarro's horseman, "he wheeled and reared his horse such that the Incas who sat nearby spooked and leapt to their feet out of fear."[8] "Understand that this kind of combat is not for any rider," advised another horseman to his sons, "but for the true mounted man-at-arms."[9]

The violence of Pizarro's cavalrymen in Peru has come to be recognized as paradigmatic of early modern Europeans' broader capacity for deepened, knowing aggression. In their capacity for opportunistic, self-consciously cultivated brutality, Pizarro's horsemen are cast not merely as late medieval military functionaries, but bearers of modernity itself. In that historical affiliation, we recognize in Pizarro's horsemen certain of de Certeau's arguments concerning kinesis and "tactical" action: arbitrary, capricious, often transgressive, such tactical movement eludes, even breaks down the strategies by which hegemonic institutions seek to determine or constrict individual action.[10] Horses were the way forward, the next step in the Andes' historical evolution.

The approach of Pizarro's company to the Cajamarca valley would seem only to reaffirm those narratives. Under the imperial gaze of Mena and the rest of Pizarro's soldiers, Cajamarca's Inca landscapes were subsumed beneath so many naturalized Western conventions of landscape and power.[11] Within a day, the tactical violence of the Pizarro's men would bring the pre-contact Inca cultural order to a close. Such argument obscures the static frameworks of cultural understanding that Europeans brought to Cajamarca. It also ignores

the kinetic structures of ecology, economy, and cultural experience in which Mena and the rest of Pizarro's men now found themselves.

THE REPORT OF THE SOLDIER CRISTÓBAL DE MENA WAS THE FIRST NARRATIVE of the Peruvian campaign to appear in print, and it was a best seller.[12] Mena's description of the Cajamarca basin was the West's first entry into that landscape as well. The Inca town was "great" (*grande*), Mena told his readers: other soldiers would assert that the settlement's central plaza was "bigger than any in Spain," and its architecture "more stout than any we had seen before."[13] Castilans were prepared to admire Peru's monumental architecture, given the imprint of Rome on the urban fabric of Iberia's ancient towns. They also admired the Inca army, then camped in white tents (*toldos blancos*) in a side-valley on the basin's opposite side.[14] Grazing animals (*carneros*) did not possess the same cultural gravity.[15] Even so, the deep vista into a pastoral landscape had its own cultural pedigree: the view of flocks in a peaceful valley was a familiar device in late medieval romances of chivalry. Mena offered his European readership an image drawn from an old literary trope: the Cajamarca valley as *verger* − in vernacular romance, a verdant garden landscape without the protection of enclosing walls.[16] After a long march through the highland Andes, the Cajamarca valley beckoned as a *locus amoenus* in the hostile wilderness. The lands of Peru, the European reader was to understand, awaited the hero's acts of possession.

And so a foundational episode in the emergence of Europe's imperial gaze was grounded in literary commonplace. One fable of power occluded another, as the landscape of European chivalry was superimposed over its native Andean rival. Though that overwritten Inca landscape is just visible in Mena's account. The author insists on those Andean "sheep" (*carneros*): the animals are not simply recalled as present in Cajamarca's surrounding fields (*estaban*, or *se encuentran*), nor were they just seen there (*vimos*). No, those shepherds and sheep were "encountered" or "discovered": *hallamos . . . carneros*, "we were given to come across . . . many llamas," recalled Mena, employing an expression of marked intensification.[17]

This passage may be only the unwieldy language of a soldier. Even so, Mena's emphasis grows less surprising if we consider the number of animals he and his companions witnessed. Sixteenth-century archival records from the Andean highlands suggest that under Inca administration a large valley system such as Cajamarca's supported tens of thousands of camelids.[18] The view of Mena and the others took in tens of thousands of animals, perhaps 50,000 or more. Those large numbers cannot be pegged exactly, but they well exceed the sylvan fictions of late-medieval romance. Indeed, after the rout of the Inca army a day later, the animals would "infest" the abandoned camp − *embarasan el*

real, wrote the expedition's notary – such that Pizarro would order the animals' indiscriminate slaughter.[19] But for now, the landscape that confronted Mena was overrun with the Incas' animals.

Mena's admiration for Inca architecture and urbanism was widely shared among early modern Europeans and among Western travelers and archaeologists since. Inca practices of ecological management and exploitation did not receive the same interest, or recognition in the canons of aesthetic judgment their writings came to inform. Pastoralism seemed to have no place among the exalted expressions of civilization – monumental architecture and sculpture, figuration and epic narrative in the visual arts, writing systems and literature. Since the late-eighteenth century, camelids have been posed as caricatures of the Andes' backward peasant economies and ancestral Neolithic lifeways (Fig. 1).[20] Even in anthropological archaeology of Inca studies, pastoralism remains a second-tier problem: archaeology's models of social complexity favor agricultural systems and the settlement typologies with which they are allied.[21] In an important 1965 article, the distinguished Andean historian John Murra felt compelled to apologize for the Incas' llamas: Inca pastoralism, he protested, was neither a Freudian "llama complex" nor "irrational."[22]

TRANSHUMANCE IS THE TERM THAT DESCRIBES THE MOVEMENT OF HERDS FROM one pasture to another. By it, domesticated animals are shifted to different feeding grounds, moved as an overlay to an alternate set of geographic coordinates. In turn, the transhumed herd redefines the territory to which it is transferred: however that landscape had been understood before, it is now pasture, a field of grazing animals. At the same time, however, the ruminant overlay does not efface the previous landscape, so much as render it a palimpsest. The traces of that other landscape persist in asserting themselves, as if pressing back against the grazing ruminants' faces and toepads. And so transhumance is an apt description of the complexly stratified Andean cultural landscape beneath the overlay of Mena's chivalric imagination.

The Cajamarca valley lies in the broad region of the northern Peruvian highlands between the Sierra Blanca range to the west and the Sierra Negra to the East. The basin is around five to six kilometers wide east to west and perhaps three times that long north to south (Figs. 2 and 3). Roughly rectangular in shape, the valley runs northwest-southeast in conformance with the prevailing geologic bias of the Andean mountain chain. The valley's sides are irregular, given alternately to steep, rocky mountainsides or narrow side-valley openings. The valley is high in elevation, about 2700 meters above sea level along its bottom. It is warm and temperate by highland Andean standards, with good soil and ample water. When the Europeans arrived there, Cajamarca was the largest and most productive agricultural region in the highlands of northern Peru.

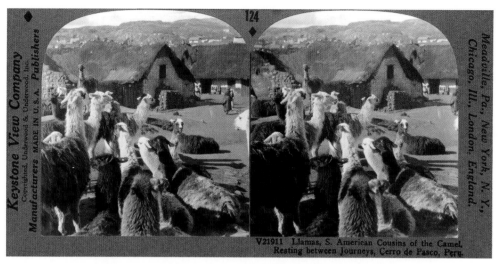

1. Stereoview, Keystone Company, ca. 1920: "Llamas, S. American cousins of the Camel, Resting between Journeys, Cerro de Pasco, Peru."

Pizarro's company of soldiers approached Cajamarca from the north. They had entered the Inca realm at its far northwestern margins, marching from the coastal settlement of Tangarará, Ecuador, to highland Cajamarca over a period of about three months. It was a journey of several hundred miles, and they arrived at Cajamarca exhausted. Even so, Pizarro's band made the trip with relative ease. Moving along Inca highways, the Europeans had merely to proceed along roads laid through the Andean landscape by the Inca state.[23] The highways were between four and ten meters wide, paved with stones or gravel.[24] The route into the highlands just extended before them. Its smooth grades and straight runs cut efficiently through the Andes' difficult terrain – along the edges of northern Peru's coastal deserts, through gaps in the mountains, past sources of water and pasturage, storage-houses and shelters.[25] The Inca road entered Cajamarca by way of a narrow valley north of the main basin, most likely along the same path as the present highway National Route 3N. The Europeans crested the final grade above Cajamarca late in the day, arriving there among squalls, long shadows, and rich colors.

Andean South America is a region of great geographic diversity, and harsh extremes of terrain, climate, and seasonal cycles. In the broad Andean landscape, islands of fertility and abundance are dispersed among vast oceans of barrenness. In this environment, Inca patterns of political administration, settlement, and ecological exploitation were "archipelagic": so many geographically dispersed islands of production were bound together within far-flung systems of differentiated but complementary resource-exploitation.[26] This was also true of the Andes' sacred geography: centers of sacred authority were dispersed among inert hinterlands. As sacral center-places, Inca dynastic

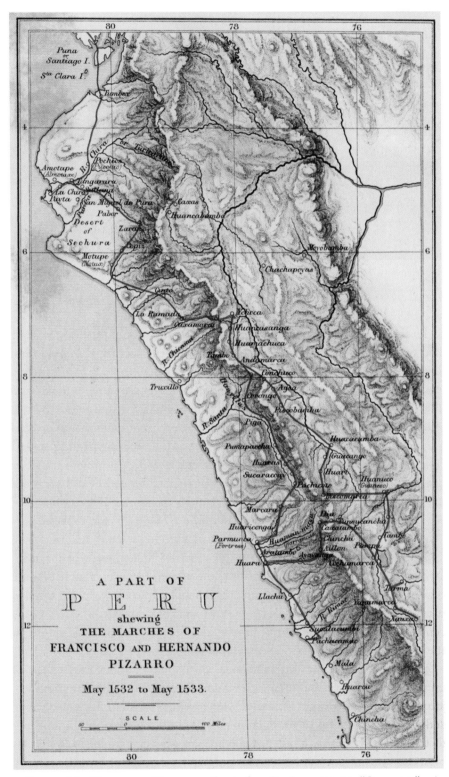

2. Route of the Pizarro expedition across the Andean Region, 1531–34. "Caxamarca" near center at 7°09′25″S, 78°31′03″W. Map from Clements R. Markham, *Reports on the discovery of Peru*, vol. I (London: Hakluyt Society, 1872).

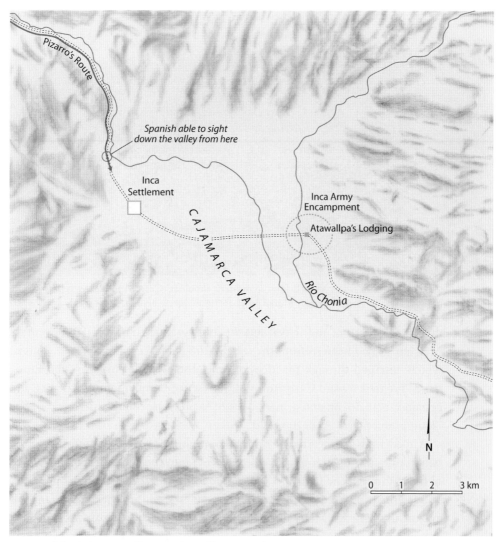

3. Map of the Cajamarca valley. Map by William L. Nelson.

centers and administrative settlements lay within the successive zones of their proximate and distant peripheries. At once radiant and gravitational, those centers anchored the centrifugal and centripetal energies that moved across the concentric landscapes in which they were set.

This is to say that the sacred centers of the Andes – the Inca adminis-trative center of Cajamarca among them – typically lay at the end of long journeys. To be sure, they were fixed places, locales of concrete geographical and spatial coordinates. Though the Andean center of authority also acceded to the status of sacral heterotopia – the elevated status of a *qozqo* (cuzco) – by means of the physical movement, temporal duration, and staged progress toward or away from it. Andean centers were thus constructed from the allied

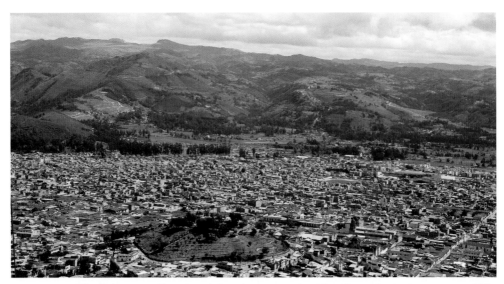

4. The Cajamarca valley viewed from its western shoulder: Cerro Apolonia at center middle ground, Plaza de Armas (former Inca main plaza) immediately behind. (Photo: Eduardo Peláez)

dramas of departure and arrival and the long, graduated interval of movement between. It had been so from the time of the Andes' earliest oracular centers, which emerged through practices of long-distance pilgrimage.[27] The Europeans' progress toward Cajamarca valley presence numbers among the last, and certainly best documented, narratives of sacred space and experience of the "long pre-contact" Andean world.

A road leads to the rim of a mountain basin. The constricted space of a blind slot-valley opens out into a deeper vista into the Cajamarca basin. Weeks of travel through the highland Andes came into still focus in a fixed prospect, a "viewshed."[28] Below a formal settlement is seen, and beyond it, animals grazing in the fields. Mena and the others in the Pizarro company experienced a moment of perceptual discomfiture, *hallamos muchos pastores y carneros*. The Pizarro company had been enlisted in an elaborate dramaturgical scheme choreographed by the Inca state. The route taken and the view given were prepared events, calculated instances of scenographic experience.

From Mena's position at the valley's northern limits, the observer sighted south, down the length of the basin. The highland landscape was for the most part treeless, and the air dry: the gaze traveled far. The main Inca settlement lay near at hand in the valley's northwestern corner. Set at the eastern base of an abrupt rocky prominence now known as Cerro Santa Apolonia, the planned town made an orderly figure on the valley bottom (Figs. 4 and 5).[29] The settlement was marked by the geometry of its formal architecture, as well as its color – the reflective, high gray of stonemasonry, and the strong yellows and reds of painted walls. A large rectangular plaza was fronted on three sides by broad stone buildings; the plaza's fourth side was defined by a wall and a

5. Rendering of the Cajamarca settlement by Emiliano Harth Terré. From Horacio H. Urteaga, *El fin de un imperio; obra escrita en conmemoración del 4° centenario de la muerte de Atahuallpa* (Lima: Librería e Imprenta Gil, 1933).

portal that faced east, across the valley. The main road moved into the valley from that entry. The road crossed the basin in a straight line, then turned south as it neared the valley's eastern shoulder about six kilometers away.[30] Two small rivers crossed the valley floor; they joined into a single stream near the center of the valley as they flowed south. The road ran across their swampy banks as an elevated causeway.[31] The Incas' animals grazed in the fields to either side.

Muchos . . . carneros, "Many llamas": Petroglyphs from Chile's Atacama Desert give some sense of the scene that met Mena's eye (Fig. 6). Petroglyphs scattered among that region's oases and watering holes record the same culture of camelid pastoralism that the Inca state imposed on the Cajamarca valley several thousand kilometers to the north. Thanks to the diligent work of Chilean investigators, the rock carvings of the Atacama's upper Río Loa region are now well documented.[32] The boulders and cliff walls of that region may bear sprawling, elaborate depictions of grazing Inca llama herds. These petroglyphs commonly depict many, many animals in jumbled profusion. Round and cruciform motifs indicate stones to which the animals were tethered for pasturing. The occasional drover is present. Those human figures wear the characteristic Inca garment of a decorated square tunic. Petroglyphs like these occur along old Inca trading routes in Bolivia, Argentina, and Chile. They

appear to record the passage of Inca pack trains past local shrines and water-
ing holes.[33] Under Inca administration, the ancient pastoral tradition of the
Atacama region was incorporated into broader Andean networks of communi-
cation, trade, and warfare.[34] That kinesis was vested with new political urgency
as cultural discourse: so the animals worked into the rock faces of the Atacama
attest, and so, several thousand kilometers north, could Mena see as he looked
into the Cajamarca valley.

THE CAJAMARCA VALLEY WAS INCORPORATED INTO THE INCA EMPIRE SOMETIME
after the mid-fifteenth century C.E. By 1532 the settlement was the Incas' most
important installation in the northern Peruvian highlands.[35] Within the ideol-
ogy of Inca governance, Cajamarca was itself another *Cuzco (qozqo)* – a sacred
center that replicated the ritual and administrative functions of the imperial
capital within the local province.[36] Its urban plan was laid out in imitation of
the Inca capital fourteen hundred kilometers to the south. The town's most
impressive buildings and monumental spaces replicated the ceremonial and
administrative architecture of the Inca capital.

As was the imperial capital, central Cajamarca was bound to its surround-
ing valley by a complex network of line-of-sight visibility and processional
routes known to the Inca as *zeq'e* (in sixteenth-century Castilian orthography,
ceques).[37] Individually, those axes of movement and intervisibility bound Inca
observers to historical landmarks, mythological locales, and supernatural land-
forms within the visible landscape. Together, the many sightlines and avenues
of "the *zeq'e* system" imposed a hierarchy of relation on the landscape of the
Cajamarca valley, positing the seat of Inca administration as a sacral center-
place. They articulated the Inca administrative installation as an orienting pole
whence lines of sight and mobile bodies radiated out into and converged
inward from the settlement's hinterland.

The *zeq'es* of Inca Cuzco were relatively well documented in sixteenth-
century Spanish administrative reports. They were probably forty-two in num-
ber; all of them converged on the Inca temple of state at the center of urban
Cuzco.[38] No such administrative record survives for the provincial Inca center
of Cajamarca. Even so, certain traces of the Incas' sacred landmarks and net-
works of intervisibilty are not hard to discern in the Cajamarca valley. They
include the old Inca road that cut rail-straight across the valley floor from the
town to a set of hot springs on the opposite side of the valley. There is also
the rocky hill now known as Cerro Santa Apolonia, an imposing prominence
that juts up from the valley floor just to the east of the old Inca settlement;
carved ledges and pedestals mark lookout positions at the hill's peak. The hill,
too, is connected to the main settlement by an old Inca road that traces a
straight line of sight to Cajamarca's central plaza. A canal system in the hills

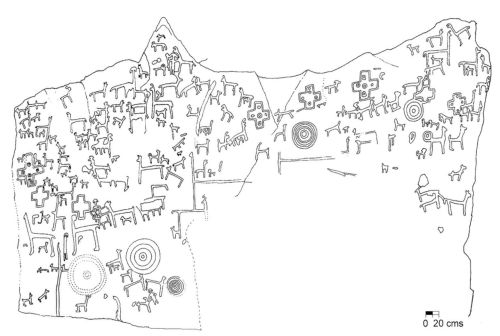

6. Inca-era rock carving from the Atacama region of northern Chile. From Flora Vilches V. and Mauricio Uribe R., "Grabados y pinturas del arte rupestre tardío de Caspana," *Estudios Atacameños* 18 (1999), Fig. 4.

west of town draws water from among prominent geological formations and narrow side valleys; rock carvings along that canal's path recognize lines of sight through those natural features.[39] An eighteenth-century churchman and historian reported the remains of an elaborate Inca shrine on the nearby mountain of Tantalluc.[40] Other than this reference, little written evidence exists to confffirm the Incas' recognition of those features as cultural landmarks; even so, they are obvious components of Inca Cajamarca's sacred landscape. And then there is Mena's account, which cites a line of sight that replicates principles of Inca landscape planning found in the Cusqueño administrative records. While there can be no sure telling, Mena's report appears to document an Inca *zeq'e*; his account amply recalls the forms of sacred visual experience identified with such planned views across Inca imperial landscapes.

The valley prospect before Pizarro's soldiers constituted a planned Inca *zeq'e* that was defined by the line of sight from the road at the northern edge of the valley to the urban center and its surrounding fields. In turn, that view triggered in the observer a form of response broadly recognized in the Quechua-speaking tradition as *wak'a*.[41] The term is inexact, a fact that owed in no small measure to its entanglement with sixteenth-century Spanish campaigns of religious extirpation.[42] In the most general sense, a *wak'a* may be identified as a sacred happening, an event that occasions conditions of elevated phenomenological and cultural experience. It was an intensified state of being linked to sudden,

disruptive variance in the stream of sensory perception and cognitive awareness. The *wak'a* was performative and phenomenologically chiasmic, a function of human affective response. The Incas' *wak'akuna* (or, *wak'as*) triggered limbic states of surprise, fear, or excitement: these bodily affects were among the principal responses by which Andeans recognized the divine.[43]

The term *wak'a* was by no means specific to Inca discourses of vision or landscape. It is the case, however, that the Inca specifically identified certain episodes of vision in the landscape as *wak'a*. This fact is documented in colonial Spanish inventories of the *zeq'es* and allied sacred locales once venerated as sacred by the pre-contact Inca state in the Cuzco valley. Those lists cite places along the major roads outside Cuzco as *wak'a*. In each case, the *wak'a* was identified and venerated on the basis of the perceptual reorientation that travelers experienced as they passed those points in the road. They are recorded in the colonial lists much as Mena's account describes his experience at the edge of the Cajamarca basin: "A high road . . . where the view of the city fell away," reads one. Another says, "a gulley along the road . . . at which point the view of the valley of Cuzco is lost."[44] And another again: "A hill at which point the vista onto Cuzco disappears."[45] The *wak'a* of Cuzco generally cite movement away from the main settlement; this is a documentary ellipsis of much more dynamic centrifugal and centripetal energies in Cuzco's landscape. In every case, the *wak'a* is cited on the basis of the perceptual reorientation that travelers experienced as they passed those portions of road. The records note views that opened up and closed again as the traveler moved through the countryside, or particular points at which prominent features were momentarily framed in the landscape (between "portals" or "little openings" *puerta, porteçuela*): "A flat spot between two hills where the view of one is blocked and the view onto the other opens up, and only for this reason they worshipped it."[46] Still other cited instances of *wak'a* mark the uncanny resemblance between distinct, unrelated landforms: they mark, that is, the instant of the mobile viewer's sudden recognition of visual similitude among distinct and widely separated landscape features.[47]

Unexpected viewsheds and eye-catching prospects were components of the network of *zeq'es* around Inca Cajamarca; they were also part of a broader Inca culture of "dynamic display" – the processions, ritual treks, and other journeys by which Inca bodies moved through sacred landscapes.[48] In turn, those kinetic phenomena carried forward more ancient Andean traditions of "landscapes of movement."[49] Andeans' interventions in the landscape – scratchings into rock faces, shifted soil, carved boulders – alternately marked routes of movement or anchored long-distance viewsheds that opened along the journey. The Nasca lines – monumental geoglyphs now recognized as processional avenues and lines of sight – offer a well-known instance of this broad Andean tradition.[50] Elsewhere in the southern Andes, groups of geoglyphs addressed

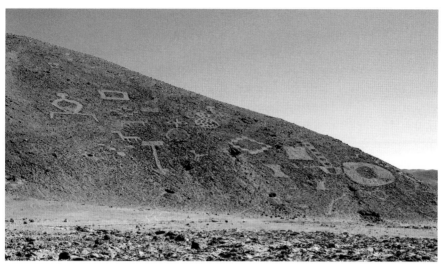

7. Geoglyphs near Iquique, Chile. (Photo: author.)

broad desert pans along caravan routes: at such sites as Iquique, Chile, costume patterns, llamas, and other power symbols were inscribed onto hillsides over-looking a major Inca artery of traffic (Fig. 7).[51] Monumental geoglyphs could also occur in the agricultural landscapes of the Andean highlands. Above the town of Macuspana (Huarochirí Province, Perú), for instance, a processional avenue moved through an elaborate system of agricultural terraces toward a sacred mountain peak (Mt. Koryokpa); the path moved through a monumental geoglyph that inscribed the stepped motif of a sacred mountain.[52]

The Inca and other Andeans recognized in the universe a complex economy of coursing energies and shifting balances, "an endemic restlessness" of numi-nous force.[53] The Andean discourse of mobile energies was encoded in the circulation of bodies through the landscape. Those kinetic bodies were them-selves a medium of transformation and energy relay. The Incas' sacred landscape existed only to the extent that it was inhabited by sentient, responsive bodies. That landscape's mobile energies excited sacral states of affective human experi-ence, and its sacrality was constituted in them. The Incas' *wak'as* recognized and facilitated that kinesis, marking those points in the landscape where its energies were strongest because most sensible. The Inca understood the body's states of being as states of becoming: they were encoded into the Incas' language, whose structure encodes states of transformation and change: Quechua includes not simply the verb "to be," but proper vocabulary expressing "to be at," "to become," "to get," "to feign," "to pretend to be."[54]

Moving past the valley rim, Pizarro's company passed into the larger Caja-marca basin, and from one framework of visibility to another. The view that opened before them defined the "near valley" context – the line-of-sight to the Inca settlement, which constituted the immediacy of that center's power.[55]

The crest on the hill above the valley was a specific point in space, one terminus of an Inca *zeq'e* that was fixed at its opposite end by the monumental settlement and its surrounding fields. This *wak'a* was a particular locus, though also a condition of response and recognition. The *wak'a*'s potency lay in its ability to fix the observer along an uncertain horizon line of present and not-present, site-specific immediacy and disembodied imagination. That sacred place – that is, the viewshed and the affect it triggered – was the boundary marker of the Inca capital, its symbolic city gate. That emplaced experience was as much part of the Incas' imperial "infrastructure of control" as the system of roads and way stations that had conveyed the Europeans to the rim of the Cajamarca basin.[56] "It is like a portal," a Spanish Jesuit recalled of one *wak'a* at the crest of the Cuzco valley.[57]

THE VIEW INTO THE VALLEY WAS ORIENTED ON THE INCA SETTLEMENT'S formal architecture and radiating roads. It also encompassed the more fluid if no less stark fact of Incas' great herd of llamas: in those animals, multiple temporal frameworks of Andean cultural practice came to fullness and peaked in unison. They marked the unsettling culmination of at least three developments: several thousand years of Andean ecological practices; the centuries-long evolution of the Inca state; and the recent meteoric expansion of Inca military power into the northern Andes.

Mena and the others in Pizarro's band had seen llamas in the highlands, though not in these numbers. Few Andeans had witnessed a herd of this size, either. It was an extraordinary sight, for a vast flock of llamas is the product of the least elastic elements of the Andean ecology – land, time, and luck. Selective breeding over thousands of generations left the animals with key biological weaknesses: low fertility, newborn frailty, and vulnerability to disease.[58] A gestation period of eleven months yields a single offspring; newborn crias easily succumb to cold and predators. Frost, hail, and lightning are common at high elevation; bad weather and disease may nullify years of increase. (The highland fox, *atoq*, occupies a place of particular ambivalence in the lore of highland Andean pastoralists.[59]) It is also the case that herd propagation cannot be intensified in the same way as agriculture. There exists no means to increase the rate or speed the cycles of the animals' reproduction. Increasing a herd's size requires more (and better) land, more animals, and more time. Any large herd was an indication of superlative wealth; it was power in the raw.

Inasmuch as the great herd intruded into the minds of its witnesses, those animals also obstructed awareness of the valley's fundamental economic activity: maize agriculture. Under Inca administration, this region was one of

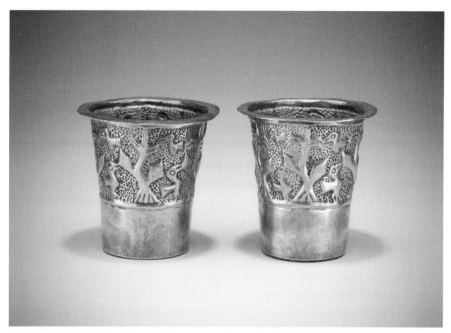

8. Pair of beakers depicting birds in a cornfield, Inca (south coast), ca. 1100–1438 C.E., gold, each 7 × 7.3 cm. Kate S. Buckingham Endowment, 1955.2589 a-b, The Art Institute of Chicago. Photography © The Art Institute of Chicago.

the highlands' great centers of maize production.[60] Inca social practice and administrative protocol required beer, and beer required corn.[61] The provision of corn beer at feasts was one of the principal means by which the Inka state formed alliances, paid its moral debts, and confirmed the obligation of its subjects.[62] A pair of Inca-era metal drinking cups now in Chicago bear the likenesses of birds in high corn: the cups depict the source of the beer they bore to users' lips (Fig. 8). To increase the production of corn in Cajamarca, the Inca had resettled farming communities there from low-elevation regions to the valley's west and northwest: communities of Pacasmayo, Zaña, Collique, Chuspo, Cinto, and Túcume were inserted into the valley's social and physical landscape.[63] A community of potters was also moved to Cajamarca from the Lambayeque River Valley; they produced the ceramics in which corn was stored as grain, and later processed and served as food.[64] Most of Cajamarca's corn appears to have been not consumed locally, but shipped south to meet the needs of Cuzco and other centers of Inca dynastic power.[65]

Cajamarca and other large Andean valley systems are topographically and climatologically varied environments. They consist of so many local microenvironments determined by altitude, topography, weather, soil conditions, and the availability of water. Herding complemented maize agriculture because the

animals did not compete with corn for the scarce ecological resources of mid-elevation. The animals were well suited to colder, windswept grasslands found above 4000 m. There was always danger at that altitude – again, from hail, hard freezes, and predation – but the animals did well in those high grasslands, where they required few herders and no standing water. During the growing season camelids were generally transhumed to those high pastures where corn and other low- and mid-elevation crops will not grow. The animals' dung was used to enrich soils on which the animals themselves did not graze; prize llamas were sacrificed to ensure the growing season's rains.

The cultivation of Andean maize and camelids, archipelagic complementarity, seasonal cycles of planting and grazing: all those phrases suggest an equilibrium of culture and environment. They point to judicious planning, sound economic administration, and careful husbanding of natural resources.[66] Such is an accurate characterization of Inca administration in the Cajamarca basin. Though it is also a profound misrepresentation, for it significantly underrepresents the dynamism inherent in Inca practices of social and ecological exploitation. Crop intensification and large herds of ruminant animals inflicted profound disequilibrium on the valley's environment. The Incas' simplified, maize-heavy crop mix stresses any soil, depleting its nutrients in only a few seasons; hungry animals quickly exhaust pasture.[67]

That ecological volatility in the valley was accompanied by – it was accomplished through – correspondingly assertive alterations to Cajamarca's social landscape. Inca administration reconfigured the valley's ethnic populations and settlement patterns. The foreign communities resettled to the valley joined an already complicated mosaic of peoples there. They upset local political détentes and enmities alike, remanding all arbitration to higher, Inca authority. By obscuring awareness of Cajamarca's primary role in the wider Andean economy, the animals grazing in the valley only underscored a deeper truth: the Cajamarca valley was an imperial landscape, and thus profoundly unsettled.

All the volatility implicit in Inca administration was exacerbated now, at the very time of the year Mena looked down into in the valley. The Andean highlands are governed by an annual wet/dry weather cycle, and the wet season generally comes to the northern Andes after mid-November. Temperatures begin to climb at this time of the year, as does precipitation. The wet season's strong rains bring nourishment to the landscape, though also strain. The Incas' corn was most vulnerable now after mid-November: planted in August and September, the plants had been irrigated with canal water over the ensuing months. The seed had germinated, and the young shoots were subject to the vicissitudes of highland Andean weather – at once dependent on natural rainfall and prone to the accidents of inclement weather.[68] With the increased humidity, too, came pests and disease: insects, rodents, and fungus. No other phase of the agricultural cycle entailed such risk for the Inca cultural order.[69]

But there the animals were, gorging themselves on the basin's young corn and tender grasses: the great herds in the valley flatly denied the season's dangers to the agricultural cycle. Typically the Incas' camelids were shifted away from agricultural fields at this time of year. The animals were transhumed to higher grasslands that burgeoned in the wet season's rain and warm temperatures. It is the case that Andean lamoids do not have the deleterious environmental impact of European sheep.[70] Even so, grazing animals will quickly destroy sprouted cornfields. They will do more damage than this. Those ruminants on a valley's skirts and bottom pushed the valley well beyond its ecological carrying capacity. To collect that many llamas in one pasture was to kill the land by overgrazing. The flocks in Cajamarca's fields disrupted the very agro-pastoral cycles that Inca administration otherwise sought to sustain. With their transhumance to the valley, the Inca sacrificed one logic of imperial administration to serve another.

The animals on the valley floor were not local livestock. Foreign to the valley, they were pack animals, tens of thousands of mature, castrated males. They were a military technology, their teeth grinding down the valley's greenery. Their management met the dictates of state-administered violence, not ecological sustainability. They were the means to transport goods and materiel over long distances, and to feed and ritually sustain an army on the march. Called by the Incas *wakaywa* or *apaq llama* ("porter-llamas"), each animal could carry a load of between 25 and 60 kg about 15 to 20 km per day.[71] (By dint of heavy loads or cultural protocol, royal caravans moved more slowly, perhaps only 4 km per day.[72]) Inca pack trains required relatively few handlers – perhaps one per 15 to 30 animals. The animals were slaughtered to feed the army: they were a ready source of food on the trail, "walking larders."[73] A 125-kg animal yields 46 kg of meat, which is savory when fresh and more than palatable when salted and dried.[74] The animals' blood and meat were sacrificed to the Incas' supernatural patrons. Other than human beings, llamas were among the Incas' most prestigious ritual offerings: it is for this reason that the handles of Inca ceremonial knives often bear the likeness of camelids (Fig. 9).[75] The great herd was a means for long-distance mobility, a steady food supply on the trail, and compliance with ritual obligation all the while: they were the basis of Inca military force projection, creatures of empire.

THE INCAS' LLAMAS HAULED LOADS, ATE MARGINAL GRASSES, AND PRODUCED rich manure. They submitted to the knife handled by priest and butcher. They hummed and clicked at signs of danger in the pasture; during Inca rituals they emitted gurgling songs on cue.[76] They were also keenly observant, with good eyesight. But to Inca understanding, llamas did not see. Vision was a higher faculty, one the animals' mere biological function could not encompass. Only humans and supernatural beings possessed the capacity of vision: sight

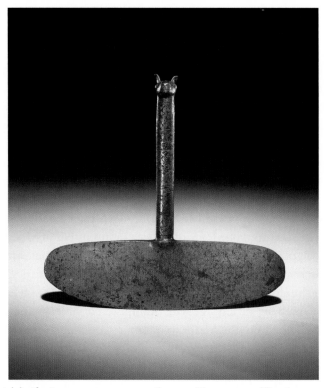

9. Ceremonial knife, Inca, 1450–1540 C.E. Bronze. H. 15.7 cm; W. 16.4 cm. Dumbarton Oaks, Pre-Columbian Collection, Washington, DC, PCB 482. Photo © Trustees of Harvard University.

in its fullest sense engendered thought, language, morality, and ethical conse-quence.[77] If the animals themselves did not see, they instigated the judgment of those beings who did. To the Andean observer a great herd occasioned moments of heightened recognition, forcing the awareness of cosmological pattern and political order.

Here, then, in the temperate highland valley of Cajamarca was a force of impressive size. It was ecologically intrusive, economically disruptive, and men-acingly aggressive. In important respects the great herd of llama was also cultur-ally foreign to the Cajamarca region. In the mythology of the Inca leadership, camelids' primordial origins were traced to the southern highlands. The first camelids were understood by the Inca to have emerged from the high grass-lands' caves and glacial lakes.[78] The animals' fertility was comprehended as an aspect of that sacred landscape's generative capacity.[79] In turn, camelids iden-tified the Inca leadership's mythological origins in those same landscapes: gold and silver effigies of llamas – the "Gold" and "Silver Heralds" (*cori napa, collque napa*) – were carried before the Inca ruler when he traveled.[80] Like other Inca effigies of camelids, those borne before the Inca ruler were executed in precious materials infused with the visible essence of the southern Andes'

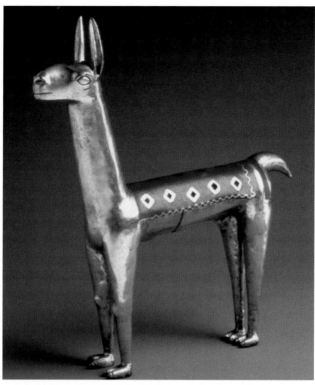

10. Silver llama figurine, Inca, ca. 1450–1532 C.E. H. 24.1 cm. American Museum of Natural History B-1618. Courtesy of the Division of Anthropology, American Museum of Natural History.

sacrality – the gold of sunlight at high elevation, and the silver of its moonlight. A fine effigy in silver is preserved in New York's Museum of Natural History (Fig. 10). Other Inca camelid effigies were executed in minerals infused with the strong, variegated colors of that region's lightning strikes, rainbows, and coronas (Fig. 11).[81] The Incas' affinity for the animals also followed from their importance to the mobile, violent human lifeways of those high grasslands – its nomadism, marauding, and caravan trading.[82]

If central to the ideological construction of Inca royal leadership, pastoralism hardly played a defining role in Cajamarca's economy. At the time of the European arrival in the Andes, pastoralism had long since spread to the northern Andean highlands and to low-altitude regions up and down the coast. In the Cajamarca region, local elites had managed complex herding economies for a thousand years or more.[83] Even so, the southern highlands remained the geographic and cultural heartland of the practice: pastoralism there was historically deeper, more territorially inclusive, and more central to local subsistence economies. In coastal areas, by contrast, camelid pastoralism was possible only through concerted husbandry.[84] Well into the nineteenth century, observers reported high rates of mortality in llama caravans that

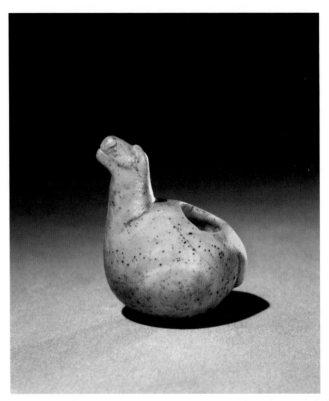

11. Llama effigy (*conopa*), Inca, 1450–1540 C.E. Serpentine with inclusions of chromite. H. 5.6 cm. Dumbarton Oaks, Pre-Columbian Collection, Washington, DC, PCB 431. Photo © Trustees of Harvard University.

traveled to the Pacific from the highlands: "despite all the care taken, a great number of llamas die in each journey to the coast" wrote naturalist Johann von Tschudi in 1847.[85] (In the early years of the colonial period, native artists on Peru's coast would anatomically conflate camelids with horses: like horses, lamoids were exotic, prestigious animals sustained at great expense [Fig. 12].[86]) Colonial Spanish administrative records suggest that the Inca resettled herders to Cajamarca from the Huambo district of the southern highlands.[87] Even so, it appears that the Inca maintained no permanent herds of great size there, even at the height of Inca administrative presence in the region: Cajamarca's grain was carried south by human porters, not llamas.[88]

The herds in the Cajamarca valley thus superimposed one material and cultural economy over another, and thus one geographic and cultural landscape over another. As they grazed in the valley, the southern Andes' grasslands and its lifeways were emplaced in a mid-elevation valley in the northern Andes.[89] This symbolic remapping of the landscape and economy emphasized the mythic southern origins of the dynastic Inca power, as well as the violence of the Inca state's expansion north into the Cajamarca region. That mythic template was laid over the ecological and ethnic strains of a regional agricultural valley. This

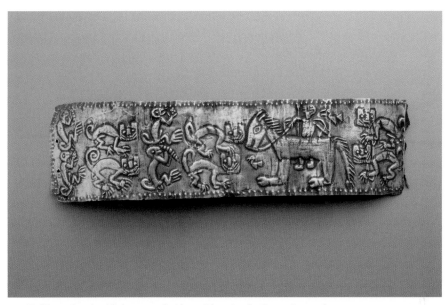

12. Gold armband with horse and rider with animals, Inca, sixteenth century. 254 × 6.2 cm. Kate S. Buckingham Endowment, 1955.2608, The Art Institute of Chicago. Photography © The Art Institute of Chicago.

imposition only intensified those local tensions, disrupting the valley's cycles of agricultural production. At the same time, it suppressed those parochial conflicts by promoting a more global mythology of Inca dominance. The animals reprised that pan-Andean political and ecological disruption: their transhumance to the Cajamarca valley reenacted the military kinesis of the region's conquest by the Inca leadership.

The llamas grazing in the Cajamarca valley embodied the static force of Inca power in the Cajamarca valley. They also affirmed the Inca authority's perpetual motion: they epitomized a pan-Andean flow of goods, prestige, and violence. They were at once premonitory reminders of the Incas' local presence, and the local means of access to the Incas' more geographically extensive networks of power. The Incas' grazing animals theatricalized both the hard facts and the beckoning opportunities of Inca political dominance.

In the Inca empire, all domesticated camelids were the property of the state: every animal was subject to the Inca leadership's prerogative to exploit, transhume, or sacrifice. Through his largesse, the Inca ruler parceled out animals to his clients and subjects. Clients were allowed to exploit the Inca ruler's animals – not possess them outright – provided that the state received due tribute in return (annual tribute obligation, labor service over the long term, or political loyalty). There were smaller herds in local hands – among the empire's lesser communities and ethnic peasantries. Those animals were there by the state's indulgence: they were understood implicitly as the Inca ruler's gifts to his subjects. Those herds could be confiscated and repartitioned as a

means to punish or reward the Incas' political subordinates. These practices of gift giving and confiscation operated on down the ladder of political power. Lesser lords who received herds from the Inca leadership could give animals as gifts to their vassals in turn. By subordinating themselves to the Inca, provincial leaders might come away with an immediate and considerable upgrade in social prestige, particularly on the level of local politics. This kind of gift giving – "institutional generosity," it has been called – was a pillar of Inca imperial strategy.[90] By some accounts, the mature Inca empire strained under its obligations to bestow lavish gifts on its client lords across the Andes.[91] There was no material shortfall here at Cajamarca: the animals were there for the asking.

The animals might also be harnessed to the Inca politics of food: eaten. Llama meat was a prestigious food, and a centerpiece of Inca feasting. The vast herd in the valley extended the invitation of Inca hospitality and commensal celebration. The richness of llama meat betokened other forms of Inca wealth that might be distributed at the feast: corn beer and high-flown oratory; gleaming metals, lustrous stones, and fine pottery; garments of supple fabric and brilliant colors. In accepting those gifts, the Incas' adversaries-turned-partners entered into a traditional Andean relationship of submission to Inca political authority.[92] By the Andean custom of *mink'a*, "brideservice," the Incas' clients would owe the Inca state obedient service, as a dutiful husband owes the wife who serves his meals.[93] This was the customary means by which the Inca leadership negotiated its dominance over the empire's provincial elites. Those animals could feed two armies, both the Inca and the Incas' erstwhile enemies: this was their suggestion. (During their march to Cajamarca, the Pizarro band had received Inca messengers bearing dishes of prepared llama meat; the Europeans' native allies advised them to refuse those gifts.[94])

The Incas' llamas may have offered the open hand of Inca patronage, though they also brandished the fist of Inca military power. The great herd facilitated – promised – a long campaign should the Incas' enemies refuse to come to terms. A long campaign was what the Inca leadership appears to have intended. Here the historical sources are scattered and contradictory. Even so, they suggest that the Inca army camped in the Cajamarca valley was a punitive expedition mounted in the wake of a bitter factional war within the Inca leadership.[95] This was the army of the victorious faction, now hardened, and on a campaign of military reprisal among their old enemies in the northern Andes. Led by seasoned commanders, this army intended to bring restive ethnic groups within in the Incas' Ecuadorian holdings to heel.[96] The campaign was to last several years; or at least, this army was provisioned with animals to carry on that long.

THE VIEW FROM THE NORTH END OF THE CAJAMARCA BASIN COMMUNICATED A specifically Inca logic of ecological management: that prepared scenographic

experience was historically particular to the time that Mena and his fellow soldiers entered the valley. At the same time, that gaze was not historically unprecedented. The Inca were not the first to set their camelids against the backdrop of a formal settlement and a fertile mountain valley. Mena and the rest of Pizarro's soldiers were not the first to be posed before that Andean cultural landscape. Armies and administrators from the southern highlands had imposed on the landscape of the northern highlands before. The animals that grazed on the valley floor were only the latest chapter in a deep history of ecological imperialism in this region of the Andes.

The Inca leadership expanded their power into the central and northern highlands around the mid-fifteenth century.[97] They understood themselves as inheritors of a southern Andean imperial tradition founded by two ancestral states, the Tiwanaku and the Wari.[98] Both had declined before 1000, and the emergence of the Inca state took place in the vacuum left by their subsidence. In its dynastic lore, the Inca leadership identified Tiwanaku and its region with divinities who created and gave order to the Andes' diverse lands and ethnicities.[99] The Tiwanaku tradition afforded the mature Inca state the means to understand its own imperial project within an ideological framework of mythological temporality and cosmological typology. Tiwanaku works of art offer useful insight into Inca cultural ambitions, for those ancestral objects shaped the ideological framework of Inca state and cosmos.

Centuries before Mena laid eyes on Inca Cajamarca, the leaders of the southern highland empire of Tiwanaku had memorialized such imperial landscapes on snuff trays, elite-status goods employed in rituals of state (Fig. 13).[100] Carved in hardwood harvested in the forests east of the Andean range, the trays were preserved in high-status graves and ceremonial caches in the Atacama Desert at the Andes' western base.[101] That geographic interval between the Amazon and the Atacama was among the ancient Andes' most trafficked caravan routes. Wood harvested from the Amazon was packed to the Pacific coast by pack trains of llama: wooden snuff trays are the material products of the wide-ranging imperial system they mythologized. The contexts in which the finished trays were used remain poorly understood; the objects' occurrence in high-status funerary contexts indicates they were employed in ritual by the Tiwanaku leadership. The user employed a tube to huff powdered hallucinogens from the tray's sunken pan.[102]

Tiwanaku snuff trays often bear flaring handles worked with low relief in the stark, geometric Tiwanaku style. These compositions depict the circulation of cosmic energy through the cultural landscape imposed under Tiwanaku administration. Their compositions are organized around a principal figure that appears large in the pictorial field. This protagonist is typically one of three iconographic types: a radiant solar being, a predator (a raptor, feline, or sacrificer deity), or a camelid. Typically as well, the central figure is

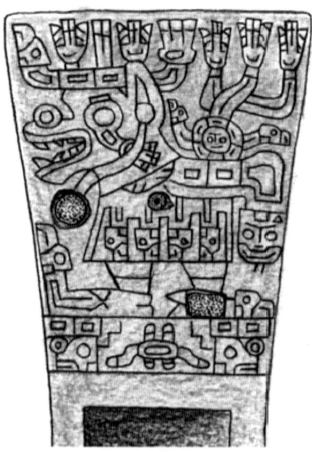

13. Rendering of snuff tray from the Atacama region, Tiwanaku, 100–800 C.E. From Agostín Llagostera Martínez, "Contextualización e Iconografía de las Tabletas Psicotrópicas Tiwanaku de San Pedro de Atacama," *Chungará: Revista de Antropología Chilena* 38:1 (2006), Fig. 10.

juxtaposed over a stepped motif. That visual device is a shorthand iconographic representation of the "generative landscape" – an iconic, semantically impacted device that represents both sacred mountains and human-made ritual structures. These compositions also include flower blossoms, feathers, and zoomorphic streams of color and light (avian and feline heads).

The scenes carved into these snuff trays describe the source of the imperial environment's energy (the sun), its relays (apex predators and sacrificing deities), and its repositories (camelids). They also identify the theater in which that energy flowed, a sacred landscape of mountains and human-made structures. Flowers and streaming bands of color are the phenomenal signs of that environment's mobile energies. The compositions describe mobility through time, space, and cosmos: flowers that bloom over the yearly temporal cycle, birds that rise to the air, and light that suffuses the theater of existence. The

imagery on these Tiwanaku snuff trays represent the visual trance state the hallucinogenic powder on their surface sought to induce. The carving depicts – and the snuff brought on – the same enhanced perceptions and sacral energies as the view Mena and the other soldiers took in from the rim of the Cajamarca basin. The language used by a colonial administrative citation of one *wak'a* in Inca Cuzco characterized that kinesis: like boiling water (*de modo que hierue el agua*).[103] That administrative citation transhumed into Castilian what was then a common image in the Inca cultural imaginary of landscape. Among the Inca leadership, boiling water was a discursive topos of beauty: it indicated effervescent springs, the iridescence of hummingbirds, the rapid motion of the eye, and the animation of light reflecting off limpid surfaces.[104]

The mind boiled: Mena was attentive enough before the view of the Cajamarca valley. Historians often insist that the Pizarro band entered the Inca realm at an opportune time for Europe's imperialist designs.[105] In some ways that is true: Eurasian diseases introduced to the Americas a few years before had done great damage to Andean populations, and they would do more harm in the coming years.[106] Though in so many other respects, the blind chance of the historical process favored the Inca: entering the Cajamarca basin, Pizarro and his men blundered into the teeth of the Inca state's imperial landscape. Even so, to Inca understanding Mena and his European readers were morally uncomprehending, and thus unseeing like the animals down in the valley.

CHAPTER TWO

UNDER ATAWALLPA'S EYES

Una manta que le cubria todo . . .

A sheet completely concealed him.[1]
Juan Ruiz de Arce, 1543

"Openweave" is skeletal, weblike fabric that was produced in the river valleys of coastal Peru after the eleventh century C.E.[2] Andean weavers worked with undyed, overspun cotton. They anchored networks of traveling warp (vertical) threads within static flights of weft (horizontal) fibers. In effect, the cloth was opened up as the fabric structure was built out. Held at the corners, a finished piece of openweave may be raised upright. It falls as a square of marbled crepe, light and transparent (Fig. 14).

The Estremaduran soldier Juan Ruiz de Arce could see as much. Late in the afternoon of 15 November 1532 he stood with about twenty other soldiers in the courtyard of a monumental Inca architectural complex on the eastern edge of the Cajamarca valley. Francisco Pizarro had sent the party forward as an embassy to the Inca ruler: they were to invite the native king to meet with Francisco Pizarro in central Cajamarca, and they were to take their measure of the Incas' forces across the valley. The massacre in Cajamarca on the following day is often recalled as the Inca leadership's first encounter with Europeans; but this occasion – there in the Inca ruler's courtyard the afternoon before – was in fact the first meeting of Europeans and the royal Inca leadership. This earlier episode is less heralded in historical writings, for it hardly confirms the Hegelian fable

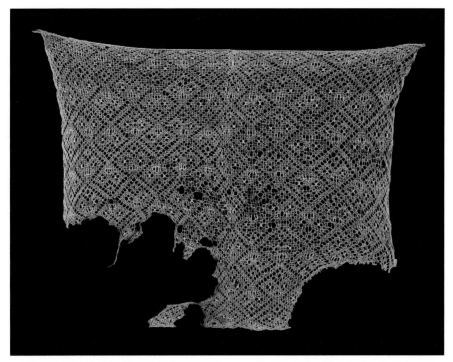

14. Openweave cloth, Chancay culture, c. 1400 C.E. Cotton embroidered square mesh open-work. 81.3 × 114.3 cm. Museum of Fine Arts, Boston, gift of Mrs. Samuel Cabot, 60.1134. Photograph © 2013 Museum of Fine Arts, Boston.

of the West's emergence. The meeting in Atawallpa's palace has much to tell concerning visual experience and power among the Inca leadership.

When he first saw the Inca king, Ruiz recalled, the native ruler was seated "behind a sheet that completely concealed him."[3] Another soldier described the scene with more words,

> The Inca [was seated before] a small house . . . in front of him, two women – one on either side – raised a sheet of thin cloth, so sheer one could see through; screened this way, no one could see the Inca directly.[4]

The Spanish adventurers stared while the veiled enemy gazed back. As the scrim was drawn across the Europeans' cone of vision, the Inca ruler was framed within the space, bracketed from ordinary human exchange. The cloth effected the observers' estrangement from courtyard's phenomenal terms, forcing a concomitant quickening of space's semiotic values. Those standing before the cloth were ratified as viewers; those beyond it were semiotized, incorporated into a cultural traffic of signs. The spatial coordinates of surface and interval were supplanted by the epistemological signs of culture as they are legible. That operation was staged on both sides of the cloth: viewers on either side saw, and they were seen in turn. As Pizarro's soldiers peered through the transparent fabric, the sensory faculty of sight was marked, given a cultural mode: whether

fitfully tangled or cleverly imbricated, Atawallpa's observers were woven into the fabric of the Inca cultural order, caught looking.

"HOW IS IT POSSIBLE," LUDWIG WITTGENSTEIN ASKED, "TO EXPERIENCE [meaning] in an instant? . . . What are we to think of that odd kind of experience?"[5] Wittgenstein's commentary on visual perception and cognition also has something to tell about the Inca order of vision and power. The philosopher characterized instants of perceptual insight as *Erleuchtung*. It is a semantically impacted German term – an intensified form of "illumination" or "lighting-up" that translates most directly to "inspiration" or "insight." With the word Wittgenstein referred to the suddenness and immediacy of visual comprehension, as well as its improbably complex ramifications. This jolting incandescence of sight and insight veers close to Inca conceptions of the sacred broadly identified as *wak'a*.

The veil raised before Atawallpa's visitors was another *wak'a* – a flaring of the sacred into human perceptual awareness.[6] It was a sacred happening that disrupted the very perceptual terms in which it was evident. Performative, temporal, and site-specific, it was akin to other *wak'as* recognized by the Inca leadership: eclipses and planetary alignments, the sun at high noon, lightning strikes or down-gusts of wind, and the traveler's glimpse of the valley at the crest of the mountain rim.[7] Like the glimpse of Atawallpa through the veil, all those events were sudden to come on and quick to pass. They instantiated sharpened moments of flux, metamorphosis, or alterity. Space, perception, thought, emotion, language, meaning: all were subject to reorientation or reimagining. These moments of perceptual discomfiture – the Incas' wonders – exposed the deep-seated fabric of the world. Posed before the Inca veil, Pizarro's soldiers were enlisted in this conjury of sacred energies.

THE VEIL SUSPENDED BEFORE THE INCA RULER PARTICIPATED IN THE DIPLOmatic protocol of greeting and intimidation typically accorded the Incas' enemies and aliens. The Inca freely admitted the small European party into Atawallpa's presence; the Inca ruler was secured from any real danger by high walls and as many as eighty thousand soldiers. We may well surmise that the Inca ruler and his retinue received the Spanish with patronizing interest. Firmer historical evidence indicates that the Inca leadership addressed the Europeans in the usual custom – with a hostile interview. The Inca leadership understood how to flatter foreign leaders if politics so demanded, though the Europeans did not receive this kind of hospitality here at Cajamarca.[8] The Inca showed them the treatment typically accorded to lesser foreign leaders and priests. They were ushered into the quarters of the Inca leadership, and there subjected to a charged meeting in which formal speech was exchanged

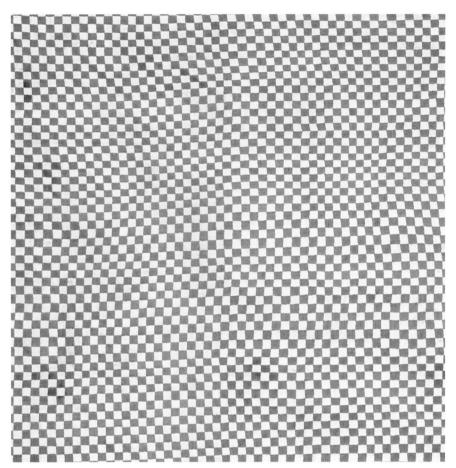

15. Cloth, Inca (?), 1450–1532 C.E. Cotton; discontinuous warp and weft. 184.15 × 180.98 cm. Los Angeles County Museum of Art, purchased with funds provided by Camilla Chandler Frost through the 2011 Collectors Committee M.2011.36.

over fermented maize beer. In these interviews the Inca demanded both deference and self-possession. Foreign priests, leaders, and holy objects that were silent in the presence of the Inca ruler were declared *atisqa*, "spent/done," and stripped of their power.[9] For the poised, the interview was the first stage in an elaborate sequence of initiations-by-trial.[10]

In size, the cloth raised before the Inca ruler was somewhere between a large kerchief and a broad sheet. Most swatches of Andean cloth tend to be narrow (less than 75 cm wide), for such were the backstrap looms on which the majority Andean cloth was produced. Several individual pieces produced on a backstrap loom may be stitched together to assemble a much larger finished work. Even wider pieces of cloth could be produced using more exotic looms or weaving techniques. One example is now preserved in the Los Angeles County Museum of Art, a cotton sheet woven in discontinuous warp and weft technique (Fig. 15). Produced on Peru's coast some time during the long era of the Wari and later Inca empires (ca. 900–1500 C.E.), that textile roughly –

though imperfectly – matches the Europeans' descriptions of the cloth raised before Atawallpa. It measures over 180 cm in both length and width, and so it has the kind of architectural scale and presence suggested in the soldiers' accounts. The fabric's discontinuous warp and weft technique means that the cloth presents a mosaic of small square panels, each one linked to its neighbors along all of its four sides. It is a fiber grid made up of hundreds of floating, independent swatches of cloth joined each other along both x and y axes. The cloth's cream-and-brown pattern is as unstable as it is monotonous: its small squares vibrate across the fabric's surface, as if straining to break free of the weave's right-angle geometry. The Spanish accounts of Atawallpa's courtyard seem to identify that sort of visual excitement, though their authors could only grope for words.

Pedro Pizarro described the fabric raised before Atawallpa as "thin . . . and sparse" [*delgada y rrala*].[11] The cloth in Los Angeles is neither sheer nor light, and so it is altogether too heavy to be the sort of cloth cited in the Spanish accounts. Any number of other Andean fabric types better suit the accounts' descriptive terms: gauze, passementerie, network, even loosely woven plain-weave. Openweave techniques were among the oldest forms of Andean weaving, having descended from the coastal mesh-weaves and fishnets of the third millennium B.C.E.[12] In the Inca era, some of the finest openweave was produced by peoples of Peru's central and northern coast: Chancay gauze, for instance (see **Fig. 14**). Fine textiles of non-Inca origin were common among Inca administrators and courtiers. As gifts and tribute from the Inca leadership's clients, such works only demonstrated the Incas' pan-Andean power.

IF INTEGRAL TO THE FABRIC OF THE INCAS' POLITICAL AND ECONOMIC SYSTEM, the raised cloth was also an architectural contrivance, a device of constructed space. The edifice in which the Inca received Pizarro's men is now gone, its stones plundered for reuse in the centuries since the Inca empire's fall.[13] It stood on or near the grounds of the thermal spa in the modern township of Baños del Inca.[14] Those hot springs – "los baños del Inca" – lie along the Cajamarca valley's irregular eastern shoulder. A stone-lined cistern there is traditionally identified as "the Inca's bath."[15]

Francisco de Xerez, the secretary to the Pizarro expedition, recalled Atawallpa's complex in his detailed account of the expedition:

> On the slopes opposite the town, . . . there was a fortress set on an escarpment (*peñol*), the greater part of which was cut stone. It was quite large, and surrounded by three walls that rise spirally. We hadn't seen anything this stout before.[16]

Xerez's notice describes the building as a kind of castle set on a natural prominence (*peñol*). Noting the structure was built of "cut stone" (*del tajado*), Xerez imparts both a sense of the building's materials – stone blocks – and its siting

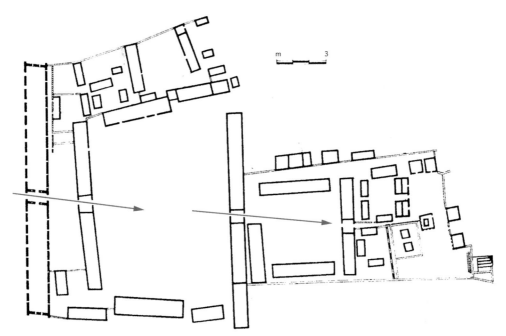

16. Plan of palace complex (zone I, subzone B) Huánuco Pampa, Peru. Inca, ca. 1450–1532 c.e. After Craig Morris, *Huánuco Pampa: An Inca City and Its Hinterland* (London: Thames and Hudson, 1987).

among abrupt natural rock formations. With "walls rising spirally," or "like a snail" (*subida como caracol*), Xerez refers to the curving walls that incorporated natural crags and escarpments into monumental Inca complexes. Many monumental Inca structures were sited directly atop natural rock formations this way – at Pisaq, Machu Picchu, and Ollantaytambo, as well as at Cuzco, the Incas' capital. Xerez's phrase "a strength such as had not before been seen" (*fuerças son que entre indios no se han visto tales*) insists on the architecture's workmanship and monumentality.[17]

The Spanish referred to the complex in which Atawallpa received them as "seat" (*aposento*) or "fortress" (*fortaleza*). Xerez noted that the structure was enclosed by several concentric walls – three in all. This description suggests a complex made up of several concentric or adjoining walled precincts – a pattern typical of Inca elite-status residential architecture (Fig. 16).[18] Larger Inca temples and domestic complexes were organized around successive courtyards framed by thatched, single-room structures. From the exterior of the complex, the visitor passed through a sequence of enclosed patios of diminishing scale and accessibility. Gated routes of entry restricted access to the innermost courtyards. Doorway apertures were tall, and usually of trapezoidal profile. Each doorway was at once gate and threshold; it bounded the individual precinct, introduced the new space beyond, and marked the progression of spaces through the wider complex. These portals typically gave on to narrow covered spaces before emerging into the next courtyard. The visitor passed

through a transitional space of enclosed darkness before emerging into the open, light-filled court beyond. The most prestigious space was found deepest within the building.

The soldiers' accounts describe a complex that conformed to this pattern. Once through the outer gate, the Incas' guests moved through a succession of broad courtyards.[19] The scribe Xerez described one patio thus: "Within Atawallpa's residence there was a court with four hundred Indians who appeared to be his guards."[20] Ruiz described the innermost courtyard of the complex as consisting of four "rooms/quarters" (*cuartos*) around a patio, by which he meant four single-story, thatched structures disposed around a square courtyard. Two of the buildings on the courtyard, he noted, consisted of "raised towers" (*dos cubos altos*): the axial structures of Inca residential blocks often had exaggerated crowns of thatch. Ruiz summarized the individual structures around the court with the words *casa pequeña*, "small house." Pedro Pizarro agreed, citing them individually as *galponcillo*, "a little shed." Though clipped, these descriptions well describe the individual component structures of monumental Inca domestic architecture. Alexander von Humboldt sketched Inca structures like this during his travels in Ecuador in 1802 (Fig. 17).[21]

Even in their most prestigious structures, Inca preferred relatively small-scale constructions of simple design and superlative masonry technique.[22] In the finest Inca buildings – and such we may consider Atawallpa's lodging above Cajamarca – stone blocks weighing between four hundred and several thousand pounds were individually cut and dressed, then fitted into the wall fabric without mortar. Walls were relieved by trapezoidal doorways and niches. These apertures dramatized the tectonic energies of the mural mass: their frames narrowed as they rose, canting inward as if squeezed by surrounding masonry. The standing ruins in the sacred sector of the Inca royal estate of Pisaq provide apt comparison: like them, the inner courtyard of the complex above Cajamarca was a technically surpassing set piece perhaps six to ten meters on a side (Fig. 18).

"THERE IN THE COURTYARD," REMEMBERED RUIZ DE ARCE, "[ATAWALLPA] SAT before the door of a house with his women."[23] "He was before his house," recalled Pedro Pizarro.[24] "The tyrant was at the door of his lodging, sitting on low stool, with many Indians before him, and women at his feet, who almost surrounded him," wrote Xerez.[25] Cristóbal de Mena set down much the same: "They found [the Inca ruler] seated at the doorway to his house, surrounded by many women."[26]

So the Spanish found Atawallpa among his retainers. He sat on a low stool – a *tiana*, the traditional seat of Andean leaders. This pedestal raised him slightly above the eye level of his seated attendants. All descriptions agree that Atawallpa was framed against the geometry of the architectural aperture behind him, his

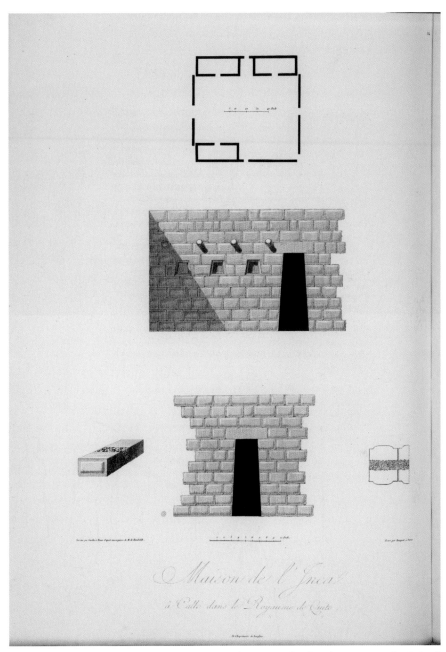

17. Inca palace structures, Ecuador: "Maison de l'Inca à Callo dans le Royaume de Quito." From Alexander von Humboldt, *Vues de Cordillères, et monuments des peoples indigenes de l'Amèrique* (Paris: F. Schoell, 1810), vol. II, 9. This item is reproduced with the permission of The Huntington Library, San Marino, California.

figure a silhouette in the doorway opening (Fig. 19). This Inca pattern of spatial organization and habitation was widely shared among Andean peoples. Similar scenes are represented in house effigies produced some centuries earlier by the Recuay of Peru's north-central highlands: a vessel now in Dallas includes a

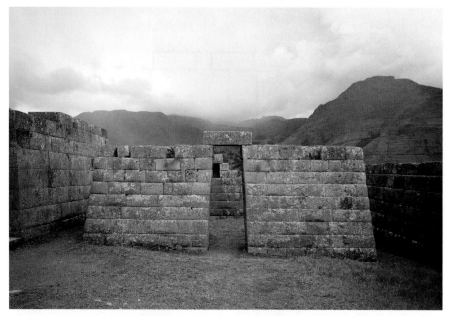

18. Inca palace structures, Pisaq, Peru. Ca. 1450–1532 C.E. (Photo: author)

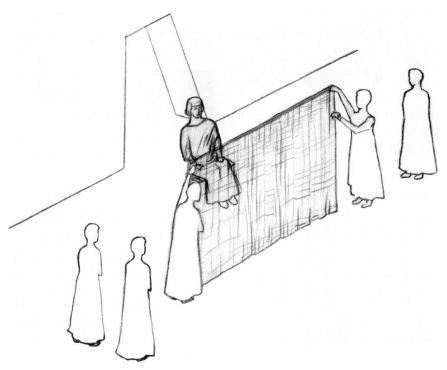

19. The Inner Courtyard: a spatial rendering. (Drawing: Diana Antohe.)

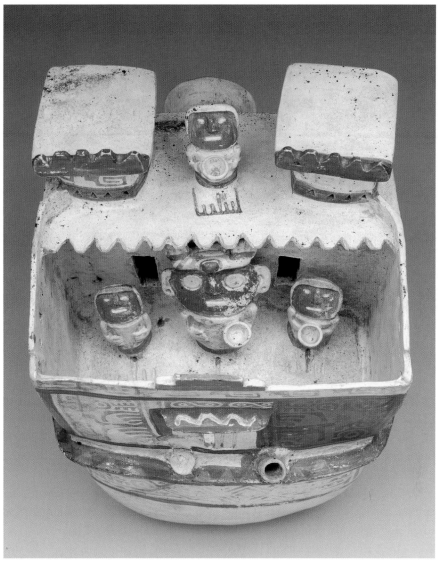

20. Ceramic architectural effigy, Recuay, 100–800 C.E. 26.35 × 17.78 × 19.05 cm. Dallas Museum of Art, the Eugene and Margaret McDermott Art Fund, Inc. 1970.23.McD. Photo courtesy Dallas Museum of Art.

ruler or other dignitary within the enclosed courtyard, seated on the building's main axis, flanked by attendants (Fig. 20).[27]

The see-through cloth hung in the space before the Spanish. A trapezoidal doorway opened along the building façade across the courtyard. The veil and the doorway opposite imposed an axis across the patio, a spine of energy down its centerline. Open and diaphanous, the two transparent uprights relieved expanses of wall otherwise both hard to the touch and impassive to vision. Though if the two apertures opened up the space, they also sealed and enclosed

21. Feather panel (macaw feathers and cotton cloth). Wari (Corral Redondo, Churunga Valley, Camaná Province, Peru), ca. 750–850 C.E. 68.5 × 209 cm. Saint Louis Art Museum, Museum Purchase 285:1949.

that precinct. If semi-transparent, they were bookending edges and boundaries all the same. There the visitors' movement was brought to a halt, the architectural narrative of the complex brought to culmination.

A patterned courtyard bounded by see-though edges: the Quechua language possesses a term for this rarefied space. It is *kancha*, a word current across most Quechua dialects from the pre-contact period through the present. The term refers to the physical structures that cordon, contain, or otherwise shelter cultural propriety and domestic life. Modern architectural historians widely associate the term *kancha* with the planning type of the walled rectangular block.[28] This identification is substantially correct, though usage of the term among Andean speakers goes well beyond architectural morphology. To the present in the Quechua cultural tradition, the term describes a human-made enclosure, a space for social propriety, whether domestic (home), pastoral (animal pen), or agrarian (sheltered field).[29]

Several important structures erected by the Inca state were described with the epithet *kancha*: the *Qurikancha* (Qorikancha, Cori Cancha), "Golden Enclosure," the principal temple of the Inca state; or *Jatunkancha (Hatun Kancha)*, the "Great Enclosure/Shelter," one of Cuzco's largest royal palaces.[30] In this toponymy, the word *kancha* described several aspects of the Incas' built environment. It referred most often to an architectural precinct *kancha* behind walls. The term had a broader semantic range than this, however. It suggested a culturally reserved space, a locus of elevated moral valuation and social prestige. Otherwise the term appears not to have drawn firm distinctions between domestic or public sphere, worldly or sacred function. *Kancha* referred both to an architecturally enclosed spatial precinct and to a privileged sphere of cultural diligence. The Inca leadership understood the *kancha* as an architectural complex that framed the sociality of the few.[31]

Inca understandings of the *kancha* conformed to widespread Andean practices of social and physical sequestration. In the pre-contact era, leaders across the Andes were framed within richly ornamented enclosures.[32] They were marked as both a human presence and mythologized construct of power.

22. Feather panel (macaw feathers and cotton cloth). Wari (Corral Redondo, Churunga Valley, Camaná Province), ca. 750–850 C.E. 71.12 cm × 2 m. Dallas Museum of Art, Textile Purchase Fund 2001.262.

Chimú lords presided within richly decorated walls: Chimú miniature house models employ mother-of-pearl inlay to represent the relief-decoration of full-scale Chimú residential compounds.[33] Wari leaders traveled with feather wall hangings that could be hung around them as tenting, or draped over the walls of temporary lodgings (Figs. 21, 22).[34] Recuay lords sat beneath canopies of cloth held up by attendants.[35] When they were not ensconced in their palaces, Inca leaders traveled in sedan chairs enclosed by patterned cloth (Fig. 23).[36]

"In front of him, two women held up a sheet of very fine cloth": The veil was one more component in the network of surfaces and spatial intervals within the Inca architectural complex. Gauze and other open weaves are among the most forthrightly architectural of Andean fabrics: their primary structure – a gridwork relieved by diagonal reaches and interlockings – lies exposed to the viewer's attention. Stone stacked on stone, yarn plied over and again: in either case, the Inca extrapolated a fundamental pattern to higher orders of magnitude.

AN ENTRY IS MADE INTO A COURTYARD. THE ACTION TRIGGERS A RESPONSE: A cloth is drawn across the line of sight. Together, the two actions result in the physical partitioning of the space in which they transpire. The screen goes up, and a new form of awareness is concretely staged. In effect, the cloth implemented a shift in "footing," per Erving Goffman's formulation, "a change in [the] frame for events."[37] Outside Atawallpa's courtyard, the sheet announced, sight operated as a faculty of unthinking self-awareness and situational assessment.[38] Here within the Inca ruler's *kancha*, the faculty of optical perception stood in – like the screen itself – as the prior and final term by which the visitors engaged the Inca leader. At once seen and seen through, the veil raised before Atawallpa did not obscure the king so much as alter the sensory terms by which he was perceived.

To Inca understanding, Atawallpa sanctified the space he inhabited. The very person of the Inca ruler was a sacral center, a *qozqo*.[39] The space of his

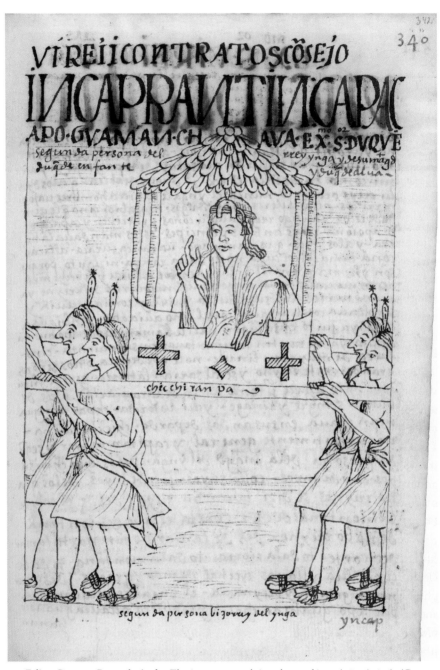

23. Felipe Guaman Poma de Ayala, *El primer nueva corónica y buen gobierno* (1615/1616), (Copenhagen, Royal Danish Library, GKS 2232 4°: facsimile at http://www.kb.dk), 342v.

presence was a "capital," a *qozqo* – thus "Cuzco," the name of the settlement in the southern highlands that would keep the name to the modern era. Atawallpa thus transformed not only spaces but the sense of space itself – his presence deepened, extended, and instrumentalized creatural sensation as cultural discourse.[40]

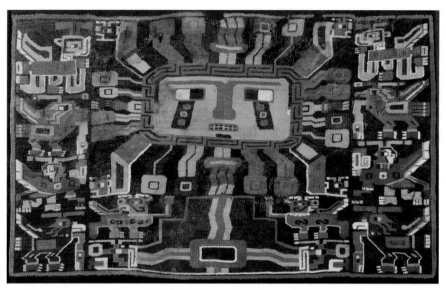

24. Woven panel, early Tiwanaku style (Titicaca region), ca. 200–400 C.E. Private collection.

Though disposed well forward of his body, the screen operated as an element of Atawallpa's costume, a raiment that framed and conditioned his outward appearance. Costumes worn by Andean leaders often worked to do as the veil did: they flattened the human figure, fixing the body and face within planar arrays of cloth and metalwork. Set within these costume screens, the frontal aspect of the human face acceded to the adornment's two-dimensional terms.[41] Flat assemblages of ornament were worn by upright, living beings: so clothed, the standing figure's frontal aspect was simplified in outline, magnified in scale, and made altogether more legible from a distance.[42] Atawallpa's costume was a construct of architectural forms and the spatial narrative through them: his body lay beyond successive doorway-apertures and a last film of translucent cotton. Behind so much cloth, Atawallpa was at once displayed before and hidden from his interlocutors. Presentation through occultation – it was a traditional Andean mode of display.

"Surrounded by many women," wrote Cristóbal de Mena.[43] They were all around Atawallpa, arrayed in camelid-wool garments of bright colors. In their midst, two women raised their arms, unfurling the veil in a choreographed flourish: the upright cloth was imposed on the space, punctuating and ordering the retinue of women. This much was readily apparent to Ruiz and the other soldiers. Though there was much else, and it could hardly have been apparent to a non-Andean. The transparent cloth participated in a calculated theatrical act: Atawallpa's guests were presented with a coded scenographic tableau drawn from the Andean visual tradition.

The staging of Atawallpa's inner courtyard may be related the composition on a woven panel produced before 400 C.E. by the Tiwanaku culture or its antecedents in the Lake Titicaca region (Fig. 24).[44] A central being

is presented in the simplified form of a frontal face woven in high yellow. The central figure appears above a plinth, a kind of architectural pedestal or stepped pyramid. Its staring eyes weep polychrome "streamers" – beams of sunlight, water, plumage, and rainbows – while more streamers radiate outward to the edges of the composition. Ranks of costumed figures are disposed to the sides. These figures appear in profile, facing inward toward the frontal being at the composition's center. Two smaller figures appear below the frontal being. They act as intermediaries: their hands are raised toward the central figure, while their faces are turned outward toward the framing figures.

The woven panel presents a formulaic composition often described in scholarship as the Frontal Deity motif. The motif's origins lie in the Tiwanaku and Wari visual traditions of ca. 400–1000 c.e.[45] If starkly schematized, it depicts clearly enough a ritual gathering of costumed leaders; the composition may be compared broadly to near-contemporary depictions of state ceremony produced by the Moche on the north coast.

As the Andes' prevailing dynastic power at 1500 c.e., the Inca knew this compositional motif well. It was a formulaic device that appeared across range of works executed in ceramic painting, metalwork, and bone and wood carving, as well as fiber. At the Tiwanaku site, it was carved into the Gateway of the Sun, a monumental architectural proscenium at the heart of that center's sacred precinct. The motif is found on service items that otherwise interacted with users' bodies – on monumental beer urns like those excavated at Conchopata, or on snuff trays from the Atacama region.[46] The frontal deity motif was commonly deployed in material goods that engaged in direct and dynamic relationship with bodies in space: the iconographic topos tended both to facilitate human pageantry as well as represent it. Centuries after the decline of the Tiwanaku and the Wari, the Inca leadership frankly adopted elements of a highland dynastic tradition considerably more ancient than the Incas' own ethnic origins – older by at least a thousand years. The complex theatrical blocking in the inner courtyard of Atawallpa's palace was one such appropriation. Arrayed before their visitors, Atawallpa and his courtiers staged an ancient iconographic formula.

In the courtyard's confines, the ancestral motif's flat array of colors unfurled in three dimensions: a paramount sovereign was flanked by ranks of courtiers, as a pair of lesser servants framed the central figure. The graphic template was represented in turn, as the choreographed scene was flattened and pulled forward to the surface of the veil. And so the motif was embodied as a stereotyped performance in the space of Atawallpa's courtyard; and it was recoded as flattened iconographic formula across the surface of the veil suspended within it. Patterned drama or dramatized pattern: The ancestral dynastic order was brought to circular fulfillment.

HELD VERTICAL, AN OPENWEAVE CLOTH WILL FLICKER WITH MOIRÉ. EXPOSED warps and wefts catch edges in the architecture beyond – the lines of the doorway frame behind the seated Inca ruler, for instance, or the geometry of the building's stonemasonry. Viewed through the cloth, Atawallpa was alternately animated and frozen against the surrounding architecture. In these transient instants of perception, the Inca king was complexly bound to his framing environment. This scenography was not accidental: it finds close parallels in the organization of contemporary Inca architectural and sacred space.

The Europeans admitted to Atawallpa's presence encountered him fixed within an upright frame – it may be considered either as a flat outline, or in volumetric terms, as a niche. The enclosing compartment of the door was itself framed within a broad panel – the square of translucent fabric raised before the visitors' eyes. The geometry of those concentric frames picked out congruent edges in the woven veil and the courtyard beyond. The doorframe's outline opened out and pulled back in restless geometric dissolution and coalescence.

Tall doorways and smaller wall niches typically relieved the mural surfaces of important Inca buildings. Within the austere conventions of Inca architectural design, these apertures were among the few elements of building decoration. All clean lines and exacting geometry, these features required considerable masonry skill to produce: for the Inca, such evidence of skilled labor was the surest sign of a building's prestige.[47] Wall openings offered the Inca more than ornament or design elaboration; they also provided for the display of sacred objects. Sixteenth-century Spanish administrators noted the Incas' placement of relics in "windows" [ventanas] – this almost certainly a reference to the use of architectural niches as mounts.[48] Elsewhere Spanish observers described niches' employment as "shelves" [estantes] or tabernacles [tabernáculos].[49]

The practices by which the Inca framed and displayed god effigies are relatively well documented. The squared frame was an integral component of the most prestigious of all documented Inca god effigies, a figure of the morning sun known to the Spanish as "El ídolo de Punchao." Given its importance to the Inca, this effigy's physical form may be taken as broadly representative of portable Inca effigies. Spanish administrators who saw the object described it as a small human figure made from gold fixed to a rectangular sheet of polished gold about forty to fifty centimeters across.[50] The panel was structurally integral to the work; from the frontal vantage, it enclosed the effigy within a rectangular boundary. Its polished surface reflected the light, backlighting the figure: one Spanish observer noted, "when struck by sunlight [the Punchao] would light up such that one could not see the idol, only the intense shine."[51] Like Atawallpa in his courtyard, the effigy was hidden in plain view.

Although few Inca god effigies survived Spanish campaigns of extirpation, the physical settings in which they were displayed have proved more durable.

These architectural frameworks confirm the importance of the backpanel as a device of exhibition in the Inca visual tradition. Squared backpanels – vertical planes bounded by rectangular or trapezoidal edges – are preserved in several Inca sculptural and spatial media beyond free-standing god effigies: in architectural composition – doorways, windows, and niches – and in carved outcroppings and other altered landscape features.

In certain instances the use of niches as pedestals is apparent in the architectural fabric of extant Inca buildings: at Cuzco's Qurikancha a large trapezoidal niche in a monumental house structure faced the central courtyard of the complex.[52] Once lined with sheets of metal, the niche faced east, presenting the framed object to the rising sun. Viewed in the strong morning light, the relic or effigy was set within a field of reflected sunshine, a veiling glare. Shrouded by sunlight, the object presided over the courtyard from the shelter of the surrounding building façade: a close analogue to Atawallpa's staging at Cajamarca.

The Inca also carved rectilinear panels and niches into naturally occurring surfaces of boulders and outcroppings of rock. These alterations served as pedestals for relics and ancestral effigies, whose presence in the landscape served to guarantee Inca land claims.[53] In effect, the portable, free-standing sculptural composition of the effigy-and-backpanel was inserted into the live rock as a site-specific mount, an emplaced backpanel. A carved outcropping in the Incamisana sector of Ollantaytambo offers an elaborate example of the type (Fig. 25). Here as in many cases the niche's recessed vertical face was polished to a mirror-like shine. Similar instances of the pattern occur among the dozens of carved outcroppings around the Saqsawaman complex above Cuzco; the carved formation known as the Chinkana Grande is among the largest and most impressive (Fig. 26).[54] In all these carved compositions, the closed form of a central niche sits within a composition of echoing geometric incisions – "niched galleries" they have been called.[55] The discrete form of the niche appears among so many disarticulated components of its own geometry. In other compositions, the primary niche may be subdivided, its internal space broken up into alternately sunken or raised geometric forms, as at the Chinkana Grande. The primary niche may also be joined on the rock face by flights of panels and pedestals, or communicating stairways and passages. In every case, networks of echoing compositional forms visually destabilize and compositionally activate the central niche: the keynote form of the central backpanel resonates across the natural surfaces of the outcropping.

Another natural feature altered by the Inca is found at Choquequilla, a sacred cave along the Huarocondo River near the modern town of Pachar.[56] Inside the cavern's shallow interior, Inca carvers inserted a wide rectangular

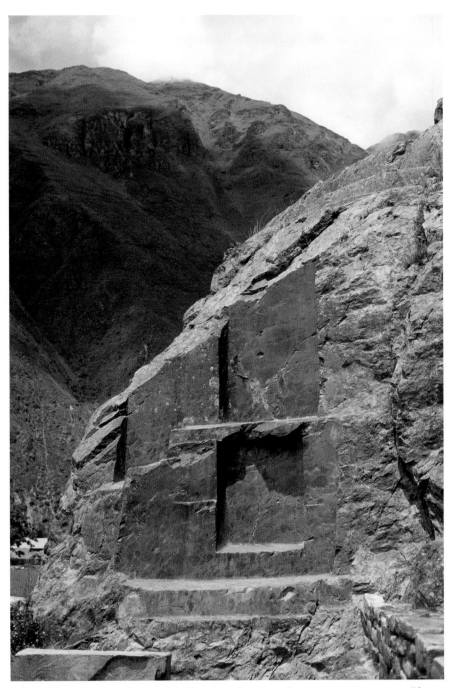

25. Carved cliff, Incamisana sector, Ollantaytambo, Peru. Inca, ca. 1450–1532 C.E. (Photo: author)

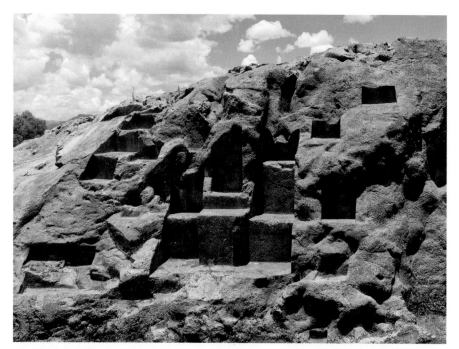

26. Chinkana Grande of Saqsawaman, Peru. Inca, ca. 1450–1532 C.E. (Photo: author)

panel into the northern wall (Fig. 27). This panel's surface was ground to a high. The light that falls across the panel is altered and subtly hardened. The center of this planar surface was worked with another panel, an upright rectangular niche. This central, primary form is surrounded by repeated elements of its own constitutive geometry. The repetition of forms – horizontals, verticals, and the corners where they meet – works to parse and destabilize that keynote rectangle. Choquequilla presents a simplified, architectonic version of the design tendencies widely seen among god effigies and carved outcroppings. Thus it was also in Atawallpa's courtyard: a central niche couched within repeating geometric forms and hazed illumination.

From the geometric hollow of a trapezoidal doorway, Atawallpa regarded his guests across the courtyard. Here as in all contexts of its employment, the backpanel activated the seen-object's capacity as itself a viewer – an object seeing as well as seen. The ocular capacity of the Inca backpanel is stated most forthrightly in architectural doorways and windows. Monumental doorways framed lines of sight into or from monumental architectural complexes.[57] The enfilade disposition of successive doorways was a stock element of Inca palace design.[58] Outer gates allowed keyhole views into the interior spaces of architectural complexes. These doorway apertures framed views onto significant landforms (Fig. 28). Windows, meanwhile, defined the vistas and outlooks of Inca observatories: at Machu Picchu – built in the decades immediately

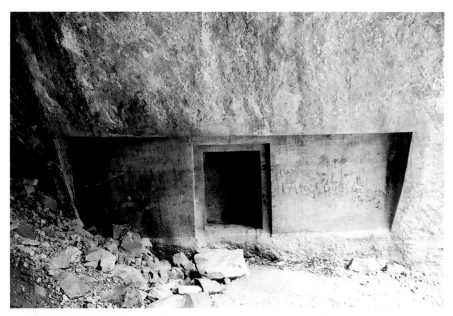

27. Carved cave wall, Choquequilla, Peru. Inca, ca. 1450–1532 C.E. (Photo: author)

preceding the European arrival in South America – the trapezoidal windows of the Torreón look out over sacred features of the land- and sky-scape (Fig. 29).[59] All these apertures framed significant objects of vision, while also incorporating lines of sight into the fabric of monumental constructions. In a similar fashion, the effigy backpanel defined the relic as seen and seeing: it acted as the work's display frame and its outward-turned eye, its oculus.

The niche behind Atawallpa, the square of fabric suspended before him, and the doorway opposite – these were the courtyard's organizing oculi. They defined the central vector of sight around which the buildings' heavy architectural fabric fell into place. In these apertures, Atawallpa's gaze was objectified as a principle of architectural design. In moving through the successive portals and courtyards of the Inca complex, Atawallpa's visitors traced the ray of his vision back to its source. That progress brought them to the upright surface of the sheer fabric.

SO THE EMBASSY TO ATAWALLPA LED PAST THE GATES OF HIS PALACE, THROUGH its courtyards, thence to its innermost patio. It culminated before an arrangement of nested frames. At the center of that intricate geometry – at the conclusion of that experiential narrative – the Inca ruler was presented to his visitors. Gates, guards, niches, and veils – these were the infrastructure of the Incas' worldly power. They were the concrete and definitive fixtures that set Atawallpa off as the Incas' paramount living administrator. The concentric

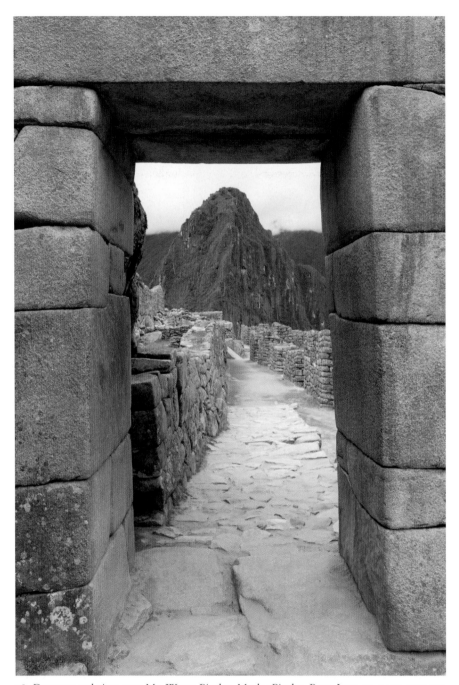

28. Doorway and view onto Mt. Wayna Picchu, Machu Picchu, Peru. Inca, ca. 1450–1532 C.E. (Photo: author)

frames around Atawallpa did more than this. They operated as ideological apparatus that identified and articulated his divinity. The framework around Atawallpa made evident a set of complementary mythological identities, narrative typologies, and temporalities.

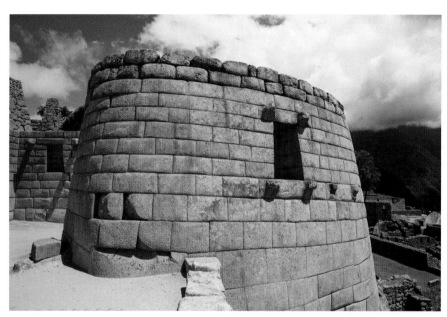

29. Torreón, Machu Picchu, Peru. Inca, ca. 1450–1532 C.E. (Photo: author)

Post-conquest accounts of the Incas' dealings with the Spanish would claim the Inca recognized Pizarro and his men as returning ancestors. In these narratives, the Spanish presence in Inca Peru was foretold in dreams and omens; once arrived there, the Spanish were addressed with the honorific *Viracocha*, "gods," or "father-ancestors." Recent scholarship has exposed these accounts as colonial-era fabrication – in effect, they are providential Christian rereadings imposed on the historical record.[60] At Cajamarca and in all the Inca-Spanish military campaigns of the 1530s, the Inca leadership never identified their Spanish adversaries as returned Andean ancestors; nor did the Inca address these foreigners with any formal honorifics of ancestry. Even so, the discourse of political actors-as-ancestors was an important strain of Andean cultural and diplomatic practice. This discourse actively structured the first Spanish-royal Inca encounter: Atawallpa was presented to his Spanish guests as *himself* an Andean ancestor.

Choquequilla, the Incamisana, Saqsawaman's Chinkana Grande, and other sites of live-rock carving may be identified with Inca practices of ancestor display. Setting living ancestors within these altered natural features, the Inca legitimated their land tenure and rights of agrarian exploitation.[61] Among the Inca and more widely in the Andean cultural tradition, mummies, body relics, or other effigies imbued with the ancestor's spirit were set above agricultural fields.[62] Often called *wank'a*, "field guardians," these relics were bodies of communal or family ancestors, petrified and thus shrunken down to their vital physical core. These ancestors supervised the land, acting as guarantors of communal rights to its use. Carved boulders and crags at Ollantaytambo, Saqsawaman, and elsewhere emplaced ancestors above watercourses and

agricultural terraces; from this privileged position, the sentient ancestor exercised its affirming, patronal oversight over both ritual enclosure and agricultural landscape. The distinct sculptural alteration of each site asserted the Incas' proprietorship, while articulating the particular identity of the sacral locus. The wider outcropping was made vital, at once guarantor of and participant in the energies of growth and fruition overseen by the ancestor emplaced there.

The cave at Choquequilla is particularly revealing of the cultural assumptions that undergirded the presentation of Atawallpa within a framing niche. The elaborate relic pedestal at Choquequilla also may be identified with the Andean ideology of the *t'oqo*, the ancestral cave of ethnogenesis and dynastic emergence.[63] The Inca among other Andean peoples identified caves as potential *paqarina*, "places of dawning/emergence." In this mythology, the *t'oqo*/cave was the site of ethnic and dynastic origin; it was a portal of mythic emergence into the human world – the openings whence the sun rose to the sky, or primordial ancestors emerged onto the earth. Among the Inca, the form of the squared frame was widely employed to represent the *t'oqo*.[64] Guaman Poma's manuscript includes a coat of arms that depicts in its lower right quadrant the signum of *Tamput'oqo*, the three caves of the Inca dynasty's emergence. Choquequilla's site design embodies the graphic motif found in Poma's drawing: a cave in a hillside, the *t'oqo* of dynastic origin (Fig. 30).[65]

Atawallpa was presented to his retinue as *wank'a* and emergent dynastic founder. As an emplaced patron-ancestor of land use, he presided over the immediate space of the palace's inner courtyard. From here his oversight extended out to the surrounding valley and countryside. His privileged position in the hillside residence posed him as the sacral field guardian: from here, he acted as guarantor and patron of the Incas' claims to the region's ecological resources. The deep social principle he enacted – sovereign Inca power – emerged from the historical process even as it transcended historical time.

The physical framework around Atawallpa identified him as living ancestor and thus emplaced him outside of historical time. Even so, his presentation in the courtyard embedded him within the immediacy of experiential narrative. His physical presence in that space implicated him in the passage of instants and moments. The restless network of squared frames around Atawallpa coalesced into a defined geometric order, then dissolved, then reformed again. Instants of perceptual experience were broken down, reconstituted, denatured. Time alternately sped up or stalled: the temporal and situational contingency of individual perception registered a larger, enduring fact. Set before the *t'oqo* of dynastic origin, Atawallpa was at the paqarina's threshold, fixed in the instant of emergence. Atawallpa burst into the viewer's awareness, a sudden, stilled hierophany.

Witnessed at the lip of the cave of origin, Atawallpa was asserted as the founding ancestor of his vassals' incorporation within the Inca political order. Emergent before his visitors and enemies, the Inca ruler effectively

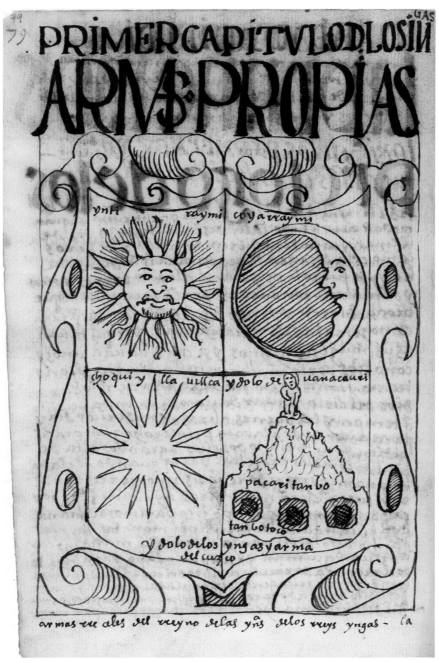

30. Felipe Guaman Poma de Ayala, *El primer nueva corónica y buen gobierno* (1615/1616) (Copenhagen, Royal Danish Library, GKS 2232 4°: facsimile at http://www.kb.dk), 79v.

nullified his antagonists' old ancestral ties and obligations. Atawallpa suddenly appeared before them, motionless, as their new patron ancestor: his guests were enfranchised within in a new framework of obligations and commitments. His audience was made witness to the primordial event of dynastic foundation – their eyes took in a disruptive reorganization of cosmic

identities and alignments. This witnessed emergence imposed new loyalties and revised genealogies. Ambassadors were made Atawallpa's clients, visitors made his subjects. Moments slowed, as instants of perception – typically irrecuperable – now persisted in the mind as fixed cosmological structures. Transitory instants of sight gave way to the enduring afterimage of cognitive insight.

"EYE CONTACT," REMARKED GEORG SIMMEL, "REPRESENTS THE MOST PERFECT reciprocity between two people."[66] Posed behind and before upright lenses, Atawallpa too was an observer.

Vision was among the primary capacities of Atawallpa as a semi-divine leader. His gaze – and the sight of all effective Inca leaders – constituted a focused, emissive energy. The Inca ruler presided over an empire of the sun, and the cosmological basis of his worldly authority lay in sunlight, a luminance of high yellow color and exaggerated intensity. He was understood as "the son of the sun" (*intip churin*), and his sight embodied the eye-burning resplendence of solar energy. Like direct sunlight, his gaze was understood as a vitalizing though dangerous force. His vision was alternately wounding and fructifying, both in the range of its capacities (sunlight that either illuminates or blinds) and its overall effect (the cut that heals, the wound that fertilizes). And it was emphatically gendered: Atawallpa's piercing gaze was a masculine quality, a function and attribute of male leadership and patriarchal honor.

Inca subordinates understood the Inca ruler to be "strong-eyed," a quality most apparent in his "gleaming" eyes that shone like the eyes of predatory felines.[67] In general, the Inca ruler's eyes were said to "dart beams of light."[68] To this Andean way of understanding, the Inca ruler's vision was both synaesthetic and moralized. It was identified in a range of allied physical sensations and elevated cultural values: sunlight, darts and pointed weapons, foot-plows, the penis – these were all like-in-kind manifestations of his gaze.[69] These instruments and their effects were the metonymic extensions of his visual capacities: piercing illumination, wounding arrows, broken and tilled soil, sexual impregnation.

At the same time, Atawallpa's vision was considered receptive and comprehending. It possessed situational awareness and decisiveness, an ability to embrace and command the world. All this was implied in the Inca royal epithet *tupaq*, a complex term of several meanings. In part it alluded to the Andean principle of complementarity, a subject-object relationship of discrete parts joined in an integral whole. *Tupaq* also described a capacity of "seeing-and-measuring," in the manner of a craftsman who makes a well-judged cut or blow.[70] Lesser leaders were "inspectors/surveyors," or "those who see all" (*tokoyrikoq*) – the title was borne by Inca provincial officials.[71] To inspect and survey, to see and measure: these words equate moral acumen with visual

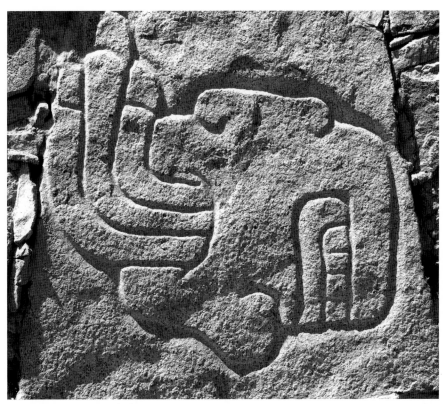

31. Architectural relief, Cerro Sechín, Peru. Cerro Sechín culture, ca. 800 B.C.E. (Photo: author)

judgment. They identify the achievement of effective leadership – sound administrative practice – with the perceptual means by which it was realized – sight. Inca dynastic lore described the Incas' greatest ruler (*Pachakuti Inka Yupanki*) as a discerning architect and urban planner; this dynast's achievement as designer and builder complemented his powers as aggressor and destroyer encoded in the name *Pachakuti*, "world-changer."

The moralized vision ascribed to leaders was only one aspect of Andeans' broader understanding of human vision. But its consequences for Andean leaders could be brutally literal. In that sightless leaders could not govern, enemies were systematically blinded. This was the case as far back as the first millennium B.C.E.: the rudimentary reliefs carvings at the early site of Cerro Sechín depict blood streaming from the empty eye sockets of captured enemies (Fig. 31). In an illustration of Andean nobleman Guaman Poma's manuscript of 1615/6, the Inca blind a rebellious noble from the Titicaca region. This latter image depicts the punishment meted out for disobedience to the Inca leadership (Fig. 32). This act of mutilation disfranchised the noble from the Inca hierarchy. Without eyes, the victim was stripped of any capacity for political authority.

As a sacred center (*qozqo*), Atawallpa was a breathing synecdoche of the Inca state's invidious asymmetries: Inca and non-Inca, rulers and ruled, centers and peripheries.[72] And so the Europeans stood in the Inca complex above Cajamarca, their supplicating eyes turned to the sunlight of Atawallpa's stare. The veil materialized the point in the courtyard where the Inca ruler's eyesight met and crossed paths with his visitors' vision. The shared tissue of perceptual experience only revealed the mythic truth of differential visual capacity; the Inca ruler saw more sharply, more masterfully, more fruitfully. In the terms of Andean cultural experience, the lesser subordinates were given to know the nature and consequence of his presence.

ATAWALLPA EPITOMIZED THE INCA IDEOLOGY OF SOVEREIGN VISION: HE WAS the Incas' principal seer and ideal witness. The enhanced moral and supernatural capacities embodied in the *Sapa Inka*'s sight was not uniquely his. Sovereign vision was an ideological capacity characteristic of Inca leaders and leadership. To wit: *Rumi Ñawi*, "Rock Eye," a general who was among Atawallpa's senior war-leaders. This figure's name offers boldface summary of vision's role within the Inca rhetoric of patriarchal honor and prestige. In the year before the Spanish arrival in the Andes, this general had scored important victories in the field, tilting the war of Inca dynastic succession in Atawallpa's favor. He also participated in the purge of Cuzco's Inca nobility that consolidated Atawallpa's position in the struggle's aftermath. Rumi Ñawi was with the Inca forces in Cajamarca when Pizarro arrived there; he may well have been present at Atawallpa's meeting with the Spanish above Cajamarca. After the the following day's disaster, Rumi Ñawi escaped Cajamarca with a significant portion of Atawallpa's army; he appears to have led that force north, off as far as the southern districts of Ecuador. Rumi Ñawi would continue to resist Spanish incursions into the Ecuadorian highlands until his armies were exhausted in late 1534. Significantly, this personage is not the only historical figure who bears the name Rumi Ñawi in the Quechua-language cultural record.[73] The name may have operated as some kind of war title, an epithet of rank or position invested in a key military supervisor among the Inca leadership.

Present-day Quechua-speakers use the phrase *rumi ñawi* to describe optical debility. It refers to wounds – the blinded eye, opaque and lifeless in the orbital socket.[74] Similar expressions describe loss of function in other parts of the body – a "stone-arm" is a paralyzed limb, for instance. This usage has obvious relevance to an old warrior; for the old campaigner, that kind of wound was a mark of distinction. "Dead Eye" – this kind of hard-bitten *nom de guerre* would have been hardly out of place within the theatrics of Andean militarism. Even so, no other sources describe his leader as having been blind in one eye. What is more, proper names among the Inca leadership generally articulated cosmological precepts or elevated states of moral being. A close reading of the

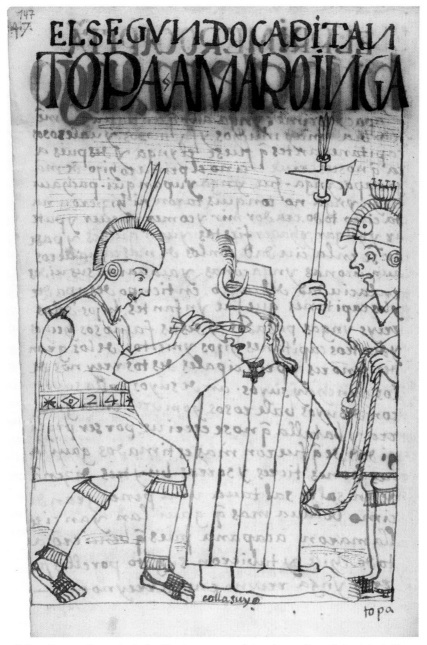

32. Felipe Guaman Poma de Ayala, *El primer nueva corónica y buen gobierno* (1615/1616) (Copenhagen, Royal Danish Library, GKS 2232 4°: facsimile at http://www.kb.dk), 147v.

proper name *Rumi Ñawi* reveals a broad cultural imaginary bearing on vision and power.

Like most honorifics associated with the Inca leadership, the name *Rumi Ñawi* was a two-word phrase. Polysemic by design, the appellation's constituent words activated and anchored a range of discursive identities. Within this field of ideological relations, key terms triggered multiple semantic

alternatives. Individual possibilities did not toggle back and forth as distinct and mutually exclusive alternative values. Rather, multiple readings co-resided as equivalents that urged each other to collaborative, outward-spiraling meanings. In this onomastics of unspooling connotation, breadth of semantic reach denoted sacral potency. Claimed by living members of the Inca leadership, these names plotted a space of social and ideological cohabitation. The title's wide-ranging mythological references were distilled and embodied in the human presence of the men and women who bore them. The mythic dimensions of Inca social being were concretely realized; the social lives of the titled figures extended that mythology's semantics further again. The truth of Inca ideology was borne out, even as the title accrued new meanings in the career of its human bearer.

Thus the general's truculent, polysemic identity: the blinded eye of the sacral leader suggests the wounded seers of the New World's shamanic spiritual traditions, for one. The stony organ of sight also engages the Andean motif of ancestral petrifaction – the oversight of the presiding ancestral benefactor. The ancestral stone/eye generates a further association specific to the myth of Inca dynastic foundation: immediately before founding the center of Cuzco, the founders of the Inca dynasty stood at the top of the highest peak in the Cuzco Valley, whence they looked out over the landscape and shot slingstones to each of the cardinal directions. The flight of projectiles from slings literalized the founders' sovereign gaze.[75] Their warlike vision – stone/eyes – laid claim to the Cuzco region (to the entirety of the Andes) as "an empire of the four quarters" (*Tawantinsuyu*).

If apparent in the broad symbolism of the general's name, this kind of semantic suggestiveness redoubles with further parsing of the personage's name. The word *rumi*, "stone," generally refers to quarried and prepared stone, to rock that may be *worked*. Quechua lexica identify rumi as neither innately precious, not inherently a "jewel" or "gem" – though also not a base material, not "ballast" or "rubble."[76] The word may be used to indicate building- or paving material – stone that is hard, consistent, strong. This said, the term rumi may be qualified and ennobled. The phrase *quispe ñawi* – "crystal-stone" – is glossed in colonial lexica as *rubí* or *marmol*, "marble." Rumi: a hard mineral that holds a shine.

Ñawi, "eye," was as a term of broad meaning and charged cultural value. González Holguín's early Quechua lexicon cites several Castilian equivalents to the word: *ojos, o fiel del peso, o punta, o vista, o rostro, o haz*, "eyes, or balance needle, or point, or gaze, or face, or beam." Other Quechua lexica confirm Holguín's glosses, citing the terms "eye," "gaze," "knife-blade," or "anything pointed."

The wide semantic reach of the Quechua word confirms the Incas' understanding of vision as an emissive, stabbing, and penetrating faculty. The

word described the physical characteristic of an object, "pointed," or the manifestation of this physical attribute in an instrument, "balance needle." Among its other operative meanings, the phrase establishes is the likeness of the eyes and face to polished gems and worked flints. It also recorded the body's directional orientation, *rostro*/"face." This bodily disposition may be extended to denote the specific beam of visual attention, *vista*/"gaze/line of sight." *Ñawi* thus encodes several complementary values. These include the face as a site of intelligible human expression; the gaze as extension of that human being, a casting forth of vital essence; and aggressive, cutting, penetrating energy. These values were uniformly grounded in performative immediacy and bodily attitude: "to direct attention" or "point out," or "zero in."

In the general Rumi Ñawi, these Andean assumptions concerning sight and mineral substance were instrumentalized and further sharpened. As "rock-eye," this war-leader was the aggressive face of the Inca leadership. He was the impassive visage of the resolute leadership: rock face. He was the blade at the tip of the stabbing spear: stone point. He was the jewel's polished surface and surface luster: gem's sparkle. His presence embodied the flawless impassivity of the polished panel, and the eye-wounding brilliance of light cast from its surface. He was the living, petrified organ of sight, the sentient stone of the vital ancestral being. His name granted him the *wank'a*'s eye – the presiding, authoritative vision of the supernatural reliquary object. He was the human eye that saw with the moral and physical force of all these images: jewel eye. *Rumi Ñawi*: the title articulated old soldier's war wound, and the ancestor's master sight, both.

If the name *Rumi Ñawi* begins to disclose a sense of how Inca leaders looked on their enemies, the name has much to say about how Atawallpa viewed his foreign guests on 15 November 1532. The name's relevance to the encounter in the inner courtyard is reinforced in another compound term recorded in early lexica. This is *Ñauiyokrumi*, "the face/eye of the stone," an entry also found in Holguín's early Quechua-Castillian lexicon.[77] The phrase sets the two terms in reverse order: it indicates a material object (eye-stone) rather than a human capacity (stone-eye). And yet the same mineral and human capacities are set in mutual orbit, tethered in semantic interplay. Holguín's lexicon describes the phrase thus: "the stone that has a face . . . flat along one part." Here the Spanish author failed to set this definition alongside any context of use or discursive reference. Nevertheless, much may be read into the definition alone: the gloss appears to describe the upright panel of the freestanding effigy or carved sacral outcropping. As "eye-stone," or "face-jewel," the phrase aptly suits the upright pedestal that, first, emplaced the effigy along the irregular surface of the outcropping; and second, indicated the beam of its visual attention. Eye-Stone: read more broadly still, the phrase describes the cloth and the doorway, the two upright lenses that set Atawallpa *en face* to his guests.

ATAWALLPA'S GAZE SUBJECTED PIZARRO'S SOLDIERS TO THE MENACING SUPER-
vision of Inca political authority. As an epistemic device, the veil raised before
the Inca ruler intensified that domineering aggression, made it all the more
visible as cultural discourse. Although the thin cloth activated other capacities
of Atawallpa's sight. It held those functions in mutual, quickening tension
with the first. "To experience meaning in an instant," mused Wittgenstein:
staring back at the Europeans, Atawallpa comprehended them – recognized
their existential place – within the grand order of Inca cosmology. The upright
cloth raised formalized that presiding universality of his sight – in Louis Marin's
use, the *éclat* or "radiance" of his power.[78]

The Inca king was a decentered being, an entity of many bodies. His person
was incorporated in companion objects and human proxies, called *wawki*,
"brothers."[79] Some were installed in Cuzco, where they were united with the
solar being in the Inca temple of state. Others supervised distant provinces,
or set off on embassies, military campaigns, tours of inspection, and retreats.[80]
Atawallpa and his essential copies operated within a pan-Andean system of
highways and provincial palaces: his partible, wide-roaming being went about
the "autopsy" – the "seeing for oneself," per Marin – of the Incas' vast Andean
realm.[81] Just as Atawallpa occupied many places at once, so also he encompassed
many points of view. Even in the particularity of his given instantiation – as an
embodied viewer, in a given space – he was a comprehensive entity of synoptic
visual capacities.

Thus it was that Atawallpa bore the title *Sapa Inka*, an epithet that identified
him alternately as a singular being ("One-and-Only Ruler") and a compre-
hensive absolute ("most-*Inka* Inca"). The specificity of Atawallpa's presence
embodied a broad utopian principle: his body was an arbitrary point where
his universality was deployed, framed, and shown to be evident. If his per-
son embodied a point of concentrated power, his presence also refused con-
tainment within fixed coordinates. Atawallpa's bodily presence occupied one
among so many echoing, mirror-image extensions of his being. Atawallpa was
an imperial order everywhere visually evident but nowhere fixed, and so all-
comprehending. Atawallpa's person offered the defining vantage from which
an array of echoing solipsism was organized.

The regressive specularity of Atawallpa's being was activated and organized
in the diaphanous cloth raised before him. Here it is worth recalling that the
defining visual attribute of that cloth – translucency – is a quality not often
ascribed to the Incas' textiles. Specialists in Andean weaving typically focus
their attention on the Incas' thick camelid wools, fabrics characterized by
unusual material density and rich, opaque colors. Rightly so: the inner court-
yard of Atawallpa's palace was richly patterned with such weavings. The thin
cloth raised before Atawallpa was indeed an eccentricity within that space,
and in the Incas' culture of cloth. Even so, the discursive energies of the veil's
transparency drew on the semantic capacities of those thicker textiles: bedding,

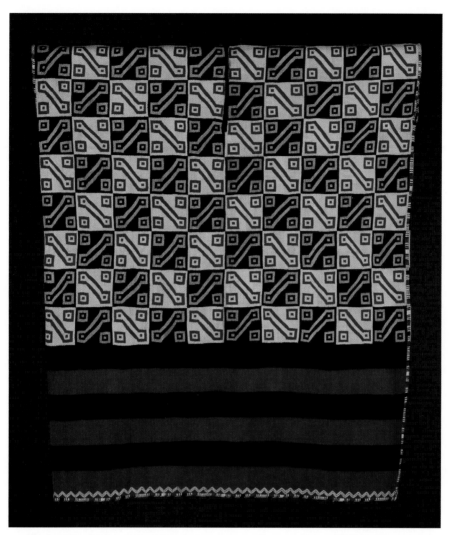

33. Man's tunic with key pattern, Inca, ca. 1450–1532. Cotton and camelid fiber tapestry weave. 92 × 76 cm. Museum Fünf Kontinente, Munich, no. x.447. Photo: M. Franke. Photograph courtesy of the museum.

seating, floor-covering, sunshades – all of those fabrics, as well as the woven garments that were the basis of Inca costume. Ruiz related that Atawallpa was wearing a "shirt without arms."[82] Inca officials generally wore a sleeveless tunic of standardized design and construction. Called an *unku*, it was an overgarment of simple, square construction and generous cut – really a poncho with sides stitched closed but for armholes at the shoulders.[83] It was made with woven wool of surpassingly high thread count and heavy, almost liquid drape.

The unkus worn by the Inca leadership bore elaborate geometric designs, or *t'oqapu*. These patterns were standardized, and their use was closely regulated by the Inca state: functionaries and vassals appear to have been assigned *t'oqapu* according to rank, specialized activity, and ethnic origin (Fig. 33). The best known *t'oqapu* is that worn by Inca soldiers, a bold pattern of black and white

34. Mural painting, La Centinela, Peru, ca. 1500 C.E. From Dwight T. Wallace, "The Inca Compound at La Centinela," *Andean Past* 5 (1998), Fig. 10.

block: Ruiz and the rest of Pizarro's advance party apparently saw thousands of these uniforms outside the gates of Atawallpa's palace and in its outer courtyards. The Spanish came to describe them as "chessboards" (*ajadrez*, or *escaques*) (see **Figs. 46–49**).[84]

The Incas' display of *t'oqapus* went well beyond ritual- and parade dress. Those motifs were also employed to define Inca architectural environments. At the coastal center of La Centinela, for instance, Inca lords sat beneath painted walls bearing the repeated *t'oqapus* along a horizontal frieze high on the wall.[85] The motif is a square field of green and orange set with a diamond and key-patterns (Fig. 34). If undocumented elsewhere in the Inca visual record, this design was certainly the *t'oqapu* identified with La Centinela's Inca (or Inca-allied) administrators. Scrolling along the wall, the design was incorporated into the physical structure and visual texture of the space. The wall painting objectified the social identities within this inner compartment of La Centinela's Inca palace complex; the same *t'oqapu* would have been on the administrators' garments and other sumptuary goods. The mural program at La Centinela subsumed the space and its occupants within the larger pattern of the Incas' comprehensive hegemony. Those patterns enabled La Centinela's Inca to see, to dwell among, and to culturally inhabit the visual terms of their social identity. Seated beneath their identifying t'oqapu, wearing that design on their garments, La Centinela's leaders saw themselves within the Incas' imperial scheme.

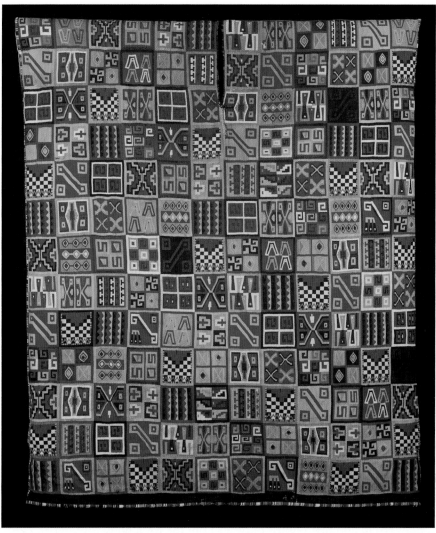

35. All-*t'oqapu* tunic. Inca, ca. 1450–1532 C.E. 91 × 76 cm. Washington, DC: Dumbarton Oaks. Dumbarton Oaks PCB 518.S1. Photo © Trustees of Harvard University.

Atawallpa, too, inhabited this cultural economy of Inca identities made visible in *t'oqapus*. None of the Europeans who visited Atawallpa's inner courtyard recalled the pattern Atawallpa wore on his body. Though in receiving the Spanish, Atawallpa may well have worn an "all-*t'oqapu* tunic," or "royal Inca tunic." It is called "all-*t'oqapu*" because the garment bears the squared forms of t'oqapus over its entire surface (Fig. 35).[86] It is called "royal" because native accounts of the colonial period specifically identify this tunic pattern with the *Sapa Inka* and no other personage in the Inca hierarchy: in the late sixteenth and early seventeenth centuries, native Andean artists would consistently identify the all-*t'oqapu* garment-type with Inca rulers. To modern scholarly awareness, it is the tunic pattern most unlike any other in the known inventory of Inca

garment types, as well as that most particular to the Inca ruler. That garment summarized the visual terms of Inca *t'oqapus*, and it epitomized the signifying capacities of the *t'oqapus'* semiotic system.

As a remarkable illustration from Martín de Murúa's *Historia General del Piru* (1616) suggests, the all–*t'oqapu* design also actively engaged the patterns of space and surface in Inca built environments (Fig. 36).[87] In this portrait of Inca ruler Pachacuti Inka Yupanki, the native Andean artist cited the visual codes of royal Inca identity, even as he formally misquoted them. The figure is dressed in an odd, diagonally canted all–*t'oqapu* tunic design. The structure behind is compositionally shrunken; the paving stones are reduced to the schema of the one-point perspectival grid. A great deal of early modern European pictorial rhetoric is at work in this image. Even so, the picture successfully imparts a sense of the Inca palace's grids and lenses – those patterns through which the all–*t'oqapu* tunic was seen, among which it was disposed, and against which it was set.

The individual *t'oqapus* on the royal tunic type obey the norms of Inca design, although the overall disposition of those design units across the tunic does not. The arrangement of *t'oqapus* on Inca tunics generally observed the structural givens of human anatomy: *t'oqapus* were generally organized around waistline belts, lower hems, or "yokes" that frame the wearer's head and face. By contrast, the all–*t'oqapu* tunic ignores human anatomical structure. Its design is not centered along the central axis of the wearer's body. The pattern does not recognize the waistline. It refuses to privilege any portion of the garment's upper quadrant to frame the wearer's face. Instead, the pattern is anatomically indifferent: The array of *t'oqapus* runs edge to edge, ending only at the tunic's arbitrarily imposed boundaries. The tunic's boundaries seem to frame one portion of a grid of signs that extends well beyond those limits. The garment's decoration is cut from a much broader pattern: the tunic offers one portion of a universal design that unfurls outward from the royal body.

The Inca ruler's all–*t'oqapu* tunic articulated his visible person as an arbitrary fragment of a larger visual totality. That universality also characterized the all–*t'oqapu* tunic's semantic operation. As Rebecca Stone has authoritatively demonstrated, most individual design patterns on the royal tunic are those of the Inca state's functionaries, servants, and allies.[88] The Inca ruler's costume included the *t'oqapus* of the soldiers, functionaries, and subject ethnicities who served him: the tunic's design includes the distinctive Inca key pattern (perhaps worn by Inca functionaries), as well as the "checkerboard" of the Inca military tunic (see **Figs. 33, 46–49**). Before his retinue, then, Atawallpa presented a comprehensive résumé of his individual retainers' identifying fabric patterns: the ruler's tunic garbed him in the sum of social identities recognized by the state.

There is more: across the surface of Atawallpa's tunic, the known was intercalated among the not-yet known, the seen mingled with the foreseen. Rebecca

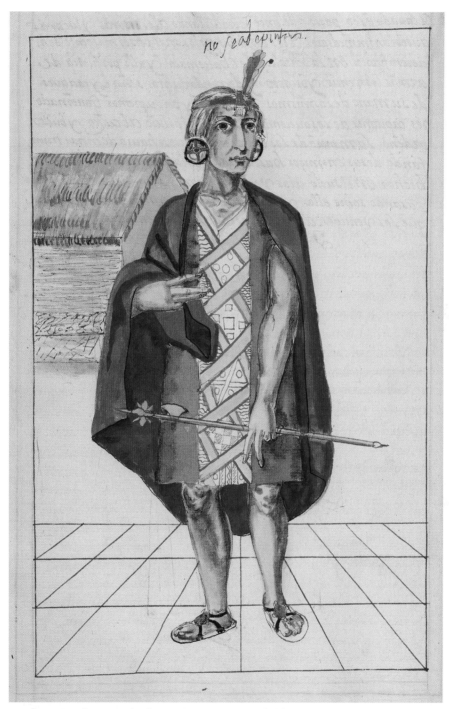

36. Illustration from Martín de Murúa, *Historia general del Piru*, 1616, Ms. Ludwig XIII 16 (83.MP.159), fol. 40v. Los Angeles, J. Paul Getty Museum.

Stone's argument shows that the royal tunic included *t'oqapus* of social identities who had not yet been incorporated into the Inca empire. The garment pattern envisioned the social identities of Incas-to-be, as well as Incas-who-are. The overall design was prospective as well as summary. Its designs comprehended both the known social world – the servants of the Inca state – and the to-be-known social world – those who are destined to be its servants. In the all-*t'oqapu* tunic the *Sapa Inka*'s proleptic comprehension was embodied, enacted, and shown forth before the ruler's courtiers and suppliants. The social world of Inca society was envisioned. The visionary capacities of its sovereign were made plainly visible.

So the Inca ruler stared at his visitors, his view framed by a squared piece of fabric. Atawallpa's objectifying gaze addressed the world, and there recognized the same patterns of identity encoded in his richly woven costume. "Thin and sparse," the cloth imposed the skeletal reticle of the plectogenic grid – the fundamental design template of the *t'oqapu* – across his line of sight. No less than his own figure, the bodies of his European suppliants were visibly animated and frozen within that transparent fiber network. They were immediately comprehended within the presiding warp and weft of the Inca regime. On the other side of the scrim – where they struggled to adjust to the courtyard's sensory terms – they were themselves seen to be incorporated into the textile's logic, visualized in the grand Inca design. They were another ordered pattern among the others and those to be. Atawallpa presided over these artfully configured onlookers, the subjects of his gaze.

SO THE PIECE OF ANDEAN OPENWEAVE HUNG IN THE SPACE BETWEEN Atawallpa and his visitors – at once a fabric in the world, and a lens through which worlds were seen. In this theater of cultural antagonism, Pizarro's soldiers found themselves the subjects of another sovereign visual order, while Europe's imperial gaze was yet a figment of desire. "No one could see the Inca clearly," Pedro Pizarro admitted in 1571.[89] (Pedro was by then a man of privilege and position in Arequipa, Peru; in 1532 he was the most junior Pizarro, an adolescent brought from Estremadura as his elder kinsmen's factotum and extra pair of eyes.) If transparent to light, the cloth constituted an array of semantically opaque signage: optic noise. Though the Europeans did not peer too deeply. Such devices were readily intelligible as traps to be refused or pitfalls avoided.[90] "No one could see," wrote Pedro Pizarro: all of us/none of us could discern. Pedro threw the issue back on to collective experience, an effort to recuperate perceptual certainty by way of group belonging. "Staring," notes Rosemarie Garland-Thomson, "creates a relationship . . . at once alienating and intimate."[91]

CHAPTER THREE

CHESSBOARD LANDSCAPE

Desde á poco rato comenzó á llover y á caer granizo, y el Gobernador mandó á los cristianos que se aposentasen en los aposentos de palacio.

Very quickly it began to rain as well as hail. The Governor ordered his men [lit. "Christians"] to take shelter in the covered spaces of the Inca palace.[1]

Francisco de Xerez, 1534

The European occupation of Cajamarca commenced in a spree of loot-ing. Francisco Pizarro's notary Francisco de Xerez used delicate language to acknowledge this stark fact. *Aposentasen en los aposentos*, the scribe wrote with awkward homophony: "they lodged in the town's lodgings." The Europeans' systematic looting of Inca palaces and storage facilities would be a sore point for the Inca leadership: as a captive, the Inca ruler would excoriate his Spanish interlocutors to their faces months later. Writing only months after the events in Cajamarca, Xerez could do little more than to point out the discomforts of the march. The fact of inclement weather might excuse the summary despo-liation of a king's properties by a lesser official (Pizarro held the rank of royal governor, *gobernador*). The Pizarro party arrived in Cajamarca at Vespers, Xerez noted: Pizarro's scribe obliquely suggests that the Europeans sought the shelter of the Inca palaces for prayer and thanksgiving.

As Pizarro's men sacked Cajamarca and other Inca settlements, they found that Inca storage houses very often contained not precious metals or stones, but textiles.[2] Those warehouses were filled with fabric garments – *preciada ropa*, "precious clothing" – much of it made from the soft, odorless wool of Andean

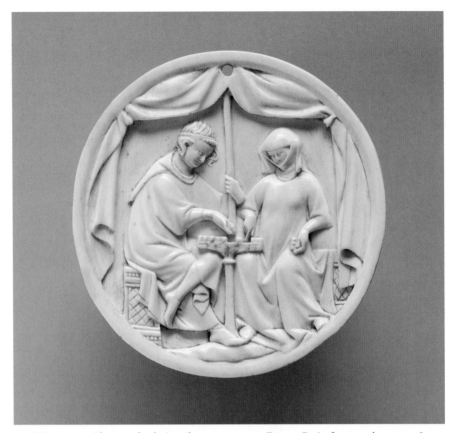

37. Mirror case with a couple playing chess, 1325–1350. France, Paris, fourteenth century. Ivory. 10.2 × 1.0 cm. The Cleveland Museum of Art, purchase from the J. H. Wade Fund 1940.1200.

camelids.[3] *Habia silos llenos de ella*, recalled Diego de Trujillo: "there were storehouses full of the stuff."[4] These high-grade Inca textiles were densely woven, supple to the touch, and remarkably insulating. Their strong colors were arranged in striking geometric patterns. *No podré dezir*, wrote Pedro Pizarro: "I wouldn't be able to describe all the different kinds of clothing that I saw in the Inca storehouses, for there was barely any time to see it, let alone make sense of it all."[5]

CUBRIAN LOS CAMPOS, PEDRO PIZARRO LATER WROTE OF THE INCA SQUADRONS that approached Cajamarca: "they covered the fields." Those native fighters bore a bold design on their bodies: the pattern read clear enough across the closing distance between the Incas and their European witnesses. *Como de juego de axedrez*, the Spanish soldiers described the pattern, or *á manera de escaques*: "like a chessboard."[6] Pizarro's campaigners were given to binges of cards and dice. If hardened gamesters, though, chess was not their game. Chess was more a fixture of the chivalric imagination than a gambling man's means to satisfaction. The game was identified with the refinement of the French and

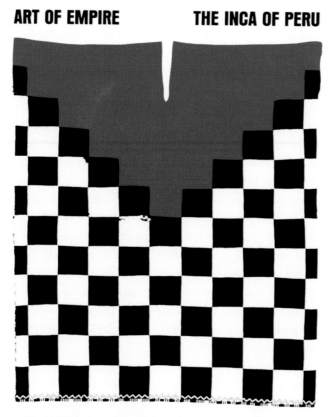

ART OF EMPIRE THE INCA OF PERU

THE MUSEUM OF PRIMITIVE ART, NEW YORK

38. Cover: Julie Jones, *Art of Empire: The Inca of Peru* (New York: Museum of Primitive Art, 1964).

Burgundian courts, and for Iberians, also the strange elegance of the Peninsula's old Moorish rulers.[7] As a contest for the possession of bodies across a grid, the game's allegorical workings were necessarily complex.[8] Chess required rational calculation, and so it was identified with the male domains of warfare, mathematics, and the intellect. The game also piqued unruly passions, such that it evoked the play of courtly love (Fig. 37). So Pizarro's men took in the sight of the Incas' chessboard livery: before them unfurled the game's high-flown seductions, at once inviting and opaque, unsteady and impassive.

In 1964, that same garment pattern appeared on the cover of an exhibition catalogue published by the Museum of Primitive Art, New York (Fig. 38). *Art of Empire: The Inca of Peru* was that institution's major exhibition for the year, a show of eighty-five works of Andean art in several media. The catalogue's text described the cover-object's pattern as "a total geometric formality... designed to be read flat." This is the manner in which the textile appeared on the exhibition catalogue's cover, and thus was it displayed in the museum's exhibition space. "When worn," the catalogue informed the reader, "the clarity of the pattern is lost."[9]

The Museum of Primitive Art's account of Inca art was a powerful example of New York's postwar modernism at high water. In artworks such as the one on the catalogue's cover, the show argued, the Inca aspired to a universal language of form, space, and human presence; and in it, too, the Inca pursued a concomitant negation of history and culture. The Incas' commitment to this grand project seemed only confirmed in the object's compositional rigor and its daring sense of repudiation: the object displayed the gallery space bore no inscriptions or text, and it carried no representational images. The work's formal purity offered at once a distinctive mode of visual expression and a systematic ideological project all told.[10]

The Museum of Primitive Art's catalogue correctly identified the Incas' concern with visual expression as discursive agency – as meaningful cultural rhetoric, certainly. At the same time, however, modernism also arrogated to itself the formal and ideological impulses of Inca visual production. Inca work was implicitly set at the meeting point of American antiquity and Western modernity, there to operate as the hinge on which turned the reciprocity of natural and modern man. In Inca artworks, the deep past of humankind's natural history pivoted forward to define man's inevitable *telos*, the modernity of mid-twentieth-century North America.[11]

Mounted in the gallery vitrine in 1964, the Inca garment was splayed flat and tipped upright, its surface set parallel to the vitrine's sheet of glass. The object was fixed within concentric modernist formalisms of history and aesthetics. Atawallpa's march toward Cajamarca spread that Inca pattern across an expanded field of culture and perception. Covering the fields, the pattern collaborated with an alternate formalism, the framework of Inca mythic history.

THE PERFORMATIVE UNFURLING OF INCA COSMOLOGY IS THE SUBJECT OF THIS chapter, although the Inca attack at Cajamarca is better known to history for its unraveling. The Inca ruler and his army suffered massive defeat soon after they entered Cajamarca's plaza. That evening Atawallpa would be held prisoner in one of Cajamarca's largest Inca palaces. He dined with Francisco Pizarro, accepting the Estremaduran's magnanimity as so many hundreds of Inca bodies lay on the pavement before the building.

Pizarro and his soldiers authored a massacre at Cajamarca. Pizarro sought to engage the enemy at close quarters, where the violence of European fighting technologies would be most deadly and most demoralizing to native opponents. Ideally, the native ruler might be captured or killed outright – a proven European tactic in the Americas. The native force could be pushed to confusion and panic, and the weight of numbers offset. This narrative is well known. Even so, the encounter at Cajamarca must be understood as a military contest,

not an unprovoked slaughter.[12] The engagement did turn brutally one-sided, though only in its final moments. Overall the confrontation pitted two military forces against one another. Both armies were led by seasoned commanders, and the rank and file on each side were skillful practitioners of coordinated mass killing; those men were armed and morally prepared for the task.

And no less than the Europeans, the Inca too had laid a deadly trap. Their plan was logical and broadly conceived: it depended on the careful maneuver of massed infantry formations, as well the moral dynamics of intimidation. If the Europeans' success hung on killing power loosed at close range, the Incas' design took shape as a coordinated set of deployments around the valley. Those movements were designed to force the surrender of the European force, or to destroy it outright.

The Incas' maneuvers outside Cajamarca may be framed in any number of ways: following the Europeans' own image, they may be cast as premeditated chess moves across a field of play. Or they may be characterized as dance – kinetic bodily performance that manifested the Incas' masculine vitality and martial strength. Alternately, they can be understood as a choreographed ritual that replicated the deep structure of Inca myth and cosmos. However they are understood, the Incas' movements amounted to an angry mass action: immediate, site-specific, truculent. And all this was legible to the enemy, both at a distance of several kilometers, and as the distance between antagonists closed. There is little doubt that the Inca king fully expected to dine with his enemies in Cajamarca that evening; there in the town's great palace he would act as indulgent patron to his rivals' submission.

Atawallpa and his generals had ample reason for confidence that afternoon. By the morning after the Europeans' arrival in the town, all the conditions of an Inca victory had been prepared. It was clear to the Inca leaders that the alien party was pinned in Cajamarca. They were small in number and weary from the previous weeks' marching. It was also apparent that the foreigners were unsure of their position and indecisive. Their brief sallies were impressive for their speed and nerve. (As the morning and afternoon wore on, recalled Diego de Trujillo, Pizarro ordered one horseman forward; it fell to Hernando de Aldana to break from the cover of the town, race toward the massed Inca formations, then scuttle back again.[13]) Those forays suggested only skittishness in the face of danger, and incipient panic. Now the Incas' antagonists cowered in Cajamarca's central precincts, having withdrawn into the palaces they had looted the afternoon before.

Atawallpa and his advisors well understood the weakness of the Europeans' position. They made a series of decisions that built their already lopsided advantage. Atawallpa's large army began to draw into fighting formation in the morning. That force waited to move until late afternoon, only after many hours of deliberate delay. The Incas' enemies were made to wait, and to stew. Down

below in Cajamarca, the Europeans were given to witness the mobilization of the large Inca army. They watched as the Incas' fighters formed and deployed in the fields. The subsequent written commentary of Pizarro's soldiers makes clear that the Incas' maneuvers were simple and methodically coordinated. They were easily read as the movements of an army deploying for attack.

Atawallpa's fighters in their tens of thousands were divided into three principal units. The bulk of the Inca force – most of the army – remained close to the Inca camp along the far eastern edges of the valley. From this position, that main group was poised like a raised hammer above the town. At any moment they could bring down the army's full weight on the enemy below. A second formation of about 20,000 soldiers was formed. That group was detached from the main body and moved off in a flanking maneuver. This group would block the Europeans' route of retreat from the town. If Pizarro's band made a hasty withdrawal from Cajamarca, this second group would stand in their path. These were to be the Inca army's real killers, the soldiers who would intercept and destroy the Incas' demoralized, fleeing enemies. And surely enough, Pizarro and his men most feared that second group. The Spanish would be told later that this group was commanded by the Inca leader Rumi Ñawi. He was a proven, resourceful field commander.[14]

As the Europeans watched, a third column was formed. This one was much smaller than the other two – perhaps four to six thousand, certainly no more than this. This group was commanded by Atawallpa himself, who was borne in their midst on an elaborate palanquin.[15] Like the other two Inca formations, this one was made up principally of fighting men. Unlike those other two groups, however, some considerable portion of this formation consisted of attendants – likely Atawallpa's servants and household staff. This third group was to be Inca army's leading element. It prepared to move directly down the slope toward Cajamarca, soldiers marching at the front.

The Europeans were at once threatened and puzzled by this tertiary formation. In an army of tens of thousands, this was the smallest and the weakest of the Incas' three contingents. It was also the most glittering – little more than an honor guard of liveried attendants and leaders in elaborate sedan chairs. Even so, it was this group, rather than the other two, that prepared to make the most aggressive battlefield movement. To the Europeans in Cajamarca, it appeared that the Inca would take the fight to them with trilling ceremony, not the blunt instrument of tens of thousands.

What the Europeans did not then comprehend was the larger strategic purpose of Atawallpa's contingent. It is clear that the task of Atawallpa's small formation was not primarily to engage the enemy in a pitched fight. Instead the group set to a more expansive task – theirs was the end game. Leading the massive army from the front, Atawallpa would press home the best option remaining to the Incas' opponents: surrender and submission. This is to say that

the Inca army's third, smallest contingent was not charged with the annihilation of the enemy by force. They were to force the enemy's political incorporation into the Inca hegemonic order. The small contingent led by Atawallpa would drive straight at the Incas' enemies in the town. At a stroke, the Inca would provide a demonstration of Inca military power and extend an invitation to peace. Like the Spanish dash to Atawallpa's palace the afternoon before, the movement of Atawallpa's small force was a demonstration of martial will and a diplomatic embassy. The horsemen's advance was all adrenaline and tactical swagger; the Incas' march to Cajamarca would effect a more deliberate, strategic maneuver.

XEREZ'S NOTICE OF THE EUROPEANS' ENTRY INTO CAJAMARCA TOUCHES ON a salient fact of the meeting there: the Europeans' arrival in the highlands coincided with the onset of the wet season. True enough: In mid-November, the Andean highlands are drizzly and prone to bouts of hail. The weeks of marching to Cajamarca had been thoroughly wet. Soaked by day, Pizarro's company slept in the open, enduring cold nighttime temperatures. *Granizaua un gran granizo*, Mena wrote of the entry to Cajamarca: "And hailing: the hail was coming down hard as we arrived."[16]

The wet season generally comes to the northern Andes in November; this period, the austral summer, arrives in the Incas' ancestral home in the southern Andes about a month later. The Inca considered it the most dangerous period in the solar year. The season's heavy rains cause rivers to rise and burst their banks. The kinetic energy of falling rain and hail loosens topsoil and so hastens erosion. Extended periods of precipitation may saturate the ground to its full capacity, such that the soil can absorb no more water. Runoff flows in unchecked torrents, gouging the landscape. Soil may tear away from the underlying bedrock, and hillsides collapse in thick sheets of mud.

Inca administration was closely tied to weather for an important reason. Within only a few decades, the Inca imposed significant changes in highland agriculture and diet. That shift was based on one crop: corn. The Inca state's identification with intensified maize production is abundantly confirmed in archival and archaeological evidence.[17] The Inca maize economy was tied to characteristic modes of gastronomic consumption as well as agricultural production. Brewed to maize beer (*chicha* or *aqha*), corn was the preeminent ritual food of the highland Inca realm.[18] Inca administration had turned "potato eaters" into "maize drinkers" across broad swaths of the Andean highlands by 1500. The ample provision of maize beer at banquets and feasts was one of the principal means by which the Inca state paid its moral debts and confirmed the obligation of its subjects.[19] "The Inca," writes one specialist, "strove to make maize itself a royal food . . . making chicha into a symbol of empire."[20]

Maize agriculture was, in the language of cultural ecology, the Incas' pre-eminent means of material and symbolic "energy capture."[21] Through maize agriculture the Inca collected the sun's energy and instituted its vitality as social and cultural practice. *Mama Aqha*, "Mother Beer," was among the epithets that described ancient Cuzco.[22]

In tying itself to corn, the Inca state had streamlined and intensified its agricultural economy. It also pinned the state's fortunes to the seasonal success or failure of a single crop.[23] It was a reasoned if daring move, for corn is an uncertain proposition in the highland Andes. Particularly in the southern Peruvian highlands – though in the more temperate north as well – maize agriculture is risky at higher altitudes. Corn is far better suited to the broad sun-struck river valleys at lower elevations than to the tight, vertical landscape of higher Andean altitudes. Maize requires both good soil and a steady supply of water; it is vulnerable to the highlands' endemic wind, hail, and frost. The dangers of the highland climatic zone were intensified with the onset of the wet season's rains. No other phase of the agricultural cycle brought equal dangers to the Inca cultural order, for at no other time was the weakness of the Inca agricultural scheme so acute.

As well as being the early rainy season, early November was the beginning of summer in the Andean highlands. In the annual cycle of the seasons, this was the sun's most active period. The sun was strongest and most intense now. Particularly in the northern Andean highlands, mid-November is the hottest time of the year. At this time of year the sun is plainly the prime mover of agricultural production: its strengthened energy spurs crops to explosive growth. The sun was also now most dynamic as a celestial body. In November it was approaching its highest point in the sky. Within a month the sun would preside over the year's longest daytime period of light. At this time – the austral summer solstice – the arc of the sun's daily movement across the sky would begin to shift. In months previous, the sun's daily transit had traced a path across the southern part of the sky; at solstice that arc began to tilt the other way, slowly transitioning to the northern half of the sky.

This period was the Inca state's ritual high season. Beginning in November, the ceremonial of the Inca state shifted along with the sun. The sun's renewed activity and strength were recognized and celebrated. That solar power was enlisted to counter the wet season's dangers. The ceremony and ritual of the Inca state swung toward solar symbolism and a rhetoric of military aggression. This public enunciation of militancy marked a shift from the agrarian, family-based, and female-inflected ritualism of the months immediately previous. The rituals of August through October emphasized agricultural acts of planting and nurturance.[24] Those agrarian rites now gave way to a cycle of explicitly martial ceremony. These rituals emphasized higher-order social structures under the state's purview – the communal life of mass ritual, state service, warfare, and

the public expression of masculine honor. That rhetoric would be aggressively flourished before the Incas' enemies at Cajamarca.

INCA RITUALISM WAS UNDERGIRDED BY REALPOLITIK. FOR THE INCA LEADER-ship, the facts on the ground were thus: the hailstorm of Friday 15 November 1532 was just another early-season squall, and the men occupying Cajamarca's palaces another band of nomadic opportunists operating along the Inca realm's margins. This raiding party was previously unknown to the Inca beyond reports sent from outlying stations in the empire's far north. Still, the fact of another challenge to Inca authority was predictable enough: conflicts with small armed bands were an inevitable consequence of the Incas' pan-Andean sovereignty. This kind of military challenge was not an uncommon occurrence along the empire's peripheries. The Inca leadership was familiar with armed incursions at the empire's southeastern reaches, for instance. There, among the Bolivian *páramos* and dry Argentine plains, nomadic peoples made regular incursions into Inca territory. Those groups were mobile, and depending on their mode of subsistence – whether they fed themselves as hunter-gatherers, or through a combination of agriculturalism and hunting – they might be wholly untethered to the seasonal rhythms of the agricultural cycle. To counter the threat of those rogue wanderers, the Inca maintained a system of fortresses and garrisons; this military infrastructure was intended to domesticate such peoples, or repel them outright.[25]

The Inca similarly contended with Amazonian peoples, small-scale societies whose warriors appear to have frustrated Inca military efforts in the low-land rainforests. It seems the Inca did all they could to bring these groups to heel diplomatically; in practice the Inca leadership eagerly employed Amazonian warriors as auxiliaries, anyway. The Amazonians' stubbornness as fighters would be recalled in highland rituals long after the demise of the Inca imperial system. The ritual combats of "Incas and Antis" staged over the centuries of the colonial era would be recorded in European-inflected representational images on wooden drinking vessels. In those ceremonial practices and in the artworks they inspired, Amazonians' challenge to Inca domination was elevated to mythic structure: the Amazonian forest peoples' stubborn opposition to Inca rule came to stand for the larger conflict of the Inca and their far-flung, uncivilized enemies.[26]

The Inca had more enemies still, and these were arguably more threatening. At the time of Pizarro's arrival in Cajamarca, the Inca ruler and his political faction were at odds with many of the settled peoples of the Inca empire's northern margins in Ecuador.[27] These northern groups were not as impetuous or unpredictable as the Amazonian forest peoples or southern hunter-gatherers. Even so, the individual groups who made up the Incas' Ecuadorian foes were

on the main considerably more populous. The Incas' strategic interactions with those peoples were necessarily more complex, given the intricate web of political relations among the peoples of that region. Relative to the nomads and forest dwellers elsewhere along Inca *limes*, these northern Andeans were more like the Inca themselves – settled peoples, agriculturalists, and successful traders with long-distance, supra-regional commercial ties. The Inca ruler's presence in Cajamarca, together with a large army and a cadre of trusted, effective field generals, was part of a larger military effort to reassert Inca dominance among those fractious northern Andean peoples. Pizarro's band – one more nomadic raiding party that looted as it went – arrived in Cajamarca just at the apex of the annual cycle of state ritual, and just as Atawallpa's faction was turning its attention to the north.

BY THE REIGN OF ATAWALLPA'S FATHER, WAYNA QHAPAQ, CAJAMARCA WAS AN elaborate Inca administrative and military installation in the northern highlands. From here the Inca administered the northern highlands and adjacent Pacific coast. Cajamarca's storage houses also provisioned Inca armies fighting further north.[28] The buildings of Cajamarca's central square probably date to the decades around 1500. Atawallpa himself would tell the Spanish these structures were intended for sojourning Inca kings. In these buildings Inca kings "would rest" during their travels in northern Peru.[29]

For the killing that would take place there, those elaborate structures and the plaza on which they stood are now infamous in Latin American history. Though at the time Atawallpa's army drew into formation outside the town, Cajamarca's monumental urban works were more reason for Inca confidence. Those handsome constructions were part of an encompassing system of revetment that supported the Inca military and administrative enterprise. An "infrastructure of control," that system has been called: roads, guard houses, way stations and storage warehouses, provincial administrative centers, and fortresses.[30] With this vast program of construction the Inca leadership militarily hardened the Andes. This infrastructure supported the Incas' aggressiveness on the offense, and it sustained Inca resiliance when falling back. The roads and way stations had conveyed these particular enemies to them. The textiles and all else looted from Cajamarca's palaces could be replaced: there was plenty more.

Why then did Atawallpa and his army of tens of thousands camp in the open above Cajamarca, rather than in the fine urban precincts constructed to receive them? The answer lies in part in strategic logic. Camped above Cajamarca, the Inca army enjoyed freedom of maneuver, and so held the battlefield initiative. Outside Cajamarca's walls, they were a mobile force prepared to fight a battle of position and momentum; they could choose where and when to fight. Down in central Cajamarca, Pizarro's men were sheltered from the elements;

they could take solace in looted cloth and food. They were also at an acute disadvantage, for in military terms they were forced into a reactive mode. The Europeans could only wait and respond to what came. This passivity weighed on the Europeans, ate at them.[31] The long hours of inaction and uncertainty were among the Incas' principal weapons in the conflict.

The Inca's opponents were set up for annihilation. Better still, they were prepared for political incorporation and subordination. Ensconced in Cajamarca's urban fabric, Pizarro and his soldiers were now embedded in an Inca complex that assumed ideological as well as physical dimensions. The Incas' enemies had entered into a set of prepared relationships by which the Inca leadership organized the Andes' human communities and set them in relation to one another. The Inca understood these relationships to be enduring: the nature and permanence of the Inca leadership's bonds to its subjects was absolute truth, a set of mythic facts that floated free from from the confining perspective of linear history. The Inca leadership, writes a prominent cultural anthropologist, subscribed to "an ideology of history that was timeless, repetitive, and fully interchangeable – and integrated – with political, social, and ritual structure."[32] There was a history between the Inca and their enemies. The Incas' march toward Cajamarca enacted that history's mythic structure: the advance of Atawallpa on the settlement recapitulated the founding history of the Inca dynastic order. With their attack, the Inca concretized dynastic myth. New enemies were substituted for those overcome before; the ideological coordinates of Inca mythic destiny were mapped onto the physical features of the Cajamarca valley.

ATAWALLPA TRAVELED WITH DYNASTIC RELICS. NO EXTANT ADMINISTRATIVE record exists that provides written citation of their presence in the royal retinue's baggage: that documentary lacuna is yet another loss suffered in the wake of the Inca defeat at Cajamarca. Even so, certain of the Inca dynasty's sacred objects were keenly recalled by colonial administrators and evangelizers in later years.[33] Of the relics identified with the Inca royal dynasty, historical accounts suggest that one in particular assumed special importance to war campaigns led by Inca rulers. This was a stone effigy of a prominent geological feature near Cuzco, Mt. Huanacauri. The landform itself overlooks the Incas' ancestral capital of Cuzco from the southern rim of the Huatanay River Valley. It is the tallest peak along the southern skyline of the Cuzco basin (Fig. 39). Mt. Huanacauri held an important role in Inca dynastic lore and in the ceremonial of the mature Inca state.[34]

Like other Inca sacred beings, Mt. Huanacauri was not one physical entity, but many. Huanacauri was manifested in several objects. Colonial Spanish administrators described one of Huanacauri's physical embodiments, an effigy

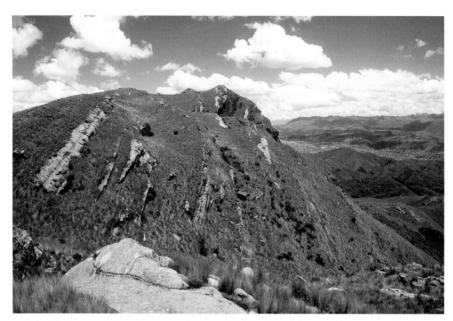

39. Mt. Huanacauri, Peru. Cusco in distance. (Photo: author)

of polished stone.[35] Working from sixteenth-century administrative reports, the seventeenth-century Jesuit Bernabé Cobo described the effigy thus:

> It was of moderate size without shape [i.e., without any discernible visual representation], and somewhat tapering... [The Inca] very commonly took this idol to war with them, particularly when the king went in person. Guayna Capa [Wayna Qhapaq] took it to Quito, whence they brought it back again with his body. The Incas, indeed, were convinced that it had a large share in their victories.[36]

The memory of that object among Cuzco's Iberian administrators and evangelists is no historical idiosyncrasy. Other Inca mountain effigies have since been documented in archaeological contexts. Those objects closely match Cobo's description. Several examples were recently excavated from a high-elevation ceremonial context in the southern Andes (Fig. 40). They may be described as smooth, conical stones just under half a meter in height.[37]

There is no sure telling if Atawallpa's retinue traveled with a relic of Huanacauri. His father and royal predecessor, however, did on his campaigns in the northern Andes: Cobo assures the reader that the object was an important talisman of victory in those wars. Now on their own campaign of pacification and conquest, the military leadership under Atawallpa could be nothing less than eager to emulate the precedent of Wayna Qhapaq's successful wars in the north. That effigy in Atawallpa's baggage was the current campaign's "index object" – the effort's key ideological principle.[38] The relic organized the army's social relations, and the constructions of space, place, and time in which those

interactions would unfold. The object was never seen in the fields or on the plaza of Cajamarca. Even so, the work set the terms of cultural visibility in those spaces. It served as the unseen, unquestioned mythic condition of the military campaign, not as the visible evidence of its righteousness. The relic pushed back the horizons of space and visual legibility, extending those dimensions of human experience into the realm of myth.

Spanish observers who saw other Inca mountain effigies compared them to a "sugar loaf" (*pan de azucar*). It is an apt enough characterization. Though the Inca would have likened their appearance to that of a seed: hard and dense, though also rounded and organic in form. As did seeds, these effigies bore life energy in condensed, durable form.[39] Like other objects of its kind, the effigy in Atawallpa's baggage was the palpable extension of the sacred landform's being – it was a type of object known to the Inca as a "brother," or "sibling" (a *guauhqui* [*wawki*]).[40] The large stone kernel in Atawallpa's baggage was a physical embodiment of Mt. Huanacauri's identity. Its physicality manifested the life essence of the great landscape feature fixed above Cuzco: it was the mountain's proxy rather than its mere representation.

Such effigies participated in the Inca leadership's complicated ideology and social practice of vital essence and numen. They embodied the ineffable but palpable presence of the being whose essence they shared. In *wawki*, the primary being's identity – or selected aspects of that identity – was parted out among a number of physical representatives. Any given sacred being was less a singular being than a network of stand-ins – so many physical instantiations

40. Inca andesite mountain effigy excavated from Inkapirqa/Waminan (Ayacucho, Peru). Rendering by Cate Davies. From Frank M. Meddens, Colin McEwan, and Cirilio Vivanco Pomacanchari, "Inca 'Stone Ancestors' in Context at a High-Altitude *Usnu* Platform," *Latin American Antiquity* 21:1 (2010), Fig. 9.

of the being's presence. The Incas' effigy doubles were principal instruments in the negotiation of status and hierarchy among the Inca leadership; they acted as social agents through which diverse political interests were advocated,

recognized, and hierarchically organized. Together these objects protagonized the primary entity's agency within the various sacral, social, and political contexts of the Inca nobility.

The Incas' *wawki* represented the interests of the Inca leadership's authoritative leaders and big men; alternately, they advocated on behalf of lesser clients, asserting political claims that would be deemed insubordinate from a human leader.[41] In other cases, effigy doubles served in diplomatic capacities among the Incas' Andean peers: The Inca effigy of the morning sun, the *Punchao* (*Punchaw*), completed a circuit of visits to temples and shrines around the Cuzco region according to a yearly calendar.[42] That sacred object was also carried wider afield in the Andes: the Inca maintained a palace for the relic of at least one, perhaps several non-Inca oracles around the Andes.[43] The Inca daytime sun is recorded to have been manifest in several effigy doubles, each of which embodied a different aspect of Inca solar divinity. The seventeenth-century Jesuit Cobo wrote that the primary solar effigy was often displayed in the Inca temple of state along with two other companion effigies.[44] During the recent crisis of dynastic succession, an effigy of *Punchao* was borne through the northern Andes, where it met with the region's leaders and other sacred beings. Atawallpa's faction employed the effigy to advocate for the northern faction's claim to the Inca monarchy. There is no record of which object served on Atawallpa's behalf, nor of which made more regular travels among the Andes' powerful oracles.

Those effigy doubles organized relations among the Inca leadership's political factions – patrons, clients, and allies. The effigy of Huanacauri that accompanied Atawallpa in the current campaign operated in a similar manner: It mediated and organized the politics of the royal Inca retinue. The effigy embodied the Inca dynasty's ties to the mountain, for the geologic feature itself was considered a "brother" of the Inca dynastic founder, Manqo Qhapaq.[45] A complicated chain of co-essence thus linked both the Inca dynastic founder and the living Inca ruler to the mountain's effigy doubles: Atawallpa *was* Mt. Huanacauri – they were a common vital essence in twin bodies.

As a landscape effigy, the *wawki* of Mt. Huanacauri served primarily and most powerfully as a device of "place changing."[46] The object set Atawallpa in a certain relation to the army under his command. It organized the Inca army's social action by reframing the cultural space in which that work would occur. Huanacauri's effigy double determined the army's a relationship to the physical terrain on which the present military struggle would occur. The effigy emplaced Atawallpa's expeditionary force on the new, old ground of the Inca capital's sacred landscape.

Coordinates of physical location also imply the plotting of temporal relation. The effigy also organized the campaign's relationship to the Inca dynastic past. Mt. Huanacauri's importance to the Inca leadership was determined by its role

in the myth of Inca dynastic foundation. According to this lore, the founders of the Inca dynasty emerged from a set of caves south of Cuzco. These figures were four sets of male-female siblings; they emerge from the cave and wander the highlands with their sacred instruments and their llamas.[47] The siblings settle temporarily before moving on, or they come into conflict with local peoples they encounter. Some of the original siblings split off from the group – one returns to the cave of origin, while others leave the group and go on to found other ethnicities around the Inca heartland. Finally the remaining siblings ascend a tall mountain on the southern edge of the Huatanay River Valley – Mt. Huanacauri. Here they are granted a number of divine omens. One brother is transformed into a great bird at the mountain peak; in various versions of the tale, either he rises into the sky in a burst of color, or he is lithified on the mountain face – made a stone. (Either version holds relevance for Atawallpa's glittering approach to Cajamarca.) The founding siblings witness a rainbow arcing over the valley; a golden rod is thrown from the mountaintop, and the projectile sinks into the thick soil of the valley bottom below.[48] These signs constitute divine dispensation to conquer and occupy the valley. The remaining siblings descend the mountain and subdue the valley's local inhabitants. The primary pair, the male founder Manqo Qhapaq and female founder Mama Waqo, then settle in Cuzco. There they set to the principal duties of Inca lordship: a domestic life of social obligation and maize cultivation.

The sacred mountain in Atawallpa's baggage was the means by which the divine ruler went about the worldly calculus of conquest. The brother effigy was the ideological anchor and prophetic bellwether of his war plan. It allowed the Inca military campaign to be plotted within Inca structures of spatial relation, sacred landscape, and mythological narrative. It banished the conflict's uncertainties: it substituted the known truths of dynastic lore for the situational complexities of war on the ground. The coming engagement would – could only – conform to the patterns innate in Andean world design and Inca dynastic myth. "Victory Destined," the Inca ruler and his army would enact the new history of an old Inca myth.

URQO, "ON HIGH," WAS THE INCAS' EPITHET FOR MOUNTAIN PEAKS. THE WORD indicated both prominent elevation and the commanding view from that height. That kind of visual mastery – the dominating view from above – was considered a moral attribute of Inca leadership. It assumed an important role in Inca myth and the discourse of masculine prestige and leadership.[49] High mountains were *urqo*, dominant male presences in the landscape. In the broad Andean cultural tradition, mountains are considered sources of fertility and sacral power.[50] As an aspect of Inca leadership's telluric orientation, a mountain bestowed divine sanction on the human community beneath its direct gaze.

In the urban topography of Inca Cuzco, ravines and low spots that lay out of Mt. Huanacauri's line of sight were considered disfavored.[51]

The term *urqo* was borne as an honorific among Inca nobility.[52] The native Andean nobleman Felipe Guaman Poma de Ayala included an Inca captain named *Inca Urcon* ("Noble On-High") in his illustrated history of the Inca empire (Fig. 41).[53] Guaman Poma used the noble to demonstrate the cruelties of the old Inca regime: raised above his subjects by a massive stone – a building block for an Inca building project – the noble drives them to haul the rock to a distant construction site. Poma's drawing offers a disapproving Christian gloss on a moral attribute once admired by the pre-contact leadership. Elevated on high, the noble is pitiless in wielding the whip hand. Even the rock beneath him weeps blood.

Guaman Poma's drawing is useful for the way it demonstrates the situation-alism implicit in the Inca ideology of *urqo*. If an undeniable quality of towering landforms, among human beings *urqo* was a manifestly a term of social and political artifice. *Urqo* was dramaturgy, Guaman Poma argues: it identified a characteristic mise-en-scene in the old regime's political theater. Guaman Poma took a jaundiced view of such stage management. The heavy stone on which Inca Urcon stands is no high mountain, nor is the captain's oversight less than cruel folly. At once footstool and dead weight, the great stone is a contrivance of Inca tyranny and that injustice's cruel fulfillment.

In early November 1532, Atawallpa and his army had arrived at Cajamarca well in advance of Pizarro's band. They chose to make camp outside the town, not in Cajamarca proper. Above Cajamarca, Atawallpa and his army staged *urqo*, the dominant view over their enemies below. More than that: Atawallpa and his company stood with Mt. Huanacauri and so also at Mt. Huanacauri. The object mapped the mythic landscape of the Incas' dynastic capital onto the theater of actual conflict. That transposition realized the hidden meanings of incidental topographies and actions. The conflict now waged would take place on the ancestral terrain of Inca dynastic origins. Across the valley from Atawallpa and his army – in mythic terms, now down the slope and below them – lay Cajamarca, another Cuzco.

Atawallpa's attack was a singular exercise: it was a definite incident within a specific campaign waged against particular enemies. The military action at Cajamarca took as its model the rituals traditionally performed in the Inca dynasty's capital at this time of year. In its singularity the attack only confirmed the routinized customs of those ritual actions, and the deeper patterns of Andean social relation they bore out.

The Inca leadership took Cuzco in triumph every year at this time. The Inca responded to the wet season's November onset with an elaborate cycle of ceremonial action. These rituals took place over a period of several weeks as they escalated toward the December solstice.[54] Among the most important

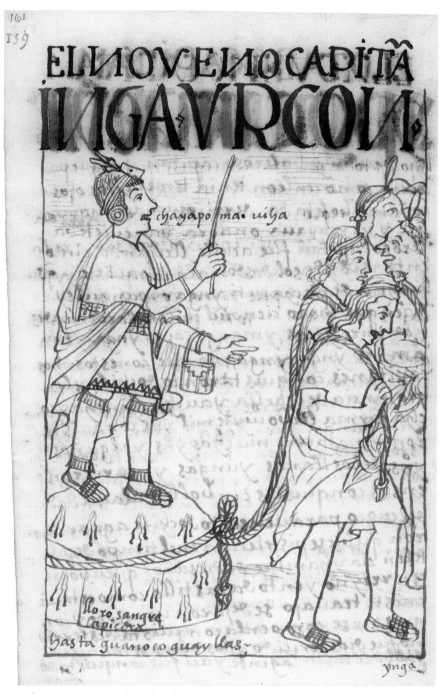

41. Felipe Guaman Poma de Ayala, *El primer nueva corónica y buen gobierno* (1615/1616), (Copenhagen, Royal Danish Library, GKS 2232 4°: facsimile at http://www.kb.dk), 161v.

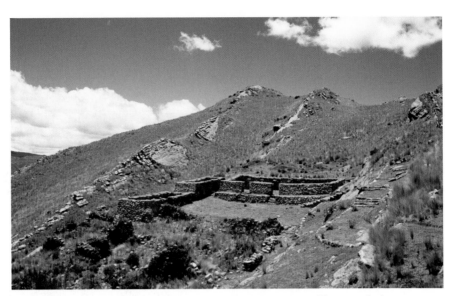

42. Inca temple at summit of Mt. Huanacauri, ca. 1450–1532 C.E. (Photo: author)

rites of the solstice was a pilgrimage to and from Mt. Huanacauri by noble adolescents. Youths preparing to enter adulthood departed from central Cuzco in a footrace; they spent several nights at the base of the mountain and then at a shrine at the mountain peak (Fig. 42). At the top of the mountain they gave sacrifices, and they were instructed in the history and duties of Inca leadership. These harangues emphasized the history of Cuzco's founding: at the temple on Mt. Huanacauri the young men were in the company of the dynastic founder's lithified brother. They looked out from the summit on the same valley prospect witnessed by that figure and the other founder-siblings. The noble boys then returned to Cuzco in a large procession: as the founders had descended to conquer and settle, so did Cuzco's new adult male nobles.

The young Inca nobles' return to Cuzco emphasized two defining themes of Inca leadership: warfare and pastoralism. The march down from Huanacauri was warlike in essence. The young men had been instructed in the founding acts of Inca conquest. They were ritually armed at the peak, and they brandished these sacral instruments on their march into town: "then they put staffs into the hands of the youths, to the upper part of which a knife was attached, which they called *yauri* (scepter)."[55] Their procession was led by sacral instruments identified with the Inca ruler: the *suntur paukar* – a conical staff faced with a mosaic of iridescent hummingbird feathers – along with two metal camelid effigies, one in gold and another in silver (*Cori Napa, Collque Napa*) (see **Fig. 11**).[56] The young men were led into town by the ideological construct of Inca kingship – as embodied in those effigies – not any of its living or historical representatives. The ritual thus displaced the initiation ceremony from immediate, actual temporality, situating it instead in mythic time.[57] They

entered town as a conquering army,
singing and dancing in triumph. Their
entry into Cuzco ended in the main plaza,
where the young men engaged in a bout
of ritual feasting with their relatives.

This militarism overlapped with the
procession's pastoral symbolism – its em-
phasis on camelid herding. The youths'
entry into Cuzco enacted the arrival of
mountain pastoralists into a community
of valley agriculturalists. The young men
progressed into town as a train of ani-
mals led by the two royal camelid effigies
and the plumed royal scepter. As them-
selves animals, the young men embod-
ied camelids' utilitarian virtues: service
(as burden-bearers), nurturance (food),
and sacrality (sacrificial animals). Pas-
toralism also bound the nobility to the
broad mythic apparatus of itinerant cre-
ator deities and once-landless conquerors.
More broadly, it identified them with
long-distance communication and trade –
with luxury goods. A woven Inca coca
bag from the sixteenth century depicts
a train of llamas, moving boustrophedon
up the object's sides.[58] Among the high-
land Inca, coca was a prestige commod-
ity imported from distant, low-altitude

43. Coca bag, Inca. Cotton and camelid fiber, ca.
1450–1532 C.E. 51 × 18 cm. Museum of Fine Arts,
Boston, The Elizabeth Day McCormick Collec-
tion 51.2452. Photograph © Museum of Fine Arts,
Boston.

provinces. Coca bags were worn over the arm, and they were a common
element of noble and high-status dress (Fig. 43). (The captain Inca Urcon
wears a coca bag on his left arm in Guaman Poma's drawing in Fig. 41.) Along
with many others, this woven Inca coca bag was elaborately decorated with
ribbons and tassels, ornamented as if earmarked in the manner of an Inca llama.
The bag that bore imagery of llamas on its sides was itself the effigy of a pack
animal. By wearing the coca bag on his arm, the Inca noble symbolically held
the lead llama of a pack train that bore him coca from distant regions.

As representatives of the broad lifeway of Andean pastoralism, the youths
returning from Mt. Huanacauri reaffirmed the Inca leadership's ties to pastoral-
ism, considered by tradition to be inherently aggressive and warlike – "wild"
and "savage." As pastoralists among agriculturalists, the young nobles enacted a
traditional form of Andean complementarity: In the Andes, drovers supplanted

farmers.[59] In some important measure, the pattern was based in historical fact. The encroachment of high-altitude pastoralists on valley agrarian societies was frequently repeated in highland Andean prehistory. There is a great deal of historical nuance in this deep Andean story: it encompasses patterns of raiding, the seizing of lands, and intermarriage within and among settled and nomadic communities. This said, the interaction of drovers and farmers was also a pattern of Andean cultural discourse.[60] Drovers-over-farmers was a long-abiding myth among the highlands' co-traditions; it was a rhetorical construct that commented on and organized social relations. The Tiwanaku and the Wari, the two great pre-Inca state entities of the southern highlands, had reified this cultural pattern in the rhetoric of state by the early- to mid-first millennium. As would the Inca after them, those leaders administered complex agro-pastoral economies; in many respects those material systems differed sharply from subsequent patterns of Inca economic management, even though, like the Incas', those earlier dominions encompassed both lowland agricultural tracts and upcountry pasturage. The opposition and unity of those dissimilar ecological zones provided discursive means to articulate tensions inherent in that economic and social complexity. In the ceremonial of the Tiwanaku and Wari states – such as it is preserved in the archaeological and artistic record of those societies – pastoralism came to stand in for the social imbalances implicit in a socially stratified, expansionist society. Social unity was founded on this dialogic antagonism, a "predatory complementarity" of wandering herdsmen displacing valley planters.[61]

"It happens remarkably often," writes Marshall Sahlins, "that the big chieftains and kings of political society do not come from the people that they govern."[62] In the Andes, that model of social complementarity has proven robust and enduring: many highland Andean communities continue to observe communal moieties of *huaris* (agriculturalists) and *llacuaces* (pastoralists). The symbolic opposition of the two traditional Andean lifeways forms the basis of complementary asymmetric duality in unified communities. This union has recently been described by two specialists in native Andean culture and language:

> Societies on the Pacific slope of the Central Andes saw themselves as partnerships between lineages of highland pastoralist origin, identified with male *huacas* (revered object or place) incarnated in snowcaps, and lineages of valley-based agriculturalists, identified with valley-based female fertility *huacas* . . . dialectical union connecting the powers of the heights (storm and water) with those of the valleys (soil and vegetation) was often mythicized as a sexual union or sibling pairing between invading male water deities and deep-seated unmoving female earth-deities. These polities understood the union as a ritualized, institutionalized, and sexualized structure of antagonistic interdependence uniting dissimilar peoples.[63]

Atawallpa's march down to the settlement took his army from an elevated boulder field – the *peñol* where he lodged with his immediate retinue – down to the enclosed space of a planned Inca town. It was a journey from high to low, the semi-wild to the cultured, and, so Atawallpa and his advisors believed, also from open conflict to advantageous, peaceful resolution. Atawallpa and his generals had planned this narrative of movement and change; under their direction the Inca army acted out this theatrical blocking.

THE TOPONYM HUANACAURI IS DRAWN FROM THE AYMARA LANGUAGE, IN which the word means "rainbow."[64] Rainbows unfurl in a sweeping, ordered luminosity – gleaming, sunlight-suffused, and deeply unnatural in the purity and strength of their colors. They assume even more specific meanings than this in the Andean tradition. Rainbows signaled the advent of new cosmic and social order, a "turning-about" both calamitous and transformative. They were also the signs of dynastic translation, their traverse across the sky understood as a transferral of sacral energies from one watery locale to another.[65]

Rainbows bear out the spiritual capacities of Inca vision. Among traditional Aymara-speaking communities of northern Bolivia, the rainbow is related to the gleam of metals and lightning, and to the glinting eyes of felines.[66] Rainbows are considered beautiful, so much so that they have a particular sweetness about them, which Aymara liken to the concentrated sugars of dried fruit, or the smoothness of fine fabric, or the mellifluous tones of kind words.[67] They are the luminous conditions in which human actions confirm mythic patterns, beings travel in many bodies, and individual places recur across vast geographic intervals.

The Inca communicated sacral identity with light. In the approach to Cajamarca Atawallpa was carried along in a resplendent sedan chair. Litters were employed by leaders across the Andes.[68] Atawallpa's conveyance is perhaps better described as a palanquin – a covered platform borne by several men. Guaman Poma illustrated royal Inca sedan chairs in his manuscript of 1615/6 (see **Fig. 23**). Palanquins like them were produced among numerous other Andean peoples. A gold miniature now in the Krannert Art Museum of the University of Illinois Urbana/Champaign depicts a palanquin and its bearers (Fig. 44). Harvard's Peabody Museum houses an elaborate, full-scale palanquin (Fig. 45). Both objects were produced on Peru's North Coast in or shortly before the Inca era; both impart a sense of the opulence and pageantry attendant on these objects.

Inca leaders typically rode into battle on palanquins.[69] The elaborate sedan-chair raised the leader above his soldiers, and so focused the army's attention on its leader. Many were large enough for the mounted figure to fight from. Andean military engagements appear to have coalesced into contests over

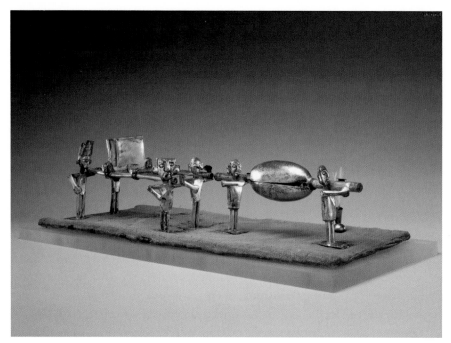

44. Miniature palanquin with attendants, north coast of Peru, ca. 1400 C.E. Silvered copper, cotton, reeds, feathers. 15.24 × 59 × 26 cm. Krannert Art Museum and Kinkead Pavilion, University of Illinois at Urbana-Champaign. Fred Olsen Collection, 1967–29–303.

leaders' sedan chairs. As the distance between the antagonists closed, battles devolved into scrums in which opponents struggled to secure or gain control of the opposing leader's palanquin. Andean generals understood this risk on the battlefield as a matter of course. Atawallpa had been pulled from his litter during a battle in the recent dynastic conflict: enemy warriors' hands apparently latched on to one of his earflares, leaving him with a mutilated ear: *Una oreja que tenía rompida,* reported Pedro Pizarro: "one of his ears had been torn."[70] Pizarro's ambush in Cajamarca would go much the same way: once Pizarro's trap was sprung, fighting focused on the native ruler's litter. Atawallpa would be roughly pulled from his palanquin and taken captive.

Atawallpa's litter was described by Xerez as having been richly worked with sheets of gold and silver, as well as the multicolored plumage of tropical birds (*plumas de papagayo de varios colores*).[71] Writing in the early seventeenth century, native author Guaman Poma described the Inca ruler's war palanquin as the *Pilco Ranpa,* "Hummingbird Throne"; his peacetime litter was the *Quispe Ranpa,* "Crystal Throne."[72] Guaman Poma's account describes a pair of individual palanquins employed in particular contexts. Poma's distinctions point to the strong possibility of a far more subtle and varied range of royal Inca litters, along with an elaborate decorum of use. Those palanquins and their context-appropriate terminology are lost.

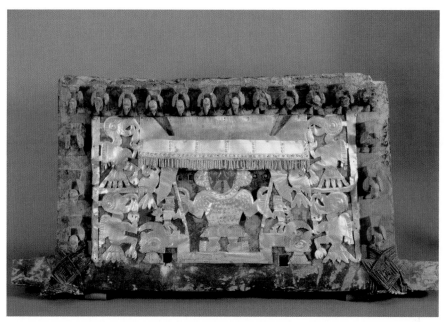

45. Palanquin, Chimú. Before 1470 C.E. © President and Fellows of Harvard College, Peabody Museum of Archaeology and Ethnology, Harvard University, PM# 52–30–30/7348 (digital file# 60743281).

Chromatism was the signature of Inca-sponsored political transformation: Atawallpa's palanquin asserted his sacral power with its brilliant color. The accounts of Poma and Xerez each ground the royal litter's communicative value in color and light effects: hummingbird-iridescent throne, the crystal-shining throne, *plumas . . . de varios colores*. Without a doubt, the palanquin was the most eye-catching thing on the plain outside Cajamarca. It was the military engagement's chromatic center, an object characterized by the strongest colors and most active reflective effects known to Andean and Amazonian peoples. As brilliant as dyed cloth may read, bird feathers possess stronger, more intense color profiles; the iridescent effects of exotic feathers are matched only by the nacre of rare seashells. High-yellow (gold) and platinum-white (silver) metals affixed to Atawallpa's litter further enhanced its brilliance.

Atawallpa flew into battle, borne forward on a feathered palanquin by his soldiers. The Andes possessed a rich inventory of avian mythology, as well as a detailed lore associated with individual avian types – highland raptors, riparian avians, hummingbirds, rainforest exotics. Guaman Poma's citation of a hummingbird palanquin, and Xerez's reference to tropical birdfeathers on Atawallpa's litter (*papagayo*: parrot/macaw) suggest that the Incas recognized distinctive ideological meanings in the diverse plumage they employed. Hummingbirds and parrots were drawn from different sectors of the broad Andean environment; the feathers of these respective birds likely invested the objects

they decorated with highly particular associations. In the broadest sense, birds were identified with the upper world of air and sky, and with the ability to move between worlds. They generally appear in Andean myth as supernatural avatars, beings from the spiritual realm that transgress world boundaries to intercede in human events. What is more, avians were ontologically linked to camelids in Andean thought.[73] Each animal was associated with fertility, wealth, and beauty. As animals of high-altitude regions, camelids were associated with supernatural origins in highland springs and pools. They were mobile and so understood to be capable of moving across both the human and supernatural realms.

The feathered litter marked Atawallpa's presence on the battlefield as a sacral intervention. In ideological terms, Atawallpa's forward movement traced a circular, mythic path: the litter staged both sacral protagonist and mythic destiny. It manifested the essential unity by which Atawallpa was bound as Inca ruler to the Inca capital of Cuzco. The word "Cuzco" is best known as the name of the Incas' ancestral capital in the southern Peruvian highlands. That word is the subject of much linguistic debate. The Inca capital's name was long identified as Cuzco, "navel," after an identification offered by Garcilaso de la Vega in 1615. This reading is in error, as Rodolfo Cerrón-Palomino persuasively argues. The city's name derives instead from "mound of rocks," an Aymara-derived usage (from the root *ququ-*) reported by several sixteenth-century Spanish authors. Cerrón-Palomino's careful inquiry reveals that the usage in turn alludes to an important episode in the Inca foundation legend: at the peak of Mt. Huanacauri, the first brother, Manqo Qhapaq, commands his lesser brother Ayar Awka to transform himself into an avian and fly to central Cuzco. According to this variant of the Inca foundation myth, Ayar Awka complies, and in his avian form he lands on a rocky crag. As he lands Ayar Awka is himself lithified at that spot.[74] The placename "Cuzco" thus constituted a truncated form of the longer toponym *Cuzco Huanca*, "the stone of the raptor/owl," or in paraphrase, "the outcrop where the bird of prey alights," or "raptor's landing."[75]

Cuzco: The name came to apply to centers of Inca administration around the Inca empire. The urban form of the Incas' ancestral capital, along with much of its ideological significance as a governing center, was replicated in the physical infrastructure of provincial Inca centers. The Inca state, as one scholar astutely observes, "copied Cuzco."[76] These centers – "new Cuzcos," they are sometimes called in early Spanish accounts – shared important building types and planning principles with the original Inca capital. Despite considerable architectural variation among provincial towns, those settlements are uniformly defined by certain keynote urbanistic features. Cajamarca's urban plan also possessed these elements in its design. If the town is nowhere explicitly identified as such in surviving written accounts, Cajamarca too was a ritual

center, another "Cuzco."[77] Now, as in every year, the Inca monarch descended to claim his ancestral capital.

FROM THE INCA CAMP ON THE EASTERN EDGE OF THE CAJAMARCA VALLEY, the distance to the gates of town was perhaps four or five kilometers.[78] Atawallpa's group made the traverse late in the afternoon of 16 November. Pedro Pizarro described their advance:

> Having eaten, and the hour of prayer over, Atawallpa began to form his contingent for the move into Cajamarca. His assembled squadrons blanketed the fields; once installed in his litter, they began the march; two thousand Indians preceded him, sweeping the path before him; to either of his sides the army moved along a straight line of advance, never crossing his path.[79]

In plainest terms, this was an attack, a frontal assault on the Spanish position in Cajamarca: thousands of soldiers advanced down the hillside in formation. Among them Atawallpa was borne on an elaborate palanquin.[80] His force consisted of perhaps five or six thousand. The group was made up of warriors; they took the front. A large portion of the group consisted of Atawallpa's personal entourage, his courtly retinue; they were in the rear of the formation, walking behind the soldiers and Atawallpa's litter.

Atawallpa's vanguard was made up of warriors closely identified with the Inca leadership. These soldiers were the core of Atawallpa's fighting force. Diego de Trujillo described them thus:

> [Atawallpa's formation] included six hundred Indians in white and red livery – like a chessboard – who marched before him clearing the road of rocks and twigs.[81]

Ruiz de Arce described Atawallpa's advance in much the same terms:

> [Atawallpa] came at us like this: in a sedan chair, with two other leaders in their own shoulder-borne litters. Leading the way were about a thousand Indians with costumes like chessboards – these soldiers cleared the path forward.[82]

And the scribe Xerez:

> Out in front went a squadron of Indians dressed in colored costume decorated with squares. These men took care of any straw on the ground and swept the path.[83]

Trujillo pegged these fighters' number at six hundred. Ruiz de Arce estimated one thousand; Mena four hundred. Pedro Pizarro thought two thousand.[84] If

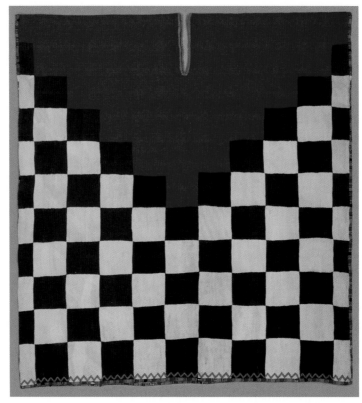

46. "Military Tunic," Inca, ca. 1450–1532 C.E. Cotton and camelid fiber tapestry weave. 88.265 × 80.01 cm. Dallas Museum of Art, the Eugene and Margaret McDermott Art Fund, Inc. in honor of Carol Robbins 1995.32.MCD.

a small portion of the Inca army above town, it was still a large contingent. This group alone outnumbered the Spanish in Cajamarca by as much as five to one.

Chessboards and squares: these words describe a particular Inca quadrangular garment pattern, a *t'oqapu*. It is a sleeveless tunic in which a red collar (or "yoke") is superimposed over a ten-by-ten grid of alternating black and white squares (Figs. 46–49). The yoke intrudes into the grid as an inverted triangle. Ladders of five blocks ascend upward from the black square at the grid's geometric center. This design is consistent across the corpus of surviving Inca tunics (known to the Inca as *unku*); the composition was codified, a uniform pattern. European descriptions of soldiers' costume at Cajamarca are corroborated by later observers, who confirm the pattern's identification with Inca warriors. Called a "military tunic" in the specialized literature of Andean studies, it is a relatively common garment design within the small corpus of extant pre-contact Inca tunics. The type's frequency in modern collections suggests that many tunics of this pattern – armies' worth – were produced and worn by the Inca.[85] Colonial administrative documents confirm that the

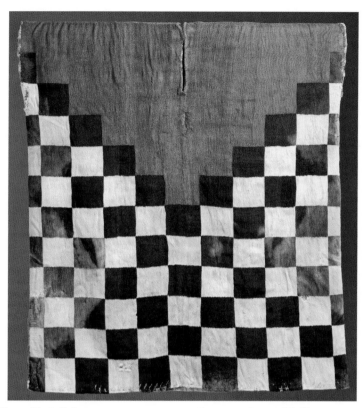

47. "Military Tunic," Inca, ca. 1450–1532 C.E. Cotton and camelid fiber tapestry weave. 87.63 × 76.2 cm. Los Angeles County Museum of Art, Costume Council Fund M.76.45.8.

Inca state maintained large workshops that produced cloth for its military.[86] This state-managed garment production complemented elaborate systems of military logistics and provision.[87]

The Inca referred to their fine textiles as *qompi* (*cumbi*), or *t'oqapu*. The first term is more widely recognized among scholars today, for it was the word early European colonial administrators employed most often to describe the highest grade of cloth woven by native Andeans. The second term, *t'oqapu*, was also current among native Andeans. Like the term *qompi*, *t'oqapu* was less a technical designation of any particular fiber content or weave than a more generalized term that indicated high-grade cloth. The word *t'oqapu*, however, could apply not only to a broad category of textiles, but to the passages of greatest design intricacy within any given piece of fabric.[88] *T'oqapu* was the finicky detail-work that distinguished the overall piece and the skill of its weaver.

Fine weaving – the cloth identified as *qompi* and *t'oqapu* – was among the most prestigious goods of the native Andean world.[89] The Inca leadership supervised the production and stockpiling of high-grade textiles, then oversaw their allocation to the state's clients and functionaries. Clothing and sumptuous

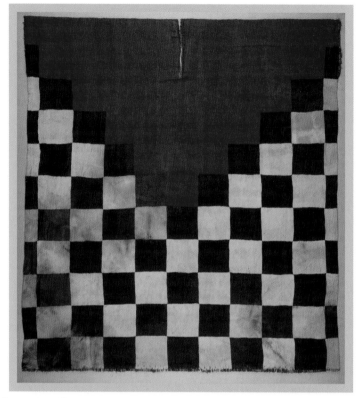

48. "Military Tunic," Inca, ca. 1450–1532 C.E. Cotton and camelid fiber tapestry weave. 84.5 × 78 cm. Museum of Fine Arts, Boston, William Francis Warden Fund 47.1097. Photograph © 2013 Museum of Fine Arts, Boston.

textiles were bestowed by Inca leaders on their subordinates. The gifting of fine clothing was among the principal means by which the state recognized and rewarded its servants: such favors constituted the "warp and weft" of the Inca social fabric.[90] The Spanish wondered at the fact that that retreating Inca armies would torch warehouses of clothing first, before those that contained food. Inca generals recognized the strategic value of clothing in ways Europeans then did not. The fine clothing was a principal resource in the gift economy that defined Andean politics. Elaborate textiles were a means to friendship and political alliance among the Andes' leaders. It was better the Incas' enemies ate now, rather than be handed the resources to enhance their political and military power over the long term.

Such was the linguistic usage of the term *t'oqapu* among Quechua speakers through the early seventeenth century. In recent decades the term has come to be used by scholars to refer to specific units of design that appear in Inca weavings and paintings. *T'oqapu*, argued archaeologist John H. Rowe, "[was a] type of design...used most commonly on tapestry garments, and

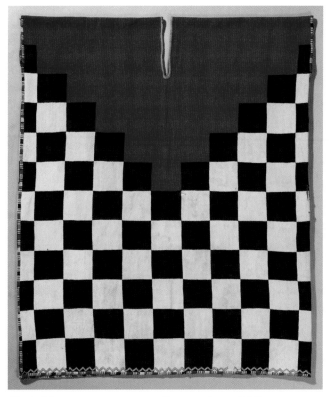

49. "Military Tunic," Inca, ca. 1450–1532 C.E. Cotton and camelid fiber tapestry weave. 96 × 80 cm. Museum Fünf Kontinente, Munich, no. x.446. Photo: M. Franke. Photograph courtesy of the museum.

it served as a badge of rank."[91] This usage of the term favors a narrowed understanding of the term. According to this understanding, *t'oqapu* refers to an individuated semiotic unit – a particular device or sign, as distinct from others that serve a similar semantic function. This reading emphasizes the semiotic capacity of Inca design patterns, rather than the social prestige of patterned cloth.

Although the term *t'oqapu* does seem to have been used to identify individual Inca textile patterns, its semantics extend considerably deeper into Andean understandings of wealth, social organization, and social identity. At root, the word *t'oqapu* identified the Incas' gift economy of resplendent objects and patronal magnanimity. The word *t'oqapu* has uncertain linguistic origins. It represent a conflation of a two-word Quechua phrase – *t'oqo-apu*: "lord's cave," perhaps an impacted reference to the identification of noble clans with caves of ancestral emergence. Alternately, the term may descend from the Aymara root-lexeme *toqa-,* "granary." In its various inflections, that term appears to have communicated "the leader generous with gifts from his grain-store."[92] In time

its denotative value evolved to refer to the brightly patterned livery of social prestige, and to the individual designs on these woven goods. In effect the term was extrapolated up the social ladder of human need: if early on employed as a reference to subsistence allowance – a leader's distribution of stockpiled grain – the term would come to enunciate the shadings of prestige – a badge of social rank and identity. In its ascent to the realm of ambition and affluence, however, the term would lose none of its social urgency. In the period of the mature Inca state, *t'oqapu* denoted the design patterns of finely woven prestige goods; the word's connotations extended to the patronal attributes of generosity, beneficence, and visual splendor. *T'oqapu* was the Inca leadership's moral order and social calculus made visible.

ATAWALLPA'S SOLDIERS WORE HIS GIFTS ON THEIR BACKS. THE INCA STATE WAS not the first to outfit its functionaries with garments of standardized design. The practice had appeared earlier among the Wari, who controlled portions of the region around Cuzco in the ninth and tenth centuries C.E. Wari administrators also wore sleeveless tunics of standardized design. Relative to the Incas' clothing, those Wari garments were exceedingly intricate, as were the techniques required to produce them (Fig. 50).[93] Inca design patterns were less elaborate and altogether less subject to individual variation from one garment to the next. The Incas' regularized garment patterns required fewer dyes and much less labor to produce. As individual works and as a unified tradition, the garments produced by the Inca state were less beholden to introverted technical bravura than their Wari antecedents.[94] Inca designs were starker in individual appearance, though also more extroverted in their overall communicative effect.

The Inca military tunic is constituted of a simple pattern. Relative to its Wari antecedents, that design is radically austere and standardized. That statement alone attests to the pattern's intelligence, for it means that the design always communicates the textile's status as a constructed object, as a woven work. *Plectogenic* was art historian George Kubler's term for visual composition based on the logic of weaving.[95] The Inca military tunic is one instance of plectogenic design: the tunic's design pattern is an elaborate form of self-reference, a statement of the object's status as woven fabric.[96] The pattern of the Inca military tunic is always a sign of the garment's own technique.[97] Whatever the range of its design's signifying capacities, the Inca military tunic never read as anything but a textile.

And of course the fabric's design itself was also a symbol, a *t'oqapu*. The pattern was a conventional motif that operated within the larger corpus of visual signs underwritten by the Inca state: as one among so many recognized

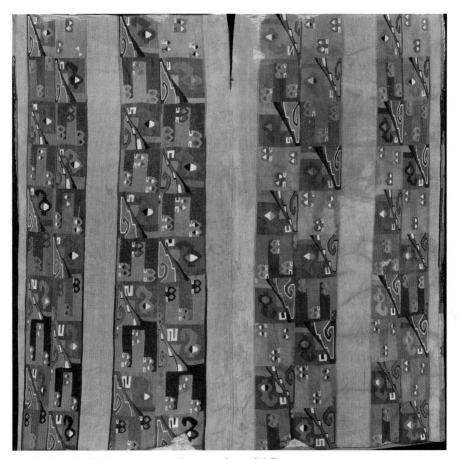

50. Man's tunic, Wari, 650–800 C.E. Cotton and camelid fiber tapestry weave. 101.3 × 104.3 cm. Dumbarton Oaks, Pre-Columbian Collection, Washington, DC PCB 500. Photo © Trustees of Harvard University.

t'oqapu designs, the pattern announced one particular social identity ("soldier") as distinct from others ("accountant," etc.).[98] As a conventional design motif, the pattern of the military tunic announced the wearer's place in the Inca social hierarchy. The pattern thus insists both on the weaving tradition and on its social implications: of cloth as a staple of social life; of pattern that begets pattern, and so constitutes a cultural tradition. The Inca military tunic speaks of the weaver who made it, the soldier who wore it on his back, and the leadership that joined the two in coordinated action.

The Inca military tunic is always "seen as" a woven artifact, and so a product of social life: as one expert in Andean textiles writes, "structure informs [visible] surface."[99] And so the garment's pattern is more human as well as more broadly social. To produce the work, wefts of dyed camelid fiber were woven through an array of sturdy cotton warps by means of intricate tapestry

weave techniques. Those materials and techniques produced strong colors and tight patterns on both faces of the cloth. The Inca tunic presses its design against the wearer's body: the wearer inhabits the pattern even as the pattern is communicated to the surrounding space. The tunic's pattern emanates from the wearer's person like body warmth. The body moves, the design distorts – per the curator's admonition. The dynamism of the wearer's body is arrogated to the design's visual restiveness: in the active tessellation of black and white squares; in the irregular drape of the checkerboard pattern across the column of the human body; in the ascending, pixelated diagonals of the yoke; in the breaking diagonals of the black-and-white grid shifting over legs in motion. As the garment was woven and as it was worn, indexicality generated design energy.

The Inca military tunic foregrounds the medium of weaving; it also places its trust in pure color. High thread counts and exotic dyes produce glowing colors. The density and depth of those hues work to dissolve the textile's surface. In the language of twentieth-century perceptual psychology, "surface color" slides to "field color": the face of the color-bearing woven object is discerned as a chromatic value without Cartesian spatial definition.[100] The eye perceives the Inca textile alternately as a colored thing, or as a collocation of differentiated optical energies. If the garment's overall design may communicate the work's facticity as a textile, the garment's colors also force the subordination of the "woven object" to "visual pattern." The object physically merges with the pattern it bears; that pattern in turn coalesces into physical objecthood. Both thing and essence, the woven work appears to shimmer before the observer.

The design of the Inca military tunic employs three principal colors; those colors were carefully selected for their optical effects. Their visible energies operated within various conditions of illumination. Black against white produces the greatest contrast between distinct chromatic values: juxtaposed, those colors imparted an impression of heightened acutance across the composition. In daylight, black against white produces a cleaner, sharper pattern than any other possible combination of colors. Red, meanwhile, retains its color value even under dim light: unlike almost all other colors, red does not lose its chromatic legibility, even in near darkness.[101] If simple, a design of those three colors is still profoundly unnatural in appearance. To native Andean understanding, the garment's hues were drawn from the rainbow rather than the natural tones of animal wool.[102] The sharp contrast among those colors, in turn, was a sign of favor and good luck.[103] When worn, the pattern of the Inca military tunic does not lose its clarity. No, it moves, now a pattern anatomically embodied. It floats, now a body transfigured into pattern.

The bold visual composition of the Inca military tunic is well suited to the longer viewing distances of the parade ground and battlefield. When the

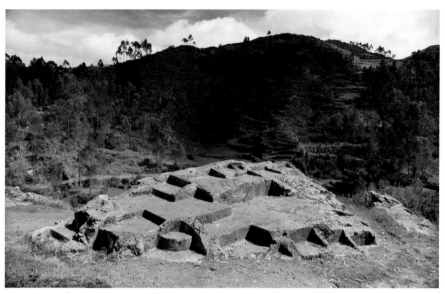

51. Carved stone outcrop, Chinchero, Peru. Inca, ca. 1450–1532. (Photo: author)

garment was worn by warriors in the field, the garment's visual pattern was also a visual icon: the check design – as the art historian Marianne Hogue has persuasively argued – offered the visual likeness of land under cultivation.[104] That likeness is apparent in the contiguous color blocks picked out by differentials of light and shadow. Inca rock carvings – "mirror-" or "echo-stones" – also employ compositions of juxtaposed squares to mimic the appearance of farmland; these carvings replicate the look of the cultivated fields against which they were set (Fig. 51).[105] Those carved outcrops culturally marked and politically claimed landscapes as "Inca."[106] As the Incas' soldiers advanced across the battlefield, the shifting drape of the tunic only enhanced the pattern's iconic effect. The fabric of individual tunics bunched and relaxed, and so their design replicated the undulating ground over which the woven schema was overlain.

To wear the military tunic was thus to enhance the pattern's semiotic charge. Draped across the bodies of Inca soldiers in formation, the design was fielded as an iconic device of site specificity: it iconically represented and so symbolically reconstituted the landscape of the battlefield. As a term of performative discourse, the military tunic assumed new physicality and spatial breadth. Garment pattern was assimilated upward to landscape panorama. The fabric's mass deployment further propagated the design's full semiotic potential. When staged in the field, the Inca military tunic became an icon. Not only this: the pattern's indexicality and symbolic value were deepened as well.

The Andean cosmos was shaped by active energies; change was inherent in the universal Inca design. The semiotic values of the Inca military tunic

also submitted to repeated transformation. That homology bound the macro-cosmic scheme to the checkered pattern pressed against the body; the tunic's rightness was made evident. Inca military tunics, as Hogue has pointed out, were intended to be viewed in multiples.[107] Worn by soldiers formed in close order – as they would be drawn up for parade or battle – individual tunics were juxtaposed. This visual collocation forced a pair of allied effects. First, the individual tunic's defining figure-ground relationship was reversed. The inverted triangle of the red yoke – the dominant form of the single tunic viewed alone – was supplanted by rising ladders of black and white blocks. What was a knifing arrow of red was now a cleft in black and white. And back again: the design flipped unsteadily in the viewer's awareness, as dominant and recessive pattern aspects exchanged identities. Next, adjacent tunics were for-mally decompartmentalized: drawn together as if by magnetism, the designs of contiguous weavings merged to define a larger design across the formation of massed bodies. Those stepped diagonals read across adjacent tunics, coalescing into upright triangles with stepped sides. Individual textile compositions were incorporated into larger visual unities. A single, saw-toothed wave extended across the broad front of Inca soldiers.

And so the woven garments assumed new symbolic value. Worn by soldiers standing in lines abreast, the checked design of individual tunics merged into a larger pattern of Andean stepped mountain motifs. As tunic patterns coalesced into a line of stepped forms, they restaged one of the most ancient iconographic devices of the southern Andean highlands, the "step mountain motif."[108] In 1532, this iconographic device was already at least fifteen hundred years old. The motif's early origins and distribution are uncertain: they may extend far back into the second and first millennium B.C.E.[109] By the first centuries C.E., it emerges as a coherent iconographic complex on works produced in the Lake Titicaca area (Fig. 52). Its most mature and historically important iteration was in the art of the Tiwanaku tradition and its immediate cultural antecedents. That body of imagery would establish the motif in the dynastic tradition of the wider southern Andean highlands, particularly the subsequent Wari culture, and after them, among the Inca.

In imagery produced by the Tiwanaku and later Wari cultures, the sim-plified, stepped form of the motif represents the stacked horizontals of an elevated platform. The precise identity of that platform is unclear: the device may represent a mountain, a ziggurat, agricultural terraces, or other monumen-tal construction. The motif likely represents all three at once: a human-made sacred mountain that is a source of sustaining water. The device generally appears as a basal motif in representations of deities and costumed leaders. As it is used in these compositions, the motif sets the main figure at the top of a sacred mountain: it thus situates the depicted narrative within a ritual

context that combines elements of naturally occurring topography, monumental architecture, and sacred landscape. (Inca metal drinking vessels may be executed with stepped profiles, perhaps an oblique allusion to the cultivated, sacral landscape in which maize beer was both produced and consumed [see **Figs. 61 and 62**].) The step motif is often complemented by imagery of fertility and beauty – flowing water, rainbows, flowers, and brilliant light, all sometimes described as "streamers" in the literature of Andean studies. In effect, the step mountain motif identified Andean rulership with divinity, agricultural fertility, and a sacral, "generative" landscape.

And so the line of adjacent Inca bodies traced a skyline of sacred mountains with tended fields below. Behind them, successive ranks of soldiers acted out more mountains and fields. A sacred landscape was made apparent as the formation advanced. The Inca *t'oqapu* was staged as a device of site and temporal specificity: the pattern visualized the here of the battlefield, and the now of the army's approach. That landscape was revealed in and as an activated pattern, an energized signal that toggled among several semiotic channels.

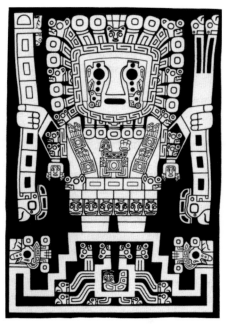

52. Rendering of "Front Face Deity" from the Gateway of the Sun, Tiwanaku, Bolivia, before 1000 C.E. From Michael E. Moseley, *The Incas and Their Ancestors* (London: Thames and Hudson, 1992), Fig. 94.

Cubrian los campos, wrote Pedro Pizarro: they covered the fields.[110] The Inca advance to Cajamarca performed the resource-based apologetics of Inca governance and administration. Atawallpa's formation enacted a pacified, domesticated, and sacred landscape. The warriors' march forward affirmed that landscape's complicated interdependence with other Inca practices: obligations of service, pastoralism, agricultural cultivation, weaving, and patronal beneficence. In their path forward these cultural politics were interwoven, and in turn they were mobilized. Now at the onset of the Andean summer the Inca leadership and its vast agrarian infrastructure faced particular dangers. As did the sun itself, they responded with greater force and movement. A highland environment made uncertain by rains and hail was cultivated in the image of a cultural landscape at once sacred and militant. The powers of the natural world were harnessed and brought to bear on human affairs. Down to the last straw in the path, the axis of advance was cleared, reframed in the Incas' aggressive march forward.

ON ITS APPROACH TO CENTRAL CAJAMARCA, THE INCA FORMATION DREW TO A
halt several hundred meters from the entrance to the town. They stopped
"at the distance of a ballista-shot" (*hasta un tiro de ballesta*).[111] The range of
a European heavy crossbow was roughly comparable to that of an Andean
slingshot – just under five hundred meters. The Inca had pulled their men
up short in preparation for the final phase of the assault. It was a typical Inca
maneuver: at this range the Inca army could soften the enemy with volleys of
slingstones. Those missiles were egg-shaped and carried over long distances:
they whistled as they flew, and hit with enough force to crush both a steel
helmet and the skull inside. Atawallpa's soldiers also could launch burning
coals at their enemies (Fig. 53).[112] That, too, was a common Inca battle tactic.
The enemy's shelter was set on fire; the survivors who straggled from burning
buildings were mopped up. At this distance, as well, the Inca were within
earshot of the enemy. They could taunt their opponents with angry chants,
dances, and body language.

Atawallpa's soldiers did none of that. They merely waited, showing them-
selves to the enemy in front of them. Now at closer distance, the Inca army
could be discerned with greater clarity. It would be apparent to the Incas'
antagonists that Atawallpa's group was relatively small, and relatively lightly
armed – a mixed group of warriors, ritual attendants, and servants. This was
less a furious army than a resplendent courtly retinue: the Incas' enemies could
see as much.

If Francisco Pizarro is widely remembered for his ploy at Cajamarca,
Atawallpa's gamesmanship is less well recognized. Stopping short of Cajamarca
was the Incas' principal gambit. The Inca army's pause worked to heighten the
stress on their opponents. Halted outside town, Atawallpa's force was a cresting
wave that refused to break. By stopping short, too, the Inca also reaffirmed
their possession of battlefield initiative. The arbitrary standstill only suggested
the sudden attack to come. In an instant, Atawallpa and his cohort could lunge
forward to press the assault on Cajamarca. Without the encumbrance of metal
armor, the Inca soldiers could move quickly; at a run they would cover the
distance to town in little time.

The Inca now enjoyed a position of tremendous military advantage. The
Inca had pushed forward their army's most important piece in order to pro-
voke a foolhardy or panicked counterattack. It was a King's Gambit: out
in front and exposed, Atawallpa and his small formation baited the enemy.
If the opponent came forward to engage, Atawallpa's group would retreat.
This was the ideal outcome for the Inca. Focused on the Inca ruler's fleeing
palanquin, the pursuing attackers would be drawn uphill. The overaggressive
opponent would be enveloped and annihilated by the massive Inca army posi-
tioned above. Halted before Cajamarca, the Inca now tested the Europeans'
nerve.

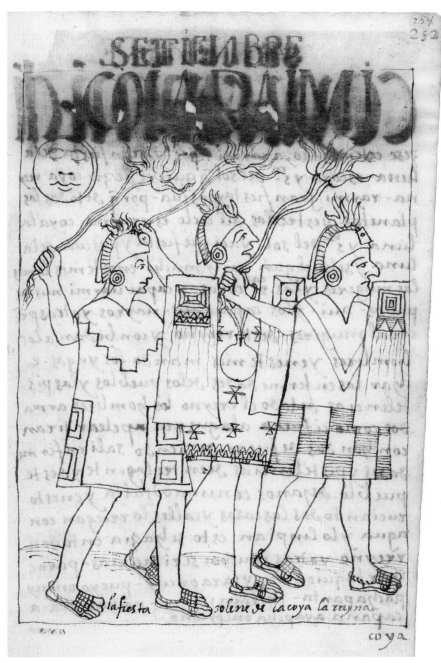

53. Felipe Guaman Poma de Ayala, *El primer nueva corónica y buen gobierno* (1615/1616) (Copenhagen, Royal Danish Library, GKS 2232 4°: facsimile at http://www.kb.dk), 254v.

Atawallpa hovered. The Europeans agonized. Several Spanish accounts describe the Europeans' puzzlement at Atawallpa's pause outside of Cajamarca. Francisco Pizarro's soldiers kept to their plan – wait for the Inca to enter the confined spaces of Cajamarca's central plaza, then attack. Even with horses,

steel weapons, and cannon, the Spanish were too few in number to risk a fight in the open field. So they sat tight, waiting for Atawallpa to determine the engagement's next phase. The tension produced by Atawallpa's halt ultimately worked to Spanish advantage, sharpening the violence of the Spanish attack once it came.

And so Atawallpa's formation neither pressed nor received an attack. The Inca now made the single most important decision of the Peruvian campaign. They loosed no barrage of slingstones or burning missiles, nor did they charge outright. Instead, Atawallpa's force processed peacefully into Cajamarca. The intention was clear: Atawallpa's column would drive home the finality of Inca advantage and receive the enemy's surrender. His soldiers put away their weapons – more than one Spanish observer noted the Inca entered Cajamarca with clubs and slings concealed beneath their loose-fitting garments. It must be assumed that the Inca deemed weapons unnecessary in this action: poise and assurance alone would effect a conclusive display of intimidation. Clubs could be brandished easily enough if the meeting soured, and Atawallpa could be confident in the tenacity of the warriors under his personal command. Though none of these measures would be required. Atawallpa would enter the town as a divine, undisputed victor. Opponents would be reconciled; *communitas* would be imposed. Defeat and victory would be recast as fealty and reciprocity. The closing of hostilities would be marked with a feast to celebrate the new social order.

Communal rituals typically move in a sequence of stages. By these rites, participants move through states of separation and sacral transition, before a final, assimilative social incorporation.[113] It is an experiential sequence common among many spiritual traditions, for it has the capacity to deliver the intensely human satisfactions of interpersonal relation. The ritual breaks the congregants into a collection of co-participants, and in turn, it reintegrates them again as a social whole. Atawallpa's attack followed a similar rhythm. The sweep toward Cajamarca enacted the myriad symbolic inversions of battle time and battle space. His advent divinely sanctioned and mythically preordained, Atawallpa came down the mountain as a dynastic founder and sacred avian. He reenacted the union of dissimilar but economically complementary zones of the highland Andean ecology. His enemies vanquished – rendered submissive – the Inca leader would enter into central Cajamarca as the esteemed male patron, as a bridegroom would take a bride. There he would act as host and patron of a socially integrative feasting event. The rituals and speeches, the drinking and the eating, would reaffirm both the political hierarchy of the new social order and the reciprocal social obligations these arrangements entailed.

The entry into Cajamarca shifted the terms by which the Inca engaged their antagonists. Military action now gave way to the choreography of state ritual and communal identity. Atawallpa and his guard initiated an elaborate pattern of ceremonial movement; now a procession, the military column closed the remaining distance to town, then made its way into Cajamarca's main plaza.[114]

CHAPTER FOUR

QURI: A PLACE IN THE SUN

Pues era tanta la pateneria que trayan de oro y plata, que era cosa estrana lo que rreluzia con el sol.

"And they bore so much gold and silver – what a strange thing it was as it glinted in the sunlight."[1]

Pedro Pizarro, 1571

Human vision is a situational faculty. The viewer occupies a position in space. From that fixed vantage, the witness assesses the relation of him- or herself to the object of the viewing act.[2] Here I stand, and there I see: subject/object, self/other. Vision is a prime means and mechanism of somatic experience. Though sight, the human body inhabits the world.

And so Pedro Pizarro took in the resplendence of Atawallpa's entourage – a seeing subject before so many witnessed objects. Though Pizarro's account hardly lays claim to perceptual certainty. *Era una cosa estrana*: "what a strange thing it was." The lexicographer Sebastián de Covarrubias commented on the word *estraño* in his encyclopedic compendium of the Castillian language of 1611. *Estraño*, the grammarian wrote, derived from the Latin *extraneus* or *alienus*, "extraneous," or "alien." Covarrubias thus identified the word with ancestral terms of dissociation, of un-relation. He went on to gloss the Castillan *estraño* as "that which is singular" (*lo que es singular*). *Singular*, in turn, meant "that which has nothing else to which we may compare."[3] By Covarrubias's definition, a strange thing – *cosa estraña* – is by its own nature irreducible in its alienness. It is obdurate in its lack of relation or likeness; it lacks an organizing system by which it might be rationalized, recognized, comprehended.

The strangeness that Pizarro witnessed – the Incas' metal shining in the sun – confronted and overturned the situational, perspectival structure of the soldier's vision. The metallic dazzle put to question the very capacity of his sensory capacities. His eyes took in sights with no corresponding likeness; the view from his position was displaced. So Pedro stood in the glare of Atawallpa's sun-struck metal, at once now and here, and nowhere at all.

Recounting his disorientation in the field, Pizarro wrote himself into an already deep history of European efforts to chart, map, and christen the lands and peoples they encountered in the New World. There can be no doubt of Pedro's participation in that triumphalist project: if the chivalric imaginary rang hollow at Cajamarca, it served to ease anxiety nevertheless. "Every man declared he would do more than Roland (*Roldán*)," wrote another soldier, "for we expected no other help save that of God."[4] That triumphalism, now so far from Carolingian Poitiers, also prompted Pedro Pizarro to employ coded language to tell his story. In strangeness – *lo estraño* – the soldier could convey the Europeans' fear at the Inca entourage's approach, as well as their admiration for the wealth the enemy paraded before their eyes. Pedro's disorientation also served to distinguish the Peruvian conquest above others before it: so glittering in appearance, so limitless in amount, the Incas' gold defied the mechanisms of perception and the calculus of culture, both.

Pedro's report may be read as objective fact: he and the others Europeans witnessed an Inca ceremonial entry, the last to be performed by a pre-contact Inca ruler. It was an elaborate rite of possession: Atawallpa and his entourage processed into the town's central plaza, and there went about the ritual accep-tance of communal obeisance. The royal Inca entourage performed a kinetic rite of sensory intensification, a staged performance of shining costumes and regalia, song and drumming. Bright, loud, kinesthetic, the procession gen-erated a set of sensible energies in which Inca sacral authority and political prestige were identified. The polished metal borne along with them was the manifestation of that numen. Disorienting and alluring to Andean observers as well as European eyes, *quri*, "gold," was a defining signature of Inca tri-umphalism.

Across the Andes, the sharp, eye-catching visual effects of shine, gleam, glint, glitter, glow, and strong colors were all considered the phenomena of sacredness.[5] The Inca shared with other Andean peoples this recognition of the social and ethical dimensions of sensory experience.[6] *Quri*, "gold," manifested the assumptions inherent in this Andean moral economy of optical brilliance. Within the synaesthetic, moralized spectrum of Andean light, the Incas' shining metal shone as an eye-wounding, ear-splitting, fear-inducing, and morally commanding peak of experience. At once material substance, effect of light, and moralized affect, *quri* articulated the discomfiting cultural refulgence of the Inca state.

"WHY WAS ATAWALLPA THERE" – ON THE CENTRAL PLAZA OF CAJAMARCA – "exposing himself to dangerous looters?"[7] It is a fair question, given the outcome of events at Cajamarca. The answer has little to do with the Inca cultural naïveté or outright foolhardiness. The Inca leadership chose to engage the European interlopers on the central plaza of Cajamarca for a straightforward reason. That space was built precisely to host such political engagement. Interethnic negotiations were carried out on the main plaza of Inca provincial administrative settlements as a matter of administrative routine. Those social transactions were among the Inca leadership's most routinized and most theatrical ritual acts.

Atawallpa's entry into central Cajamarca went quickly. Or so it seemed to the Europeans who witnessed and described the Inca processional: for Pizarro's soldiers the event was overshadowed by the ambush and bloodletting that came soon after. Certainly the men in Pizarro's band had less time to consider the entry than they had to take in the Inca column's slow, halting approach to town. Even so, the Europeans' accounts impart a clear enough sense of the Inca retinue's progress into the main plaza.

> They carried great drums and many trumpets, as well as banners – that column was a beautiful thing as it moved.[8]
>
> They just kept coming in an unbroken line . . . and they entered into the plaza with a great deal of music.[9]
>
> Behind the soldiers in livery came another three squadrons dressed differently, all of them singing and dancing . . . then came many people in formation with crowns of gold and silver.[10]
>
> So Atawallpa's squadrons began their entry with great songs, and proceeded to occupy all of the plaza, every corner of it.[11]
>
> Arriving at the center of the plaza Atawallpa signaled for them all to stop – all his people as well as the sedan chairs in which he and the other leaders were carried on high. There was no end to the people entering the plaza.[12]
>
> Then the Inca entered the plaza; as they reached the plaza center, Atawallpa's men positioned themselves in such a way as to form a central station or stopping-point; Atawallpa himself entered once the leaders of the *suyos* (cardinal regions of the Inca empire) and their people had arranged themselves accordingly. Atawallpa advanced through them until he mounted the palanquin at the center of his complement. He stood in the middle of that platform and spoke in a strong voice . . . [13]

So the Inca processed into Cajamarca's plaza. A place was made for Atawallpa at the center of the square. He stood on his palanquin, made a speech, countenanced the approach of Pizarro's Dominican preacher. The rest went quickly, and it is known to history. The soldier Pedro Cataño recalled, "the first cavalry

charge passed right through their ranks."[14] Very soon, four to six thousand Inca bodies lay on the plaza floor, dead and dismembered: one native Aullauca lord who was at Cajamarca described the attack of Pizarro's soldiers with the phrase "maiming and killing" (*herir y matar*).[15] Like all massacres, this one was confused and violent – even its victorious participants disagreed as to its details. Lawyers, administrators and historians since have sought to reconcile the confused testimony of the attack: a cascading series of events that led to violence, or a calculated act of brutality? (In these pages here: calculated.) Atawallpa's entry into Cajamarca's plaza is less well recalled, and so little debated. That is an oversight, for with Atawallpa's entry in Cajamarca the Inca enunciated a nuanced comprehension of human conflict, divine order, and sensory experience.

"The behavior of Atahualpa" – so George Kubler described it in 1945 – presents a difficult problem for Western historians.[16] Writing months and years after November 1532, Spanish authors relied on two summary words to describe the Inca ruler's conduct: *soberbia* and *recelo* – "arrogance" and "suspicion." If fundamentally maladroit, at least these terms catch a sense of the Inca leader's calculation. They ascribe to the Inca king some modicum of thought and agency, even if they peg the psychology of his actions as either ritualized presumption ("arrogance"), or reactiveness ("suspicion"). Taken individually, these words are hardly the attributes of effective leadership. Taken together, they collude to produce something worse – a sense of mean-spiritedness in the exercise of power: tyranny. Writing of Inca ceremonial discourse several centuries later, two distinguished anthropologists render a more supple description of the Inca leadership's rhetorical posturing: "alternately exalted and brutally threatening."[17] This latter characterization is more true to the intricacies of historical fact. And it is fair to all sides – both to what the Inca sought to convey to their enemies, and to what European observers sensed in this communication. The formal language of Inca ritual and diplomacy spoke clearly to the Incas' subjects; that rhetoric conveyed a ringing sense of prerogative and menace.

"TIME AND THE OTHER"; "A SPACE FOR PLACE": THE WESTERN IMPULSE toward anthropological timelessness and utopianism finds apt likeness in Inca gold.[18] The Inca and gold are easily joined as ideological fellow travelers. As a timeless people, the Inca possessed the universal metallurgical standard of value, in unimaginable quantities. It is a familiar trope, one in which both terms – the Inca and their gold – lose their luster. What if the Incas' gold was re-recast according to the particularities of historical events and phenomenal encounter? What would Inca gold communicate then?

The cultural discourse of Inca gold revealed itself in specific spatial and temporal contexts. The impressive urban context that was Inca Cajamarca was

such a setting (see **Fig. 5**). The stamp of Inca governance was everywhere present in the settlement's design. Its central precincts were rigorously planned and monumental in scale. The town's largest structures were disposed around a central square. Architectural formality governed overall – it was an environment of disciplined geometry and hard physical surfaces. Cajamarca's Inca plaza is roughly preserved in the modern town's central square, the Plaza de Armas. Cajamarca's Inca buildings, like the leadership responsible for erecting them, have long disappeared from the town's urban landscape. Ruiz reported that in the wake of the Inca defeat at Cajamarca – well after Atawallpa's capture and execution, and the military campaign's movement south – the Incas' former subjects in the Cajamarca region tore down the Inca center's monumental buildings.[19] The plan of Pumpu, another Inca administrative settlement along the main Inca road though the northern highlands, offers a reasonable likeness to Inca Cajamarca (Fig. 54). Or at least, Pumpu's layout roughly matches the descriptions that Ruiz and Xerez provided of central Cajamarca.

> The main plaza exceeds anything like it in Spain; the whole space is enclosed by walls but for two streets that lead off into the town. The buildings on the plaza are more than 140 meters wide and about ten meters tall, and very well built. Their sturdy walls support timbered roofs covered with thatch. A few palaces are much better built than the others: these are divided into eight rooms, and the walls that define their precincts and doors are built of fine stonemasonry; in their enclosed spaces there are water fountains fed by water channels. On the side of the plaza toward the countryside, there is a fortress of stone that had stone staircases inside on the plaza, and false doorways along its exterior face.[20]

> There were three palaces, each was about two-hundred *pasos* wide (about 140 meters). They formed three sides of a plaza, and the town's streets entered at the corners between the buildings. A street led into the plaza from the countryside, passing through a standing tower at the center of a wall along the plaza' fourth side. This wall fully enclosed the plaza from the fields beyond.[21]

Cajamarca's monumental core was organized around an open plaza. This central area was a four-sided space about 140 meters on a side. The three sides toward town were defined by imposing monumental buildings. Between those buildings, streets led off from the plaza into the settlement: Trujillo counted ten streets (*bocacalles*) that exited Cajamarca's main plaza.[22] A low wall defined the fourth side of the central square. That barrier separated the plaza and town from the countryside beyond. It extended fully across the plaza, so as to enclose the plaza as an urban precinct.

The structures around Cajamarca's monumental plaza were buildings of rectangular plan, simple mass, and tall thatched roofs. Their wide facades extended uninterrupted across the plaza sides, punctuated by intermittent doorways of trapezoidal outline.[23] Behind the wide façade, a load-bearing wall

54. Plan of Inca administrative center of Pumpu (Junín Province), Peru. From Ramiro Matos Mendieta, *Pumpu: Centro administrativo inka de la puna de Junín* (Lima: Editorial Horizonte, 1994).

55. A structure along the main plaza at the site of Huchuy Cuzco, Peru. Inca, ca. 1450–1532 C.E. (Photo: author)

and heavy piers ran the length of the building. The generous interior space beneath its roof could house large groups of people for short periods of time – armies, delegates, itinerant communities. These were the palaces looted by Francisco Pizarro's men in November 1532; as Atawallpa' entered town with his entourage, these structures concealed the bulk of Pizarro's forces – horses, riders, and artillery included.

Remnants of buildings like those described at Cajamarca survive within the fabric of colonial and modern buildings along Cuzco's Plaza de Armas. More are preserved at the ruins of such provincial Inca centers as Huánuco Viejo, Pumpu, and Tambo Colorado.[24] A standing structure along the main plaza of the royal Inca estate of Huchuy Cuzco also recalls the type (Fig. 55). If simple in plan, these structures were impressive in scale and masonry technique. One of Cajamarca's Inca structures still stands a few blocks to the west of the modern Plaza de Armas. Often called "Atawallpa's Ransom-House" (*El Cuarto de Rescate*), this small structure was once part of an Inca residential compound set on a rocky shoulder southwest of Cajamarca's main plaza (Fig. 56).[25] Any role the structure played in Atawallpa's history is entirely unconfirmed. The building was constructed of carefully dressed masonry blocks set without mortar; its walls feature the precise masonry technique of the Inca capital, if not the workmanship of the greatest buildings there.

Most of the large buildings facing Cajamarca's main plaza probably served as lodging and banqueting space for visiting Inca administrators, dignitaries, and retainers.[26] Atawallpa would claim that one of them was built by his

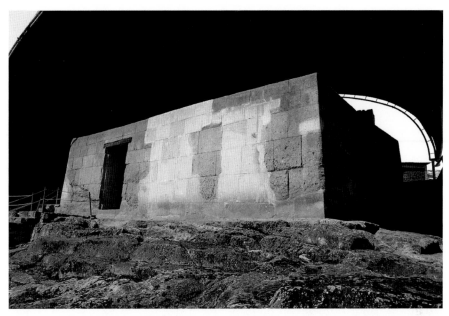

56. Inca structure ("El Cuarto de Rescate"), Cajamarca. Ca. 1460–1532 C.E. (Photo: author)

father, the ruler Wayna Qhapaq, who erected it as a place "where he [Wayna Qhapaq] would rest" on his travels in northern Peru.[27] One structure was likely an *aqllawasi*, "House of the Chosen Women," which housed young females indentured to the Inca state as ceremonial attendants; those women's duties included the brewing of corn beer for the great public ceremonies that took place on the settlement's main square.[28] Another structure along or in the plaza was not a palace, but a raised platform, an architectural type now commonly called an *usnu*.[29] These platforms were another standard component of Inca urban design, and they were generally sited on the central plazas of administrative centers. The Inca *usnu* is a complex ritual and planning form – the full *usnu* encompassed a complement of subsidiary structures, as well as watercourses and fountains. The main *usnu* platform was intended as a focal point for the public performance of ritual action – astronomical observance, libation, or animal sacrifice.

In the early 1930s, the Peruvian architect and historian Emiliano Harth Terré worked up a careful rendering of the old Inca town; the drawing catches much of the Inca settlement's spirit and substance, even if it omits the monumental tower and gate along the eastern wall (see **Fig. 5**).[30] Ruiz de Arce's description makes clear that this tower acted as the town's primary gateway. Tower entries and gatehouses were a common feature of monumental Inca plazas: vestiges of such towers still stand at the site of Quispiguanca in the modern town of Urubamba (Fig. 57).[31] If the tower at Cajamarca was like others, it was a two-story structure whose elevation was articulated with trapezoidal niches around a central portal. Carved architectural effigies preserved in the collections of the

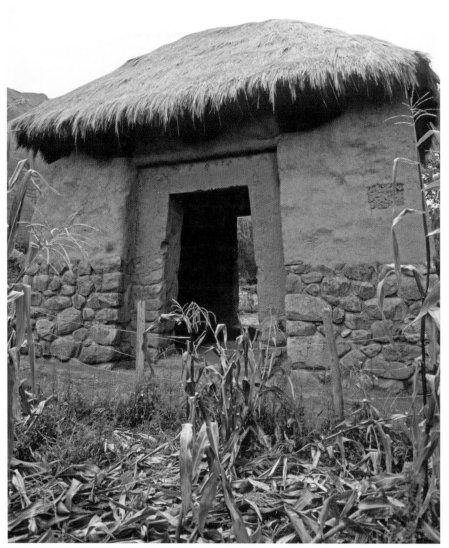

57. Remains of Inca tower gate, Quispiguanca/Urubamba, Peru. Inca, ca. 1450–1532 C.E. (Photo: author)

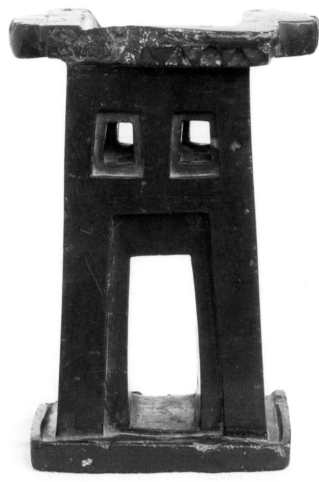

58. Architectural miniature, Inca, ca. 1400–1532 C.E. H. approx. 23 cm. Museo de la Universidad Nacional de San Antonio Abad, Cuzco, Inv. 923. (Photo: author)

Universidad Nacional de San Antonio Abad and the Chicago Field Museum also convey the appearance of the typical Inca gatehouse (Fig. 58). A road issued forth from Cajamarca's gate. It ran as a wide ceremonial avenue of several lanes and framing walls, before narrowing to a one-lane track beyond the town's immediate vicinity.[32] That road and gated entry – a purpose-built ceremonial avenue – conveyed Atawallpa and his squadrons into Cajamarca's central precinct.

THE IMPRESSIVE PHYSICAL FABRIC OF INCA CAJAMARCA WAS ONLY A FEW decades old when the Europeans arrived there. The Cajamarca region came under Inca domination in the middle decades of the fifteenth century, either late in the reign of Pachakuti Inka, or early in the rule of his immediate successor, Thupa Inka Yupanki. The Inca relatives of Cuzco settler Juan Díez de

Betanzos claimed that Cajamarca was conquered by a son of Pachakuti in the latter part of that ruler's reign.[33] If other sixteenth-century accounts of Inca dynastic history may be trusted, the area would have fallen under Inca control in the years around 1460.

During the reign of Atawallpa's royal predecessor and father, Wayna Qhapaq, Cajamarca became the Incas' most important strategic outpost in the northern highlands. At that time – the first decades of the sixteenth century – the settlement's role as a crossroads town had been formalized by the layout of the Inca road system. The Incas' main highland road passed through the center on its way to Inca settlements further north in Ecuador. Two trunk roads branched off here to the coast.[34] Cajamarca was by then an elaborate Inca administrative and military installation; from this center, the Inca oversaw the northern highlands and adjacent Pacific coast and provisioned their armies fighting farther north. The monumental Inca buildings and public spaces built there probably date to that time.[35]

Mena reported meeting only a few hundred Inca administrators and guards on their arrival – *muy poca gente*; these men guarded the entries to the town's large compounds.[36] Although archaeological evidence hints of pre-Inca construction beneath the settlement, the Inca substantially expanded and reshaped that earlier center. Other Inca installations along the main highway were built from the foundations up as planned new towns inserted among the older non-Inca communities of the area.[37] Its central precincts housed a permanent garrison of administrators and soldiers, as well as specialized craftsmen settled there by the Inca state.[38] A high-ranking Inca official resided in town year-round. That figure oversaw local political affairs, adjudicated disputes, and ensured delivery of tribute to the Inca state. Other, higher-ranking Inca officials – in particular, a son of the Inca ruler – arrived for periodic inspection at least once a year. These visits were meant to ensure provincial stability and the year-round administrator's loyalty.[39]

The bulk of Cajamarca's population lived off-site: the local, non-Inca populace lived among their traditional communities in the surrounding region. The local leaders were ethnically non-Inca, though now the Incas' clients and the empire's "intermediate elites." Those leaders acted as go-betweens who bound local populations and customs to the Inca cultural and political system. With their submission to the Inca state, they gave up certain privileges, though they were granted others. They received Inca ceremonial garb and exotic goods; one of their children might be taken for sacrifice in Cuzco, and so sanctified by the Inca state.[40]

In previous centuries, the elites of the Cajamarca region had resided along the northern edges of the Wari empire.[41] The remains of Wari-style prestige goods are found scattered through the Cajamarca region, though the overall archaeological footprint of Wari in the area is relatively light. Archaeologists

surmise that particularly in the century immediately before 1000 C.E., the elites in Cajamarca adopted certain Wari forms of cultural practice – and perhaps received sumptuary items as gifts from the Wari – even though the region lay outside the proper boundaries of the Wari empire. Cajamarca's local leaders acted as "aggrandizers": if not directly members of the Wari power structure, they employed certain Wari material and cultural forms as a means of negotiating local hierarchies of status and prestige.[42] In the 900s, too, the nearby Wari presence may have brought the Quechua language to the region, further strengthening the area's ties to the broader ethnic community of the Peruvian highlands.[43] By the mid-fifteenth century, power in the Cajamarca region had been consolidated among a few powerful seats. These lords would fall the to Inca, retreating to hilltop fortresses before their ultimate surrender.[44] Cajamarca's local elites had a long history of interaction with supraregional structures of political power – at their fall they were on good terms with the kingdom of Chimor on the North coast, although those powerful coastal lords failed to come to the Cajamarquinos' aid.[45] The Cajamarquinos' tradition of interaction with more powerful foreign leaders likely eased and sped the imposition of Inca administrative apparatus at Cajamarca after the mid-1400s.[46]

In the Inca era, the native lords of the Cajamarca region appear to have resided in hilltop fortresses that commanded valuable lands and routes of movement among surrounding valleys. Other populations were moved closer to fields where they were put to work as agricultural labor.[47] In other cases, foreign communities were relocated to Cajamarca as colonists (*mitmaes*): these were farming communities brought to Cajamarca to boost the basin's agricultural production. They included peoples from mountainous regions to Cajamarca's north and east (Chachapoyas and Huambos) and from coastal river valleys to the west and northwest (Pacasmayo, Zaña, Collique, Chuspo, Cinto, and Túcume).[48] The complex program of resettlement here in Cajamarca province was hardly unusual. The Inca leadership commonly resettled Andean communities in order to exploit their specialized competency as indentured laborers: at Cajamarca, these included a community of potters from the Lambayeque River Valley.[49] (Further afield, the Inca leadership resettled metalsmiths from north coast to Cuzco to produce gold for Inca state.[50]) The Inca leadership also uprooted communities as a punitive measure – exiling peoples from their ancestral regions. In certain documented cases, the Inca leadership pursued ethnic resettlement in order to offset local political tensions in the region of relocation.[51]

Down in the regional administrative center, Inca administrators monitored local peoples and politics without disrupting established patterns of settlement and agricultural production. Where Inca administrators were present, there too were storehouses: those structures lay around the Cajamarca valley, though they were concentrated near the Inca monumental nucleus.[52] From their facility

astride the highway, Inca officials managed the local tribute economy – labor, goods, and animals – while overseeing the region's integration into the wider traffic of the imperial Inca economy.

"WHEN IS A KIVA?" ASKED THE SOUTHWESTERN ARCHAEOLOGIST WATSON Smith.[53] The nature of sacred architecture, Smith insisted, lies less in atemporal building typologies (kivas, churches, chapels) than in time-bound episodes of ritual action. Sacred spaces come into being through sacred events. The Inca settlement of Cajamarca was such a staged and enacted cultural environment. Cajamarca was an institutional facility that housed the social mechanisms of Inca governance. As a physical component of administrative apparatus – the bricks-and-mortar instantiation of the Inca state's "infrastructure of control"[54] – it was a shell. Although an impressive and enduring architectural statement of Inca hegemonic presence in the northern Andes, Cajamarca may be described as an occasional Inca center. Its monumental core was realized as a authoritative center place at specific times and among particular cultural constituencies: Cajamarca was a *qozqo* on significant feasts of the Inca state's ritual calendar, at which times the Incas' diverse local clients were convened in the presence of signal representatives of Inca leadership.[55] Now was such a time, as Atawallpa stood on his palanquin at the center of Cajamarca's main square.

Like other Inca administrative outposts, Cajamarca served as a nucleus of administration and specialized craft production; for the processing and storage of foodstuffs and other products; and as a garrison for Inca military units. No less importantly, the town served as a ceremonial center in which the Incas' subject ethnicities reaffirmed their role in the larger scheme of Inca power. Here, local clients – their leaders in particular – performed their submission to Inca hegemony. In turn, those local leaders received gifts from the Inca leadership: costumes and regalia, prestigious objects, and the banqueting food itself. This redistribution of sumptuary goods – the Inca state's bestowal of gifts – was a principal component of the ceremonial enacted at Cajamarca and other Inca provincial centers: "The [Inca] state saw itself pressured to give continuous gifts to diverse categories of lords and innumerable military chiefs."[56] Cajamarca's main plaza was the space in which the Inca leadership and its clients theatricalized – and so finalized – that interdependence.[57] It was a zone of muster, parade, and mass ceremonial.[58] Framed by walls and gates, this formal urban space was large enough to accommodate the assembly of the Incas' local and regional vassals, as well as the rally of a massed army.

The Inca leadership exercised an impressive suppleness in the administration of its far-flung empire. Their executive flexibility was a response to marked differences among the peoples incorporated into the Inca realm. Settled regions with dense populations required different strategies of control than did arid

plains thinly inhabited by wandering bands. Local traditions also powerfully shaped local Inca administrative practices – the elaborate gift economies among the peoples of Ecuador, for instance, or the veneration accorded high mountain peaks in the southern highlands.[59] Despite all these regional differences, the Inca leadership relied on an annual cycle of public ceremonial to govern its regional dependencies.

At appointed times of the year, Cajamarca's local communities gathered in this great open space with visiting Inca dignitaries and their retinues.[60] The ceremonial performed there appears to have been a broad ritual *koine* that was comprehensible across the Incas' many subject peoples.[61] Together, the Inca and their ethnic clients performed the ceremonies that reaffirmed the Inca state's obligations to its subject communities, while reaffirming those local peoples' fealty to the Inca regime. These ceremonies enunciated astronomical, agricultural, dynastic, and military themes.[62] They also included ritualized acts of violence: mock battles and sacrificial ceremonies sought to resolve local disputes over territory or honor among a given region's peoples.[63]

The great communal rituals overseen by the Inca leadership invariably culminated in extended bouts of feasting. Banqueting was a common Andean means of social formality and ritual observance. Corn beer, called *chicha* or *aqha*, was "the Andean luxury food."[64] It assumed a central role in the sacral and social economy of these rites.[65] Drunk or poured out in offering, the consumption of corn beer enacted respect and obligation; its ample provision at banquets and feasts was one of the principal means by which the Inca state formed alliances, paid its moral debts, and confirmed the obligation of its subjects.[66] "From noon to sunset was passed in rejoicings, and in drinking," wrote a sixteenth-century mendicant of these Inca ceremonies.[67] As a "New Cuzco," Cajamarca was also another mother: it too was *Mama Aqha*, "Mother Beer."[68]

It is with these assumptions that Atawallpa and his column entered into Cajamarca's main plaza. That entry enacted the space as a *qozqo*, a ritual center. From his palanquin, Atawallpa would receive the Europeans' fealty. As the new alliance – the Europeans' submission – was sealed with oratory and drink, the Inca leadership would transition to a new role.[69] To this point, they had employed the masculinist rhetoric of the battlefield. The Inca conquered in male guise: angry, wild, noisy, they descended from the distant mountain to vanquish their enemies. This conflict closed, the Inca state assumed an alternate rhetorical posture. It administered its realm as a female. And so the Inca state shed the masculinity of warfare to take up the femininity of service.[70] The Inca fed and nurtured their former enemies, acting as their new wife. Performed in sequence, the Inca state's two gender aspects revealed the cosmological integrity of the Inca state. In turn, the Incas' new clients would be beholden to the Inca, bound to them in moral obligation as a husband is bound to the

wife who feeds him. The Incas' metal – gold and silver – announced those complementary identities.

THE RICH CHOREOGRAPHY OF ROYAL INCA PROCESSIONAL IS LOST TO HISTORY. The accounts of Pizarro's soldiers offer skeletal descriptions of its protocol, at best. It is clear, however, that Atawallpa's entry into Cajamarca observed established, highly formalized conventions. Colonial descriptions of Inca processions make clear that these performances emphasized signal themes of Inca cosmology. Later in the sixteenth century, the Inca Titu Cusi Yupanqui of Vilcabamba travelled with an entourage that was organized into a strict processional order. The ruler's litter was near the front of the procession, followed by advisors, administrators, trumpeters and flutists, and a contingent of Amazonian warriors understood to be cannibals. This order mapped out a hierarchy of civilization (embodied in the ruler) to uncivilized (non-Inca cannibals).[71] Other descriptions of Inca processions record that complementarity was paramount in processional order: marchers would process in pairs, often in male-female couples.[72] In other instances, attendants bearing gold objects were paired off with those bearing silver. In all cases, marchers moved in unbroken lines such that the mass movement traced long, undulating files. Processionals made circuits around open urban plazas, then wound in converging circles toward the plaza's center. Inca processions acknowledged the breadth and symmetry of the Incas' expansive urban spaces: they performed a walking traverse of the whole plaza, corner to corner. This recognition performed, their movement would then gravitate toward the center point. Inca ritual movement "circled the square": processional itineraries inscribed principles of fluidity and liquid motion onto rectilinear urban space.[73]

Within these uncertainties and generalities, one larger fact is apparent: with Atawallpa's entry, a multiethnic social complement was unified under the aegis of Inca power. The Inca leadership, so writes the distinguished historian of the Inca realm Maria Rostworowski de Diez Canseco,

> "did not try to abolish the great macroethnic groups [of the Andes], since their socioeconomic structures depended on them. The individual ethnic characteristics of these groups were therefore not suppressed. For the Inca it was sufficient to receive recognition of his absolute power . . . [and] apart from these demands, each macroethnic group preserved its regional traditions, free from any effort by the Inca state to eliminate its individual character."[74]

The confederation of peoples united under the authority of the *Sapa Inka*, the "Ruler Alone," carried important implications for Atawallpa's actions at Cajamarca, and it determined the nature of the army with which he entered that town's main square.

The Inca's provincial clients campaigned in their distinctive ethnic costume and regalia.[75] Ruiz recalled that two non-Inca leaders rode into Cajamarca in litters. One of these was identified by Pedro Pizarro as "a lord of the Chincha" – a reference that could refer to any number of coastal Andean people from the *Chinchaysuyu* (northwestern) portion of the Inca realm.[76] This figure presumably advanced at the center of a group of ethnic warriors under his command. Atawallpa had strong ties to the northern highlands. More than one Ecuadorian people sided against him in the recent war of succession; still, the Inca forces at Cajamarca can only have included warriors from several, perhaps many Ecuadorian ethnic groups. Mena described several kinds of warriors in the main body of Atawallpa's army – fighters bearing pikes, bows, slings, and clubs.[77] As a rule ethnic-Inca warriors fought with slings and clubs; the men bearing other weapons were likely non-Inca auxiliaries. Bows, for instance, were the traditional weapon of lowland Amazonian peoples. The non-Inca contingents fighting in the Incas' service retained their traditional weapons and war costume, and they were led by non-Inca nobles loyal to Inca authority.

The ethnic diversity within Atawallpa's army modeled the sound logic of capitulation to the Inca leadership. Even within a given Inca contingent, certain tasks appear to have been delegated to ethnic non-Incas: the Inca leadership preferred the Andamarca Lucanas of the central Andean highlands' Carahuarazo Valley as litter bearers, for instance. "The feet of the Inca" (*Incap chaquin*) the Lucanas were called.[78] Atawallpa's personal servants likely included many ethnic non-Inca in his service: burials at Machu Picchu amply confirm that Inca royal households included retainers (*yanacona*) from around the Incas' Andean possessions.[79] Sixteenth-century Spanish administrative records make clear that Atawallpa's force also included non-Inca fighting units. Allauca from the mountainous Yauyos region east of Lima were serving in Atawallpa's army, for instance. "They brought everything with them," recalled a colonial descendant of those Allauca nobles who were with Atawallpa at Cajamarca; "they [the Allauca nobles] brought the best they had," another remembered. The Incas' local Cajamarquino allies were present as well: Caruatongo, prince and heir to the local lordship of Cajamarca, died on the plaza as a member of Atawallpa's entourage.[80]

As the array of Andean ethnic contingents bore down on central Cajamarca, the message was made clear: submission to Inca hegemony hardly entailed annihilation of local identity. Instead, that fealty entailed the reaffirmation of traditional identities – of local hierarchies of command, ceremonial garb, and battlefield trappings. More than this, submission to Inca hegemony offered access to military power and prestige on a scale well beyond provincial possibility or imagining. "The Inca did not offer an equal alliance but rather promised that [submission to Inca authority] would end the chaotic and anarchistic warfare that existed among the smaller competing communities," writes one specialist.[81] Under the Inca banner, local identities were

reaffirmed, the Incas' relationships with regional peoples were stabilized, and parochial antagonisms among those peoples were resolved. All involved were invested with new universality – the Inca leadership and their many local clients. As Atawallpa moved to accept the Europeans' fealty, his multiethnic army embodied and performed the favorable terms he offered.

Among colonial descriptions of Inca public ceremony, Garcilaso de la Vega left one of the most complete. As Craig Morris and Alan Covey have pointed out, Garcilaso's account provides a detailed account of the multiethnic dynamic that animated so much Inca public ceremony, particularly that enacted at regional Inca administrative centers. Garcilaso's narrative is found in his *Comentarios Reales* of 1609; in it, the author describes the ritual entry of the Incas' subject peoples into the central plaza of the Inca capital:

> The lords of the entire district of that great center came to it to perform the celebration, accompanied by all their relations and all the nobles of their provinces. They all bore ornaments and regalia (*galas, ornamentos, e invenciones*) with which the Inca used to celebrate their great feasts. Some came . . . clothed in the skins of lions with their heads fully covered by the animal's head, because they understood themselves to be descended from a lion. Others wore birds' wings of a great bird that they called condor set on their backs . . . because they thought they were descended from that bird. And so came others with painted devices, like springs, rivers, lakes, mountains, peaks, caves because they said their founding fathers came from those places. Others bore strange devices with their clothing ornamented with gold and silver. Others were garlanded in gold and silver; other came made monstrous, with hideous faces and the skins of various animals as if they had hunted them making great faces playing as if insane to please their masters in all ways possible, some with grandiosity and riches, others with insanities and miseries. They bore their drums, flutes, shell trumpets and other musical instruments. Many provinces brought their women behind the men, so that they could help peal and chant . . . each people entered according to its antiquity (such as they were conquered by the Inca).[82]

Garcilaso was an unreliable witness, of course. Born in Cuzco, he had spent a portion of his boyhood there before a move to Spain. His *Comentarios* were written almost three generations after the fall of Inca Cuzco; they were so much exquisite literary confection – an Inca history told by a humanist steeped in the writings of Roman historians. However, Garcilaso's account articulates certain principles of the Incas' public ceremonial order clearly enough.

Garcilaso records that in multiethnic gatherings, the Incas' clients were drawn up in costume that distinguished their ethnic and political identities. The Incas' subjects were arrayed for the Incas' supervision: individuated costumes vested subject peoples with a recognizable visual signature. The Inca leadership was known for its autocratic imposition of dress on subject peoples: the Incas'

first king, recalled one native Andean author, "commanded that the dress and
the garments in each town [should be] different, just as their speech is different,
to identify [them]."[83]

Many of the costumes cited in Garcilaso's account carry the attributes of
the given people's supernatural patrons – felines or condors. Other dress bore
iconographic heraldry that identified ethnic origins. The springs, rivers, moun-
tains, caves, and other natural features Garcilaso cites are clearly *paqarinas*,
places of emergence whence ancestors rose from the underworld to found
their respective ethnicities. Garcilaso's passage may be read in such a way as to
suggest that Andean ethnic groups wore visual representations of their ances-
tral *paqarinas*; and this is the case, although such visual representations were
conventionalized design motifs identified with those sacred locales, rather than
any visually descriptive, iconic portrayal of these natural features.

Garcilaso's description further correlates proper social organization with vis-
ible order: the Incas' subject peoples turned out in their corporate costume,
and they arrayed themselves in good order. This sense of visual and spatial
legibility is confirmed among traditional Andean communities today: during
public ceremonial the space of plazas may be parceled out among the com-
munity's constituent social groups in set units (*cchuta*).[84] An illustration from
Martín de Murúa's *Historia General del Piru* (1616) conveys the sort of visual
and spatial discipline formerly imposed on the Incas' subaltern peoples: Here,
the ruler Waskhar rides on a palanquin borne by costumed nobles from each
of the Inca realm's four world quarters (Fig. 59).[85]

The order that governed physical space and social display is further con-
firmed by a representation of an Inca muster painted on a cliff wall at Pucará de
Rinconada, Argentina (Fig. 60).[86] The painting's composition depicts an Inca
army assembled for campaign in the southeastern region of the Inca realm.
Solid rectangles of mats or rugs appear next to the rounded form of large beer
jugs; a female attendant appears in the center of the composition. Figures with
spears and clubs attend a line of stripped captives strung together at the neck.
The composition includes figures wearing several costume patterns; they are
arrayed in careful order, with each group of costumed figures consigned to
its own sector of the composition. This is clearly a victory ritual, the sort of
ceremony of social affirmation and order that the Inca anticipated in central
Cajamarca.

SO ATAWALLPA AND HIS RETINUE PROCESSED INTO CAJAMARCA; THAT ENTRY
enacted the elaborate ceremonial of Inca political dominance. Now as in any
given instance of this ceremony, a complex social aggregate was reimagined as a
unified community. The phenomenal coordinates of human experience – time,
space, and sensory perception – underwent concomitant reimagination. That

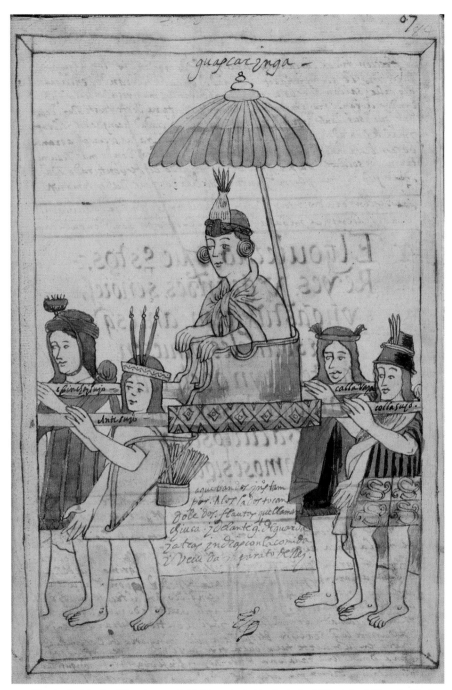

59. Martín de Murúa, *Historia general del Piru*, 1616, Ms. Ludwig XIII 16 (83.MP.159), fol. 84r. Los Angeles, J. Paul Getty Museum.

60. Painted rock face, Pucará de Rinconada, Argentina. Inka, ca. 1500 C.E. After Eric Boman, *Antiquités de region andine de la République argentine et du desert d'Atacama* (Paris: Imprinte Nationale, 1908), pl. LXI.

process of transformation was made visible in the Incas' shining metal. That optical stimulus – the harsh gleam of metal – articulated a raft of ideological truths. The Incas' reimagining of space, experience, and identity was also announced by sound. The Inca greeted their clients with an angry surge of light and noise. This output of multisensory energy prepared the way for the social integration that would follow.

Atawallpa's arrival was exceedingly loud. All Europeans notices relate that Atawallpa's entry was accompanied by trumpets, drums, and singing. These sources record little else about the musical accompaniment. Mellifluous, rhythmic, cacophonous? – the European sources do not tell. One fact is clear: the Inca ruler's entry filled Cajamarca's plaza with noise as well as people and goods.[87] That sonic materialism was another manifestation of Inca state and cosmos.

In the mid-sixteenth century, Inca nobles in Cuzco recalled that victorious Inca armies would enter into subject towns singing songs and chants. Their singing recounted the events of the triumph recently concluded.[88] A few Inca victory songs are recorded in documents of colonial era; these Quechua-language chants are heavily inflected by Puquina- and Aymara-language formalisms.[89] If these comparisons hold, Atawallpa's column may well have filed into town singing of their victory at Cajamarca.

Not that the physical strains of the campaign were over: A lifted voice requires no small effort of physical exertion. Marching songs come from the bottom of the chest: "Martial" chant is brought forth from the gut.[90] As much as marching and fighting, singing too was work. The soldiers' song announced the military campaign's entry into its symbolic phase – better, their voices announced a new phase of military symbolism. The fight was now doubly closed: militarily decided in the Incas' favor, and discursively recognized in an arrangement for voice. Telling the story of their own deeds

just past, the authors of the military triumph were now its principal heralds and witnesses.

Warriors who sang of the fight now over: the Inca deployed their warriors as agents of transition as well as instruments of military dominance. The duties of labor and the pleasures of victory were encoded in the name by which the Inca leadership recognized its soldiers. Soldiers are identified in colonial-era narrative accounts and lexica as "*aucay camayoc*." This title, like most exalted Quechua names and titles, consists of a two-word phrase; "Camayoc" is its semantic root.[91] The verb *kamay* is used elsewhere in the Quechua language tradition to express command – the act of ordering or having something done. It is also employed as a term of spirit possession – to be possessed by/the medium of. The word's broader meanings connoted the exercise of intentional action, of physical realization and the imposition of order. The phrase *aucay camayoc* (soldier) is an instance of the Inca state's use of the agentive form of the word – *kamayoq*, "do-er" – to identify a skilled laborer in its service. As officials of the Inca state, soldiers were designated as "masters," *kamayoq*. The term was applied by the Inca state to the craftsmen and specialists in its service. It was usually paired with a noun to make a two-word phrase that identified the worker's occupation: *qero kamayoq*: "woodworker"; *qompi kamayoq*, "master of fine weaving"; *khipu kamayoq*: "keeper of *khipus* (cord-records); *llama kamayoq*; "llama herder."[92] This official usage implies the exercise of specialized competency and ethnocentric notions of that competency's righteousness.[93] These designations were part of the Incas' elaborate system of labor administration involving both tribute-labor (*mit'a*) and indentured servitude (*yana*). With the label *kamayoq*, the Inca leadership ennobled the skilled artisans who labored at its behest, while reaffirming the intelligence of the command economy all told. For their part, workers were incorporated into a social compact of asymmetrical reciprocity: identified as *kamayoq*, their skilled labor was accorded special social value. With this recognition – and craft specialists' participation in the larger project of the Inca state – those activities claimed a dignity they would not otherwise possess. The term sanctioned workers as the agents and executors of the larger Inca cultural scheme: woodworkers in the Inca mode; khipu-keepers according to the Inca way.

Sixteenth- and seventeenth-century authors identified Inca soldiers using the lexical conventions of the period. The early modern transliteration "*aucay camayoc*" likely conceals or misreads outright the linguistic subtleties of the Quechua speech it purports to record. The phrase poses several possibilities of translation. Most immediately and surely, *aucay* refers to "battle" (*awqa*): Inca soldiers were thus "masters of battle." Alternately, the word's consonant may soften, to yield *awka*, an intensifier often employed as an honorific (e.g., *auquicuna*, "great-ones," or "nobles").[94] As *aucay camayoc*, the soldier was "the great master." Alternately, *aucay* may slide to the aspirated *haucay*, a verb

associated with vocalization – crying or keening sound – and the happy idleness of accomplished work: "to revel/rejoice in rest."[95] Spanish lexica often identify the verb *haucay* with the autumn season, when harvests were in and laborers were idle.

Wordplay, double entendre, and poetic form were characteristic of most titles attached to important or sacral people, places, or events.[96] The distinguished Andean scholar John Rowe translated the Classic Quechua term *aucay* with the noun "leisure." Rowe's word choice aptly captures a sense of activity-within-repose, the work of Inca rest.[97] That activity, it is to be understood, was ceremonial. In Inca terms, that ritualism principally involved feasting, extended bouts of eating and drinking accompanied by singing and dance. With *aucay camayoc* the Inca state thus constructed its soldiers as something like "masters of well earned rest-and-ceremony."[98] The phrase alluded to multiple social identities and forms of labor; it merged them into a single specialized occupation.

Atawallpa's soldiers announced the new order in bellowing voices. Indeed, *what* Atawallpa's soldiers sang may be less important than *how* their raised voices communicated. The music and drumming that accompanied Atawallpa's entry into Cajamarca may be considered an audible expression of heightened structure and inflection – without question, it was "song." Their song – so we may reckon – recounted a martial narrative, one suited to the truths of Inca dynasty and cosmos. Whatever their song told, their vocalization was also a means of spatial production. Drums and raised voices created a "soundscape."[99] It imposed an acoustic logic on the monumental urban space of central Cajamarca. The song reconfigured the relationship of plaza's occupants to themselves and to each other. The architectural space became a framework of sensory self-awareness and social interaction. The listener was at once more isolated by the song's din, more closed in on her/himself; more social, as a co-participant in the experience with others; and more definitively located in that space. In the Incas' song of triumph, the senses of self, of others, and of the physical setting were magnified, dramatized.

Recent archaeological inquiry has shown that the spaces of Inca plazas trap and amplify the sounds generated within them.[100] The sound reverberates: acoustic energy echoes repeatedly as it reflects off the plaza floor and the walls of surrounding buildings. The physical dimensions of the space distort, as the location and direction of sound multiplies and blurs. The sound itself builds and grows more indistinct. Music tends to flatten and lose its aural particularity and legibility. The sound grows in overall intensity as its distinct aural components are compressed and blurred. Songs shed their recognizable signature, as the music slides to a sonic roar. Music takes on a new character altogether: undertones boom and overnotes peak, producing brief, bent harmonies or passing cadences. The song swells as it is repeatedly distorted and transformed.

The narrative enunciated in the Incas' song did not recount a given war victory, so much as invoke a state of sensory experience and bodily response. As one scholar of song in the Andes observes, "Sound is always meaningful and whole. Speech threatens that integrity by fracturing the sound so that the meaning is parceled out to one syllable, one word, one sentence, or one spoken idea at a time."[101] As the Inca entered Cajamarca, they made music that imposed a state of intensified physicality.[102] Their song operated prior to and outside the logic of cognition and the subtleties of linguistic articulation. It was a sensory triggering of the body's lived materiality. The Incas' song communicated to autonomic responses that exist below the threshold of consciousness, thought, and language.

The music of Atawallpa's entry produced a bodily state of being recently described by cultural theorists as "affect": "an experience of. . . unformed and unstructured potential."[103] At root, affect is a neurologically triggered brain-body condition of a "nonsignifying, nonconscious 'intensity' disconnected from the subjective, signifying, functional-meaning axis."[104] Affect comprehends the most basic human impulses: fear, desire, fight-or-flight. These states are generated among the neural pathways of the amygdala and other limbic regions of the brain. These are the brain's oldest regions, the preconscious source of the human body's most fundamental survival mechanisms. Affect is an activation of the brain's "chemical messengers" by cultural means.[105]

Atawallpa's entry claimed the monumental space of Cajamarca's plaza by energizing it. This act of assertion was achieved by the physicality of bodies in motion, certainly. The Inca possessed the space by altering the terms of perception and experience in that locus. Cajamarca's urban landscape was remade as soundscape: monumental buildings and spaces became a zone of overpowering sensory intensity. The material surfaces of plaza floor and building facades fell away, to be replaced by a corporeal and cognitive state of estrangement – an enhanced bodily affect. This is not to say that the observer in that space was estranged from the sense of self, or otherwise removed from the physical context of Cajamarca's plaza. It was the means to define the Inca center by a deepening of human experience within it. The corporeal status triggered with affect was itself a device of site specificity. The body was pushed to inhabit space and time more fully, more thickly. The observer was made more aware of the body's own material presence in that space, in those instants. The intensification of perceptual terms denatured architectural space but energized self-awareness. The witness was less a passive observer than a committed set of eyes.

THUS DID THE INCA SOVEREIGN PERFORM A ROARING, SHINING ARRIVAL AT the main plaza of public ceremony. Atawallpa's entry into Cajamarca finds

its nearest analogue in the ceremonies performed at December solstice in Cuzco. Those rites were performed in the same time of year as Atawallpa's entry to Cajamarca. Recognized by the state as the highpoint of the annual ritual calendar, the Inca Solstice ceremonies (*Qhapaq Raimi*) culminated in a ceremonial advent, a ritual of entry and seating. The Inca celebration of December Solstice culminated with the sun's "being seated" (*esta sentado* in Guaman Poma de Ayala's words) over the central plaza of Cuzco.[106] On that day, so the Inca leadership understood, the sun positioned itself directly over the plaza, balanced in the sky overhead. The Incas' cosmic order was arrayed around that celestial entity as the sun's visible echo. Atawallpa's presence in central Cajamarca was something like this. He presided over the plaza and his subjects as a divine solar being. His presence at the center of the plaza effected the unity of time, dynastic eminence, and provincial clientele.

Like Atawallpa's entry to Cajamarca, the rituals of December solstice were rites of noise and light. They involved coordinated ritual drumming and singing by Cuzco's populace.[107] The music the Inca produced in that ritual is better described as crowd noise, a coordinated din. Golden drums were played to announce the sun's victory.[108] The bellowing peaked at noon, as the sun attained its zenith directly overhead.[109] (During eclipses, the Inca worked up a similar pitch of noise – even whipping dogs until they howled – to restore the sun's weakened luminous energy.[110])

Of course, it was the gold that bellowed. The Inca recognized in the sun's energy the capacity to "unite multiple sorts of realness and demonstrate them through varied manifestations."[111] The yellow luminance of gold and sunlight was considered aggressive, life-giving, eye-pleasing, if also potentially threatening and blinding. The Inca equated sunlight to biological and spiritual vitality, night to death: this dichotomy is apparent in Inca discourses of day and night, the living and the deceased, Cuzco and not-Cuzco, Inca and non-Inca people.[112]

Like other Andean peoples, the Inca recognized that the sacred was sensible across the human faculties of perception. *Quri* was one such instance of divine synaesthesia, arguably its master trope. *Quri* was understood as a network of metonymic equivalents that encompassed divine energy, material substance, and human perception. It was identified with the complex dynastic mythology of the sun, as well as the immediately tangible physical substance of sunlight itself. *Quri* was recognized in phenomenal experience as sensory intensification, particularly booming noise and shining, blinding brilliance. Finally, *quri* assumed physical embodiment as gold.

In the colonial era, *quri's* sensory reverberations were identified with thunderclaps or the rumble of earthquakes; the crack of whips, the explosive report of cannon and harquebuses, massed drums beating, or crowd roar.[113] Sunlight – *quri* – tended toward an ear-splitting, crashing din, particularly at the peak of

its power. In the scope of human experience, it operated as a wide-ranging principle of amplification. It was brighter, hotter, higher, sharper, louder, more alive – an activation or enhancement of the senses themselves. The sun's quickening energies also assumed moral and ethical dimensions. Solar numen was alluring and discomfiting. It was identified with social prestige and masculine honor.

Within the visible domain, the Inca understood glittering light, the shining surfaces of gold, and spearlike instruments to operate as a set of metonymic proxies, together with a final, master term, sunlight. Colonial lexica of the Quechua language identify beams of sunlight with arrows, snakebites and scorpion stings, footplows, and sexual penetration.[114] Other Quechua-language sources recognize *quri's* metallic, flashing light in flashes of lighting, the sparkle of water, and the shine of lustrous hair.[115] *Quri* was experienced in the uncomfortable extremes of heat and eye-wounding, high yellows and golds. The Inca recognized a hardness or beaming strength in *quri*: it was identified as streaming yellow light that piqued, darted, penetrated, or stung. In that the term denoted an effect of light – a metallic, stabbing glint – the domain of *quri* encompassed spears and darts, and gold itself, the material with a piercing, high yellow shine.

Quri was closely allied with another term, *chuqi*: "When we say *choqui* [sic] we mean gold (*quri*)."[116] Among seventeenth-century Aymara speakers of the southern highlands, *chuqi* signified both gold ("the most valuable metal") and esteem ("my dear/golden child").[117] Among the Inca, *quri* and *chuqi* could be used interchangeably, though *quri* was generally the stronger and more forceful of the two.[118] *Quri* was more closely tied to material things and physical contexts – with metals and their contexts of display. *Chuqi* was a more generalized optical effect – the stabbing effect of light – along with that light's many synaesthetic and moral correlates.

Mary Helms has described the Inca leadership's relationship to gold as "architectural."[119] By this she means that the spaces and contexts identified with the Inca leadership were broadly fitted out with the metal. Inca buildings were trimmed with gold plate; vessels and service fashioned from it; costume and adornment defined by its use. *Tanta la pateneria*, wrote Pedro Pizarro, "so many metal things": Inca space and society were gilded. Among the Inca leadership gold was prevalent in tangible material objects. In its physicality and spatiality, the term "architectural" well describes gold as a one of the preeminent hard surfaces of Inca cultural life. (A vast system of mineral extraction, resource expropriation, labor management, and metallurgical acumen produced that material in its finished form; the discussion here focuses on gold's meanings in social and ceremonial contexts, that is, in the display of its finished objects.[120]) Gold was also a structure of logic, a cultural way of thinking. As a device of epistemic construction, gold shaped the sensuous dimensions of Inca cultural experience.

As humans we are bound to an exterior world through our faculties of per-
ception; yet as thinking beings and practitioners, we project our consciousness
onto that world in turn. We are shaped by experience and we shape it in turn.
Human experience is defined in neither subjective nor objective terms, but
across them. The distinction between subject and object dissolves, displaced by
what phenomenologist Maurice Merleau-Ponty described as "the flesh of the
world."[121] Martin Heidegger articulated the recursiveness of subjective experi-
ence in more ideological terms, as "dwelling."[122] In both cases, humans reside
in the world and exist of the world; and that world is patterned by culture in
turn. That space of interpenetration is the world we know and inhabit. *Quri*
was the architecture, the flesh, and the dwelling of the Inca leadership's world.
In this sensorium of Inca experience, the mechanisms of human perception
were indexed to a set of cultural expectations. Inca gold vitalized, in David
Abram's phrase, "the more-than-human natural world."[123]

As a condition of sensory intensity, the sonic energy generated by the
Inca state enlisted bodily, autonomic responses as means of cultural significa-
tion. Maurice Blanchot wrote of a light "that in clarity clamors but does not
clarify."[124] Jonathan Crary has described it as "the potentially dangerous daz-
zlement of the senses by the light of the sun."[125] The clamoring of Atawallpa's
arrival in Cajamarca's square was the sonic embodiment of that condition. It
was the sound of sunlight.[126] In *quri*, the Inca conjured and politically harnessed
the sacral phenomenology of the sun's energy.

THE INCA RULER ENTERED CAJAMARCA WITH A DEAFENING, BLINDING ROAR.
That is, he arrived there as the sun. His presence in Cajamarca embodied a
complex chain of likeness and being, creatural sensation and cosmological
truth. The Inca solar deity possessed a specific identity; that distinctiveness is
now difficult to chart, other than as a principle of superlative being, and of
order. The sun's primary manifestation was widely referred to by the Inca as
Inti. In this guise, the solar being was first, highest, brightest, most powerful.
Over and again, the sun was set above rival entities and states of being: it
was both morally and physically superior; a force of life as opposed to death;
light and heat against night and cold; a creator and bringer of order relative
to formlessness; noisy rather than silent; all-powerful and wealthy relative to
human weakness and poverty; masculine as opposed to feminine.

The Incas' solar being was protean, a divine entity of many aspects and
guises. Struggling to comprehend the Inca sun's several manifestations, one
seventeenth-century Jesuit described a tripartite identity: *Apu Inti*, "lord Sun,"
the sun in its primary and mature aspect, often allied with the hottest periods
of the year around the December solstice. *Churi-Inti* or *Punchao*, "Child-Sun,"
was the immature sun of June solstice, though also possessed of youth, a

vitality revered by the Inca in their rhetoric. The *Punchao* also appears to have served as the Inca state's premier effigy and oracle. Finally, *Inti-Guauhqui*, "Son-Brother," was a being identified with the sun's role as a creator being and patron of dynastic ancestry.[127] The sun as creator gestured to the solar being's role in the cosmology of world creation, as well as to the sun's patronal role in the course of dynastic succession. The solar being's transcendent vitality was epitomized the change it itself experienced. In Lord-Sun and Child-Sun, the solar being was comprehended according to its manifestation in the annual cycle. The sun's changing path of movement over the year set it in changing relationships with landforms and with other features of the sky. These changes, in turn, were subject to predictable cycles; this disciplined, predictable cyclicity maintained balance and order in a cosmos otherwise ruled by movement and change. In its aspect of Sun-Brother, the sun was identified with deeper temporal cycles of world and dynastic generation. All these identifications must remain tentative, given the Christian overtones the sun took on among the colonial observers who recorded Inca solar lore; however shaped by Christianity, colonial sources present the pre-contact Inca solar being as a divinity of multiple aspect, manifestation, and temporality.

The Incas' sun was also complexly allied with other exalted supernatural beings of the Inca pantheon, particularly the creator god, *Viracocha*: "sometimes [the Inca] hold up the sun as the creator, and other times they say it is Viracocha," wrote a sixteenth-century Spanish settler who had married into the Cuzco nobility.[128] Such confusion arose not from faulty memory or mistaken storytelling in the colonial era, but from the sun's partible essence and multiple aspects. This source appears to identify Viracocha with the aspect of Inti known elsewhere as Sun-Brother. The Inca sun also appears to have shared its being with other gods of the sky and meteorological phenomena, most importantly thunder and lightning. The Inca sun is perhaps best understood as "a manifold sky god": the solar being's manifestations include the creator divinity (*Viracocha*), the god of Lightning and Thunder (*Illapa*), the god of the sky (*Thunupa*), and divinities of the rainbow and of the stars.[129]

The supernatural entity that arrived in Cajamarca on 16 November was less a singular being than an animating social principle. The Inca ruler's shining presence embodied vitality itself, a principal set in polar opposition to the shaded, darkened beings and regions of death.[130] The Inca ruler was venerated as the "son," or "page of the sun" *Intip Churin*. Although the primary human representative of the Inca political hierarchy, the Inca ruler shared his identity with an ulterior and more powerful cosmological power, the sun itself. He was not alone in this capacity to channel higher energies of sacral beings. Spirit possession was central to the Inca leadership's political life. Inca priests and ritual performers were commonly "infused" or "vitalized" by supernatural

beings; in effect, they were "possessed" by those beings.[131] These practitioners assumed temporary states of supernatural animation in the course of ritual performance. However real and palpable their identification with or as the animating being, their identities were only temporarily collapsed with the ulterior being. Their spiritual identification with the divinity was evanescent, as suggested in their very name, *kamasqa* – a past-participial form of "to enliven," and thus "animated one." That ritual state of spirit possession was a condition that only temporarily displaced or added to their quotidian social identities. In contrast to those other mediums, the Inca ruler was more permanently bound to the sun. As *churin*, he was the solar being's child, rather than its medium, speaker, or proxy.[132] He enjoyed his connection with the solar being by nature and in perpetuity. His corporeal, sentient body connection with that divine entity transcended the immediacy of ritual moments and contexts.

Atawallpa shared his identity with the sun, and so the human actor's actions bore likeness to the solar being's activity. As "son of the sun," the Inca ruler was at once resplendent and reflective, an embodiment of sunlight's supernatural origin, and a prime agent of its biological implication in the cultural order. The Inca ruler's conduct was governed by elaborate ritual protocol.[133] Like the sun, the Inca ruler was a being in constant, periodic motion. He returned to the Inca capital of Cuzco several times a year – back from itineraries of inspection and embassy, military campaigns, and soujourns at country estates.[134] In town, the son of the solar deity walked on paths prepared for his passage with iridescent bird feathers and the glittering powder of ground seashells.[135] The spiritual potency and visible brilliance of sunlight – along with other cosmic forces, among them time, water, biological fecundity, and luck – were affirmed in his person and repartitioned in concrete measure through his actions.[136]

As the Inca monarch, Atawallpa was not the ultimate source of sunlight, but an offspring of its patriarchal and celestial origin. His conduct modeled the devolution of authority, both its partibility and sanctioned delegation, and its translation across the senses as so many coordinated synaesthetic phenomena. His energies did not concentrate in one place or instant so much as they reflected across many others as a wide-ranging principle of amplification. The Inca ruler, like sunlight itself, animated other things, assisted wider processes: his presence made landforms more salient, human spaces more lucid, colors brighter, corn taller, water more crystalline, instants in time perceptually more alive and urgent.

Materially and ideologically, Inca civility was understood as the reflection of the ruler's brilliance: At the ritual of "The Corona" (*Itu*), retainers drew around him like a halo of vapor around the summer sun, their bodies clad in customary regalia of mirrors (*lirpu*) and rainbows (*kuychi*).[137] At "The Shining" (*Citua*), processions dispatched from Cuzco moved to the distant communities of the

empire, shining forth, as it were, the magnificence of Inca administration.[138] This formalized ritual discourse of brilliant luminance is confirmed by the archaeological record: the onset of Inca hegemony after the turn of the first millennium C.E. is marked by increased frequency of shining objects (gold, silver, shells and coral, polychrome pottery) in archaeological contexts.[139]

The energy epitomized in *quri* echoed and reflected through such Inca dependencies as Cajamarca-province. Brightly patterned cloth was hung from exterior walls of buildings on the occasion of the Inca ruler's entry into town.[140] Local lords who pledged loyalty to Inca leadership were granted titles of visual resplendence, among them *illa* (bright, shining) and *pawkar* (scintillating); trusted captains received the names of shining metals and glossy animal skins.[141] The state also vested them with the kind of gilded regalia witnessed by the Spanish in their first meeting with the Inca court. (Archaeological patterns indicate that the Inca state effectively arrogated metals to itself, drawing these sumptuary goods away from local contexts where they had been in use before; in the Inca empire, to possess precious metal was to be a client of the state.) In Inca public ceremony, hierarchies among the Inca leadership and its provincial clients were distinguished according to the materials employed by various participants.[142] The Inca leadership likened the retinue surrounding a living monarch to a mantle of intricate feather mosaic worn around his shoulders.[143] When the Inca ruler was close to death, bright clothing and reflective jewelry were put away, their colors and luster dimming with his reduced life force.[144]

TANTA LA PATENERÍA, WROTE PEDRO PIZARRO, "SO MANY METAL THINGS." Pizarro described the gold and silver worn by Atawallpa's army as *pateneria*. In it strictest sense, the word equates to something like "altar-service." This translation well captures the range of objects born on the bodies and in the hands of Atawallpa's retainers. Few objects of Inca gold and silver survived colonial smelters, though Inca metalwork had close affinities with gold work from Peru's north coast. The Inca leadership even ordered the transfer of whole communities of metalsmiths from that region to Cuzco, so that they could produce their fine gold and silver for the Inca.[145] More works from that region have survived to the present, and that corpus offers a general – if only general – understanding of Inca metallurgy. Many of the objects borne by Atawallpa's retinue were likely drinking service: urns, goblets, and beakers that held beer (Figs. 61, 62). Others were costume ornaments or personal items: adornments worn in the hair or on the person, metal appliqué affixed to garments, or gilded instruments (see **Figs. 8–10, 12; Figs. 63–65**).

Rreluzia con el sol, "how it all shined in the sunlight": Andean metal smiths were skilled in the metallurgy of robust, gleaming sheet metal. Inca "gold" and

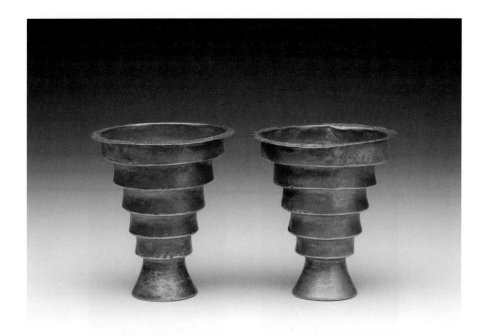

61. Stepped beakers, Inca. Gold alloy, ca. 1450–1532 C.E. H. 6.4 cm. Dia. 7 cm. Museum of Fine Arts Houston. Gift of Alfred C. Glassell, Jr. 2001.1008.1, 2.

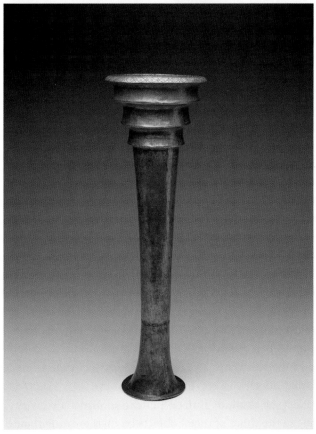

62. Stepped beaker, Inca. Gold alloy, ca. 1450–1532 C.E. H. 17.5 cm. Dia. 11.7 cm. Museum of Fine Arts, Houston. Purchase funded by the Alice Pratt Brown Museum Fund 2004.2445.

63. Chimú (?) gold plume, coast of Peru, before ca. 1470 C.E. H. 38.1 cm. Washington, DC: Dumbarton Oaks. Dumbarton Oaks B-447. Photo © Trustees of Harvard University.

"silver" were high copper-content alloys, generally arsenic-bronze.[146] These metal alloys lent the work structural resilience and strength. The surfaces were then purified by immersion in chemical baths. The work's external, visible surfaces were altered down to the molecular level, as lesser metals were chemically stripped away through processes of surface enrichment and depletion gilding. The result was a veneer of high-grade gold or silver: if the objects were not gold or silver through-and-through, the surfaces that met the eye approached molecular purity.

"Above all others," writes an eminent scholar of Andean metallurgy, "the property . . . that metalworkers sought to control was color."[147] The Inca sought an effect of absolute surface perfection and reflectivity. Inca metalsmiths enhanced the shine of metal objects by manipulating their shape as well

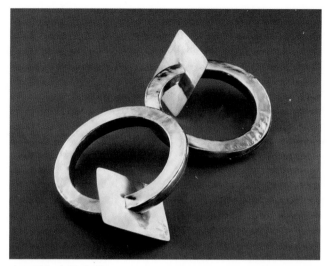

64. Gold bangles, Chimú (?), before ca. 1470 C.E. Diam. 13 cm. Washington, DC: Dumbarton Oaks. Dumbarton Oaks B-452. Photo © Trustees of Harvard University.

as their metallurgical structure. Inca objects tended to resolved as simplified, unrelieved planes: fluted cylinders of drinking cups; plates or tesserae of gold leaf fixed into cloth understructures; broad, curled sheets that formed armbands, wristlets, and anklets; thin metal sheets mounted on poles. Gilded Inca

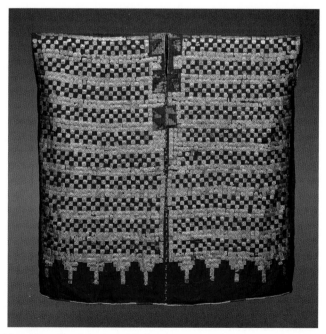

65. Tunic with gold appliqué (*curi cusma*), Inca, ca. 1450–1532 C.E. 86.36 × 91.44 cm. Dallas Museum of Art, The Nora and John Wise Collection, gift of Mr. and Mrs. Jake L. Hamon, the Eugene McDermott Family, Mr. and Mrs. Algur H. Meadows and the Meadows Foundation, Incorporated, and Mr. and Mrs. John D. Murchison 1976.W.575.

costumes included tunics of fine alpaca and vicuña wool fixed with sheets of gold. Guaman Poma de Ayala referred to garments of this type as *curi cusma*. One example is preserved in the Dallas Museum of Art (see **Fig. 65**).[148] Inca gilded objects also included *lirpu*, "mirrors," metal disks that hung loose from the neck, catching and reflecting light as they dangled. Spanish accounts often refer to handheld metal objects as *alberdas*, a word that accurately describes their general form, though these works are useless for any purpose other than catching and reflecting light.[149]

Tanta la pateneria: The cultural world over which Atawallpa presided was both ideologically undergirded and physically built out with metal. Pizarro's account describes the range of metallic objects in the Incas' possession. It also catches the depth and expansiveness of yellow metal in Inca cultural discourse. Indeed, his remark may be understood two ways. On the one hand, so much Inca metalwork was apparent to the viewer's eye; and on the other, so many Inca works were arrayed before the eye like metal.

The Inca looked for metallic perfection in the surfaces of prestige goods and sacral objects; and so the look of metal crossed media and materials of Inca cultural expression. Inca sacrificial rituals lent special importance to all-black llamas, for instance; those monochrome animals possessed the same surface perfection as metal, whereas white or brown llamas, even if they had a perfect coat, were marred by the animal's black nose.[150] Similarly, children were selected for sacrifice on the basis of their perfect, unblemished skin: "with neither scars nor blemishes . . . they were beautiful."[151] The children's skin shone in the sunlight with a metallic gleam. Their live flesh may be compared to the broad, unrelieved surfaces of contemporary Andean mummy masks (Fig. 66).

The aesthetic of metal is most immediately apparent in high-status Inca wooden objects. Inca woodworkers produced drinking goblets, bats and scepters, and other personal goods. Carved from close-grained, rosiny hardwoods, these objects were burnished to a high luster (Fig. 67). Their surfaces were worked with parallel linear incisions arranged in geometric panels across the object's surface. The incisions may trace complex, meandering paths that form sharp corners and elbows across the surface of the work. The incised lines do not appear as individual figures against a neutral ground; instead, they are the means to create differentiated passages of surface reflectivity. The parallel channels variously dull or heighten the object's shine, as if to emulate the appearance of metal repoussé or raised bosses of gold or silver. These linear incisions "gild" the vessels, bringing their wooden surfaces closer to the burnished appearance of metal sheet.[152]

The visual character of metal is also apparent in Inca costume patterns and weaving techniques. Here the visual character of metal is more subtly

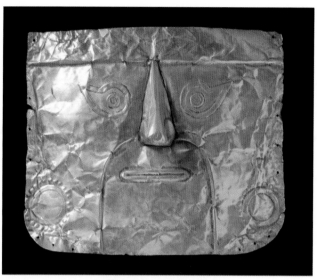

66. Gold mummy mask, Chimú, before 1532 C.E. H. 24.13 cm. Los Angeles County Museum of Art, Phil Berg Collection M.71.73.247.

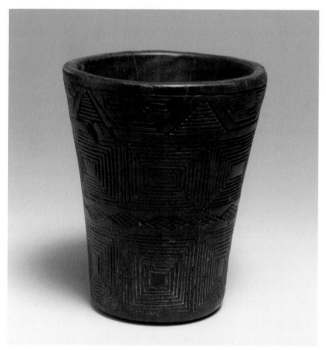

67. Wooden drinking cup (*Qero*), Inca, ca. 1450–1532 C.E. Wood (escallonia?). H. 14.6 cm. Metropolitan Museum of Art, New York. Bequest of Arthur M. Bullowa, 1993 (MMA 2004.212). Image copyright © The Metropolitan Museum of Art. Image source: Art Resource, NY.

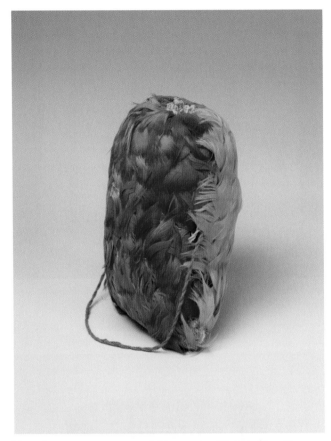

68. Feathered bag, Inca, ca. 1450–1532 C.E. H. 15.2 cm. Metropolitan Museum of Art, New York. Bequest of Arthur M. Bullowa, 1993 (MMA 1994.35.101). Image copyright © The Metropolitan Museum of Art. Image source: Art Resource, NY.

articulated; though not always, as may be seen in garments woven with plumage and feather mosaic. These are perhaps the finest and most rare examples of Inca clothing: a well-preserved Inca bag in New York imparts the appearance of Inca garments worked with feather (Fig. 68; **see also Figs. 21 and 22**). Bird plumage was threaded into the garment's backing cloth to produce an outer surface of bright color.[153] Bird feathers are naturally iridescent: they have an active sheen that plays in the light. This is to say, plumage shares its defining visual characteristics with sheet metal: strong, high-tone color; high reflectance; and mobile, often iridescent effects of surface luminance. Inca garments of woven feather were relatively few. They were worn by the same leaders and high-status figures who also wore golden adornments. Whether clad in gold or feather, Inca recognized authority in gleaming reflectivity.

Cloth of woven camelid fiber and cotton possesses little of metal's aggressive shine. Even so, Inca design patterns assimilated those woven fabrics to the look of metal. Inca garments were defined by their bold overall design, rather than

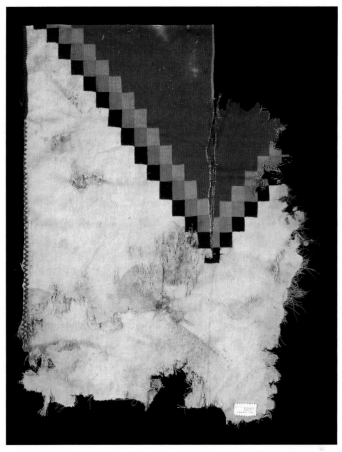

69. Man's tunic, Inca, ca. 1450–1532 C.E. Cotton and camelid fiber tapestry weave, 76.2 × 60.9 cm. Museum of Fine Arts, Boston. Gift of Landon T. Clay 1977.131. Photograph © Museum of Fine Arts, Boston.

local passages of detail. The great majority of Inca woven compositions favored the pattern's broad gestalt (**see Figs. 33, 46–49; Fig. 69**). In the typical Inca weaving, individual panels of color build to produce the larger compositional whole: contiguous geometric blocks join one another to assemble a unity of complementary forms. To achieve compositional unity, the individuality of each panel of color is suppressed. Each individual passage of color reads as a self-contained solid. Those slabs of color show no internal chromatic variance. The block of color is smooth and even, unmarked by any vagaries in the color of yarn or lazy-lines in the weave. Those inconsistencies might introduce local inflections of color or surface texture that would distract from the weaving's broader formal structure.

Inca garment patterns were thus defined by the purity of their color and the clarity of their overall geometry. This is to say that the visual effect of Inca garment designs depends on differentials in the character of light across the

object's surface. Blocks of hot, active color abut panels of cooler, recessive color; chromatic fields alternately push forward or pull back from the garment's face. Differentials in adjacent colors produce marked effects of linear edge contrast along the weaving's flat surface. (Inca design patterns tend not to rely on strengthening frame lines around individual blocks of color; linear effects in these compositions tend to arise from the dissimilar color value of adjoining passages of color, an effect that relies on the sharp edges of demarcation produced by tapestry weaving techniques.) Inca garment designs amount to a metallic formalism: these weavings are defined by differentials in surface patination, as if they were arrangements of metal sheets.

"Abstract" is a common descriptor for Inca compositions. In most cases the term is employed relatively neutrally, as a term of absence or lack. Figuration or other iconic representation are generally absent from Inca compositions. Inca work also generally downplays iconographic representation, or else sublimates iconographic imagery to larger compositional ends. However, the neutral-seeming term of abstraction also conceals deeper philosophical commitments informed by Kantian idealism and Hegelian historicism. "Abstraction" in the modernist sense implies an ideological disavowal of figuration, iconographic depiction, and textual expression; it also suggests a visual language of pure form in their stead. There is so much to disagree with here. Inca design did not pursue a universalized aesthetic ideology, so much as it went about a set of practical visual strategies.

The design aesthetic of Inca weavings was not a banishment of figural narrative and iconographic devices, so much as it was an ambition toward the appearance and visual behavior of sheet metal. Importantly, this aesthetic impulse did not seek to subordinate the aesthetic logic of one medium (weaving) to that of another (metalwork). The issue here is less concerned with the formal structure of discrete, competing media, but rather bears on the wider logic of Inca ritual environments. Inca design was contextual. In ceremonies such as Atawallpa's entry into Cajamarca, works of disparate artistic media created a unified environment of moralized sensation: kinetic, reverberating, disorienting.

DECADES AGO VICTOR TURNER FAMOUSLY ADDRESSED THE RITES THAT EFFECT social transition, those rituals that Arnold van Gennep earlier had described as "change of place, state, social position, and age."[154] Turner focused on the symbolic uncertainty, the in-between time and undetermined status that was a characteristic phase in any ritual cycle. He described those transitional states as "the liminal" – "the cultural realm that has few or none of the attributes of the past or coming state." "Liminality," Turner noted, "is frequently likened to death, to being in the womb, to invisibility, to darkness, to bisexuality, to the

wilderness, to an eclipse of the sun or moon."[155] Something like that liminal state was recognized by the Inca in the concept of *pachakuti*, "cataclysm."[156] *Pachakuti* was a renewal through destruction, a dissolution of known relations and the establishment of a new order. *Pachakuti* was closely identified with Inca dynastic kingship: violent transformation was a principle of Inca authority. Even the name was borne by Inca kings as an honorific. *Quri*, in turn, was the sensible signature of that transformative capacity. It was the phenomenal evidence and epistemic device of Inca dynastic power's creative violence. Deafening, blinding, angry, and masculine: gold was the Incas' liminality.

"Speak no evil against the sun, the moon, or shining objects . . . nor against me," the Inca ruler was recalled to have declared, "as I will surely kill you, I will exterminate you without a doubt."[157] If gold was preeminent within the Inca sensory order, it did not operate in isolation. *Oro y plata*, wrote Pedro Pizarro: "Gold *and* silver." Silver was gold's complement within a far-reaching system of reciprocities. Innumerable Andean accounts set gold (quri) against silver (*collque; qullqi*) as the masculine element to the feminine complement, the sun's light as opposed to the softer shine of the moon.[158] The Inca also distinguished between sunlight as an elemental force, and artificial light – the lamplight and cooking fires of domesticity and intimate life – which illuminated more gentle, sustaining aspects of human existence.[159] *Quri* bore directly on the masculinist rhetoric of ritual, honor, and social prestige under the Inca state. Those qualities are refracted through the accounts written by European soldiers, settlers, administrators, and evangelizers; less so the discourses of femininity and intimacy. Those softer, necessary forms of luminance would also determine the conduct of Inca civility at Cajamarca.

Atawallpa and his retainers processed into Cajamarca's plaza. *Quri* roared in a blinding, percussive earthquake of power. The angry blast of royal energy spent, the new polity would commence with an extended feast. In the ritual process of the Inca royal entry, silver was the visual keynote of the status system that followed upon the violent incumbency of the liminal state. As the ideological complement to gold, silver held forth the integrative impulses of Inca hegemony. As gold's complement, it offered the dialogic principle – the more complex, more humanly satisfying sparkle of social conversation and reciprocal expression.[160] This was the luminance in which cultural production and reproduction took place. Inca Cajamarca would assume its status as another Cuzco, and so also another *Mama Aqha*, "Mother Beer."[161] The high gleam of silver was understood as the light of the moon (*pacsaquilla; phaqsa killa*) or stars on a clear night.[162] *Pasca* (*phaqsa*) referred to subdued luminance of the moon through clouds.[163] A bout of eating and drinking would take place by the gentle light of hearth fires and the moon above: "The satisfaction of human nutritional needs," writes one anthropologist, "generally clears the way for the expression of other psychological and mental urges . . . the consumed

food/energy is immediately spent planning future action . . . or in expressive activity, producing . . . signs and objects."[164]

Installed in the plaza, Atawallpa's blinding solar power would give way to the chromatic variegation of sociality. The Inca and their descendants recognize the breadth of color across cultural experience. These colors and states of luminance were understood to be less potent then the sun's energies; and from this difference arose the particular sacrality of each. *Illa* was a steady, clear light – the suffusing shine or illumination of daybreak, for instance, or the light on mountain glaciers.[165] Semiprecious stones and other polished, glowing things are *illa*.[166] In traditional Andean thought, the term is associated with both surface luster and the sacred: *illa*, "shining things," possess sacral properties; these objects' precious essence is perceptible as glowing light or bright color.[167] *Lipic* (*lipiq*) described more subdued glimmering – winking starglow or the sheen of a silken garment.[168] *Quispe* (*qispi*) denoted translucent or sparkling things – a sharp but diffusive, lesser radiance. *Paucar* (*pawkar*) was the iridescence of bird feathers; *mullu* the nacreous luster of shell, mother of pearl, or coral. Many of these optical phenomena were apparent among Atawallpa's retinue on the square in Cajamarca. If *quri* and *chuqi* were the dominant sensory keynote of the Inca ruler's presence, these others were silver's offspring. In the signifying system that was the Inca leadership's imaginary community, gold spoke the cold culture of Inca dynastic myth, silver the hot culture of the historical process.[169] With beer, song, and oratory, they were the diverse sensations of communal sociability: in them the blinding mythopraxis of dynastic installation gave way to the many-colored *habitus* of communal life.

Those lights of communal ritualism did not come to pass. As Pizarro's horsemen surged forward and his gunners touched off their cannon, the Inca entourage suffered the full weight of globalism at its truest and most merciless. The equestrian military technology of the central Asian steppes; the ancient metallurgical tradition of the Near East; the pyrotechnic technology of East Asia: all were brought to bear on a people who had known none before. Atawallpa dined as Francisco Pizarro's prisoner in the fine palace the Inca's father had built, while the bodies of the royal Inca retinue lay on the paving stones outside. And so the long conversation of Andean modernity began.

Years later, Andeans recalled the passing of Inca authority: in 1536, a miraculous apparition of the Virgin Mary blinded an Inca army that had laid siege to Spanish Cuzco, putting the Inca to rout (Fig. 70).[170] This native Andean understanding of the struggle contrasts sharply with European accounts of the siege: Europeans recalled that Mary intervened to extinguish fires in Cuzco's center. But native lore understood the eclipse of pre-contact Inca power in terms more proper to Andean cultural rhetoric: the pre-Christian Inca were vanquished by a burst of celestial light.[171] Today the word *punčaw* is "day," or "daytime" in the Quechua dialect of the Cajamarca region. The word is

70. Felipe Guaman Poma de Ayala, *El primer nueva corónica y buen gobierno* (1615/1616) (Copenhagen, Royal Danish Library, GKS 2232 4°: facsimile at http://www.kb.dk), 404v.

anomalous within Cajamarca Quechua, for its pronunciation is at variance with that local dialect's typical sound structure. As it is spoken in Quechua in the northern highlands, the word *punčaw* obeys a distinctly southern-highland phonic structure. Modern-day Cajamarquinos inherit an old linguistic importation. All evidence suggests that *punčaw* is a usage brought to their region by the Inca.[172] The word is an apt relic of Inca administration there.

CONCLUSION: FOUNT OF BEAUTY

Todos los cavellos que se le cayan por el vestido los tomauan las mugeres y los comian.

The women picked off all the stray hairs that fell onto [Atawallpa's] clothes, and they ate them.[1]

Juan Ruiz de Arce, 1543

In several dialects of southern Peruvian Quechua, beautiful things are described with a singsong vocalization. *Llyu* − *, llyu* − : the speaker's voice rolls from a liquid palatal to an open, high back vowel.[2] This patterned utterance describes aesthetically pleasing, most often bright things – shine, glint, or sparkle of any chromatic value. The sound is an instance of phonetic iconicity, an ono-matopoetic equivalent of liquid brilliance. The speaker's voice represents sparkling, flowing water; it echoes the idea of motion, making an imita-tion of swirling, curved movement. Speakers may embellish, making repeated curved gestures with the hand.[3] The voice climbs to the end of the scale, to start again at the bottom; the finger follows, tracing linear figures in space.

Then there are the objects recognized as Inca art. The works in that institu-tional archive do not speak, as they bear no writing. They do not show, for they convey few representational images. They are composed of debased metals, oddly variegated minerals, or friable organic materials. Their formal structure is repetitive, and their workmanship anonymous. Mounted in the museum space, Inca works are not upright and statuesque, but furry and lank. Their materials

are friable and quickly break down under strong artificial illumination. And so it is that Inca artworks figure as orphans in contemporary art surveys and gallery installations. They are the last works produced in the pre-Columbian Americas, and they are among the least satisfying to Western cultural values. "Deficient in imagination" wrote archaeologist Alfred Kroeber of Inca art in 1951; "psychologically intolerable" wrote art historian George Kubler a year later.[4]

Atawallpa and his retinue processed into Cajamarca on the afternoon of 16 November 1532. Complicated events followed, and conflicting histories came to be told. The pagan king threw a Christian breviary onto the pavement, it was claimed.[5] Within seven months, a room was filled with ransom gold. Decades on, one of Pizarro's adventurers would boast that he lost the Incas' golden idol of the sun during an all-night game of cards. In those same years Cuzco's Inca nobility kept what they claimed were ancestral, pre-Hispanic pictures of their old kings, full-length portraits in contrapposto like those of the Spanish monarchs.[6]

All those tales constituted "a plurality of half-understood meanings": they were so many opportunistic arguments in a rapidly sedimented colonial literature of the implausible.[7] So many of them were just ugly bluster, the means to frighten readers off certain questions and toward others. That they have done so for so long is unfortunate, for the space they carve out and occupy is that of historical memory. It is that interval which separates, though it also might unite, post-Enlightenment accounts of Andean society on the one hand, and all the enigmatic objects behind museum glass on the other.

The issue is not that the Inca imperial regime suffered a crippling defeat at Cajamarca. This historical fact is final, even if wider ramifications of its world-historic significance are not. The more productive line of inquiry gets at how, as well as what, we remember. For in those questions, we get at ways of thinking about society and self that compel alternative ways of seeing and disclose other means of knowing the world: Inca artworks stand to emerge from this discussion both more strange to our eyes, and less.

Fallen hair was not difficult to make out against the stark geometric patterns of Inca costume. Any loose filament would meander ostentatiously among the design's straight edges and right-angle compartments. The fallen strand of hair tends to coil freely when freed from the anchoring hair follicle. The colors of Inca tapestry-woven garments glow a deep matte, while a loose human hair glints with sharp, irregular luster. A fallen hair was easily seen on Atawallpa's garment.

Inca cultural power gave rise to flights of rigorous, intellectualized pattern. Its reach extended across full landscapes. Its performative dramaturgy transfigured monumental spaces, and it reimagined communities. Inca power was known, too, through its bodily intimacies. The shining curl of a stray hair, or

the fiber's sinuous resilience in the mouth: human perceptual faculties are finely attuned to those sensations. Cultivated Inca bodies recognized them as significant cultural phenomena. Those forms of Inca expression – and the Incas' concomitant practices of ingestion – are ill served by the Enlightenment's project of aesthetic exaltation. Even so, it is in those close, fleshy contexts that Inca power may have realized its greatest potential as material economy and as systematic rational order. And so the Inca logic of cultural power necessarily posed the problem: What can human perceptual experience be trusted to divulge, and what can it convincingly assert? Sensuous, theatrical, choreographed, coded: trichophagia – the Incas' eating of hair – asked just those questions.

BY THE LATE SIXTEENTH CENTURY, NATIVE ANDEANS WOULD SCARCELY REMEMber the Inca retinue's first encounter with Europeans at the complex across the valley from Cajamarca's main settlement. Cuzco's Inca nobility recalled only that Atawallpa was at a retreat several kilometers from Cajamarca when the European invaders arrived at the town.[8] Writing around 1613, Joan de Santa Cruz Pachacuti Yamqui Salcamaygua omitted the episode entirely; that native author cared little for Cajamarca or its people, describing the place as a province where "they eat their own dead."[9] Around the same time Garcilaso de la Vega also recalled the meeting. The Cuzco-born peninsular humanist turned the episode to his own literary ends: in his telling Atawallpa greeted the Europeans with an Aristotelian disquisition on kingship.[10]

Those strategic elisions and emendations lay in the future. For now, the soldier Juan Ruiz de Arce stood and watched as the Inca ate Atawallpa's hair. It is fair to say that Ruiz struggled with the memory years later. Ruiz described the scene of Atawallpa's palace above Cajamarca in 1543, eleven years after he was received there. By that date he had long since retired to his native province of Estremadura, where the spoils of the Peruvian campaign allowed him to lead the life of a propertied rural gentleman.[11] Ruiz dictated his account of the Peruvian campaign to a hired scribe – it is uncertain whether this choice was determined by illiteracy or aristocratic affectation. Throughout his account, Ruiz's deadpan Castillian diction tends to masks nuance and emotions. In this instance, though, the complexity of Ruiz's feelings is betrayed by the wider passage in which it figured. "*Atabalipa*," Ruiz dictated,

> [*Atabalipa*] *no escupia en el suelo quando gargajua o escupia poniale vna mujer la mano y en ella escupia todos los cavellos que se le cayan por el vestido los tomauan las mugeres y los comian.*

> Atawallpa ... did not spit on the ground when he cleared his throat or spat. A woman would put her hand out and he spat in it. The women picked off all the stray hairs that fell onto his clothes, and they ate them.

Atawallpa's attendants pressed inward, Ruiz's account suggests, their hands outstretched, mouths open. *Escupia . . . escupia . . . escupia*: Ruiz mouthed the word three times in two short sentences. The soldier spat, while the notary scribbled: It was a shadow play of the practice his story described. Safely ensconced in his home in Estremadura, Ruiz restaged the Inca scene in the seigneur's act of dictation; the strange memory was contained within the cultural space of early modern literary production. Or so Ruiz seems to have wished. To close the passage, the old campaigner laid down a flat declarative. *Los comian*, "they ate them." Four syllables, bitten off: Ruiz's account swallows hard, as if to have done with the matter.

Ruiz's discomfort arose in part from his own implication in the wider transit of Atawallpa's fluids. The economy of emission and ingestion extended well beyond the native king's disconcertingly intimate relation with his female retainers. According to Ruiz and other Europeans who told the episode, Atawallpa insisted over and again that Pizarro's soldiers drink with him. Women came forward bearing cups. Formal in their manner, they held goblets of maize beer out to the Spanish. The Europeans demurred at first, or so their written accounts would insist. Atawallpa was undaunted, the accounts relate, and the women pressed forward again: all narratives of the interview note the ruler's persistence in offering maize beer to the Europeans. *Importunados por él, lo aceptaron*, "urged on by Atawallpa, they accepted the beer," recalled the notary Xerez.[12] (Decades later, Inca nobles would claim that Pizarro's men refused Atawallpa's beer – that they emptied their cups onto the ground before the Inca ruler; whether or not the Spanish drank at Cajamarca, the image succinctly distilled forty years of Inca grievance with Spanish viceregal administration.[13])

The consumption of corn beer was among the most significant ritual and social acts performed by Andean leaders. The importance assigned to drinking among the Inca leadership carried forward a deep Andean tradition of ceremonial practice and sociality.[14] Patrons furnished their subordinates with drink; those who imbibed were bound to their hosts in clientage and service.[15] In bidding the Europeans to drink, Atawallpa was establishing his primacy as patron and provider. By accepting, the Europeans consented to this relationship. Ingesting Atawallpa's beer, they drank in his political dominion over them. Ruiz and his companions were hardly attentive students of Andean customs, but that order of relations was clear enough.

It was also apparent to Ruiz's eyes that Atawallpa's spit and hair were magical: if dissimilar in form and consistency, the two were alike as bearers of his essence. Ruiz was also correct to recognize that Atawallpa's bodily matter stood in indexical relation to Atawallpa himself: Atawallpa's spit and hair retained his identity even when physically separated from his body. This transfer of spirit between bodies was all the more unsettling what for its formalization

as routinized ingestion. It was him – his presence – there in the palm of the female's hand, in her mouth. Ruiz was correct in these assumptions. Men drank, and so firmed up a hierarchy of masculine power. What of the women's acts of ingestion?

The manipulation of bodily waste by women suggested witchery to any European of Ruiz's era. Unruly hair signaled witches as well – the early modern European imaginary pictured witches with mops of tousled, fly-away hair.[16] Atawallpa's female attendants, however, were not witches in the early modern European sense – that is, the women around Atawallpa were not social outsiders who threatened the integrity of community and polity. No, these females were fully empowered members of the Inca state apparatus. The Inca ruler was surrounded both by wives (*mamakuna*) and by female consorts ("chosen women," *aqllakuna*), the latter of whom cycled through his presence on a fixed calendar.[17] We know these women acted as mothers and wives to the *Sapa Inka*, carrying out symbolically charged duties of domesticity, princi-pally weaving and food preparation and -service. We may presume that at least some of them not only tended the Inca ruler, but slept with him as well, their offspring populating the extended kin groups that made up the Inca leader-ship. (A daughter of Atawallpa by a secondary female in his retinue would be given by the Inca king to Francisco Pizarro.[18]) The reproductive potency of the Inca ruler was another commonplace, in fact a prerequisite of acceding to the status of *Sapa Inka*. A similar set of assumptions concerning biological fertility, sexual intercourse, and political authority is documented in ceramics produced earlier among the Moche of Perú's northern Peruvian coast: these sexually explicit ceramics probably record an important aspect of palace life, the sanctioned congress of Andean rulers with their female attendants. There are so many of these vessels from the Moche civilization – so great a number as to suggest the routinization of the practice as a fixture of Andean royal life.

In an examination of those objects, Mary Weismantel points out that tra-ditional Andean peoples subscribe to the reproductive ideology of "seminal nurturance."[19] According to this understanding biological reproduction takes place not in a single performance of insemination, but through multiple, accu-mulative acts: the fetus grows and matures as it receives greater quantities of life-giving semen. Human reproduction is less the result of a single biologi-cal interaction than an accretive process that takes place over the months of gestation. Food, semen, and other life-giving substances – water, song, fra-grance – are ingested or otherwise incorporated into the mother's body during the pregnancy. Fluids bearing bodily fat and energy collect at the center of the body, feeding and sustaining the infant. These fluids bear heat and energy, as well as fatty, aqueous nourishment. The fetus grows larger and stronger as it is brought to term. Indeed, little distinction is drawn between the female

reproductive tract and the female body's heart and digestive organs. The under-
standing of female physiology is dominated by the term *sonqo*, or heart. Found
in the abdominal cavity, the *sonqo* is a vital mass that is considered the seat of
female vitality and energy (a domain often described with the Quechua term
lloq'e).[20] Infants stand in close relationship to the *sonqo*: they are conceptual
near-equivalents, such that effigies of infants employed in ritual practices –
"bread babies" – may be specifically identified by the term *sonqo*.

Andean peoples recognized the hair as a locus of spiritual power. The impor-
tance of hair is evident even in the earliest Andean representations of supernat-
ural beings. Visual images in the Chavín style depict the hair of supernatural
beings as the entwined bodies of serpents. In the Amazonian lowlands, the
head was understood as the seat of human power and vitality; these assumptions
contributed to that region's rich traditions of head and scalp taking. Almost
uniformly, Amazonians identified the head with male identity, sexuality, and
power. Hair was identified with trophy heads' vitality, and their capacity to
think and act.[21] Among later peoples, prestigious woven goods might include
passages of woven human hair; and when human hair was used, it was spun
and plied in the reverse direction from ordinary wools and cottons. (That is,
human hair was s-spun and z-plied, as opposed to the otherwise near-universal
pattern of z-spun and s-plied).[22]

Heads and head hair were central to constructions of authority among the
pre-contact Inca leadership. The Incas' descendants also identify heads with
masculine power. The head is understood as the male's seat of memory and
intelligence; soul-spirit is concentrated in the head as a seed-substance.[23] The
pre-contact Inca leadership observed elaborate protocols of hair grooming and
curation. The Inca decapitated their enemies, keeping those heads as trophies.[24]
The men of the Inca nobility wore a distinctive haircut: visual images produced
in the colonial period depict it as an abrupt crop, short all around with straight
bangs at the forehead. The right to wear the hair this way was earned by
privilege of birth, right of age, and ritual ordeal: adolescent males initiated to
adulthood submitted to ritual tonsure. Inca armies on campaign brought along
barbers who tended soldiers' hair.[25]

Hair was also an important component of Inca reliquary practices. Hairs and
other bodily materials were incorporated into effigies that shared a common
identity with the royal tissue donor. Many of the Incas' sacred effigies – the
"brothers" (*wawki/guauhqui*) – consisted of extruded bodily matter: hair, nail
clippings, and dead skin.[26] These packages were portable body relics that the
Inca understood to embody the spiritual being of the personage whose bodily
material they contained. They may be related in turn to the reverence accorded
mummified remains of rulers among the Inca and many other Andean leader-
ships; royal mummies were living beings, the vital pith of the once-fleshy ruler.
Even decades after the conquest, the family of Christianized Inca noble Paullu

Inca gathered his hair and nails to create an effigy, which "although he died a Christian . . . was venerated just as much as any of the bodies of their other Inca kings."[27] These mummies were an aspect of the ruler's sacred personhood: undying, they resided in palaces, kept their household, and most important, also retained rights to their land, property, and tribute labor. The physical remains of Inca rulers were also incorporated into the most prestigious effigy, the *Punchao*, or morning sun. Spanish administrators who saw this figure describe it as human male figure about the size of a small child. In it chest was a cavity that held the collected bodily tissue of individual Inca rulers. The bodies of Inca rulers were made consubstantial with the physical embodiment of the solar deity. The practice reaffirmed the shared identity of Inca rulers with the sun. It also mirrored the reproductive labor of the females who attended the Inca ruler. Their abdomens, too, sheltered the physical essence of the divine ruler; and from this diligent curation, they also reproduced his being.

Among the Inca leadership, as in all Andean cultural and natural environments, the defining logic of biology and cosmology was hydrological. The principle is aptly illustrated by the ancestral Tiwanaku and Wari compositions, where streaming forms flow from the central being's face (**see Figs. 24 and 52**). Light, color, and water: rendered as iconographic devices, these "streamers" all are alike as luminous manifestations of the central figure's centrifugal spiritual energy. The body acts of emission and ingestion Ruiz saw and participated in constituted one circuit within the much more circuitous flow of energy through Inca state and cosmos. The slough of Atawallpa's body was akin to the brewer's spittle in maize slurry, the grain kernel in freshly split sod, or the trickle of water over dry seedbed: not waste, but seed. Atawallpa's numen was incorporated into the bodies of his attendants, and thus into the wider corpus of the polity he ruled. The individual act of ingestion was absolved of its solipsism, denied any status as irreducible or singular. Instead, it became the means for incorporation into higher orders of comprehension.[28] As expectorated fluid and stray hairs were metonymic fragments of Atawallpa's numen, so his servants' bodies were proxies for the wider human society constituted by Atawallpa's human subjects.

Atawallpa's women did not eat alone: they ate for all Inca mouths, and their bodies ingested for all Inca lands. Atawallpa's female servants demonstrated the Inca ideology of ecological interconnection by bending the stream of vitality back on itself. They made Atawallpa's radiant energies cyclical, and by so doing they transformed them. Centrifugal emission was met by centripetal ministration. The raw sacral dynamism that flowed from Atawallpa was captured and incorporated into the order of sociality. Universal energies catalyzed diligent human society. And that social practice fed back to universal energy once again. The Inca ruler shed, and his servants ate: the excretory was made alimentary.

The Inca recognized the discursiveness of sex and power in these practices, though also pleasure and beauty. By custom, Inca rulers periodically retired to rural estates and "pleasant places" (*moyas*) for rest and comfort. These rural installations commonly included ponds that served as reservoirs and the cultivation of fish and aquatic reeds, and as reflecting pools.[29] Atawallpa's complex above Cajamarca was fitted with elaborate waterworks also. One of the most important was at the Europeans' feet. Ruiz described it thus:

> *en el patio estaua hecho vn estanque en el qual estanque entrauan dos caños de agua vno caliente otro frio estos dos caños salian de dos Fuentes, y estas dos Fuentes etauan juntas en quel estanque se lauauan el y sus mugeres.*

> In the patio they had made a pool fed by two water pipes, hot and cold, these two pipes came from two sources, such that they met in the tank where he bathed with his women.[30]

Similarly, Pedro Pizarro recalled

> *en un estanque grande que tenían hecho, muy labrado de cantería, y al estanque benían dos caños de agua: uno caliente y otro frío, y allí se templaua la una con la otra, para quando el señor se quería bañar y sus mujeres, que otra persona no osaua entrar en él so pena de la uida.*

> In a large tank they had constructed with very well lain masonry; two water pipes led to the tank, one hot and the other cold, so the temperature could be adjusted for when the lord wished to bathe with his women, though no one else could enter that pool on pain of death.[31]

Not that Ruiz or Pedro Pizarro dwelt on the detail of Atawallpa's bath: in both accounts, the eroticized warm-water encounter was fleeting and allusive, a suggestive aside that summarized the larger tensions of the visit to Atawallpa's complex. The anecdote intended to titillate, as it did in Ruiz's mind in 1543: it braided themes of sexuality, physical danger, geotemporal distance, and the culturally alien.

Among the Inca leadership, moving waters – springs and rivers – were identified with the realm of the sensuous and the sensual. They were mellifluous: the water of rivers and springs "sang" and "spoke."[32] More than one important river in the Andean world was known as "the speaker" (Rimac and Apurimac). Springs were very often associated with images of beautiful, mobile light: *Choquepuquio*, "Golden-Radiant Spring," and *Pillcopuquio*, "Hummingbird Spring" are two common names in the Quechua toponymy of springs. The *viroypaqcha*, "fount of fat/beauty" was a fixture of Inca irrigation networks; these basins generally occurred near the head of Inca canal systems.[33] Atawallpa's bath was such a fount: the water that flowed from it bore away his fructifying, fatty essence. That numen fed Cajamarca's fields and settlements, just as it did his female retainers' bodies.

Rivers and springs were also explicitly identified with sexuality and desire. They were home to beautiful and alluring supernatural beings. The early-seventeenth-century Huarochirí manuscript cited the temptations of female water spirits.[34] Around the same time Guaman Poma depicted an Inca ritual in which male youths sat on a local mountaintop and played panpipes for the female river spirits of the Huatanay River valley (Fig. 71).[35] The poetics of sexual desire govern Guaman Poma's image young men sit on an elevated peak, addressing their music to the female spirits below, who are rendered with the European iconographic signifiers of sirens and witches.[36]

The sexualized, generative potential of rivers was especially strong at those points where rivers and streams joined. Called *tinku* – a Quechua term also used for social meetings and congress – these sections of the stream were identified with gender and communal complementarity and with the fruitfulness of sexual congress.[37] The waters where streams joined formed "lion's tail" (*pumap chupan*), which waved back and forth in sexual arousal. The banks along these sections of river were considered especially generative farmland. The Inca leadership recognized the district of Cuzco where the Tullumayo met the Saphi River by this name; there at the Lion's Tail the Inca held rituals of field opening and planting to inaugurate the yearly agricultural cycle. The joining of rivers had important sacral connotations: the settlement of Cuzco itself was built around a temple founded at a conjoining of streams, as were other important Inca shrines and oracles.[38]

Here as in so many cases, Inca ideology hewed to ancestral precedent. The Tiwanaku and Wari visual traditions privileged the imagery of sacred mountain lakes. The Tiwanaku gave special prominence to lakes sheltered within or among sacred mountains. The iconographic motif of the mountain lake is an important component of Tiwanaku visual compositions. Monumental architectural assemblages at the Tiwanaku site appear to have been built on the model of the sacred mountain and the lake: the Akapana pyramid supported a raised reservoir the fed an elaborate system of drainage canals. The Tiwanaku and Wari visual iconography also identified lakes as eyes. This association is confirmed by more recent linguistic practice: in some traditional Quechua-speaking communities, mountain lakes may be identified as "eyes" (*ñawi*).[39] Tiwanaku iconography further identifies eyes as birds – in the common "bird-eye" motif, by which eyes are rendered as avian bodies (**see Figs. 24 and 52**). This usage is echoed in Quechua language, *phichiw/ppichiu*, identified in a Spanish-Quechua lexicon of 1608 as *todo pajaro y la niña del ojo,* "all birds and the pupil of the eye."[40] This cultural imaginary equated natural fecundity with the visible gleam of feathers and the glistening orifice of the eye-socket.

In traditional Andean thought and lore today, the confluence of water and light produces a quality known as *sami*. Rainbows – light, water, and color – are instances of sami; they are among the most propitious and beautiful phenomena

71. Felipe Guaman Poma de Ayala, *El primer nueva corónica y buen gobierno* (1615/1616) (Copenhagen, Royal Danish Library, GKS 2232 4°: facsimile at http://www.kb.dk), 318v.

encountered in nature.[41] So also are streams and rivers, natural features more common than rainbows though no less potent. Anthropologist Catherine Allen noted of the Quechua speakers of Isluga, Perú: "In general, the shining of reflected light is felt to be creative, amplifying the realms of possibility," she

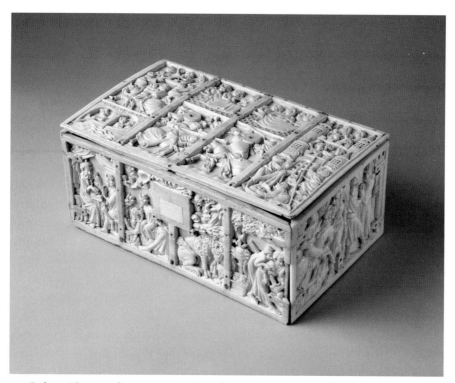

72. Casket with scenes from romances. Paris, fourteenth century. Ivory. Overall: 10.9 × 25.3 × 15.9 cm. Top: 15 × 25.1 × 0.8 cm. The Metropolitan Museum of Art, Gift of J. Pierpont Morgan, 1917 (17.190.173ab). Image © The Metropolitan Museum of Art.

writes, continuing, "the sun is said to 'dance'; stream water is thought to have powerful medicinal qualities at the moment the sun's light first strikes it."[42] *Sami* works across the senses. It describes sweet tastes and gratifying visual appearances, for instance. It operates within an expansive semantic domain of beauty, fertility, and wealth.[43] *Sami* also identifies favorable outcomes as well as aesthetically pleasing things: It may indicate good fortune, though also bounty and happiness in general. It is most often translated as "good luck."

And so the European soldiers were received into the charged spaces of Atawallpa's fine courtyard. Since the mid-fifteenth century, Europe's princes had maintained elegant country villas and gardens dedicated to the cultivation of refined manners and the arts. Garcilaso de la Vega wrote of the soldier Pedro de Alvarado's visit to the retreat of Aranjuez in order to kiss Charles V's hand; Alvarado was received in one of the garden's grand alleys, Garcilaso wrote, and there the monarch praised Alvarado's fine self-possession (*el buen aire que Don Pedro llevaba*).[44]

Casa de plazer – "pleasure house" – was the expression Ruiz used to describe the context in which Atawallpa received him and his companions.[45] The phrase was not Ruiz's alone; it was widely employed among early Spanish soldiers and settlers in Andean South America to refer to native residences. The usage was

also current in the more elevated literary production of the Iberian Peninsula and Europe: in those literary contexts *casa de plazer* referred to palaces suited to the pursuits of courtly love and sensual pleasure. In *Don Quixote* (1605) Cervantes includes the phrase in a provincial duchess's suggestive invitation to Sancho Panza: "have your master [Quixote] to come serve me . . . in a pleasure house (*casa de plazer*) the Duke and I possess hereabouts."[46]

To Europe's intellectuals, and to less educated men such as Ruiz de Arce, a *casa de plazer* was a country retreat, a rural place of comfort and pleasure: though no less than this, it was a space that harbored, even beckoned transgressive impulses. *Plazer*, pleasure, invoked the erotics of piqued desires and lowered inhibitions. Even so, a *casa de plazer* was by no means a place of routinized sexual commerce and tangible creatural satisfactions. It was instead a space of imaginative suggestion. *Plazer*, so Ruiz and other early modern Europeans understood, betokened leading thoughts no less than pleasured bodies. There was no knowledge, no knowing, in a *casa de plazer*; only an invitation to knowingness. The females' ingestion of stray hair was at home in this space of leading questions.

Courtly pleasure was then a stock motif in European visual imaginary as well. Back in Iberia, scenes of delight appeared on the walls of manor houses, on elegant sumptuary items, and in contemporary print culture (Fig. 72).[47] These artworks boasted scenes of mixed company, food and drink, basins of warm water. Chivalric, humanist, alchemical – in whatever guise, these compositions were flat, busy, and utterly inaccessible. The pattern was read into Atawallpa's courtyard easily enough – it was a place at once sensuously enhanced and sensually charged. Sexual libertinism was useful shorthand, for it allowed Ruiz to signal the strangeness he perceived in the space. The Iberian soldier could find no better words, though the phrase he used did acknowledge a prevailing irony: the place offered little pleasure to the visiting Spanish soldiers.

NOTES

INTRODUCTION

1. Since the nineteenth century, the episode at Cajamarca is most often framed according the narrative of Western expansion and the emergence of hegemonic European modes and exemplars of subjectivity; instances of that vast literature include W. H. Prescott, *History of the Conquest of Peru: With a Preliminary View of the Civilization of the Incas*, 2 vols. (Boston: Philips, Sampson, 1855); Clements R. Markham, *Reports on the Discovery of Peru*, vol. I (London: Hakluyt Society, 1872); Rómulo Cúneo-Vidal, *Vida del conquistador del Perú, don Francisco Pizarro, y de sus hermanos Hernando, Juan y Gonzalo Pizarro y Francisco Martín de Alcántara* (Barcelona: Maucci, 1925); Raúl Porras Barrenechea, *Pizarro* (Lima: Editorial Pizarro, 1978); Stuart Sterling, *The Last Conquistador: Mansio Serra de Leguizamón and the Conquest of the Incas* (Phoenix Mill, England: Sutton Publishing, 1999); Hugh Thomas, *Who's Who of the Conquistadors* (London: Cassell and Co., 2000). Consequential scholarly examinations of the meeting at Cajamarca in English include John Hemming, *The Conquest of the Incas* (New York: Harcourt, 1970), 23–70; and Jared Diamond, *Guns, Germs and Steel: The Fates of Human Societies* (New York: Norton, 1997), "Collision at Cajamarca," 67–82. Recent revisionist scholarship that privileges the ambush of Atawallpa includes Sabine MacCormack, "Atahualpa and the Book," *Dispositio* XIV; Patricia Seed, "'Failing to Marvel': Atahualpa's Encounter with the Word," *Latin American Research Review* 26 (1991): 7–32; Tom Cummins, "'Let Me See! Reading is for them' Colonial Andean Images and Objects 'como es Costumbre tener los Caciques Señores,'" *Native Traditions in the Postconquest World*, ed. Elizabeth Boone and Tom Cummins (Washington, DC: Dumbarton Oaks, 1998), 91–

148; Gonzalo Lamana, "Beyond Exotization and Likeness: Alterity and the Production of Sense in a Colonial Encounter," in *Comparative Studies in Society and History* 47:1 (2005): 32–33; Lamana, *Domination without Dominance: Inca-Spanish Encounters in Early Colonial Peru* (Durham, NC: Duke University Press, 2008). My analysis of the episode at Cajamarca is indebted to recent critiques of coloniality and subalternity offered by, inter alia, Edward Said, *Beginnings: Intention and Method* (New York: Columbia University Press, 1976); Michel de Certeau, *Heterologies: Discourse on the Other*, trans. Brian Massumi (Minneapolis: University of Minnesota Press, 1986); Peter Hulme, *Colonial Encounters* (New York: Methuen, 1986); Clendinnen, *Ambivalent Conquests: Maya and Spaniards in Yucatán, 1517–1570* (New York: Cambridge University Press, 1987); Walter Mignolo, "Afterword: From Colonial Discourse to Colonial Semiosis," *Dispositio* XIV: 36–38 (1989): 333–37; José Rabasa, "Columbus and the New Scriptural Economy of the Renaissance," *Dispositio* XIV: 36–38 (1989): 271–301; Dipesh Chakrabarty, *Provincializing Europe: Postcolonial Thought and Historical Difference* (Princeton. NJ: Princeton University Press, 2000); J. P. Rubies, "Travel Writing as a Genre: Facts, Fictions and the Invention of a Scientific Discourse in Early Modern Europe," *Journeys* 1 (2000): 5–33; Gustavo Vedesio, "Forgotten Territorialities: The Materiality of Indigenous Pasts," *Nepantla: Views from South* 2:1 (2001): 85–114; Rolena Adorno, "Sur y Norte: El Diálogo crítico literario latinoamericanista en la segunda mitad del siglo veinte," *Hofstra Hispanic Review* 1:1 (2005): 5–14.

2. Here my thinking follows from Christian Metz's use of the phrase "scopic regime" in *The Imaginary Signifier* (1975; Bloomington:

Indiana University Press, 1982); Martin Jay, "Scopic Regimes of Modernity," in *Vision and Visuality*, ed. Hal Foster (Seattle: Bay Press, 1988), 3–28; Alfred Gell, "Vogel's Net: Traps as Artworks and Artworks as Traps," *Journal of Material Culture* 1:1 (1996): 15–38; Whitney Davis, *A General Theory of Visual Culture* (Princeton, NJ: Princeton University Press, 2011), 277–321. My thinking also owes a debt to Michael Baxandall's formulation of "visual discrimination" and "demotic visual skills," in *The Limewood Sculptors of Renaissance Germany* (New Haven, CT: Yale University Press, 1980); and to Marshall Sahlins, "Colors and Cultures," *Semiotica* 16 (1976): 1–22.

3. Joachim Schäpers, "Francisco Pizarros Marsch von San Miguel nach Cajamarca," *Ibero-Amerikanisches Archiv Neue Folge* 9:2 (1983): 241–51; Lamana, "Beyond Exotization and Likeness," 4–39.

4. *Al derredor de aquella casa a cada parte estaua cubierto de toldos blancos.* Cristóbal de Mena, in Alexander Pogo, "The Anonymous *La Conquista Del Peru* [Seville, April 1534] and the *Libro Vltimo Del Svmmario Delle Indie Occidentali* [Venice, October 1534]," *Proceedings of the American Academy of Arts and Sciences* 64:8 (1930), 233.

5. Pedro de Cieza de León, *El Descubrimiento y Conquista del Perú* (1553; Madrid, 1984), Chapter 44, 152–54.

6. On the *Requerimiento*, see Patricia Seed, "'Failing to Marvel,'" and Seed, *Ceremonies of Possession: Europe's Conquest of the New World, 1492–1640* (Cambridge: Cambridge University Press, 1995), 69–99.

7. On fighting around Cusco in 1536/7, see Thomas Flickema, "The Siege of Cuzco," *Revista de Historia de América* 92 (1981): 17–47.

8. *Vestidos de una librea de colores á manera de escaques estos venian quitando las pajas del suelo y barriendo el camino:* Xerez, *Verdadera Relación*, 89. *De librea como de juego de axedrez estos venian delante limpiando el camino:* Ruiz de Arce, *La Memoria*, 85. *A manera de ajadrez, que venían delante, limpiando las piedras y pajas del camino:* Trujillo, *Relación*, 133.

9. Pedro Pizarro, *Relación*, 181.

10. For recent archaeological assessments of the Inca state's origins and emergence, see Terence N. D'Altroy, *The Incas* (Oxford: Blackwell, 2002); R. Alan Covey, "A Processual Study of Inca State Formation," *Journal of Anthropological Archaeology* 22 (2003): 333–57; Covey, *How the Incas Built their Heartland: State Formation and the Innovation of Imperial Strategies in the Sacred Valley, Peru* (Ann Arbor: University of Michigan Press, 2006); Covey, "The Inca Empire," in *Handbook of South American Archaeology*, ed. Helaine Silverman and William H. Isbell (New York: Springer, 2008), 809–30.

11. Sabine Dedenbach-Salazar Sáenz, *Inka Pachaq Llamanpa Willaynin: Uso y Crianza de los Camélidos en la Epoca Incaica. Estudio Lingüístico y Etnohistórico basado en las Fuentes Lexicográficas y Textuale del Primer Siglo después de la Conquista* BAS 16 (Bonn: Bonner Amerikanische Studien 1990), 330.

12. On questions of the language of the pre-contact Inca, I generally follow the lead of Rodolfo Cerrón-Palomino, "Unraveling the Enigma of the 'Particular Language' of the Incas," in *Archaeology and Language in the Andes: A Cross-Disciplinary Exploration of History*, ed. Paul Heggarty and David Beresford-Jones (Oxford: British Academy/Oxford University Press, 2012), 265–94; see also Cerrón-Palomino, "El aimara como lengua oficial de los Incas," *Boletín de Arqueología Pontífica Universidad Católica del Perú* 8 (2004): 9–21.

13. For a brief introductions to the Inca dynastic struggle, see Franklin Pease G. Y., *Los Ultimos Incas del Cusco* (Lima: Taller Gráfica Villanueva, 1972); John Hemming, *The Conquest of the Incas* (New York: Harcourt, 1970); María Rostworowski de Diez Canseco, *History of the Inca Realm*, trans. Harry B. Iceland (Cambridge: Cambridge University Press, 1999); Terence D'Altroy, *The Incas* (Oxford: Blackwell, 2002), 76–83.

14. Pizarro's faction would claim that Atawallpa's subordinates held Waskhar and his close relatives in captivity at the time of Atawallpa's own capture at Cajamarca, and that during his own imprisonment Atawallpa would secretly order the execution of Waskhar and his circle: see, for instance, the extended account of Pedro Pizarro, in his *Relación*, 45–54. Those assertions would be repeated frequently in histories later written by Spanish authors: see D'Altroy, *The Incas*, 83.

15. On the question of Atawallpa's execution and its history of the colonial era, see Mark Thurner, "Peruvian Genealogies of History and Nation," in *After Spanish Rule: Postcolonial Predicaments of the Americas*, ed. Mark Thurner

and Andrés Guerrero (Durham, NC: Duke University Press, 2003), 141–57.

16. See Mariusz S. Ziólkowski, *La Guerra de los Wawqis: Los Objectivos y los mechanismos de la rivaldad dentro de la élite Inka, siglos XV y XVI* (Quito: Biblioteca Abya-Yala, 1997), 285–386.

17. George Kubler, "The Behavior of Atahualpa, 1531–33," *The Hispanic American Historical Review* 25:4 (1945), 413.

18. Most recently, in Marshall Sahlins, "The Stranger-King or, Elementary Forms of the Politics of Life," *Indonesia and the Malay World* 36:105 (2008): 177–99. See also Sahlins, *Culture and Practical Reason* (Chicago: University of Chicago Press, 1976); M. H. Fried, *The Evolution of Political Society* (New York: Random House, 1967).

19. Richard P. Schaedel, "Early State of the Incas," in *The Early State*, ed. Henri J. M. Claesson and Peter Skalník (The Hague: Mouton, 1978).

20. Frank Salomon, "Vertical politics on the Inca frontier," in *Anthropological History of Andean Polities*, ed. John. V. Murra, Nathan Wachtel, and Jacques Revel (Cambridge: Cambridge University Press, 1986), 89–118.

21. On Inca structures of social identity and rank, history, and mythology, see R. Tom Zuidema, *Inca Civilization in Cuzco* (1986), trans. Jean-Jacques Decoster (Austin: University of Texas Press, 2000).

22. Schaedel, "Early State," 14–15.

23. Raymond Williams, *Keywords: A Vocabulary of Culture and Society* (New York: Oxford University Press, 1976), 76–82.

24. On the documented members of the Pizarro expedition, see the important work by James Lockhart, *The Men of Cajamarca: A Social and Biographical Study of the First Conquerors of Peru* (Austin: University of Texas Press, 1972).

25. Hernando Pizarro – half-brother to Francisco Pizarro, a man of aristocratic airs and pretention – offered a short, self-serving account to the officials of the Real Audiencia of Santo Domingo, Panamá in 1533: Hernando Pizarro, "A los Magníficos señores Oidores de la Audiencia Real de Su Majestad, que residen en la Ciudad de Santo Domingo," in J. Amador de los Ríos, ed., *Historia general y natural de las Indias de Gonzalo Fernández de Oviedo y Valdés* [1539–48] (Madrid 1851; repr. J. Pérez de Tudela Bueso, Madrid 1959), Book 46, Chapter 16, 84–90. A detailed account complied by Pizarro's professional notary

Francisco de Xerez was first published in 1534: Xerez, *Verdadera Relación de la Conquista del Perú* [1534] (Madrid: Tip. de J. C. Garcia, 1891). Cristóbal de Mena's memoir ran through several printed editions in Europe after 1534 (Alexander Pogo, "The Anonymous *La Conquista Del Peru* [Seville, April 1534]"). Juan Ruiz de Arce's record of 1543 was dictated for the horseman's heirs: Juan Ruiz de Arce, *La Memoria*. Diego de Trujillo produced a short report – one unafraid to expose the questionable though inspiring arrogance of the Pizarro brothers in the field (Diego de Trujillo, *Relación del Descubrimiento del Reino del Perú* [1571], in *Tres testigos de la conquista*, ed. Conde de Carnilleros [3rd ed., Madrid, 1954]). Pedro Pizarro's account of 1571 was more extended; if loyal to his kinsmen, his record was also among the most lucid of those produced among the members of Francisco Pizarro's company (Pedro Pizarro, *Relación*). Other participant-accounts of the Peruvian campaign continue to emerge: Gaspar de Marquina's account of 1533 (in Wulf Oesterreicher, "'Uno de Cajamarca,' Gaspar de Marquina schreibt an seinen Vater [20 Juli 1533]," in Sybille Große and Axel Schönberger, eds., *Dulce et decorum est philologiam colere: Festschrift für Dietrich Briesemeister zu seinem 65. Geburtstag* [Berlin: DEE, 1999], 37–81) and Pedro Cataño's record of 1543 (cited in Gonzálo Lamana, "Beyond Exotization and Likeness: Alterity and the Production of Sense in a Colonial Encounter," in *Comparative Studies in Society and History* 47:1 [2005]: 32–33).

26. Carlo Ginzburg, *The Cheese and the Worms: The Cosmos of a Sixteenth-Century Miller*, trans. John Tedeschi and Anne Tedeschi (Baltimore: Johns Hopkins Press, 1980). See also the commentary of Stephanie Jed, "The Scene of Tyranny: Humanism and the History of Writing," in *The Violence of Representation* (London: Routledge, 1989); Jed, "Relations of Prose: Knights Errant in the Archives of Early Modern Italy," in *The Project of Prose in the Early Modern West*, eds. Elizabeth Fowler and Roland Greene (Cambridge: Cambridge University Press, 1997).

27. On the subsequent reception of the early accounts, see the incisive commentary by Cristián A. Roa-de-la-Carrera, *Histories of Infamy: Francisco López de Gómara and the Ethics of Spanish Imperialism*, trans. Scott Sessions

(Boulder: University of Colorado Press, 2005), 187–238.

28. These sources are described as "eyewitness accounts," or "chronicles" in the Anglo-American historiographic tradition, e.g., John H. Rowe, "Inca Culture at the Time of the Spanish Conquest," *Handbook of South American Indians*, Vol. 2, ed. Julian H. Steward, Bureau of American Ethnology Bulletin 143, Vol. 2 (Washington, DC: Smithsonian Institution, 1946); Terence D'Altroy, *The Incas* (Oxford: Blackwell, 2002), 11; Franklin Pease G. Y., "Chronicles of the Andes in the Sixteenth and Seventeenth Centuries," in *Guide to Documentary Sources for Andean Studies, 1530–1900*, ed. Joanne Pillsbury (Norman: University of Oklahoma Press, 2009), 11–22.

29. Lockhart comments on Diego Trujillo's narrative, in Lockhart, *The Men of Cajamarca*, 364. If not works of humanist artifice, the accounts of sixteenth-century Iberian soldiers in the New World are not without poetic structure: see, for instance, Yanira Angulo-Cano, "The Modern Autobiographical 'I' in Bernal Díaz del Castillo," *Modern Language Notes* 125:2 (2010): 287–304. See also Wulf Oesterreicher, "Kein sprachlicher Alltag – der Konquistador Alonso Borregán schreibt eine Chronik," in *Sprachlicher Alltag – Linguistik, Rhetorik, Literatur: Festschrift für Wolf-Dieter Stempel*, ed. Annette Sabban and Christian Schmitt (Tübingen: Niemeyer, 1994), 379–418; Oesterreicher, "'Uno de Cajamarca,' Gaspar de Marquina schreibt an seinen Vater (20 Juli 1533)," in Dulce et decorum est philologiam colere: *Festschrift für Dietrich Briesemeister zu seinem 65. Geburtstag*, ed. Sybille Große and Axel Schönberger (Berlin: DEE, 1999), 37–81; Eva Stoll, "Estudio introductorio," in *La Memoria de Juan Ruiz de Arce (1543): Conquista del Perú, saberes secretos de caballería y defense del mayorazgo*, ed. Eva Stoll (Frankfurt and Madrid: Vervuert Verlag/Iberoamericana, 2002), 11–47; Lamana, *Domination without Dominance*.

30. Holger Cahill, "American Sources of Modern Art," in *American Sources of Modern Art* (New York: Museum of Modern Art, 1933), 5–21; Julie Jones, *Art of Empire: The Inca of Peru* (New York: Museum of Primitive Art, 1964); César Paternosto, *The Stone and the Thread: Andean Roots of Abstract Art*, trans. Esther Allen (Austin: University of Texas Press: 1996); Paternosto, ed., *Abstraction: The Amerindian Paradigm*

(Brussels: Palais des Beaux-Arts de Bruxelles/Institut Valencià d'Art Modern, 2001). See also Esther Pasztory, *Inka Cubism: Reflections on Andean Art* (Columbia University web publication, 2010): http://www.columbia.edu/~ep9/Inka-Cubism.pdf.

31. Body and the senses: Constance Classen, "Sweet Colors, Fragrant Songs: Sensory Models of the Andes and the Amazon," *American Ethnologist* 17 (1990): 722–35, and *Inca Cosmology and the Human Body* (Salt Lake City: University of Utah Press, 1997). Religion: Sabine MacCormack, *Religion in the Andes: Vision and Imagination in Early Colonial Peru* (Princeton, NJ: Princeton University Press, 1991).

32. Most important in this regard is Rebecca R. Stone's important study of vision and shamanic practice in the pre-contact art of Central and South America: Stone, *The Jaguar Within: Shamanic Trance in Ancient Central and South American Art* (Austin: University of Texas Press, 2011). Significant in this context as well are archaeological perspectives on sensory experience in the Andes, including Jerry D. Moore, *Architecture and Power in the Ancient Andes: The Archaeology of Public Buildings* (Cambridge: Cambridge University Press, 1996); Dennis Ogburn, "Dynamic Display, Propaganda, and the Reinforcement of Provincial Power in the Inca Empire," *Archaeological Papers of the American Anthropological Association* 14 (2005): 225–239; George F. Lau, "The Work of Surfaces: Object Worlds and Techniques of Enhancement in the ancient Andes," *Journal of Material Culture* 15: 3 (2010): 259–86.

33. Louis Baudin, *A Socialist Empire: The Incas of Peru* (Paris, 1928), trans. Katherine Woods (Princeton: D. van Nostrand, 1961), 115. Baudin's arguments were revisited and enriched in the work of R. Karsten, *A Totalitarian State of the Past: The Civilization of the Inca Empire in Ancient Peru: Commentationes Humanarum Litterarum* XVI:1 (Helsingfors: Societas Scientiarum Fennica, 1949).

34. George Kubler, *The Shape of Time: Remarks on the History of Things* (New Haven: Yale University Press, 1962), 7–8.

35. J. Uriel Garcia, "El Cuzco Incaico," in *Cuzco: Capital arqueológico de Sud America* (Buenos Aires: Editorial Pampa, 1951), 8: "Stone is the concretization of history, it triumphantly withstands the inclemencies of the destroyer's era, it

continues to watch over the subtle secret of the Indian's spirit, it is the synthesis of the complicated Inca lifeway, it is the summary of the centuries, the face of its infinite course."

36. Black box: Norman Hammond, "Inside the Black Box: Reconstructing the Maya Polity," in *Classic Maya Political History: Hieroglyphic and Archaeological Evidence*, ed. T. Patrick Culbert (New York: Cambridge University Press, 1991), 253–284. "Concretization": J. Uriel Garcia, "El Cuzco Incaico," in *Cuzco: Capital arqueológico de Sud America* (Buenos Aires: Editorial Pampa, 1951), 8; "Materialization": Elizabeth DeMarrais, Luis Jaime Castillo, and Timothy Earle, "Ideology, Materialization, and Power Strategies," *Current Anthropology*, 37:1 (1996): 27–30.

37. "Decorative": John H. Rowe, *An Introduction to the Archaeology of Cuzco. Papers of the Peabody Museum of American Archaeology and Ethnology*, Vol. XXVII, no. 2, (Cambridge, MA: Peabody Museum of American Archaeology and Ethnology, Harvard University, 1944), 25; "arguably more interesting," R. T. Zuidema, *Inca Civilization in Cuzco*, trans. Jean-Jacques Decoster (Austin: University of Texas Press, 1990), 2.

38. Carolyn Dean and Dana Leibsohn, "Hybridity and Its Discontents: Considering Visual Culture in Colonial Spanish America," *Colonial Latin American Review* 12:1 (2003): 13–19.

39. This tendency in Andean studies may be understood in some senses as a discourse of sublimity inherited from nineteenth-century historical and travel accounts. On the sublime as a response to visual expression, see Mieke Bal, "Visual Essentialism and the Object of Visual Culture," *Journal of Visual Culture* 2:1 (2003): 12. Characterizations such as "decorative effect" and elsewhere, "wallpaper," also recall the skepticism of US commercial journalism for the non-figurative, non-iconographic aspects of mid-twentieth-century Modernist art: e.g., Tom Wolfe, *The Painted Word* (New York: Farrar, Straus and Giroux, 1975). "Wallpaper": Elizabeth Boone, as cited in Joanne Pillsbury, "Reading Art without Writing: Interpreting Chimú Architectural Sculpture." In *Dialogues in Art History, from Mesopotamian to Modern: Readings for a New Century* Studies in the History of Art, Vol. 74 (Washington, DC: Center for Advanced Study in the Visual Arts, 2009), 73–89.

40. Julie Jones, *Art of Empire: The Inca of Peru* (New York: Museum of Primitive Art, 1964), 42.

41. See Geoffrey Conrad, "Inca Imperialism: The Great Simplification and the Accident of Empire," in *Ideology and Pre-Columbian Civilizations*, ed. Arthur Demarest and Geoffrey Conrad (Santa Fe, NM: School of American Research, 1992), 159–174. See also Elizabeth DeMarrais, Luis Jaime Castillo, and Timothy Earle, "Ideology, Materialization, and Power Strategies," *Current Anthropology*, 37:1 (1996): 15–31, esp. 27–30. "The Inca case suggests that expansionist empires may simplify ideology into critical elements that are 'transportable' across cultural boundaries, among them representations of military power, state insignia, and massive ceremonialism."

42. Pedro Pizarro, *Relación*, 67–68.

43. Mary Louise Pratt, *Imperial Eyes: Travel Writing and Transculturation* (New York: Routledge, 1992), esp. 107–40; see also Jorge Cañizares-Esguerra, *How to Write the History of the New World: Histories, Epistemologies, and Identities in the Eighteenth-Century Atlantic World* (Stanford, CA: Stanford University Press, 2001). As Pratt first pointed out, so much Enlightenment-era investigation into Latin American natural history tended to cast early modern narrative historical writings as inherently unreliable and pit those writings against empirical evidence gathered in the field. This remains a characteristic of much anthropological archaeology, in which – despite its clear successes – linear "advances" in scientific knowledge are set against the error of early modern narrative accounts. See, for instance, R. A. Covey, "The Inca Empire," in *Handbook of South American Archaeology*, ed. Helaine Silverman and William H. Isbell (New York: Springer, 2008), 809–11.

44. David Howes, *The Sixth Sense Reader* (Oxford: Berg, 2009), 1. On multisensory experience in the Andes, see also the seminal work of Constance Classen, including "Sweet Colors, Fragrant Songs"; Classen, "Foundations for an Anthropology of the Senses," *International Social Science Journal* 153 (1997): 401–12; Classen, *Inca Cosmology and the Human Body* (Salt Lake City: University of Utah Press, 1997).

45. Archival/historical scholarship: James Lockhart, *The Men of Cajamarca: A Social and Biographical Study of the First Conquerors of Peru* (Austin: University of Texas Press, 1972).

Recent revisionist scholarship and postcolonial critique that treat the episode at Cajamarca include Sabine MacCormack, "Atahualpa and the Book," *Dispositio* XIV; Patricia Seed, "'Failing to Marvel': Atahualpa's Encounter with the Word," *Latin American Research Review* 26: (1991): 7–32; Tom Cummins, "'Let Me See! Reading is for them' Colonial Andean Images and Objects 'como es Costumbre tener los Caciques Señores,'" *Native Traditions in the Postconquest World*, ed. Elizabeth Boone and Tom Cummins (Washington, DC: Dumbarton Oaks, 1998), 91–148; Lamana, "Beyond Exotization and Likeness"; Lamana, *Domination without Dominance: Inca-Spanish Encounters in Early Colonial Peru* (Durham, NC: Duke University Press, 2008), 27–64; Peter Gose, *Invaders as Ancestors: On the Intercultural Making and Unmaking of Spanish Colonialism in the Andes* (Toronto: University of Toronto Press, 2008).

46. Homi K. Bhabha, "Of Mimicry and Man: The Ambivalence of Colonial Discourse," *October* 28 (Spring 1984): 125–33, reprinted in *The Location of Culture* (London and New York: Routledge, 1994); "the anomalous gaze of otherness" 29. On anamorphosis, see Jacques Lacan, "Of the Gaze as Objet Petit A," *The Seminar of Jacques Lacan, Book XI: The Four Fundamental Concepts of Psychoanalysis*, ed. Jacques-Alain Miller, trans. Alan Sheridan (first edition 1973; rev. ed. New York: W. W. Norton 1998), 67–119.

47. Rolena Adorno, *Guaman Poma: Writing and Resistence in Colonial Peru* (Austin: University of Texas Press, 1988), esp. 80–120. See also Mignolo, "Crossing Gazes and the Silence of the 'Indians': Theodor De Bry and Guaman Poma de Ayala," *Journal of Medieval and Early Modern Studies* 4:1 (2011): 173–223, esp. 184–96; Thomas B. F. Cummins, *Toasts with the Inca: Andean Abstraction and Colonial Images on Quero Vessels* (Ann Arbor: University of Michigan Press, 2002); Carolyn Dean and Dana Leibsohn, "Hybridity and Its Discontents: Considering Visual Culture in Colonial Spanish America," *Colonial Latin American Review* 12:1 (2003): 5–35; Stella Nair, "Localizing Sacredness, Difference, and *Yachacuscamcani* in a Colonial Andean Painting," *The Art Bulletin* 89:2 (2007): 211–38.

48. George Kubler, "On the Colonial Extinction of the Motifs of Precolumbian Art," *Studies in Ancient American and European Art: The Collected Essays of George Kubler*, ed. Thomas Reese (New Haven, CT: Yale University Press 1985), 66–74.

49. See the insightful remarks by Carolyn Dean, "The Trouble with (the Term) Art," *Art Journal* 65:2 (Summer 2006): 24–32.

50. Rodolfo Cerrón-Palomino, "Cuzco: la piedra donde se posó la lechuza. Historia de un nombre," *Revista Andina* 44 (2007), 143–74.

51. D'Altroy, *The Incas*, 325–30.

CHAPTER 1

1. Cristóbal de Mena, in Alexander Pogo, "The Anonymous *La Conquista Del Peru* [Seville, April 1534] and the *Libro Vltimo Del Svmmario Delle Indie Occidentali* [Venice, October 1534]," *Proceedings of the American Academy of Arts and Sciences* 64:8 (1930), 230.

2. Alfred Kroeber, "Great Art Styles of Ancient South America," in Kroeber, *The Nature of Culture* (Chicago: University of Chicago Press, 1952), 293 (reprinted from Sol Tax, ed., *The Civilizations of Ancient America: Selected Papers for the XXIXth International Congress of Americanists* (1951), 207–15); George Kubler, *The Art and Architecture of Ancient America: The Mexican, Maya and Andean Peoples* (New Haven, CT: Yale University Press, 1962), 311–22; Julie Jones, *Art of Empire: The Inca of Peru* (New York: Museum of Primitive Art, 1964).

3. Roger Leonardo Mamani Siñani, "Carneros de la tierra, guanaco y vicuñas: La importancia del Ganado, una visión desde las crónicas," *Serie Anales de la Reunión Annual de Etnología* 18:1 (2004), 104–05; Duccio Bonavia, *Los camélidos sudamericanos. Una introducción a su estudio* (La Paz: IFEA, UPCH, Conservación Internacional, 1996), 259.

4. *Llamas, que son los carneros de la tierra*: Bernabé Cobo, *Historia del Nuevo Mundo* (1653), in John Howland Rowe, "An Account of the Shrines of Ancient Cuzco," *Ñawpa Pacha* 17 (1979), 30.

5. Hugo D. Yacobaccio, "Social dimensions of camelid domestication in the southern Andes," *Anthropozoologica* 39:1 (2004), 245.

6. R. B. Cunnighame Graham, *The Horses of the Conquest*, ed. Robert Moorman Denhardt (Norman: University of Oklahoma Press, 1949): 18–20; short lances aimed at the face, 62. On sixteenth- and seventeenth-century riding and fighting in Spain and its American

possessions, see Benjamín Flores Hernández, "*La jineta indiana* en los textos de Juan Suárez de Peralta y Bernardo de Vargas Machuca," *Estudios Americanos* 54:2 (1997): 639–64. See also Angel Cabrera, *Caballos de América* (Editorial Sudamericana, 1945); Robert Moorman Denhardt, "The Truth about Cortés's Horses," *Hispanic American Historical Review* 17 (1937): 525–35; Denhardt, "The Equine Strategy of Cortés," *Hispanic American Historical Review* 18 (1938): 500–55.

7. Inga Clendinnen, "'Fierce and Unnatural Cruelty': Cortés and the Conquest of Mexico," *Representations* 33 (winter 1991): 65–100.

8. *Hernando de Soto se desuió y en un llano que allí hizo hacer una escaramuça a los de a cauallo, y acaso llegando los de a cauallo con la escaramuça junto a unos yndios que estauan sentados, los yndios se leuantaron de miedo.* Pedro Pizarro, *Relación*, 33.

9. *Alançealde el cauallo y antes que el cauallo caiga bolved sobre el antes que se apee porque si se apea tiene lança larga como la vuestra . . . el encontrar es para hombres de armas y no para ginetes*: Juan Ruiz de Arce, *La Memoria de Juan Ruiz de Arce (1543): Conquista del Perú, saberes secretos de caballería y defense del mayorazgo*, ed. Eva Stoll (Frankfurt and Madrid: Vervuert Verlag/Iberoamericana, 2002), 122.

10. Michel de Certeau, *The Practice of Everyday Life* (*Arts de faire* vol. I: *L'Invention du Quotidien*, 1980), trans. Steven Rendall (Berkeley and Los Angeles: University of California Press, 1984). The close identification with movement is central to the history of modernity and its affects: see, for example, Wolfgang Schivelbusch, *The Railway Journey: Trains and Travel in the Nineteenth Century*, trans. Anselm Hollo (New York: Urizen Books, 1979), and Paul Virilio, *Speed and Politics: An Essay on Dromology*, trans. Mark Polizzotti (New York: Semiotext(e), 1986).

11. The theoretical construct of the "imperial gaze" is articulated in Walter Mignolo, "Crossing Gazes and the Silence of the 'Indians': Theodor De Bry and Guaman Poma de Ayala," *Journal of Medieval and Early Modern Studies* 41, no. 1 (2011), 175–86. "Naturalized conventions" borrowed from W. J. T. Mitchell, "Imperial Landscape," in *Landscape and Power*, new ed. (Chicago: University of Chicago Press, 2002), 5. On Iberian constructions of landscape in the sixteenth-century exploration and military invasion of South America, see Heidi V. Scott, *Contested Territory: Mapping Peru in the Sixteenth*

and Seventeenth Centuries (Notre Dame: University of Notre Dame Press, 2009), esp. 17–48.

12. An initial edition was printed in Seville in 1534 – produced less than a year after the events Mena's account describes – and more editions followed in several European languages: see Alexander Pogo, "The Anonymous *La Conquista Del Peru* [Seville, April 1534]." On Mena's career, see also Lockhart, *The Men of Cajamarca*, 133–35.

13. *Mayor que ninguna en España . . . fuerzas son que entre indios no se han visto tales*: Xerez, *Verdadera Relación*, 78.

14. Mena, in Pogo, "The Anonymous *La Conquista Del Peru* [Seville, April 1534]," 233.

15. Pizarro and many of his soldiers were from the Castilian province of Estremadura, whose sere landscapes were scoured by sheep. At the time Estremadura was Spain's least developed province commercially and technically. This is to say that herds of ruminants did not possess the same cultural prestige as monumental urban architecture or vast, ordered military encampments. On the Estremaduran origins of Pizarro and many of his soldiers, see Lockhart, *The Men of Cajamarca*, 27–31, 42.

16. Ernst Robert Curtius, *European Literature and the Latin Middle Ages* (new ed. Princeton, NJ: Princeton University Press, 2013), 200–03. Curtius cites the stanza 2698 from the Cid:

> *Los montes son altos, las ramas pujan con las nuoves,*
> *E la bestias fieras que andan aderredor.*
> *Fallaron un vergel con una limpia fuont.*

17. Sebastián de Covarrubias, *Tesoro de la Lengua Castellana* (Madrid: 1611), 47–8; Covarrubias cites the antiquity of the Castilian verb *hallar*, relating its etymology to the Greek word *phalis*, "splendidus, lucidus, albus."

18. This number is an only an estimate. It is based on three main pieces of evidence. First, the size of the Inca fighting force, estimated at 80,000 men by Pizarro's own soldiers (e.g., Mena, in Pogo, "The Anonymous *La Conquista Del Peru*," 233) and recalled as 87,000 by the Inca nobility of Cuzco twenty years later (Pedro de Cieza de León, *El Descubrimiento y Conquista del Perú* [1553; Madrid, 1984], Chapter 44, 152–54). As *yanaquna* (workers indentured to the Inca state), those soldiers did not carry their own baggage; pack llamas transported their baggage. (Garcilaso de la Vega

reported that these and other specialists in the Incas' service did not bear loads on long journeys [*Commentario Real de los Incas*, Book 5, Chapter X, 260. Cited in Bonavia, *The South American Camelids*, 211].) Next, an Inca force much reduced from that which met the Europeans at Cajamarca (and a force unequipped for a long campaign, and unaccompanied by a royal entourage) abandoned a large number of animals in its retreat from the Junín basin: those animals numbered 15,000 cargo llamas, while a strategic reserve of another 100,000 was available elsewhere in the same valley (David L. Browman, "Pastoral Nomadism in the Andes," *Current Anthropology* 15:2 [1974], 189 [cites Augustín de Zarate, *Historia del descubrimiento y conquest del Perú* (1555) Biblioteca de Autories Españoles 26: 459–574 (1886), 483; see also J.E. Rivera Martínez. *Imagen de Jauja* [Huancayo: Universidad Nacional del Centro del Perú,1968], 62). Third, in the days after the defeat of the Inca army at Cajamarca, the vast abandoned military camp was, per Pizarro's notary Francisco de Xerez, "infested with animals" (*embarazan el real*), prompting Pizarro to order the animals' indiscriminate slaughter: *El Gobernador mandó que soltasen todas las ovejas, porque era mucha cuantidad y embarazaban el real, y que los cristianos matasen todos los dias cuantas hobiesen menester.* Xerez, *Verdadera Relación*, 97–98. These facts together suggest a very large number of llamas at Cajamarca, certainly in the tens and perhaps in the scores of thousands.

19. Xerez, *Verdadera Relación*, 97–98. See Note 20.

20. For a mid-twentieth-century Anglo-American perspective on Peru's traditional modes of transport, see Paul Kosok, *Transport in Peru* (London: W. Clowes and Sons, 1951). For valuable ethnographic corrections to same, see T. L. West, "Sufriendo nos Vamos: From a Subsistence to a Market Economy in an Aymara Community of Bolivia," Ph.D. dissertation, New School of Social Research, 1982. On colonial-era constructions of the Inca and the "politics of nostalgia," see Peter T. Bradley and David Cahill, *Habsburg Peru: Images, Imagination and Memory* (Liverpool: Liverpool University Press, 2000), esp. 87–144. On the polemics of indigineity and traditional culture in twentieth-century Peru, see Marisol de la Cadena, *Indigenous Mestizos: The Politics of Race and Culture in Cuzco, Peru 1919–1991* (Durham, NC: Duke University Press, 2000).

21. Alfred Kroeber noted that pastoralism is predominantly Asiatic and African economic complex: A. L. Kroeber, *Anthropology: Culture Patterns and Processes* (New York: Harcourt Brace, 1963). See Duccio Bonavia's commentary on the question "did pastoralism exist in the Andes?" in his volume *The South American Camelids: An Expanded and Corrected Edition*, trans. Javier Flores Espinoza (Los Angeles: UCLA Cotsen Institute of Archaeology, 2008), 437–42.

22. John V. Murra, "Herds and Herders in the Inca State," in *Man, Culture, and Animals*, ed. Anthony Leeds and Andrew P. Vayda (Washington, DC: American Association for the Advancement of Science, 1965), 186.

23. Alberto Regal, *Los Caminos del Inca en el Antiguo Perú* (Lima: San Martí y cía., 1936); Victor Wolfgang von Hagen, *Highway of the Sun* (New York: Duell, Sloan, and Pearce, 1955); León Strube Erdmann, *Vialidad imperial de los incas: desde Colombia hasta Chile central y sur de Mendoza (Argentina) con inclusión de sus proyecciones orientales* (Córdoba: Dirección General de Publicaciones, 1963); Hyslop, *The Inca Road System* (New York: University Press, 1984), 255. See also Joachim Schäpers, "Francisco Pizarros Marsch von San Miguel nach Cajamarca," *Ibero-Amerikanisches Archiv Neue Folge* 9:2 (1983): 241–51.

24. Hyslop, *The Inca Road System*, 255.

25. Hyslop, *The Inca Road System*, 41.

26. Alejandro Camino, Jorge Recharte, Pedro Bidegaray, "Flexibilidad calendarica en la agricultura tradicional de las vertientes orientales de los Andes," in Heather Lechtman, ed., *La Tecnología en el mundo andino*, vol. I (Mexico City: Universidad Autónoma de México, 1981), 169–94.

27. Tom Cummins, "The Felicitous Legacy of the *Lanzón*," in *Chavín: Art, Architecture, and Culture*, ed. William J. Conklin and Jeffrey Quilter (Los Angeles: Cotsen Institute of Archaeology, 2008), 279–304; see also Brian S. Bauer and Charles Stanish, *Ritual and Pilgrimage in the Ancient Andes: The Islands of the Sun and the Moon* (Austin: University of Texas Press, 2001).

28. Here my thoughts are informed by anthropology of "visibility analysis," including Tim Ingold, *Hunters, Pastoralists and Ranchers: Reindeer Economies and Their Transformations* (Cambridge: Cambridge University Press, 1980); Christopher Tilley, *A Phenomenology of*

Landscape (Oxford: BAR, 1994); R. Bradley, *The Significance of Monuments: on the Shaping of Human Experience in Neolithic and Bronze Age Europe* (London: Routledge, 1998).

29. Horacio H. Urteaga, *El fin de un imperio; obra escrita en conmemoración del 4° centenario de la muerte de Atahuallpa* (Lima: Librería e Imprenta Gil, 1933).

30. On recent archaeological investigation and conservation of this road, see Cecilia Camargo Mareovich and Wilder Javier León Ascurra, "Caminos Inca Cajamarca-Baños del Inca" (n.d.), *Qhapaq Ñan: El Gran Camino Inca*: http://www.qhapaqnan.gob.pe.

31. Hyslop, *The Inca Road System*, 59–60.

32. See the fine articles in the volume *El Dominio Inca en las quebradas altas del Loa superior: Un acercamiento al pensamiento político andino*, Special issue of *Estudios Atacameños* 18 (1999), particularly Flora Vilches V. and Mauricio Uribe R., "Grabados y pinturas del arte rupestre tardío de Caspana," *Estudios Atacameños* 18 (1999): 73–87. See also Mauricio Uribe Rodríguez, "La arqueología del Inka en Chile," *Chungará: Revista de Antropología Chilena* 15 (1999–2000): 63–97. See also J. Berenguer, Caravanas, interacción y cambio en el *desierto de Atacama* (Santiago, Chile: Sirawi Ediciones, 2004), 425–93. See also Persis Clarkson and Luis Briones, "Geoglifos, senderos y etnoarqueología de caravanas en el desierto chileno," *Boletín del Museo chileno de Arte precolombino* 8 (2001): 35–45; Luis Briones, Lautaro Núñez, and Vivien G. Standen, "Geoglyphs and Prehispanic Llama Caravan Traffic in the Atacama Desert (Northern Chile)," *Chungará: Revista de Antropología Chilena* 37:2 (2005): 195–223.

33. The Incas' caravans shuttled among the farming, mining, and administrative settlements among the southern Andean cordillera and the lower-elevation valleys to its east and west. The Incas' operation of caravans along those routes carried forward patterns of "circuit mobility" among "fixed axis settlements" of the southern Andes: see Tom D. Dillehay and L. Nuñez, "Camelids, Caravans, and Complex Societies," in *Recent Studies in Precolumbian Archaeology*, ed. Nicholas J. Saunders and Olivier de Montmollin (Oxford: BAR International, 1988), 611.

34. In a larger sense, the Inca leadership modeled the economic activity of the emergent Inca state after these economies of the south-ern sierra: see John V. Murra, *The Economic Organization of the Inca State* (1955; reprint Greenwich, CT: Jai Press, 1980). On Inca administration and ecological management in the southern Andes, see Dillehay and Nuñez, "Camelids, Caravans, and Complex Societies," 603–33; see also the valuable case study provided by Terence N. D'Altroy, Ana María Lorandi, Verónica I. Williams, Milena Calderari, Christine A. Hastorf, Elizabeth DeMarrais, Melissa B. Hagstrum, "Inka rule in the northern Calchaquí Valley, Argentina," *Journal of Field Archaeology* 27:1 (2000): 1–26.

35. Betanzos, *Suma y narración* (Madrid: Ediciones Atlas 1987), Chapter 25, 125. On the history of the Inca annexation of the Cajamarca region, see Maria Rostworowski de Diez Canseco, "Patronyms with the Consonant F in the Guarangas of Cajamarca," in *Andean Ecology and Civilization: An Interdisciplinary Perspective on Andean Ecological Complementarity*, ed. S. Masuda, I. Shimada, and C. Morris (Tokyo: University of Tokyo Press, 1985), 401–21; M. Remy Simatovic, "Organización y cambios del reino de Cuismancu 1540–1540," in *Historia de Cajamarca: Vol. II, Etnohistoria y Lingüística* ed. F. Silva Santisteban, W. Espinoza Soriano, and Rogger Ravines (Cajamarca: Instituto Nacional de Cultura/Cajamarca and Corporación de Desarrollo de Cajamarca, 1985), 35–68.

36. On the Inca understandings of the term *cuzco* as a ritual center, see I.S. Farrington, "The Concept of Cusco," *Tawantinsuyu* 5 (1998): 53–59; Thomas B.F. Cummins and Stephen Houston "Body, Presence and Space in Andean and Mesoamerican Rulership," in *Palaces of the Ancient New World*, ed. Susan Tobey Evans and Joanne Pillsbury (Washington, DC: Dumbarton Oaks, 2005), 359–398; Susan Elizabeth Ramírez, *To Feed and Be Fed: The Cosmological Bases of Authority and Identity in the Andes* (Stanford: Stanford University Press, 2005), 74–80. On the replication of the form and function of the Inca capital of Cuzco in provincial centers, see Terence N. D'Altroy, *Provincial Power in the Inka Empire* (Washington, DC: Smithsonian, 1992), 77; D'Altroy, *The Incas* (Oxford: Blackwell, 2002), 67–68. On Inca provincial centers replicating the plan and component structures of Cuzco, see John Hyslop, *Inka Settlement Planning* (Austin: University of Texas Press, 1990), 69–101; Jessica Joyce Christie,

"Did the Inca copy Cusco? An Answer Derived from an Architectural-Sculptural Model," *Journal of Latin American and Caribbean Anthropology* 12:1 (2007): 164–199, and Lawrence Coben, "Other Cuscos: Replicated Theaters of Inca Power," in *Archaeologies of Performance: Theaters of Power, Community, and Politics*, ed. Takeshi Inomata (Lanham: Altamira Press, 2006), 223–59.

37. Fundamental discussions of the Cuzco *zeq'e* system include R. Tom Zuidema, *The Ceque System of Cuzco: The Social Organization of the Capital of the Inca* (Leiden: Brill, 1964); John Howland Rowe, "An Account of the Shrines of Ancient Cuzco," *Ñawpa Pacha* 17 (1979): 1–80; Hyslop, *Inka Settlement Planning*, 65–68; Brian S. Bauer, *The Sacred Landscape of the Incas* (Austin: University of Texas Press, 1998); Maarten van de Guchte, "The Inca Cognition of Landscape: Archaeology, Ethnohistory, and the Aesthetic of Alterity," in *Archaeologies of Landscape*, ed. Wendy Ashmore and Bernhard Knapp (Malden, MA: Blackwell, 1999), 149–68.

38. Rowe, "An Account of the Shrines of Ancient Cuzco," 60–61.

39. Cumbemayo was first published by Julio C. Tello, "La cuidad inkaica de Cajamarca," *Chaski* 1:3 (1941): 3–7. Subsequent publications include Hans Horkheimer, *Vistas arqueológicas del noroeste del Perú* (Trujillo: Instituto Arqueológico del la Universidad Nacional de Trujillo, 1944); Horacio Villanueva Urteaga, "Cajamarca prehispánica y colonial," *Revista Universitaria del Cusco* 33 (1944); Georg G. Petersen, "Cumbemayo: acueducto arqueológicoque cruza las divisoria continental (Departamento de Cajamarca, Perú)," *Tecnia* (Lima) 3 (1969): 112–39; Alberto Regal, *Los trabajos hidráulicos en el antigüo Perú* (Lima: 1970); Rogger Ravines, *Cajamarca Prehispanica: Inventario de monumentos arqueológicos* (Cajamarca: Instituto Nacional de Cultura de Cajamarca, 1985), 72–82; Horacio Villanueva Urteaga, "Hacia la ciudad de Cajamarca la Grande," *Revista Universitaria* (Cuzco) 36: 93 (1947): 45–77; Villanueva Urteaga, *Cajamarca: Apuntes para su historia* (Cuzco: Editorial Garcilaso, 1975); Kimberly Lynn Jones, "Cupisnique Culture: The Development of Ideology in the Ancient Andes," Ph.D. dissertation, University of Texas at Austin, 2010, 11–160.

40. Baltasar Jaime Martínez Compañón y Bujanda, *Trujillo del Perú* [1781–9], ed. Jesús Domínguez Bordona (Madrid, Patrimonio de la República, Biblioteca de Palacio, 1936): see Thomas Besom, *Of Summits and Sacrifice: An Ethnohistoric Study of Inka Religious Practices* (Austin: University of Texas Press, 2009), 78–79; Colin McEwan, "Cognising and Marking the Andean Landscape: Radial, Concentric, and Hierarchical Perspectives," in *Inca Sacred Space: Landscape, Site and Symbol in the Andes*, ed. Frank Meddens, Katie Willis, Colin McEwan, and Nicholas Branch (London: Archetype, 2014), 38.

41. Sacred locales were often allied with audible sound and vocalization: *huaca/wak'a*, the folk term commonly applied to sacred sites, likely derives from the Quechua *huaccan*, "to cry," and "to sound a bell," or "play an instrument." See Jean-Philippe Husson, *La Poesie Quechua dans la chronique de Felipe Waman Puma de Ayala* (Paris: L'Harmattan, 1985), 131.

42. For recent anthropological-archaeological perspectives on *wak'as*, see Maarten van de Guchte, "The Inka Cognition of Landscape: Archaeology, Ethnohistory, and the Aesthetic of Alterity," in *Archaeologies of Landscape*, ed. Wendy Ashmore and A. Bernard Knapp (Oxford: Blackwell, 1999), 149–69; Tamara L. Bray, "An Archaeological Perspective on the Andean Concept of Camaquen: Thinking Through Late Pre-Columbian Ofrendas and Huacas," *Anthropology Faculty Research Publications Paper* 1 (Digital Commons@Wayne State University, 1999); Mariusz Ziólkowski, "Los Wakakuna de los Cusqueños," in *Los Dioses Antiguos del Perú* (Lima: Banco de Crédito, 200), 268–328; Carolyn Dean, *A Culture of Stone: Inka Perspectives on Rock* (Durham, NC: Duke University Press, 2010), 2–3. On sacred landscape and practices of memory in the Andes, see the important study by Thomas A. Abercrombie, *Pathways of Memory and Power: Ethnography and History among an Andean People* (Madison: University of Wisconsin Press, 1998).

43. Here I follow the usage of distinguished Polish linguist Mariusz Ziólkowski in identifying sacred sites as "*wak'akuna*" (Ziólkowski, "Los Wakakuna de los Cusqueños"). Bruce Mannheim (n.d.) points out that the Quechua term *wak'a* is a more general term that refers to a quality of being ("the sacred") rather

than an onomastic or toponymic term refer-
ring to specific places, events, or people. Here
I prefer Ziólkowski's usage, which seems to
conform more closely to pre-contact Inca
religious practice, whereas Mannheim's usage
appears to describe the more dichotomized,
Christianized cosmology (sacred/profane) of
the sixteenth- and seventeenth-century Pas-
toral Quechua. On surprise and fear in Andean
understandings of the sacred: Regina Harrison,
*Signs, Songs, and Memory in the Andes: Translating
Quechua Language and Culture* (Austin, Univer-
sity of Texas Press, 1989), 45–48. See also Don-
ald Joralemon and Douglas Sharon, *Sorcery and
Shamanism: Curanderos and Clients in Northern
Peru* (Salt Lake City: University of Utah Press,
1993), 235–36.

44. These sites were listed in Bernabé Cobo, *Histo-
ria del nuevo mundo* [1653]; they are transcribed
in John Howland Rowe, "An Account of the
Shrines of Ancient Cuzco," *Ñawpa Pacha* 17
(1979): 1–80. *Curauacaja* (Antisuyu 6:7): *[E]s
un altozano camino de Chita, donde se pierde de
vista la ciudad; y estaua señalado por fin, y mojon
de las Guacas deste Ceque. Tenían alli un leon
muerto, y contauan su origen es largo* (Rowe, "An
Account," 36). And another, the *site of Chucu-
racay Puquiu* (Cuntisuyu 3:4): *[E]s una quebrada
que esta camino de Tambo, donde se pierde de vista
el valle del Cuzco* (Rowe, "An Account," 54).
See also Brian S. Bauer, *The Sacred Landscape
of the Inkas* (Austin: University of Texas Press,
1998).

45. *Mascata Urco* (Cuntisuyu 8:6): *[E]s un cerro donde
se pierde la vista de Cuzco por este Ceque* (Rowe,
"An Account," 56).

46. *Macaycalla* (Antisuyu 2:10): *[E]s un llano entre
dos cerros donde se pierde de vista lo que esta destotra
parte, y se descubre la otra de adelante, y sola esta
raçon lo adorauan* (Rowe, "An Account," 32).

47. *Maychaguanacauri* (Antisuyu 4:7): *Era una piedra
llamada, Maychaguanacauri, hecho a manera del
cerro de Hunacauir, que se mando poner en este
camino de Antisuyu, y le ofrecian de todo* (Rowe,
"An Account," 34–35).

48. Dennis Ogburn, "Dynamic Display, Propa-
ganda, and the Reinforcement of Provincial
Power in the Inka Empire," *Archaeological Papers
of the American Anthropological Association* 14
(2005): 225–39.

49. Timothy Earle, "Routes through the Land-
scape: A Comparative Perspective," in *Land-
scapes of Movement: Trails, Paths, and Roads

in Anthropological Perspective*, ed. James E.
Snead, Clark L. Erickson, J. Andrew Darling
(Philadelphia: University of Pennsylvania,
2009), 253–309.

50. See the important volume *The Lines of Nazca*,
ed. Anthony F. Aveni (Philadelphia: American
Philosophical Society, 1990), esp. Gary Urton,
"Andean Social Organization and the Main-
tenance of the Nazca Lines: Anthropologi-
cal and Archaeological Perspectives," 173–206;
Helaine Silverman, "The Early Nasca Pilgrim-
age Center of Cahuachi and the Nasca Lines:
Anthropological and Archaeological Perspec-
tives," 207–44.

51. See also Tom B. F. Cummins' discussion of the
monumental geoglyph inscribed above Ollan-
taytambo during the European-Inca struggles
in the Cuzco region of 1536–37: Cummins,
Toasts with the Inca, 123–28.

52. Rebecca Carrión Cachot, *El Culto al Agua
en el Antiguo Peru: La Pacha Elemento Cultural
Pan-Andino: Separata de la Revista del Museo
Nacional de Antropología y Arqueología* II:2 (Lima:
Museo Nacional de Antropología y Arque-
ología, 1955), 18, plate IX.

53. "Endless restlessness," Rebecca R. Stone,
"'And All Theirs Different from His': The
Dumbarton Oaks Royal Tunic in Context,"
in *Variations in the Expression of Inka Power:
A Symposium at Dumbarton Oaks*, ed. Richard
L. Burger, Craig Morris, and Ramiro Matos
Mendieta (Washington, DC: Dumbarton
Oaks, 2007), 385.

54. Frank Salomon, "How the Huacas Were: The
Language of Substance and Transformation in
the Huarochirí Quechua Manuscript," *RES:
Anthropology and Aesthetics* 33 (1998), 9–10.

55. Colin McEwan, "Cognising and Marking the
Andean Landscape: Radial, Concentric, and
Hierarchical Perspectives," in *Inca Sacred Space:
Landscape, Site and Symbol in the Andes*, ed.
Frank Meddens, Katie Willis, Colin McEwan,
and Nicholas Branch (London: Archetype,
2014), 29–47. Mena's position at the limit of the
valley recalls the Andean tradition of bound-
ary markers allied with *apacheta* and the *saywa*:
see Christian Vitry, "Apachetas y mojones,
marcadores espaciales del paisaje prehispánico,"
Revista Escuela de Historia 1:1 (2002): 179–
91; Carolyn Dean, "Rethinking Apacheta,"
Ñawpa Pacha 28 (2006): 93–108; Dean, *Cul-
ture of Stone: Inka Perspectives on Rock* (Durham,
NC: Duke University Press, 2010), 154–55.

56. Craig Morris, "The Infrastructure of Inka Control in the Peruvian Central Highlands," *The Inca and Aztec States, 1400–1800: Anthropology and History*, ed. George A. Collier, Renato I. Rosaldo, and John D. Wirth (New York: Academic Press, 1982), 153–71.

57. *Yancaycalla* (Antisuyu 3:9): *[E]s una como puerta donde se ue el llano de chita, y se pierde la vista del cuzco: alli hauia puestoas guardas para que ninguno lleuase cosa hurtada: sacrificase por los mercaderes cada vez que pasauan; y rogauan que les sucediese bien en el viage; y era coca el sacrificio ordinario*: Rowe, "An Account," 32.

58. Spanish-language scholarship on Andean camelid pastoralism is indebted to the work of Jorge A. Flores Ochoa: see, inter alia, Flores Ochoa, "Pastores de Paratía: Una introduction a su estudio," *Serie Antropología Social* (Mexico City: IEP, 1968), 5–159; Flores Ochoa, "Enqa, enqaychu, illa y khuya rumi: Aspectos magico-religiosos entre pastores," *Journal de la Société des Américainistes* (Paris) 63 (1974–76): 245–62; Duccio Bonavia, *Los camélidos sudamericanos: Una introducción a su estudio* (La Paz: IFEA, UPCH, Conservación Internacional, 1996); Roger Leonardo Mamani Siñani, "Carneros de la tierra, guanaco y vicuñas: La importancia del Ganado, una visión desde las crónicas," *Serie Anales de la Reunión Annual de Etnología* 18:1 (2004): 103–14. Engligh-language scholarship on Andean pastoralism follows from two classic articles: John V. Murra, "Herds and Herders in the Inca State," in *Man, Culture and Animals: The Role of Animals in Human Ecological Adjustments*, ed. A. Leeds and A. Vayda (Washington, DC: American Association for the Advancement of Science, 1965), 185–216; David L. Browman, "Pastoral Nomadism in the Andes," *Current Anthropology* 15:2 (1974): 188–96. That work also includes Kent Flannery, Joyce Marcus, and Robert G. Reynolds, *The Flocks of the Wamani: A Study of Llama Herders on the Punas of Ayacucho, Peru* (New York: Academic Press, 1989); Penny Dransart, *Earth, Water, Fleece, and Fabric: An Ethnography and Archaeology of Andean Camelid Herding* (London: Routledge, 2002); George F. Lau, "Animal resources and Recuay cultural transformations at Chinchawas (Ancash, Peru)," *Andean Past* 8 (2007): 449–76; C.A. Westreicher, J.L. Mérega, G. Palmili, "The Economics of Pastoralism: A Study of Current Practices in South America," *Nomadic Peoples* 11:2 (2007): 87–105.

59. See Gerald Taylor, "El Zorro y otros cuentos Yauyinos," in *Camac, Camay y Camasca y Otros Ensayos Sobre Huarochiri y Yauyos* (Lima: Institut francais d'etudes Andines, 2000), 151–70.

60. Murra, "Herds and Herders," 206. On local ethnic groups of Cajamarca uder Inca and Spanish administration, see Martti Pärssinen, *Tawantinsuyu: The Inca State and Its Political Organization* (Helsinki: Societas Historica Finlandiae, 1992), 306–20.

61. Christine A. Hastorf and Sissel Johannessen, "Pre-Hispanic Political Change and the Role of Maize in the Central Andes of Peru," *American Anthropologist* (ns) 95:1 (1993): 115–138. See also Justin Jennings, La Chichera y El Patrón: Chicha and the Energetics of Feasting in the Prehistoric Andes," *Archeological Papers of the American Anthropological Association* 14:1 (2004): 241–259. Tamara L. Bray, "To Dine Splendidly: Imperial Pottery, Commensal Politics, and the Inca State," in *The Archaeology and Politics of Food and Feasting in Early States and Empires*, ed. Tamara. L. Bray (New York: Kluwer/Plenum, 2003), 93–142; also Paul S. Goldstein, "From Stew-Eaters to Maize-Drinkers: The *Chicha* Economy and the Tiwanaku Expansion," in *Archaeology and Politics of Food and Feasting in Early States and Empires*, 143–72 Timothy Earle and Cathy Lynne Costin, "Status Distinction and Legitimation of Power as Reflected in Changing Patterns of Consumption in Late Prehispanic Peru," *American Antiquity* 54:4 (1989): 691–714. "Much of the significance of maize beer rested on its power to symbolize the agricultural economy upon which society depended . . . the Inca strove to make maize itself a royal food . . . making chicha into a symbol of empire": Mary J. Weismantel, "Maize Beer and Andean Social Transformations: Drunken Indians, Bread Babies, and Chosen Women," *Modern Language Notes* 106:4 (1991), 875–76 (861–79); Cummins, *Toasts with the Inca*, 39–58.

62. Peter Gose, "The State as a Chosen Woman: Brideservice and the Feeding of Tributaries in the Inca Empire," *American Anthropologist* (n.s.) 102:1 (2000): 84–97.

63. These farmers were transferred from Pacasmayo, Zaña, Collique, Chuspo, Cinto, Túcume: see Daniel Julien, "Political Geography of the Cajamarca Region," 252; cites C. de Barrientos "Visita de las siete guarangas de la provincial de Caxamarca" [1540], in

Waldemar Espinoza Soriano, *El Primer informe etnológico sobre Cajamarca. Año de 1540: Revista Peruana de Cultura* 11–12 (1967), 5–41. On Cajamarca in the Inca and the early colonial eras, see Waldemar Espinoza Soriano, "El primer informe etnológico sobre Cajamarca: Año de 1540," *Revista Peruana de Cultura* 11–12 (1967): 5–41; "Los mitmas yungas de Collique en Cajamarca, siglos XV, XVI, XVII." *Revista del Museo Nacional* 37 (1969–70): 9–57; Horacio Villanueva Urteaga, *Cajamarca: apuntes para su historia* (Cuzco: Editorial Garcilaso, 1975); María Rostworowski de Diez Canseco, "La estratificación social y el Hatun curaca en el mundo andino," *Historia* I:2 (1977): 249–86. On this history of Cajamarca's native population under colonial administration, see Jorge Zevallos Quiñonez, "Consideraciones sobre la fiesta del Corpus en Cajamarca en el año 1684," in *Historia: Problema y Promesa*, ed. F. Miró Quesada and Franklin Pease G. Y., and D. Sobrevilla (Lima: Pontífica Universidad Católica del Perú, 1978), 621–635.

64. Espinoza Soriano, "Los mitmaes yungas," 15; Daniel Julien, "Political Geography," 253.

65. John V. Murra, "Herds and Herders in the Inca State," in *Man, Culture and Animals: The Role of Animals in Human Ecological Adjustments*, ed. A. Leeds and A. Vayda (Washington, DC: American Association for the Advancement of Science, 1965), 206.

66. W. Mitchell, "Local Ecology and the State: Implications of Contemporary Quechua Land Use for the Inca Sequence of Agricultural Work," in *Beyond the Myths of Culture: Essays in Cultural Materialism*, ed. E. B. Ross (New York: Academic Press, 1980), 139–54.

67. My understanding of soil fertility and maize agriculture in the Andes is informed by Alex J. Chepstow-Lusty, Michael R. Frogley, Brian S. Bauer, Melanie J. Leng, Andy B. Cundy, Karin P. Boessenkool, and Alain Gioda, "Evaluating Socio-Economic Change in the Andes using Oribatid Mite Abundances as Indicators of Domestic Animal Densities," *Journal of Archaeological Science* 34:7 (2007): 1178–86. On the general topic of maize agriculture and soil exhaustion, see the essays in *Soil Fertility Research for Maize-Based Farming Systems in Malawi and Zimbabwe: Proceedings of the Soil Fert Net Results and Planning Workshop Held from 7 to 11 July 1997 at Africa University, Mutare, Zimbabwe*, ed. S. R. Waddington, H. K. Murwira, J. D. T. Kumwenda, D. Hikwa, and F. Tagwira (Harare: Soil Fert Net and CIMMYT-Zimbabwe, 1998).

68. D'Altroy and Earle, "Staple Finance," 191.

69. R. Alan Covey, *How the Incas Built their Heartland: State Formation and the Innovation of Imperial Strategies in the Sacred Valley, Peru* (Ann Arbor: University of Michigan Press, 2006), 172–78, 225–26.

70. On the effects of European sheep on New World landscapes and peoples, see the classic study by Elinor G. K. Melville, *A Plague of Sheep: Environmental Consequences of the Conquest of Mexico* (Cambridge: Cambridge University Press, 1997). See also Virginia DeJohn Anderson, *Creatures of Empire: How Domestic Animals Transformed Early America* (Oxford: Oxford University Press, 2002).

71. The earliest recorded Quechua terms for pack llamas include *llama huacauya, huacauia,* and *llama chunca*: see Diego de Gonzalez Holguin, *Vocabulario de la lengua general de todo el Peru llamada lengua Quichua o del Inca* [1608] (Lima: Instituto de Historia, Universidad de San Marcos, 1952), 270–71; see also Sabine Dedenbach-Salazar Sáenz, *Inka Pachaq Llamanpa Willaynin: Uso y Crianza de los Camélidos en la Epoca Incaica. Estudio Lingüístico y Etnohistórico basado en las Fuentes Lexicográficas y Textuale del Primer Siglo después de la Conquista* BAS 16 (Bonn: Bonner Amerikanische Studien 1990), 167–71.

72. John Hyslop, *The Inca Road System,* 302–03.

73. J. Clutton-Brock, ed. *The Walking Larder: Patterns of Domestication, Pastoralism, and Predation* (London: Unwin Hyman, 1989).

74. Browman, "Pastoral Nomadism," 193–94.

75. On Andean ritual practices involving camelids, see Sabine Dedenbach-Salazar Sáenz, *Inca Pachaq Llamanpa Willaynin: Uso y Crianza de los Camélidos en la Epoca Incaica. Estudio Lingüístico y Etnohistórico basado en las Fuentes Lexicográficas y Textuale del Primer Siglo después de la Conquista* BAS 16 (Bonn: Bonner Amerikanische Studien 1990), 181–227. On two important Inca ceremonial knives in museum collections, see Elizabeth Hill Boone, *Andean Art at Dumbarton Oaks: Pre-Columbian Art at Dumbarton Oaks, No. 1* (Dumbarton Oaks Research Library and Collection, Washington, DC, 1996), 313–15, pl. 92. See also a Inca knives in the Michael C. Carlos Museum, Emory University 1989.008.051, 1994.18.40: Rebecca Stone-Miller, *Seeing with New Eyes: Highlights of the*

Michael C. Carlos Museum Collection of the Art of the Ancient Americas (Atlanta: Michael C. Carlos Museum, 2002), 210–12.

76. Dedenbach-Salazar Sáenz, *Inka Pachaq Llamanpa Willaynin*, 216–24.

77. On the cosmology of human vision, see Constance Classen, *Inca Cosmology and the Human Body* (Salt Lake City: University of Utah Press, 1993), 52–54, 68–70; Billie Jean Isbell, *To Defend Ourselves: Ecology and Ritual in an Andean Village* (Austin: University of Texas Press, 1978), 139; Regina Harrison, "Modes of Discourse: The Relación de Antigüedades deste Reyno del Pirú by Joan de Santacruz Pachacuti Yamqui Salcamaygua," in *From Oral to Written Expression: Native Andean Chronicles of the Early Colonial Period* (Syracuse, NY: Syracuse University, 1982), 65–99; Adam Herring, "'Shimmering Foundation': The Twelve-Angled Stone of Inca Cusco," *Critical Inquiry* 37:1 (2010), 89–90; Herring, "Caught Looking: Under the Gaze of Inka Atawallpa, 15 November 1532," *Journal of Medieval and Early Modern Studies* 44:2 (Spring 2014): 373–406. See also Rebecca R. Stone's important treatment of the instrumental role of human vision in contexts of elevated sacrality among Central and South American peoples: Rebecca R. Stone, *The Jaguar Within: Shamanic Trance in Ancient Central and South American Art* (Austin: University of Texas Press, 2011), esp. 13–33.

78. For an overview of Inca mythology and its relationship to the southern Andes, see Gary Urton, *Inca Myths* (Austin: University of Texas Press, 1999). See also the commentary in Maarten van de Guchte, "The Inca Cognition of Landscape: Archaeology, Ethnohistory, and the Aesthetic of Alterity," in *Archaeologies of Landscape*, ed. Wendy Ashmore and Bernhard Knapp (Malden, MA: Blackwell, 1999), 149–68.

79. Scott C. Smith, "Generative Landscapes: The Step Mountain Motif in Tiwanaku Iconography," *Ancient America* 12 (2012): 1–69; Frank M. Meddens, Colin McEwan, and Cirilio Vivanco Pomacanchari, "Inca 'Stone Ancestors' in Context at a High-Altitude *Usnu* platform," *Latin American Antiquity* 21:2 (2010): 173–94.

80. Molina, *Fábulas y mitos*; On the Suntur Paucar, see Juan Larrea, "El Yauri, insignia Incaica," *Corona Incaica* (Córdoba, Spain: Facultad de Filosofía y Humanística 1960), 68.

81. Pacchas and Conopas: Jorge A. Flores Ochoa, "Enqa, enqaychu, illa y khuya rumi: Aspectos magico-religiosos entre pastores," *Journal de la Société des Américainistes* (Paris) 63 (1974–76): 245–62; Viviana Manríquez S., "El término Ylla y su potencial simbólico en el Tawantinsuyu: Una reflexión acerca de la presencia inca en Caspana (río Loa, desierto de Atacama)," *Estudios Atacameños* 18 (1999): 107–18.

82. Kelly J. Knudson, Kristin R. Gardella, Jason Jaeger, "Provisioning Inca Feasts at Tiwanaku, Bolivia: The Geographic Origins of Camelids in the Pumapunku Complex," *Journal of Archaeological Science* 39 (2012): 479–91.

83. The economy of Cajamarca was primarily agricultural. As feasting food and the source of fine fiber, camelids seem to have served as a means to define the region's local elites, not support its populace. Melody Shimada, "Continuities and changes in patterns of faunal resource utilization: Formative through Cajamarca Periods," in *The Formative Period in the Cajamarca Basin, Peru: Excavations at Huacaloma and Layzón, 1982*, ed. Kazuo Terada and Yoshio Onuki (Tokyo: University of Tokyo, 1985), 289–310. See also Jane C. Wheeler, "On the Origin and Early Development of the Camelid Pastoralism in the Central Andes," in *Animals and Archaeology: Early Herders and Their Flocks*, vol. 3, ed. Juliet Clutton-Brock and Caroline Grigson (Oxford: BAR International Series 202, 1984), 395–410.

84. Melody Shimada and Izumi Shimada, "Prehistoric Llama Breeding and Herding on the North Coast of Peru," *American Antiquity* 50 (1985): 3–26. For an insightful inquiry into camelid herding on the southern coast of Peru, see María Cecilia Lozada, Jane E. Buikstra, Gordon Rakita, and Jane C. Wheeler, "Camelid Herders: The Forgotten Specialists in the Coastal Señorío of Chiribaya, Southern Peru," in *Andean Civilization: A Tribute to Michael E. Moseley*, ed. Joyce Marcus and Patrick Ryan Williams (Los Angeles: UCLA Cotsen Institute of Archaeology, 2009), 351–64.

85. J. J. von Tschudi, *Travels in Peru, During the Years 1838–1842* [1847] (London: David Brogue, 1966), 243, cited in Bonavia, *The South American Camelids*, 307.

86. Tom Cummins, "The Madonna and the Horse: Becoming Colonial in New Spain and Peru," in *Native Artists and Patrons in Colonial Latin*

America, ed. Emily Umberger and Tom Cummins (Arizona State University Press, 1995), 52–83.

87. Waldemar Espinoza Soriano, "La pachaca de Pariamarca en el reino de Caxamarca, siglos XV–XVIII," *Historia y Cultura* (Lima) 10 (1976–77), 141 note 3.

88. Murra, "Herds and Herders," 206.

89. As pastoralists among agriculturalists, the young nobles enacted a traditional form of Andean complementarity: In the Andes, drovers supplanted farmers. See Gary Urton, "The Herder-Cultivator Relationship as a Paradigm for Archaeological Origins, Linguistic Dispersals, and the Evolution of Record-Keeping in the Andes," in *Archaeology and Language in the Andes*, ed. Paul Heggarty and David Beresford-Jones (Oxford: British Academy/Oxford University Press, 2012), 321–43; Pierre Duviols, "Huari y Llacuaz: Agricultores y pastores: Un dualismo prehispanico de oposición y complementaridad," *Revista del Museo Nacional* (Lima) 34 (1973): 153–91.

90. John V. Murra, *The Economic Organization of the Inca State* (1955; reprint Greenwich: Jai Press, 1980), 54–55, 77, 122–23; Murra, "On Inca Political Structure," in *Systems of Political Control and Bureaucracy in Human Societies: Proceedings of the 1958 Annual Spring Meetings of the American Ethnological Society*, ed. Verne F. Ray (Seattle: University of Washington Press, 1958), 30–41. Strains of gift-giving: María Rostorowski de Diez Canseco, *History of the Inca Realm* (trans. Harry B. Iceland) (Cambridge: Cambridge University Press, 1999), 224–25.

91. Murra, *The Economic Organization of the Inca State*, 54–5, 77, 122–23; Murra, "On Inca Political Structure," 30–41. Strains of gift-giving: María Rostorowski de Diez Canseco, *History of the Inca Realm*, 224–25.

92. Cummins, *Toasts with the Inca;* Frank Salomon and George L. Urioste in *The Huarochirí Manuscript: A Testament of Ancient and Colonial Andean Religion*, Chapter 23, 114–15.

93. Peter Gose, "The State as a Chosen Woman: Brideservice and the Feeding of Tributaries in the Inca Empire," *American Anthropologist* (n.s.) 102:1 (2000): 84–97. On Mink'a, see C. Fonseca Martel, "Modalidades de la minka," in *Reciprocidad e intercambio en los Andes Peruanos* (Lima: Instituto de Estudios Peruanos, 1974), 89–109.

94. *Y auia auisado al gouernador que ninguna cosa de comer que el Atabalipa embiasse, no la moiessemos: y assi fue hecho: que toda la vianda que el Atabalipa embio, fue dado a los indios que lleuauan las cargas.* Mena, in Pogo, "The Anonymous *La Conquista Del Peru* [Seville, April 1534]," 230.

95. For a brief introduction to the Inca dynastic struggle, see Franklin Pease G. Y., *Los Ultimos Incas del Cusco* (Lima: Taller Gráfica Villanueva, 1972); John Hemming, *The Conquest of the Incas* (New York: Harcourt, 1970); María Rostworowski de Diez Canseco, *History of the Inca Realm*, trans. Harry B. Iceland (Cambridge: Cambridge University Press, 1999); Terence D'Altroy, *The Incas* (Oxford: Blackwell, 2002).

96. Frank Salomon, *Native Lords of Quito in the Age of the Incas: The Political Economy of North Andean Chiefdoms* (Cambridge: Cambridge University Press, 1986); see also Frank Salomon, "Vertical Politics on the Inca Frontier," in *Anthropological History of Andean Polities*, ed. John. V. Murra, Nathan Wachtel, and Jacques Revel (Cambridge: Cambridge University Press, 1986), 89–118. See also Martti Pärssinen, *Tawantinsuyu: The Inca State and Its Political Organization* (Helsinki: Societas Historica Finlandiae, 1992).

97. Juan de Betanzos, *Suma y narración de los incas* (1551: Madrid: Ediciones Atlas 1987), Chapter 25, 125. On the history of the Inca annexation of the Cajamarca region, see Maria Rostworowski de Diez Canseco, "Patronyms with the Consonant F in the Guarangas of Cajamarca," in *Andean Ecology and Civilization: An Interdisciplinary Perspective on Andean Ecological Complementarity*, ed. S. Masuda, I. Shimada, and C. Morris (Tokyo: University of Tokyo Press, 1985), 401–21; M. Remy Simatovic, "Organización y cambios del reino de Cuismancu 1540–1540," in *Historia de Cajamarca: Vol. II, Etnohistoria y Lingüistica*, ed. F. Silva Santisteban, W. Espinoza Soriano, and Rogger Ravines (Cajamarca: Instituto Nacional de Cultura/Cajamarca and Corporación de Desarrollo de Cajamarca, 1985), 35–68.

98. On the Tiwanku-Wari iconographic tradition, see Jan Szeminski, *Wira Quchan y sus obras: teología andina y lenguaje, 1550–1662* (Lima: Instituto de Estudios Peruanos, 1997); J. J. Hiltunen, *Ancient Kings of Peru: The Reliability of the Chronicle of Fernando de Montesinos: Correlating the Dynasty Lists with Current Prehistoric Periodization in the Andes* (Helsinki:

Suomen Historiallinen Seura, 1999); Krzyztof Makowski Hanula, "Royal Statues, Staff Gods, and the Religious Ideology of the Prehistoric State of Tiwanaku," in *Tiwanaku: Essays from the 2005 Mayer Center Symposium at the Denver Art Museum*, ed. Margaret Young-Sánchez (Denver: Denver Art Museum, 2009), 133–64; see also William H. Isbell and Patricia J. Knobloch, "SAIS: The Origin, Development, and Dating of Tiwanaku-Huari Iconography," in *Tiwanaku: Essays from the 2005 Mayer Center Symposium at the Denver Art Museum*, 165–210.

99. Franklin Pease G. Y., *El Dios creador andino* (Lima: Mosca Azul, 1973); Arthur A. Demarest, *Viracocha: The Nature and Antiquity of the Andean High God* (Cambridge, MA: Peabody Museum, Harvard University, 1981), 22–41; Gary Urton, *Inca Myths* (London: British Museum Press, 1999), 39–40.

100. Constantino Manuel Torres, *The Iconography of South American Snuff Trays and Related Paraphernalia* (Göteborg: Etnografiska Museum, 1987); Agustín Llagostera Martínez, "Art in the Snuff Trays of San Pedro de Atacama (Northern Chile)," in *Andean Art: Visual Expressions and its Relation to Andean Beliefs and Values*, ed. Penelope Z. Dransart (Aldershot, England: Avebury, 1995), 51–77; Constantino M. Torres, "Iconografía Tiwanaku en la parafernalia inhalatoria de los Andes Centro-Sur," *Boletín de Arqueología PUCP* 5 (2001): 427–54; Llagostera Martínez, "Contextualización e iconografía de las tabletas psicotrópicas Tiwanaku de San Pedro de Atacama," *Chungara: Revista de Antropología Chilena* 38:1 (2006): 83–111; Smith, "Generative Landscapes."

101. Hermann M. Niemeyer, "On the Provenience of Wood Used in the Manufacture of Snuff Trays from San Pedro de Atacama (Northern Chile)," *Journal of Archaeological Science* 40:1 (2013): 398–404.

102. Constantino Manuel Torres, "Tiwanaku Snuffing Paraphernalia," in *Tiwanaku: Ancestors of the Inca*, ed. Margaret Young-Sánchez (Lincoln: Denver Art Museum/University of Nebraska Press, 2004), 114–20. See also Rebecca Stone, *The Jaguar Within: Shamanic Trance in Ancient Central America and South American Art* (Austin: University of Texas Press, 2011), 176–82.

103. *Tipicpuquiu* (Antisuyu 1:8): *era una fuente que esta cerca de Tambomachay; llamase asi porque mana de modo que hierue el agua* (Rowe, "An Account," 30–31).

104. Smith, "The Generative Landscape," 23, cites Joseph Bastien, *Mountain of the Condor: Metaphor and Ritual in an Andean Allyu* (St. Paul, MN: American Ethnological Society/West Publishing, 1978), 195–96. That usage is related to the classic Quechua term *Phichiw*: Jan Szemiński, *Léxico de Fray Domingo de Santo Tomás, 1560* (Lima: Convento de Santo-Domingo-Qorikancha/Sociedad Polaca de Estudios Latinoamericanos/Universidad Hebrea de Jerusalén, 2006). 402: "Ppichiu. Todo Pajaro y la niña del ojo." It is also related to the more recent Quechua usage of the term *sami*: Catherine J. Allen, "When Pebbles Move Mountains," in *Creating Context in Andean Cultures*, ed. Rosaleen Howard-Malverde (Oxford Studies in Anthropological Linguistics, Oxford University Press, 1997), 80; Allen, *The Hold Life Has: Coca and Cultural Identity in an Andean Community* (Washington, DC: Smithsonian Institution, 2002), 36. See also Enrique Urbano, "Sami y Ecaco: Introducción a la noción de 'fortuna' en los Andes," in *Religions des andes et langues indigenes: Équateur-Pérou-Bolivie avant et après le conquete espagnole*, ed. Pierre Duviols (Aix-en-Provence: University of Provence, 1993), 235–43.

105. For those accounts, see Introduction Note 1.

106. See also the recent important reassessment of disease in the Andes immediately before the European arrival: James B. Kiracofe and John S. Marr, "Marching to Disaster: The Catastrophic Convergence of Inca Imperial Policy, Sand Flies, and El Niño in the 1524 Andean Epidemic," in *El Niño: Catastrophism, and Culture Change in the Ancient Americas*, ed. Daniel H. Sandweiss and Jeffrey Quilter (Washington, DC: Dumbarton Oaks, 2008), 145–66.

CHAPTER 2

1. *Una manta que le cubria todo*: Juan Ruiz de Arce, *La Memoria de Juan Ruiz de Arce (1543): Conquista del Perú, saberes secretos de caballería y defense del mayorazgo*, ed. Eva Stoll (Frankfurt and Madrid: Vervuert Verlag/Iberoamericana, 2002), 83.

2. See Raoul D'Harcourt, *Textiles of Ancient Peru and Their Techniques* (Paris, 1934; trans. reprint Seattle: University of Washington Press, 1962), 50–53; Irene Emery, *The Primary Structure of Fabrics: An Illustrated Classification*, 2nd ed. (Washington, DC: Textile Museum, 1980), 181–86. See also extended bibliographic entry in Rebecca Stone-Miller, *To Weave for the Sun: Ancient Andean Textiles*, (New York: Thames and Hudson, 1992), 146.

3. Ruiz de Arce, *La Memoria*, 83.

4. *Y Atawallpa estaua en este galponcillo como tengo dicho, sentado en su duho, y una manta muy delgada rrala, que por ella uía, la qual tenían do mugeres, una de un cabo y otra de otro, delante dél, que le tapaban, por que nadie le viese, que lo tenían de costumbre algunos destos señores no ser uistos de sus vasallos sino raras vezes.* Pedro Pizarro, *Relación*, 32–33.

5. Wittgenstein, *Philosophical Investigations*, ed. P. M. S. Hacker and Joachim Schulte (Oxford: Blackwell, 2009): 175. On Wittengstein's engagement with the active work of seeing and thinking, see Hana Gründler, "'A Labyrinth of Paths': Ludwig Wittgenstein on Seeing, Drawing, and Thinking," in *Linea II: Giochi, Metamorfosi, Seduzioni della Linea*, ed. Marzia Faietti and Gerhard Wolf (Florence: Giunti Editori, 2012), 223–35; see also Whitney Davis, *A General Theory of Visual Culture* (Princeton, NJ: Princeton University Press, 2011), 290.

6. Sacred locales were often allied with audible sound and vocalization: *huaca/wak'a*, the folk term commonly applied to sacred sites, may derive from the Quechua *huaccan*, "to cry," and "to sound a bell," or "play an instrument." See Jean-Philippe Husson, *La Poesie Quechua dans la chronique de Felipe Waman Puma de Ayala* (Paris: L'Harmattan, 1985), 131.

7. Inca skywatching: Mariusz Ziolkowski, "Hanan Pachap Unancha: las 'señales del cielo' y su papel en la etnohistoria andina," *Revista Española de Antropología Americana* 15 (1985): 147–82; R. Tom Zuidema, "The Inca Calendar," in *Native American Astronomy*, ed. Anthony Aveni (Austin: University of Texas Press, 1977), 219–59. Lightning: Jorge Flores Ochoa, "Aspectos mágicos del pastoreo: Enqa, enqaychu, illa y khyua rumi," in *Pastores de la Puna: uywmichiq punarunakuna*, ed. Jorge Flores Ochoa (Lima: Instituto de Estudios Peruanos, 1977), 211–37. The sun at noon:

Gary Tomlinson, *The Singing of the New World: Indigenous Voices in the Era of European Contact* (Cambridge: Cambridge University Press, 2007), 124–67; R. T. Zuidema, "Inca Cosmos in Andean Context: From the Perspective of the Capac Raymi Camay Quilla Feast Celebrating the December Solstice in Cusco," in *Andean Cosmologies through Time: Persistence and Emergence*, ed. Robert V. H. Dover, Katherine E. Seibold, and John H. McDowell (Bloomington: Indiana University Press, 1992), 23. Wind: Brian S. Bauer, *The Sacred Landscape of the Incas* (Austin: University of Texas Press, 1998), 167 (Guayra, Ch. 6:4), 172 (Guayra, Co. 1:8). The disappearance of a landform to the traveler's view: Bauer, *The Sacred Landscape*, 169 (*Macaycalla*, An. 2:10), 170 (*Yancaycalla*, An. 3:9 and *Curauacaja*, An. 6:7), 171 (*Atpitan*, Co. 1:6), 175 (*Chucuracay Puquiu*, Cu. 3:4), 176 (*Mascata Urco*, Cu. 8:6). For recent anthropological-archaeological persepctives on wak'as, see Maarten van de Guchte, "The Inca Cognition of Landscape: Archaeology, Ethnohistory, and the Aesthetic of Alterity," in *Archaeologies of Landscape*, ed. Wendy Ashmore and A. Bernard Knapp (Oxford: Blackwell, 1999), 149–69; Tamara L. Bray, "An Archaeological Perspective on the Andean Concept of Camaquen: Thinking Through Late Pre-Columbian Ofrendas and Huacas," *Anthropology Faculty Research Publications Paper* 1 (Digital Commons@Wayne State University, 1999); Mariusz Ziólkowski, "Los Wakakuna de los Cusqueños," in *Los Dioses Antiguos del Perú* (Lima: Banco de Crédito, 200), 268–328; Carolyn Dean, *A Culture of Stone: Inka Perspectives on Rock* (Durham, NC: Duke University Press, 2010), 2–3.

8. Carmen Arellano and Ramiro Matos Mendieta, "Variations between Inca Installations in the Puna of Chinchayqocha and the Drainage of Tarma," in *Variations in the Expression of Inka Power*, ed. Richard R. Burger, Craig Morris, and Ramiro Matos Mendieta (Washington, DC: Dumbarton Oaks, 2007), 24.

9. Mariusz Ziólkowski, "El Inka ye el breviario, o del arte de conversar con las huacas," in *El Hombre y los Andes: Homenaje a Franklin Pease G. Y.*, ed. Javier Flores Espinoza y Rafaél Varón Gabai (Lima: Pontifica Universidad Católica del Perú, 2002), 597–610. Here I diverge from Ziólkowski, as well as Lamana, in identifying the key episode of interview with the

interview at Atawallpa's palace, rather than the plaza of Cajamarca the next day (Lamana, "Beyond Exotization and Likeness.").

10. On Inca initiatory rites administered to the non-Inca nobility, see Isabel Yaya, "The Importance of Initiatory Ideals: Kinship and Politics in an Inka Narrative," *Ethnohistory* 55:1 (2008): 52–85.

11. Pedro Pizarro, *Relacion*, 33.

12. On early openweaves, see Grace Katterman, "Early Cotton Network Knotted in Colored Patterns," *Andean Past* 9 (2009): 249–75.

13. On Baños del Inca, see Rogger Ravines, *Cajamarca prehispanica: Inventario de monumentos arqueológicos* (Cajamarca, Perú: Instituto Nacional de Cultura de Cajamarca/ Corporación de Desarrollo de Cajamarca, 1985), 109–10.

14. Idem.

15. Hyslop, *Inca Settlement Planning*, 59–60.

16. *Sobre este pueblo en la ladera de la sierra a donde comiençan las casa del esta otra Fortaleza assentada en un peñol la mayor parte del tajado. Esta es mayor que la otra cercada de tres cercas hecha subida como caracol. Fuerzas son que entre indios no se han visto tales.* Francisco de Xerez, *Verdadera Relación de la Conquista del Perú* [1534] (Madrid: Tip. de J. C. Garcia, 1891), 78.

17. The Inca are known to have imported fine stone quarried from the Cusco region to construct important buildings at distant administrative centers of their empire. Such may have been the case at the fortress above Cajamarca. See Dennis Ogburn, "Dynamic Display, Propaganda, and the Reinforcement of Provincial Power in the Inca Empire," *Archaeological Papers of the American Anthropological Association* 14 (2005): 225–239. See also Caroline Dean, *A Culture of Stone: Inka Perspectives on Rock* (Durham, NC: Duke University Press, 2010), 121.

18. This layout is amply documented at Huánuco Pampa, Pumpu, and other provincial Inca administrative centers. Elite-status Inca residential complexes were composed of successive precincts described by archaeologists and architectural historians as "walled rectangular blocks." William H. Isbell and Anita G. Cook, "A New Perspective on Conchopata and the Andean Middle Horizon," in *Andean Archaeology II: Art, Landscape, and Society*, ed. William H. Isbell and Helaine Silverman (New York: Kluwer Academic/Plenum, 2001), 292–

94 (249–305); Martin de Murúa, 1987, 58–59); Craig Morris and Donald Thompson, *Huánuco Pampa: An Inca City and its Hinterland* (London: Thames and Hudson, 1985). William H. Isbell, "Landscape of Power: A Network of Palaces in Middle Horizon Peru," in *Palaces and Power in the Americas: From Perú to the Northwest Coast*, ed. Jessica Joyce Christie and Patricia Sarro (Austin: University of Texas Press, 2006), 44–98, esp. 51–52; David O. Brown, "Administration and Settlement Planning in the Provinces of the Inca Empire: A Perspective from the Inca Provincial Capital of Pumpu on the Junín Plain of Highland Perú," Ph.D. dissertation, University of Michigan, Ann Arbor, 1991; Ramiro Matos Mendieta, *Pumpu: Centro administrativo inka de la puna de Junín* (Lima: Editorial Horizonte, 1994); Carol Mackey, "Elite Residences at Farfán: A Comparison of the Chimú and Inca Occupations," in *Palaces and Power*, 313–52; Jessica Joyce Christie, "Houses of Political Power among the Ancient Maya and Inca," ibid., 354–96. For an overview of Inca palace design, see Graziano Gasparini and Louise Margolies, *Inca Architecture*, trans. Patricia J. Lyon (Bloomington: Indiana University Press, 1980), 181–93; on lines of sight: 105–08. See also Ann Kendall, *Aspects of Inca Architecture* (Oxford: British Archaeological Reports 1985), and John Hyslop, *Inca Settlement Planning* (Austin: University of Texas Press, 1990). For a careful recent analysis of Inca administrative palace complex, see Craig Morris, R. Alan Covey, and Pat H. Stein, *The Huánuco Pampa Archaeological Project. Volume 1, The Plaza and Palace Complex: Anthropological Papers of the American Museum of Natural History* 96 (New York: American Museum of Natural History, 2011). See also Dwight T. Wallace's underrecognized but insightful discussion of an Inca palace complex at La Centinela on the south Coast of Perú: Wallace, "The Inca Compound at La Centinela," *Andean Past* 5 (1998): 9–34.

19. Craig Morris, "Enclosures of Power: The Multiple Spaces of Inca Administrative Palaces," in *Palaces of the Ancient World*, ed. Susan Toby Evans and Joanne Pillsbury (Washington, DC: Dumbarton Oaks, 2009), 299–323. See also Morris and R. Alan Covey, "La plaza central de Huánuco Pampa: Espacio y transformación," in *Boletín de Arqueología PUCP* 7 (2003): 133–49.

20. *Y llegado al aposento de Atabalipa, en una plaza habia cuatrocientos indios que parecian gente de guardia:* Xerez, *Verdadera Relación*, 82.

21. Alexander von Humboldt, *Vues de Cordillères, et monuments des peoples indigenes de l'Amerique* (Researches, concerning the institutions and monuments of the ancient inhabitants of America), trans. Helen Maria Williams (London: Longman, Hurst, Rees, Orme and Brown, J. Murray and H. Colburn, 1814), vol. II, 9.

22. The construction techniques of elite-status Inca domestic architecture varied considerably. Fieldstone and adobe masonry were relatively common in elite-status Inca structures, as were rubble- and mud-core stone walls. The construction briefly described here characterizes "Cusco-style" stonemasonry techniques, which were employed in only the most prestigious Inca buildings.

23. *A la puerta de esta casa estava un prado el con sus mujeres:* Ruiz de Arce, *Memoria*, 82.

24. *Y Atawallpa estaua en este galponcillo como tengo dicho, sentado en su duho, y una manta muy delgada rrala, que por ella uía, la qual tenían do mugeres, una de un cabo y otra de otro, delante dél, que le tapaban, por que nadie le viese, que lo tenían de costumbre algunos destos señores no ser uistos de sus vasallos sino raras vezes.* Pedro Pizarro, *Relacion*, 32–33.

25. *Y el tirano estaba á la puerta de su aposento sentado en un asiento bajo, y muchos indios delante dél, y mujeres en pié, que cuasi lo rodeaban.* Xerez, *Verdadera Relación*, 82.

26. *Hallaron lo que estaua assentado a la puerta de su casa: con muchas mugeres al derredor del*: Mena, in Pogo, "The Anonymous La Conquista," 236.

27. Joan M. Gero, "Stone Knots and Ceramic Beaus: Interpreting Gender in the Peruvian Early Intermediate Period," in *Gender in Pre-Hispanic America*, ed. Cecelia F. Klein (Washington, DC: Dumbarton Oaks, 2001), 15–55. On Recuay residential structures, see George George F. Lau, *Andean Expressions: Art and Archaeology of the Recuay Culture* (Iowa City: University of Iowa Press, 2011), 67–76.

28. John H. Rowe introduced the term *kancha* into the discourse of Inca culture history: *An introduction to the archaeology of Cusco. Papers of the Peabody Museum of American Archaeology and Ethnology XXVII:2* (Cambridge, MA: Peabody Museum of Archaeology and Ethnology, Harvard University, 1944): 24; "Inca culture at the time of the Spanish conquest," in *Handbook of South American Indians*, Vol. 2, ed. Julian H. Steward, Bureau of American Ethnology Bulletin 143, Vol. 2 (Washington, DC: Smithsonian Institution, 1946): 223. Other early uses of the term include Jean-François Bouchard, *Contribution à l'étude de l'architecture Inca: Establissement de la vallée du Rio Vilcanota-Urubamba (Cahiers d'archéologie et d'ethnologie d'Amérique du Sud* (Paris: Editions de la Maison des Science de l'Homme, 1983). See also Susan Niles, *Callachaca: Style and status in an Inca community* (Iowa City: University of Iowa Press, 1987); Jean-Pierre Protzen, *Inca Architecture and Construction at Ollantaytambo* (Oxford: Oxford University Press, 1993), 53–65.

29. Civility of the home: Barbara Y. Butler, *Holy Intoxication to Drunken Dissipation: Alcohol among Quichua Speakers in Otavalo, Ecuador* (Albuquerque: University of New Mexico Press, 2006), 58–60. Civility of the enclosed animal pen: Penelope Y. Dransart, *Earth, Water, Fleece, and Fabric: An Ethnography and Archaeology of Andean Camelid Herding* (London: Routledge, 2002).

30. For a useful introduction to the comprehension of native Andean palaces in Andean Studies, see Joanne Pillsbury, "The Concept of the Palace in the Andes," in *Palaces of the Ancient New World*, ed. Susan Toby Evans and Joanne Pillsbury (Washington, DC: Dumbarton Oaks, 2005), 181–86.

31. Jerry D. Moore, "Life behind Walls: Patterns in the Urban Landscape on the Prehistoric North Coast of Peru," in *The Social Construction of Ancient Cities*, ed. Monica L. Smith (Washington, DC: Smithsonian Books, 2003), 81–102.

32. George F. Lau, "The Work of Surfaces: Object Worlds and Techniques of Enhancement in the ancient Andes," *Journal of Material Culture* 15: 3 (2010): 259–86.

33. Joanne Pillsbury, "Reading Art without Writing: Interpreting Chimú Architectural Sculpture," in *Dialogues in Art History, from Mesopotamian to Modern: Readings for a New Century*, Studies in the History of Art, Vol. 74 (Washington, DC: Center for Advanced Study in the Visual Arts, 2009), 73–89.

34. For example, blue and yellow feather panels from Huari Pampa Ocoña, ca. 700–850 C.E., including examples in the collections of Dumbarton Oaks (B-522), the Metropolitan Museum of Art, the University Museum of

the University of Pennsylvania, the St. Louis Art Museum, the Dallas Museum of Art, and the Musées Royaux d'Art de d'Histoire, Brussels; see *Andean Art at Dumbarton Oaks*, vol. 2, ed. Elizabeth Hill Boone (Washington, DC: Dumbarton Oaks, 1996), pl. 120, 417–18. See also Heidi King, *Peruvian Featherworks: Art of the Precolumbian Era* (New York/New Haven, CT: Metropolitan Museum of Art/Yale University Press, 2012), 28–30.

35. Museo Arqueologico Rafael Larco Herrera, Lima XSC04002 ML 013682 INC 554444. Recently exhibited in *Peru: Art from Chavín to the Incas* (Paris: Skira/Paris-Musées, 2006) 134/Fig. 155.

36. Felípe Guaman Poma de Ayala, *El primer nueva corónica y buen gobierno* (1615/1616), (Copenhagen, Royal Danish Library, GKS 2232 4°: facsimile at http://www.kb.dk), 342v.

37. Erving Goffman, "Footing," *Semiotica* 25: 1/2 (1979), 5.

38. Tim Ingold, "Culture on the Ground: The World Perceived through the Feet," *Journal of Material Culture* 9:3 (2004): 326–79.

39. Ian S. Farrington, "The Concept of Cusco," *Tawantinsuyu* 5 (1998): 53–59; Thomas B.F. Cummins and Stephen Houston "Body, Presence and Space in Andean and Mesoamerican Rulership," in *Palaces of the Ancient New World*, ed. Susan Tobey Evans and Joanne Pillsbury (Washington, DC: Dumbarton Oaks, 2005), 359–398. See also Susan Elizabeth Ramírez, *To Feed and Be Fed: The Cosmological Bases of Authority and Identity in the Andes* (Stanford, CA: Stanford University Press, 2005), 74–80.

40. See, inter alia, Michel Foucault, "Des Espaces Autres," 1967: trans. "Of Other Spaces," *Diacritics* 16 (Spring 1986): 22–27. On the deictic field, see inter alia, William F. Hanks, "Explorations in the Deictic Field," *Current Anthropology* 46:2 (2005): 191–221.

41. Recently exhibited in *Peru: Art from Chavín to the Incas* (Paris: Skira/Paris-Musées, 2006), Fig. 179/p. 155.

42. E.g. Plumed Headdress, Parabolic Headdress Element, and Funerary Mask, Lambayeque-Sicán Culture. Museo Nacional de Sicán, Ferreñafe Perú. Inv. Nac. 37957 HL-T1-91–61; 37882 HL-T1–91–141/142/143; 37827 HL-T1–91–39; this assemblage was recently exhibited in *Peru: Art from Chavín to the Incas* (Paris: Skira/Paris-Musées, 2006), Fig. 179/p. 155.

43. There is no doubting this passage, for female consorts played a vital role in any noble household's prestige – as wives, child-bearers, servants, and negotiators: see Salomon, *Native Lords of Quito in the Age of the Incas*, 129–30; Ramírez, *To Feed and Be Fed*, 28–9.

44. Margaret Young-Sánchez, *Tiwanaku: Ancestors of the Inca* (Denver/Lincoln, Neb.: Denver Art Museum/University of Nebraska Press, 2004), Fig. 1.9.

45. For the most recent interpretation of Staff God imagery as well as summary of previous scholarship, see Krzysztof Makowski, "Cuando aún no Llegaron los Incas: templos, rituals, y dioses de los Andes centrales (2700 a.C. – 1470 d.C.)," in *Y Llegaron los Incas*, ex. cat. (Madrid: Museo de América, 2006), 35–56, and Makowski, "El Panteón Tiahuanaco y las deidades de báculos," in *Los Dioses de antiguo Perú*, ed. Krzysztof Makowski, vol. II (Lima: Banco de Crédito, 2001), 67–104. Wood: Constantino Manuel Torres, *The Iconography of South American Snuff Trays and Related Paraphernalia* (Göteborg: Etnografiska Museum, 1987), 41–54, 90–96, pls. 76–79. Ceramics: Dorothy Menzel, "Style and Time in the Middle Horizon," *Ñawpa Pacha* 2 (1964): 1–106; Anita G. Cook, *Wari y Tiwanaku: Entre el estilo y la imagen* (Lima: Pontifica Universidad Catolica del Peru, 1994), esp. 183–206; Sergio Jorge Chávez, "Funerary Offerings from a Middle Horizon Context in Pomacanchi, Cusco," *Ñawpa Pacha* 22–23 (1984–85): 1–48; Anita G. Cook, "The Middle Horizon Ceramic Offerings from Conchopata," *Ñawpa Pacha* 22–23 (1984–85): 49–90; William H. Isbell, "Conchopata, Ideological Innovator in Middle Horizon 1a," *Ñawpa Pacha* 22–23 (1984–85):91–126. William H. Isbell and Patricia J. Knoblauch, "Missing Links, Imaginary Links: Staff God Imagery in the South Andean Past," in *Andean Archaeology* III, eds. William H. Isbel and Helaine Silverman (New York: Springer, 2006), 307–51; Krzysztof Makowski, "¿Convención figurativa o personalidad?: Las deidades frontales de báculos en las iconografias Wari y Tiwanaku," in *Huari y Tiwanaku: Modelos vs. Evidencias, segunda parte*, ed. Peter Kaulicke and William H. Isbell; *Boletín de Arqueología PUCP* 5 (2001): 337–73. Weavings: Margaret Young-Sánchez, *Tiwanaku: Ancestors of the Inca* (Denver/Lincoln, Neb.: Denver Art Museum/University of Nebraska Press, 2004),

Figs. 1.9, 2.22, 2.26a. Jeffrey Quilter, "The Moche Revolt of the Objects," *Latin American Antiquity* 1:1 (1990): 42–65; see also Donna McClelland, *Moche Fineline Painting from San Jose de Moro* (Los Angeles: Cotsen Institute of Archaeology at UCLA, 2007).

46. See Note 45, above.

47. Susan A. Niles, "Niched Walls in Inca Design," 277. See also John Hyslop, *Inca Settlement Planning* (Austin: University of Texas Press, 1990), 12–16; Dean, *A Culture of Stone*, 51.

48. See the display of sacred objects in "windows" cited in Polo de Ondegardo's list of waqas of Cusco, reproduced in Brian S. Bauer, *The Sacred Landscape of the Inca* (Austin: University of Texas Press, 1998), e.g., 165 (*Racramirpay*, Ch. 2:2), 169 (*Turuca*, An. 1:2).

49. These fixtures were described as *estantes* by Cieza de León, and *tabernáculos* by Garcilaso de la Vega: Brian S. Bauer, *Ancient Cusco: Heartland of the Inca* (Austin: University of Texas Press, 2004), 148–49.

50. Before the Spanish arrival in the Andes the object was housed in the main temple of the Inca state, the Cuzco Qurikancha. In the upheaval of the Spanish invasion, the Inca leadership carefully sequestered and stewarded the object; the *Punchao* was kept from the Spanish until its capture in the sack of Vilcabamba in 1572. Garcilaso, "twice as wide as those planks used to cover the walls" (i.e., two *palmos*): Duviols, 157. *Una tercia*: Bernabe Cobo, *Historia del Nuevo Mundo*, ed. D. Marcos Jiménez de la Espada (Seville: Rasco, 1893), Chapter 12, 9.

51. *Tenia una manera de patenas de oro a la redonda para que dandoles el sol relumbrasen de manera que nunca pudiesen ver el ydolo sino el resplandor.* Letter of Francisco Toledo to Spanish king in late 1572, cited in Catherine Julien, "History and art in translation: The *paños* and other objects collected by Francisco Toledo," *Colonial Latin American Review* 8:1 (1999), (61–89) 81 n. 7 (cites D. Roberto Levillier, *Gobernantes del Perú: Cartas y Papeles Siglo XVI*, vol. 4 [Madrid: Juan Pueyo, 1924], 344–45). Pierre Duviols, "'Punchao': Idolo Mayor del Coricancha, Historia y Tipologia," *Antropolgía Andina* 1–2 (1976): 156–83.

52. For descriptions of this niche, see John H. Rowe, *An Introduction to the Archaeology of Cuzco: Expeditions to Southern Peru Peabody Museum, Harvard University Report No. 2* (Cambridge, MA: Peabody Museum, Harvard University, 1944), 30–32.

53. "Field Guardians," John H. Rowe, *An Introduction to the Archaeology of Cusco. Papers of the Peabody Museum of American Archaeology and Ethnology*, Vol. XXVII, no. 2 (Cambridge, MA: Peabody Museum of American Archaeology and Ethnology, Harvard University, 1944), 317. See also Pierre Duviols, "Un Symbolisme de l'occupation, de l'aménagement et de l'exploitation de l'espace: Le Monolithe 'huanca' et sa fonction dans les Andes préhispaniques," *L'Homme* 19:2 (1979): 7–31.

54. On the Chinkana Grande, or the "Tired Stone," see Maarten van de Guchte, "El ciclo mítico andino de la piedra cansada," *Revista Andina* 2:2 (1984): 539–56; Van de Guchte, "'Carving the World': Inca Monumental Sculpture and Landscape" (Ph.D. dissertation, Department of Anthropology, University of Illinois Urbana/Champaign, 1992), 119–42.

55. Albert Meyers, "Toward a Reconceptualization of the Late Horizon and the Inca Period," in *Variations in the Expression of Inka Power*, 238.

56. Luis A. Llanos, "Informe sobre Ollantaytambo: Trabajos arqueológicos en el Departamento del Cusco bajo la Dirección del Dr. Luis E. Valcarcel," *Revista del Museo Nacional, II Semestre* 5:2 (1936), 154; Walter Krickeberg, *Felsplastik und Felsbilder bei den Kulturvölkern Altamerikas* (Berlin, 1949), plate 5b; Heinrich Ubbelohde-Doering, *On the Royal Highway of the Inca* (Tübingen: Verlag Ernst Wasmuth, 1956), 262; John Hemming and Edward Ranney, *Monuments of the Incas* (New York: New York Graphic Society, 1982), 159 and 174; Kendall, *Aspects of Inca Architecture*, 364–70; van de Guchte, "Carving the World," 191–94.

57. Taplin, "The Shape of Power"; Graziano Gasparini and Louise Margolies, *Inca Architecture*, trans. Patricia J. Lyons (Bloomington: Indiana University Press, 1980), 105–08. See also the insightful commentary on Inca framing by Dean, *A Culture of Stone*, 27–28.

58. On enfilade doorways in the design of Inca palaces, see Gasparini and Margolies, *Inca Architecture*, 105–08.

59. David S. P. Dearborn and Raymond E. White, "The 'Torreón' at Machu Picchu as an Observatory," *Archaeoastronomy* 5 (1983): S37–S49;

see also Dearborn, Katharina J. Schreiber, and Raymond E. White, "Intimachay, a December Solstice Observatory," *American Antiquity* 52 (1987): 346–52.

60. On the discourse of enemies-as-ancestors as a formalized mode of diplomatic engagement in the colonial era, see Peter Gose, *Invaders as Ancestors: On the Intercultural Making and Unmaking of Spanish Colonialism in the Andes* (Toronto: University of Toronto Press, 2008), 36–80, esp. 49–51.

61. For an overview of ancestor veneration in the politics of Andean and Inca communities and descent-groups, see William H. Isbell, *Of Mummies and Mortuary Monuments: A Postprocessual Prehistory of Andean Social Organization* (Austin: University of Texas Press, 1997). Atawallpa's presentation in the inner courtyard of his palace above Cajamarca may be considered as an instance of what Isbell describes as "the open sepulcher" (75).

62. Pierre Duviols, "'Camaquen, upani': Un Concept animiste des anciens Péruviens," in *Amerikanische Studien: Festschrift für Hermann Trimborn*, ed. R. Hartmann and U. Oberem) (St. Augustin, Switzerland: Collectanea Instituti Anthropos 1978), 32–144; Duviols, "Un Symbolisme de l'occupation, de l'aménagement et de l'exploitation de l'espace"; A. Alonso, "Las Momias de los Incas: su función y realidad social," *Revista Española de Antropología Americana* 19 (1989), 109–35; Maarten Van de Guchte, "Sculpture and the concept of the double meaning among the Inca Kings," *RES* 29/30 (1996): 256–69; Frank Salomon, "The Beautiful Grandparents: Andean Ancestor Shrines and Mortuary Ritual as seen through Colonial Records," in *Tombs for the Living: Andean Mortuary Practices*, ed. T. Dillehay (Washington, DC: Dumbarton Oaks, 1995), 331–53; George F. Lau, "Ancestor Images in the Andes," *The Handbook of South American Archaeology IX* (2008): 1027–45. See also Dean, *A Culture of Stone*, 44–46, 123–26.

63. On the *t'oqo* and myths of ethnogenesis, see the extended account of Inca dynastic origins in Gary Urton, *The History of a Myth: Pacaritambo and the Origin of the Incas* (Austin: University of Texas Press, 1990). See also R. T. Zuidema, "Shaft Tombs," *Journal of the Steward Anthropological Society* 9 (1977): 133–78.

64. The mythology surrounding the Andean *t'oqo* is both complex and regionally particular; its iteration among the pre-contact Inca leadership remains poorly understood. Nevertheless, it is clear that as a *paqarina*, the *t'oqo* also possessed funerary associations. In the burial practice associated with wall tombs, ancestors were re-inserted into the opening whence they had emerged – a practice grounded in one of the documented myths of Inca dynastic foundation. Squared wall tombs and rectangular cave openings are common in the Andes, as at the site of Otuzco, a pre-Inca site near Cajamarca.

65. The cave at Choquequilla may be identified as a *paqarina* once associated with some important local ancestor or founder of an ethnic group allied with the Inca leadership. Choquequilla's ideological association with wall-tombs is made further evident in the portion of the cave opposite the carved wall: here the Inca inserted a masonry wall articulated with rows of trapezoidal niches. These forms imitate the traditional motif of the wall-tomb, establishing the fundamental association of the cave with ancestors and practices of ancestor-veneration. These themes are in turn simplified and concentrated in the large niche on the cave's opposite wall.

66. Georg Simmel, "Sociology of the Senses: Visual Interaction," in *Introduction to the Science of Sociology*, ed. R. E. Park and E. W. Burgess (Chicago: University of Chicago Press, 1921), cited in Michael Argyle and Janet Dean, "Eye-Contact, Distance and Affiliation," *Sociometry* 28:3 (1965), 289.

67. Constance Classen, "Sweet Colors, Fragrant Songs: Sensory Models of the Andes and the Amazon," *American Ethnologist* 17 (1990), 726; cites Juan de Santa Cruz Pachacuti Yamqui Salcamayhua, *Relación de antigüedades deste Reyno del Perú* (1613; reprint Asunción, Paraguay: Editorial Guaraní, 1950), 230. Eyes and felines: Felipe Guaman Poma de Ayala, *Nueva Corónica y buen gobierno* (1615/6), 109v., facsimile at www.kb.dk/permalink/2006/poma.

68. M. Lopez Baralt, "The Quechua Elegy to the All-Powerful Inca Atawallpa," *Latin American Indian Literatures* 4 (1980): 79–86; cited by Sabine MacCormack, "Pachacuti: Miracles, Punishments, and Last Judgment," *American Historical Review* 93:4 (1988), 1001.

69. Adam Herring, "'Shimmering Foundation': The Twelve-Angled Stone of Inca Cusco," *Critical Inquiry* 37:1 (2010), 89–90.

70. The word *tupaq* numbers among the most important and enigmatic titles born by Inca leaders. Its understanding is clouded by the complex and understudied cultural discourse of pre-contact Inca noble and royal titles. The word *tupay* is recorded in Quechua lexica as a verb describing "meeting" or "joining," a gloss that likely appeals to Andean understandings of complementarity and integrity (Esteban Hornberger and Nancy Hornberger, *Diccionario tri-lingue quechua de Cusco* [Lima: Centro de Estudios Andinos Bartolome de Las Casas: 2008]; also Willem F. H. Adelaar, *Tarma Quechua: Grammar, Texts, Dictionary* [Lisse: Peter de Ridder, 1977], 484: "to but, run against, to meet.") Translation of the term is further complicated by inconsistencies in colonial-era transcription: the term appears in colonial-era accounts variously as *tupaq* and *thupa*. The aspirated initial consonant form of the word stem *tupa/thupa* probably represents a courtly honorific that eluded transcription in early Spanish lexica. Its alternative, *tupaq*, likely presents an agentive form of the Quechua verbstem *thupani*, "to file/saw/polish/sharpen/cut" (Jan Szemiński, *Léxico de Fray Domingo de Santo Tomás, 1560* [Lima: Convento de Santo-Domingo-Qorikancha/Sociedad Polaca de Estudios Latinoamericanos/Universidad Hebrea de Jerusalén, 2006], 562–63.) The title relates to actions of physical intervention that effect an alteration to the object's physical form – cutting, filing, sawing. The term implies the wielding of transformative physical force – usually some form of splitting or parsing – as well the exercise of astute judgment in this action. The agentive expression *tupaq* then describes the practitioner who applies the measured application of physical force.

71. Terence D'Altroy, *The Incas* (Oxford: Blackwell, 2002), 235 (cites Juan de Betanzos, *Narrative of the Incas* [1557], trans. Roland Hamilton and Dana Buchanan [Austin: University of Texas Press, 1996], 110–11).

72. I. S. Farrington, "The Concept of Cusco," *Tawantinsuyu* 5 (1998): 53–59; Thomas B. F. Cummins and Stephen Houston "Body, Presence and Space in Andean and Mesoamerican Rulership," in *Palaces of the Ancient New World*, ed. Susan Tobey Evans and Joanne Pillsbury (Washington, DC: Dumbarton Oaks, 2005), 359–98. See also Susan Elizabeth Ramírez, *To Feed and Be Fed: The Cosmological Bases of Authority and Identity in the Andes* (Stanford, CA: Stanford University Press, 2005), 74–80.

73. Guaman Poma also cited Rumi Ñawi, describing him as a traitor (*Corónica*, 163 [165]). Here Poma's politics as a servant of the Spanish administration determined his view of Atawallpa's general.

74. Rodolfo Cerrón Palomino, personal communication, 11/3/2011. On Quechua linguistic inflections of *rumi*, see also Dean, *A Culture of Stone*, 25. See also Rosaleen Howard, "Rumi: An Ethnolinguistic Approach to the Symbolism of Stone(s) in the Andes," in *Kay Pacha: Cultivating Earth and Water in the Andes*, ed. Penelope Dransart (BAR/Oxford: Archaeopress, 2006), pp. 233–45.

75. This incident falls within a complicated mythological account involving the migrations of the founding Inca siblings following their emergence from the cave of origin (*Tambo T'oqo*). It relates specifically to the violence of one of those siblings, though it also expresses the aggression of which all the founding siblings – and their heirs, the Inca leadership – are capable. Juan de Betanzos, *Suma y Narración de los Incas* (1551), trans. and ed. Maria del Carmen Martin Rubio (Madrid: Atlas, 1987), 18: *y subiendo un día al cerro Guanacaure para de allí mirar y divisar donde fuse major asiento y sitio para poblar y subiendo ya encima del cerro Ayarcache que fue el primero que salió de la cueva sacó su honda y pose en ella una piedra y tiróla a un cerro alto y del golpe que dio derribó el cerro y hizo en él una quebrada y ansi mismo tiró otras tres piedras y hizo de cada tiro una quebrada grande en los cerros altos . . .*

76. Diego de González Holguín, *Vocabulario de la lengua general de todo el Perú llamada lengua qquichua o del Inca* (1608; reprint Lima: Universidad Nacional Mayor de San Marcos, 1989), 258: *ojos, o fiel del peso, o punta, o vista, o rostro, o haz*. Jan Szemiński, *Léxico de Fray Domingo de Santo Tomás, 1560* (Lima: Convento de Santo-Domingo-Qorikancha/Sociedad Polaca de Estudios Latinoamericanos/Universidad Hebrea de Jerusalén, 2006), 356: *ñawi: ojos . . . filo de cuchillo . . . punta de cosa aguda.*

77. Holguín, *Vocabulario*, 258: *Nauiyokrumi: La piedra que tiene haz. Llana por una parte.*

78. Louis Marin, *Portrait du roi* (Paris: Éditions de Minuit, 1981), 88.

79. On Inca *wawki*, see Maarten Van de Guchte, "Sculpture and the Concept of the Double among the Inca Kings," 256–69; Peter Gose, "Oracles, Divine Kingship, and Political Representation in the Inca State," *Ethnohistory* 43:1 (1996): 19–20; Carolyn Dean, *Culture of Stone*, 41–45.

80. On "the court in motion," see Dennis Ogburn, "Dynamic Display, Propaganda, and the Reinforcement of Provincial Power in the Inca Empire," *Archaeological Papers of the American Anthropological Association* 14 (2005): 225–39.

81. Marin, *Portrait*, 87–88. See also commentary by Jacques Derrida, *The Beast and the Sovereign, Volume 1*, trans. Geoffrey Bennington (Chicago: University of Chicago Press, 2009), 292–96.

82. Ruiz, *La Memoria*, 83.

83. On Inca tunics and *t'oqapus*, see John H. Rowe, "Standardization in Inca Tapestry Tunics," in *The Junius B. Bird Pre-Columbian Textile Conference*, 1973, ed. Ann Pollard Rowe, Elizabeth P. Benson, and Anne-Louise Schaffer (Washington, DC: Textile Museum and Dumbarton Oaks, 1979): 239–64; John H. Rowe and Ann Pollard Rowe, "Inca Tunics," in *Andean Art at Dumbarton Oaks*, vol. 2 (Washington, DC: Dumbarton Oaks, 1996): 453–66; Anne Pollard Rowe, "Inca Weaving and Costume," *The Textile Museum Journal* 34:5 (1997): 5–54; Mary Frame, "Los vestidos del Sapa Inca, la Coya, y los nobles del imperio," in *Señores de los Imperios del Sol*, ed. Krysztof Makowski (Lima: Banco de Crédito, 2010), 261–81.

84. On Inca military tunics, see the extended bibliography in Stone-Miller, *To Weave for the Sun: Ancient Andean Textiles* (New York: Thames and Hudson, 1992), 172. "Chessboards": *vestidos de una librea de colores á manera de escaques*, Xerez, *Verdadera Relación*, 89; *libreas blancas y colorada, a manera de ajedrez*, Trujillo, *Relación del Descubrimiento*, 133; *de librea como de juego de axedrez*, Ruiz de Arce, *Memoria*, 85; note also Murúa, *Historia del orígen y genealogía real de los Reyes Incas del Perú*, ed. Constantino Bayle (Madrid, [1590] 1946), 215, Book 3, Chapter 21. Cited by R. Tom Zuidema, "Guaman Poma and the Art of Empire: Toward an Iconography of Inca Royal Dress," in *Transatlantic Encounters: Europeans and Andeans in the Sixteenth Century*, ed. Kenneth J. Andrien and Rolena Adorno (Berkeley: University of California Press, 1991), 195 n. 38.

85. See Max Uhle, "Explorations in Chincha," *University of California Publications in American Archaeology and Ethnology* (Berkeley: University of California Press), 12: 2 (1924): 55–94. See also Dwight T. Wallace, "The Inca Compound at La Centinela," *Andean Past* 5 (1998): 9–34; R. Alan Covey, "Inca Administration of the Far South Coast of Peru," *Latin American Antiquity* 11:2 (2000): 119–38; Craig Morris and Julián Idilio Santillana, "The Inca Transformation of the Chincha Capital," in *Variations in the Expression of Inka Power*, ed. Richard R. Burger, Craig Morris, and Ramiro Matos Mendieta (Washington, DC: Dumbarton Oaks, 2007), 135–64.

86. See *Andean Art at Dumbarton Oaks*, vol. 1, ed. Elizabeth Hill Boone (Washington, DC: Dumbarton Oaks, 1996). On the all-*t'oqapus* pattern, see Zuidema, "Guaman Poma and the Art of Empire," in *Transatlantic Encounters*, 195; Mary Frame, "What Guaman Poma Shows Us, but Does Not Tell Us, About *tukapu*," *Ñawpa Pacha* 30:1 (2010): 25–52. This pattern is exceedingly rare within the inventory of known Inca tunics. Atawallpa may or may not have worn a tunic of this pattern when he met his Spanish visitors above Cajamarca; if he did not, the tunic nevertheless reveals important aspects of his personhood and social being.

87. On these illustrations, see Elena Phipps, Nancy Turner, and Karen Trentelman, "Colors, Textiles, and Artistic Production in Murúa's *Historia General del Piru*," in *The Getty Murúa: Essays on the Making of Martín de Murúa's "Historia general del Piru," 1616, Ms. Ludwig XIII 16*, ed. Thomas B. F. Cummins and Barbara Anderson (Los Angeles: J. Paul Getty Trust, 2008), 125–46; Thomas B. F. Cummins, "The Images in in Murúa's *Historia General del Piru*: An Art Historical Study," in *The Getty Murúa: Essays on the Making of Martín de Murúa's "Historia general del Piru," 1616, Ms. Ludwig XIII 16*, 147–74.

88. Rebecca R. Stone, "'And All Theirs Different from His': The Dumbarton Oaks Royal Inka Tunic in Context," in *Variations in the Expression of Inka Power*, Richard R. Burger, Craig Morris, and Ramiro Matos Mendieta, eds. (Washington, DC: Dumbarton Oaks, 2007), 385–422.

89. Pizarro, *Relación*, 33.

90. "Entrapment": Alfred Gell, "Vogel's Net: Traps as Artworks and Artworks as Traps," *Journal of Material Culture* 1:1 (1996): 15–38.

91. Rosemarie Garland-Thomson, "Ways of Star-ing," *Journal of Visual Culture* 5 (2006), 175.

CHAPTER 3

1. Francisco de Xerez, *Verdadera Relación de la Conquista del Perú* [1534] (Madrid: Tip. de J. C. Garcia, 1891), 81.

2. John V. Murra, "Cloth and Its Function in the Inca State," *American Anthropologist* 64:4 (1962): 710–24, esp. 717. The classic studies of Inca storage and redistribution include John V. Murra, *Formaciones económicas y políticas del mundo andino* (Lima: Instituto de Estudios Andinos, 1975), 241–54; Craig Morris, "Storage in Tawantinsuyu," Ph.D. dissertation, University of Chicago, 1967; Terence N. D'Altroy and Timothy K. Earle, "Staple Finance, Wealth Finance, and Storage in the Inka Political Economy," *Current Anthropology* 26:2 (1985): 187–206.

3. Cieza de León, *El Descubrimiento y Conquista del Perú* (1553), ed. Carmelo Sáenz de Santa Maria (Madrid: Historia 1984), Chapter 48, 165–68.

4. Diego de Trujillo, *Relación del Descubrimiento del Reino del Perú* [1571], in *Tres testigos de la conquista*, ed. Conde de Carnilleros (3rd ed. Madrid, 1954), 129.

5. *No podré dezir los depósitos que vide de rropas de todos géneros que este rreyno hazían, que faltaría tiempo para vello y entendimiento para comprender tanta cosa.* Pedro Pizarro, *Relación del descubrimiento y conquista del Peru* [1571], ed. Guillermo Lohmann Villena and Pierre Duviols (Lima: Pontífica Universidad Católica del Perú, 1978), 100.

6. These literary descriptions of checker-pattern Inca costume would determine much early modern representation of Inca costume. An "Inca" figure dressed in checker-pattern appears in Cesare Vecellio, *Habiti antichi, et moderni di tutto il mondo. Vestitius Antiquorum, Recentiorumque Totius Orbis* (Venice: Giovanni Bernardo Sessa, 1598), fol. 487v.

7. On chess in Iberia, see Olivia Remie Constable, "Chess and Courtly Culture in Medieval Castile: The Libros del Ajadrez of Alfonso X, El Sabio," *Speculum* 82 (2007): 301–47.

8. For a brief commentary on the erotics of chess in the art of the late Medieval era, see Michael Camille, *The Medieval Art of Love: Objects and Subjects of Desire* (London: Laurence King, 1998), 124–26.

9. Julie Jones, *Art of Empire: The Inca of Peru* (New York: Museum of Primitive Art, 1964), 42.

10. See also César Paternosto, *The Stone and the Thread: Andean Roots of Abstract Art* (Austin: University of Texas Press, 1996).

11. See Adam Herring, "An Archaeology of Abstraction: *Ollantaytambo,*" *World Art* 3:1 (2013): 41–65.

12. Here my analysis of Inca militarism is indebted to the classic study of Inca warfare, Joseph Bram, *An Analysis of Inca Militarism* (New York: Augustin, 1941).

13. Trujillo, *Relación*, 133.

14. This group is more shadowy. Rumi Ñawi, the general identified as the commander of this detachment, did escape Cajamarca with a large force. Pedro Pizarro wrote: *Aquesta misma noche despacho Atagualpa veinte mill yndios con un capitan suyo, que se llamaua Lumenaui, con muchas sogas, que tomasen las espaldas a los espanoles y secretamente estuuiesen para que quando huyesen diesen en ellos y los atasen, creyendo que otro dia, uista la mucha xente que lleuaua, todos se auian de huir.* ["That same night, Atabalipa despatched twenty thousand soldiers, under a captain of his called Lumenavi, with many ropes, to capture the rear-guard of the Spaniards, and secretly they awaited the time when they [the Spaniards] should flee so that they might attack them and tie them up . . ."], Pedro Pizarro, *Relación del Descubrimiento y Conquista del Peru,* ed. Guillermo Lohmann Villena (Lima: Pontifica Universidad Catolica del Peru, 1978), 177. Pedro Cieza de León also noted that Rumi Ñawi (*Rumiñabi*) had been sent off with a large detachment intended to catch the Spanish with nets (Cieza *Descubrimiento*, Chapter 43). On Rumi Ñawi's later campaigns in Ecuador, see Frank Salomon, *Native Lords of Quito in the Age of the Incas: The Political Economy of North Andean Chiefdoms* (Cambridge: Cambridge University Press, 1986), 148–50, 182–84.

15. Susan Elizabeth Ramírez, *To Feed and Be Fed: The Cosmological Bases of Authority and Identity in the Andes* (Stanford, CA: Stanford University Press, 2005), 179–91. See also José Luís Martínez Cereceda, *Autoridades en los Andes: Los atributos del señor* (Lima: Pontífica Universidad Católica del Perú, 1995), 106–07.

16. Mena, in Alexander Pogo, "The Anonymous *La Conquista Del Peru* [Seville, April 1534] and the *Libro Vltimo Del Svmmario Delle Indie*

Occidentali [Venice, October 1534]," *Proceedings of the American Academy of Arts and Sciences* 64:8 (1930), 234.

17. R. Alan Covey, *How the Incas Built Their Heartland: State Formation and the Innovation of Imperial Strategies in the Sacred Valley, Peru* (Ann Arbor: University of Michigan Press, 2006), 172–78, 225–26.

18. Christine A. Hastorf and Sissel Johannessen, "Pre-Hispanic Political Change and the Role of Maize in the Central Andes of Peru," *American Anthropologist* (ns) 95:1 (1993): 115–38. See also Justin Jennings, "La Chichera y El Patrón: Chicha and the Energetics of Feasting in the Prehistoric Andes," *Archeological Papers of the American Anthropological Association* 14:1 (2004): 241–59; Tamara L. Bray, "To Dine Splendidly: Imperial Pottery, Commensal Politics, and the Inka State," in *The Archaeology and Politics of Food and Feasting in Early States and Empires*, ed. Tamara L. Bray (New York: Kluwer/Plenum, 2003), 93–142; also Paul S. Goldstein, "From Stew-Eaters to Maize-Drinkers: The *Chicha* Economy and the Tiwanaku Expansion," *The Archaeology and Politics of Food and Feasting in Early States and Empires*, ed. Tamara L. Bray, (New York: Kluwer/Plenum, 2003), 143–72; Timothy Earle and Cathy Lynne Costin, "Status Distinction and Legitimation of Power as Reflected in Changing Patterns of Consumption in Late Prehispanic Peru," *American Antiquity* 54:4 (1989): 691–714.

19. Peter Gose, "The State as a Chosen Woman: Brideservice and the Feeding of Tributaries in the Inka Empire," *American Anthropologist* (n.s.) 102:1 (2000): 84–97. For a recent discussion of feasting and imperial politics, see Donna Nash, "The Art of Feasting: Building an Empire with Food and Drink," in *Wari: Lords of the Ancient Andes*, ed. Susan E. Bergh (New York/Cleveland: Thames and Hudson/Cleveland Museum of Art, 2012), 82–102.

20. "Much of the significance of maize beer rested on its power to symbolize the agricultural economy upon which society depended . . . the Inka strove to make maize itself a royal food . . . making chicha into a symbol of empire": Mary J. Weismantel, "Maize Beer and Andean Social Transformations: Drunken Indians, Bread Babies, and Chosen Women," *Modern Language Notes* 106: 4 (1991), 875–76.

21. This is associated with the American school of cultural ecology, derived from the writings of V. Gordon Childe, *Man Makes Himself* (London: Watts, 1951), Leslie White, *The Evolution of Culture* (New York: McGraw-Hill, 1959) and Julian Steward, *Theory of Culture Change* (Urbana/Champaign: University of Illinois Press, 1960).

22. Felipe Guaman Poma de Ayala, *El primer nueva corónica y buen gobierno* (1615/1616) (Copenhagen, Royal Danish Library, GKS 2232 4°: facsimile at http://www.kb.dk), 31v.

23. D'Altroy and Earle, "Staple Finance," 191.

24. R. Tom Zuidema, "The Lion in the City: Royal Symbols of Transition in Cusco," in *Animal Myths and Metaphors in South America*, ed. Gary Urton (Salt Lake City: University of Utah Press, 1985), 194–96.

25. On the Incas' frontiers, see essays in Tom Dillehay and Patricia J. Netherly, eds., *La Frontera del estado Inca* (Oxford: BAR International, 1988); Rodolfo Raffino, *Los Inkas del Kollasuyu* (2nd ed.) (La Plata, Argentina: Romas Adriaca Editora, 1983); Raffino, *Inka: Arqueología, historia, y urbanismo del altiplano andino* (Buenos Aires: Corregidor, 1993); Terence N. D'Altroy, *The Incas* (Oxford: Blackwell 2002), 257–58.

26. Cummins, *Toasts with the Inca*, 193–94. See also See Carolyn Dean, "War Games: Indigenous Militaristic Theater in Colonial Peru," in *Contested Visions of the Spanish Colonial World*, ed. Ilona Katzew (Los Angeles: LACMA, 2011), 132–49.

27. See Frank Salomon, *Native Lords of Quito*, 143–86.

28. Terence N. D'Altroy, *Provincial Power in the Inca Empire* (Washington, DC: Smithsonian, 1992), 77; D'Altroy, *The Incas* 67–68. On Inca provincial centers, see Lawrence Coben, "Other Cuscos: Replicated Theaters of Inka Power," in *Archaeologies of Performance: Theaters of Power, Commnity, and Politics*, ed. Takeshi Inomata (Lanham, MD: Altamira Press, 2006), 223–59.

29. Xerez, *Verdadera Relación*, 86; Pedro Pizarro, *Relación*, 175.

30. Craig Morris, "The Infrastructure of Inca Control in the Peruvian Central Highlands," in *The Inca and Aztec States, 1400–1800: Anthropology and History*, ed. George A. Collier, Renato I. Rosaldo, and John D. Wirth (New York: Academic Press, 1982), 153–71.

31. *No esperauamos otro Socorro, sino el de Dios*. Mena, in Pogo, "The Anonymous," 234.

32. Gary Urton, *The History of a Myth: Pacariqtambo and the Origin of the Incas* (Austin: University of Texas Press, 1990), 8.

33. Jan Szeminski, "Wana Kawri Waka," in *El Culto Estatal del Imperio Inka: Memorias del 46th Congreso Internacional de Americanistas, Amsterdam, 1988*, ed. Mariusz S. Ziólkowski (Warsaw: University of Warsaw, 1991), 35–53; Mariusz S. Ziólkowski, *La Guerra de los Wawqis: Los Objectivos y los mechanismos de la rivaldad dentro de la élite Inka, siglos XV y XVI* (Quito: Biblioteca Abya-Yala, 1997), 65–71, 156–64.

34. See, for instance, Cieza de León, *Second Part of the Chronicle of Peru*, trans. Clement Markham [1883] (reprint Cambridge: Cambridge University Press, 2010), Chapter 7,17: "[The Inca nobility] say that the practice of assuming the [costume] and arming the knights began here [Huanacauri]." On Huanacauri, with references to the mountain's appearance in colonial histories, see John H. Rowe, *An Introduction to the Archaeology of Cusco. Papers of the Peabody Museum of American Archaeology and Ethnology*, Vol. XXVII, no. 2 (Cambridge, MA: Peabody Museum of American Archaeology and Ethnology, Harvard University, 1944), 41–43. For a challenging alternative account of native Andean reverence for mountains, see Peter Gose, *Invaders as Ancestors: On the Intercultural Making and Unmaking of Spanish Colonialism in the Andes* (Toronto: University of Toronto Press, 2008).

35. Carolyn Dean, *Culture of Stone: Inka Perspectives on Rock* (Durham and London: Duke University Press, 2010), 154–5. Dean cites Bernabé Cobo, *Inca Religions and Customs* [1653], ed. and trans. Roland Hamilton (Austin: University of Texas Press, 1990), 74.

36. *Era mediana, sin figura, y algo ahusada… Lleuauan este ídolo a la guierra mui de ordinario, partiularmented quando yua el Rey en persona: y Guayna capa lo lleuo a Quito, de donde lo tornaron a traer con su cuerpo. Porque tenian entindido los incas que hauia sido gran parte en sus vitorias* (cited in Cobo's account as *wak'a* Collasuyu 6:7, transcribed in John Howland Rowe, "An Account of the Shrines of Ancient Cuzco," *Ñawpa Pacha* 17 (1979), 46–47).

37. Frank M. Meddens, Colin McEwan, and Cirilio Vivanco Pomacanchari, "Inka 'Stone Ancestors' in Context at a High-Altitude *Usnu* platform," *Latin American Antiquity* 21:2 (2010), 181–88.

38. María Nieves Zedeño, "Animating by Association: Index Objects and Relational Taxonomies," in *Cambridge Archaeological Journal* 19:3 (2009): 407–17.

39. Pierre Duviols, "'Camaquen, upani': Un Concept animiste des anciens Péruviens," in *Amerikanische Studien: Festschrift für Hermann Trimborn*, ed. R. Hartmann and U. Oberem (St. Augustin, Switzerland: Collectanea Instituti Anthropos 1978), 32–144; Duviols, "Un Symbolisme de l'occupation, de l'aménagement et de l'exploitation de l'espace"; A. Alonso, "Las Momias de los Incas: su función y realidad social," *Revista Española de Antropología Americana* 19 (1989), 109–35; Maarten Van de Guchte, "Sculpture and the Concept of the Double Meaning among the Inca Kings," *RES: Anthropology and Aesthetics* 29/30 (1996): 256–69; Frank Salomon, "The Beautiful Grandparents: Andean Ancestor Shrines and Mortuary Ritual as Seen through Colonial Records," in *Tombs for the Living: Andean Mortuary Practices*, ed. T. Dillehay (Washington, DC: Dumbarton Oaks, 1995), 331–53. On hard and compact vital things in the Quechua tradition, see Catherine J. Allen, *The Hold Life Has: Coca and Cultural Identity in an Andean Community* (Washington, DC: Smithsonian Institution, 1988), 63.

40. Van de Guchte, "Sculpture and the Concept of the Double among the Inca Kings," 256–69; on Manqo Qhapaq and Huanacauri, see esp. 265–66. See also Peter Gose, "Oracles, Divine Kingship, and Political Representation in the Inka State," *Ethnohistory* 43:1 (1996): 19–20; Carolyn Dean, *Culture of Stone*, 41–45.

41. Peter Gose, "Oracles," 1–32.

42. On last day of the month before the December solstice "*la statua llamada Huyna Punchao*" was carried "*a las casas del sol llamadas puquin*": Cristóbal de Molina, *Fábulas y Mitos de los Incas* [1585], ed. Henrique Urbano and Pierre Duviols (Madrid: Historia, 1988), 60; on this ritual, see also Brian S. Bauer, *The Sacred Landscape of the Inca* (Austin: University of Texas Press, 1998), 129–30.

43. This is the oracle of Pachacamac, which is recorded to have been understood as a "sibling" to the Inca sun god: see Catherine Julien, "Punchao en España," in *El Hombre y los Andes: Homenaje a Franklin Pease G. Y.*, ed. Javier Flores Espinoza and Rafaél Varón Gabai (Lima,

Pontificia Universidad Católica del Perú, 2002), 73–78.

44. These effigies were "Lord/Father Sun" (*Apu Inti*), "Child Sun" (*Punchao*, or *Churi Inti*), Sun's Double-Effigy (*Inti Guauhqui*): see Bernabe Cobo, *Inca Religion and Customs*, trans. Roland Hamilton (Austin: University of Texas Press, 1990), Book I, Chapter 5, 25–28.

45. See See also William Isbell, *Mummies and Mortuary Monuments: A Postprocessual prehistory of Central Andean Social Organization* (Austin: University of Texas Press, 1977), 84.

46. "Place Changing": Davíd Carrasco, *To Change Place: Aztec Ceremonial Landscapes* (Boulder: University of Colorado Press, 1991).

47. Molina, *Fábulas y mitos*, 20–21; Francisco de Avila, in *Dioses y hombres de Huarochiri* (1608), trans. J. M. Arguedas (Lima, 1966), Chapter 5; Sarmiento de Gamboa, *Historia*, Chapter 6, 207a; Cabello Valboa, *Miscelánea Antártica*, 3.9, 262. See also R. T. Zuidema, "La Imagen del sol y la huaca de Susurpuquio en el sistema astronómico de los Incas en el Cusco," *Journal de la Société des Américanistes* 63 (1974–6): 199–230; Sabine MacCormack, "Pachacuti: Miracles, Punishments, and Last Judgment," *American Historical Review* 93:4 (1988), 998–1003; Brian S. Bauer, "Pacariqtambo and the Mythical Origins of the Inka," *Latin American Antiquity* 2:1 (Mar., 1991), 7–26. See also Dean, *Culture of Stone*, 36 and 194–95 n. 39.

48. On the dynastic myth's transformations in the colonial era, see insightful analysis of Gary Urton, *The History of a Myth*.

49. Thérèse Bouysse-Cassagne, "Urco and uma: Aymara concepts of space," in *Anthropological History of Andean Polities*, ed. John V. Murra, Nathan Wachtel, and Jacques Revel (London: Cambridge University Press, 1986), 205; Carolyn Dean, *Culture of Stone*, 132–33.

50. On the importance of mountains in Inca ritual practice, see Thomas Besom, *Of Summits and Sacrifice: An Ethnohistoric Study of Inka Religious Practices* (Austin: University of Texas Press, 2009); Besom, *Inca Human Sacrifice and Mountain Worship: Strategies for Empire Unification* (Albuquerque: University of New Mexico Press, 2013).

51. Atpitan, *Huaca* Co. 1:6 (Brian S. Bauer, *The Sacred Landscape of the Inca* [Austin: University of Texas Press, 1998], 171), and 217 n. 10; Cumpu Huanacauri, "avalanche Huanacauri," *Huaca* Cu.5:5 (Bauer, *Sacred Landscape*, 175).

52. Peter Gose, "Mountains Historicized: Ancestors and Landscape in the Colonial Andes," in *Kay Pacha: Cultivating Earth and Water in the Andes*, ed. Penelope Dransart (Oxford: BAR International, 2006), 29–28. On mountain effigies in Andean ritual practice, see also Catherine J. Allen, "When Pebbles Move Mountains," in *Creating Context in Andean Cultures*, ed. Rosaleen Howard-Malverd, Oxford Studies in Anthropological Linguistics (Oxford: Oxford University Press, 1997), 73–83.

53. Felipe Guaman Poma de Ayala, *El primer nueva corónica y buen gobierno* (1615/1616), (Copenhagen, Royal Danish Library, GKS 2232 4°), 159/161. On this illustration see also Maarten van de Guchte, "El ciclo mítico andino de la piedra cansada," *Revista Andina* 2:2 (1984): 539–56; see also Carolyn Dean, *Culture of Stone*, 50–53.

54. R. T. Zuidema, "Masks in the Inkaic Solstitial and Equinoctal Rituals," in *The Power of Symbols: Masks and Masquerade in the Americas*, ed. N. Ross Crumrine and Marjorie Halpin (Vancouver: University of British Columbia Press, 1983), 149–62; Zuidema, "The Lion in the City: Royal Symbols of Transition in Cusco," in *Animal Myths and Metaphors in South America*, ed. Gary Urton (Salt Lake City: University of Utah Press, 1985), 183–250; Zuidema, "Inca Cosmos in Andean Context: From the Perspective of the Capac Raymi Camay Quilla Feast Celebrating the December Solstice in Cusco," in *Andean Cosmologies through Time: Persistence and Emergence*, ed. Robert V. H. Dover, Katherine E. Seibold, and John H. McDowell (Bloomington and Indianapolis: Indiana University Press, 1992), 17–45; Gary Tomlinson, *The Singing of the New World: Indigenous Voices in the Era of European Contact* (Cambridge: Cambridge University Press, 2007), 124–67.

55. November rituals of Qhapaq Raymi: Molina, *Narratives of the rites and laws of the Yncas*, translated Clements R. Markham (London: Hakluyt Society, 1873), 40–42.

56. Molina, *Narratives of the rites and laws of the Yncas*, 42; On the Suntur Paucar, see Juan Larrea, "El Yauri, insignia Incaica," *Corona Incaica* (Córdoba, Spain: Facultad de Filosofía y Humanística 1960), 68.

57. Colin McEwen and Maarten Van de Guchte, "Ancestral Time and Sacred Space in Inca State Ritual," in *The Ancient Americas: Art from Sacred*

Landscapes (Chicago: Art Institute of Chicago, 1992), 359–71.

58. Lauren Hughes, "Weaving Inka Imperial Ideas: Iconography and Ideology of the Inka Coca Bag," *Textile: The Journal of Cloth and Culture* 8:2 (2010): 148–79.

59. Gary Urton, "The Herder-Cultivator Relationship as a Paradigm for Archaeological Origins, Linguistic Dispersals, and the Evolution of Record-Keeping in the Andes," in *Archaeology and Language in the Andes*, ed. Paul Heggarty and David Beresford-Jones (Oxford: British Academy/Oxford University Press, 2012), 321–43.

60. Pierre Duviols, "Huari y Llacuaz: Agricultores y pastores: Un dualism prehispanico de oposición y complementaridad," *Revista del Museo Nacional* (Lima) 34 (1973): 153–91.

61. "Predatory complementarity": George F. Lau, "Animal resources and Recuay cultural transformations at Chinchawas, North Highlands, Peru," *Andean Past* 8 (2007): 449–76.

62. Marshall Sahlins, *Islands of History* (Chicago: University of Chicago Press, 1985), 83.

63. Frank Salomon and Sue Grosboll, "A Visit to the Children of Chaupi Ñamca: From Myth to History via Onomastics and Demography," in *History and Language in the Andes*, ed. Paul Heggarty and Adrian J. Pearce (London: Palgrave, 2011), 40–41. See also Pierre Duviols, "Huari y Llacuaz"; Duviols, "Sumaq T'ika: La Princesse du village sans eau," *Journal de la Société des Américanistes* 63 (1974–76): 153–98.

64. On Huanacauri, see note 33.

65. López-Baralt, Mercedes. "The *Yana K'uychi* or Black Rainbow in Atawallpa's Elegy: A Look at the Andean Metaphor of Liminality in a Cultural Context," *Myth and the Imaginary in the New World* (1986): 261–303; Sabine MacCormack, "Pachacuti: Miracles, Punishments, and Last Judgment: Visionary Past and Prophetic Future in Early Colonial Peru," *The American Historical Review* 93 (1988): 960–1006; Constance Classen, "Sweet Colors, Fragrant Songs: Sensory Models of the Andes and the Amazon," *American Ethnologist* 17 (1990): 722–735; and "Creation by Sound/Creation by Light: A Sensory Analysis of Two South American Cosmologies" in *The Varieties of Sensory Experience: A Sourcebook in the Anthropology of the Senses*, ed. David Howes (Toronto: University of Toronto Press, 1991), 238–55.

66. Veronica Cereceda, "A Partir de los Colores de un Pajaro," *Boletín del Museo Chileno de Arte Precolombino* 4 (1990), 216.

67. José Luís Martínez Cereceda, *Autoridades en los Andes: Los Atributos del Señor* (Lima: Pontífica Universidad Católica del Perú, 1995), 200.

68. For an introduction to Inca sedan chairs, see John H. Rowe, John H. Rowe, "Inca culture at the time of the Spanish conquest," *Handbook of South American Indians, Bureau of American Ethnology Bulletin* 143, Vol. 2, ed. Julian H. Steward (Washington, DC: Smithsonian Institution, 1946), 239.

69. Such tactics would seem confirmed by the capture of Atawallpa's half-brother Waskhar at the Battle of Apurímac in early 1532. Waskhar's capture is often ascribed to a battlefield ruse, though it was more likely a consequence of Inca leaders' practice to lead from the fore: on this episode see Pedro Cieza de León, *El Descubrimiento y Conquista del Perú* (1553), ed. Carmelo Sáenz de Santa Maria (Madrid: Historia 1984), Chapter 60, 142–43.

70. Pedro Pizarro, *Relación*, 45.

71. *Una litera aforrada de pluma de papagayos de muchos colores, guarnecida de chapas de oro y plata.* Xerez, *Verdadera Relación*, 89.

72. Felipe Guaman Poma de Ayala, *El primer nueva corónica y buen gobierno* (1615/1616) (Copenhagen, Royal Danish Library, GKS 2232 4°: facsimile at http://www.kb.dk), 336.

73. Scott C. Smith, "The Generative Landscape: The Step Mountain Motif in Tiwanaku Iconography," *Ancient America* 12 (2012): 30–34.

74. See Dean, *Culture of Stone*, 132, 194–95 n. 39.

75. Rodolfo Cerrón-Palomino, "Cuzco: la piedra donde se posó la lechuza. Historia de un nombre," *Revista Andina* 44 (2007), 143–74. Reference to the *mojon de piedra* ("mound of rocks") also relates to indengous Andean practices of marking land partitions: see Lindsey Crickmay, "Stone: Spanish 'mojon' as a Translation of Quechua and Aymara Terms for 'Limit,'" in Kay Pacha: *Cultivating Earth and Water in the Andes*, ed. Penelope Dransart (Oxford: BAR International, 2006), 71–76.

76. Jessica Joyce Christie, "Did the Inka Copy Cusco? An Answer Derived from an Architectural-Sculptural Model," *Journal of Latin American and Caribbean Anthropology* 12:1 (2007): 164–99.

77. "Cuzco" was also embodied in the persons of important political figures. The body of the Inca ruler, in particular, constituted a "Cuzco," a sacral Inca center. See I. S. Farrington, "The Concept of Cusco," *Tawantinsuyu* 5 (1998): 53–59; Susan Elizabeth Ramírez, *To Feed and Be Fed: The Cosmological Bases of Authority and Identity in the Andes* (Stanford, CA: Stanford University Press, 2005), 74–80; see also Thomas B. F. Cummins and Stephen Houston, "Body, Presence and Space in Andean and Mesoamerican Rulership," in *Palaces of the Ancient New World*, ed. Susan Tobey Evans and Joanne Pillsbury (Washington, DC: Dumbarton Oaks, 2005), 359–98.

78. Roland Chardon, "The Elusive Spanish League: A Problem of Measurement in Sixteenth-Century New Spain," *The Hispanic American Historical Review* 60:2 (1980): 294–302.

79. *Despues de auer comido, que acauaria a ora de misa mayor, enpezo a leuantar su xente y benirse hazia Caxamarca, y hechos sus esquadrones, / que cubrian los campos, y el metido en unas andas, empezo a caminar, uiniendo delante del dos mill yndios que le barrian el camipo por donde benia caminando, y la xente de guerra, la mitad de un lado y la mitad del otro, por los campos, sin entrar en camino. Traya asimismo al senor de Chincha consigo, en unas andas, que parescia a los suyos cosa de admiracion, porque ningun yndio, por senor principal que fucsc, auia de parescer.* Pedro Pizarro, *Relación*, 180.

80. Susan Elizabeth Ramírez, *To Feed and Be Fed*, 179–91. See also Martínez Cereceda, *Autoridades en los Andes*, 106–07.

81. *Traía seiscientos indios de libreas blancas y coloradas, a manera de ajadrez, que venían delante, limpiando las piedras y pajas del camino.* Trujillo, *Relación*, 133.

82. *Venia de esta manera: en unas andas rrasas, dos señores con el en otras dos andas venian en ombros de yndios. Venian delante del mill yndios de librea como de juego de axedrez estos venian delante limpiando el camino.* Ruiz de Arce, *La Memoria*, 85.

83. *Venia delante un escuadron de indios vestidos de una librea de colores á manera de escaques estos venian quitando las pajas del suelo y barriendo el camino.* Xerez, *Verdadera Relación*, 89.

84. Pedro Pizarro, *Relación*, 181.

85. John H. Rowe, "Standardization in Inca Tapestry Tunics," in *The Junius B. Bird Pre-Columbian Textile Conference, 1973*, ed. Ann Pollard Rowe, Elizabeth Benson, and Anne-Louise Schaffer (Washington, DC: Textile Museum and Dumbarton Oaks, 1979): 239–64; John H. Rowe and Ann Pollard Rowe, "Inca Tunics," in *Andean Art at Dumbarton Oaks*, vol. 2 (Washington, DC: Dumbarton Oaks, 1996), 453–66; Ann Pollard Rowe, "Inca Weaving and Costume," *The Textile Museum Journal* 34:5 (1997): 5–54. See also Rebecca Stone-Miller, *To Weave for the Sun: Ancient Andean Textiles* (New York: Thames and Hudson, 1992), 23, 49, 54, 62, and extended bibliographic entry on 172. For valuable commentary on pre-contact and colonial Inca tunics, see Joanne Pillsbury, "Inka Unku: Strategy and Design in Colonial Peru," in *Cleveland Studies in the History of Art* 7 (2002): 68–103, esp. 75; Pillsbury, "Inka-Colonial Tunics: A Case Study of the Bandelier Set," in *Andean Textile Traditions: Papers from the 2001 Mayer Center Symposium at the Denver Art Museum*, eds. Margaret Young-Sanchez and Fronia W. Simpson (Denver: Denver Art Museum, 2006), 120–68.

86. John V. Murra, "The Expansion of the Inca State: Armies, War, and Rebellions," in *Anthropological History of Andean Politics*, ed. J. Murra, Nathan Wachtel, and Jacques Revel (Cambridge: Cambridge University Press, 1986), 49–58. See also Murra, "Los olleros del Inka: Hacia una historia y arqueología del Qollasuyu," in *Historia, problema y promesa: Homenaje a Jorge Basadre* (Lima: Universidad Católica), 1979. On textile production, see Cathy Lynne Costin, "Housewives, Chosen Women, Skilled Men: Cloth Production and Social Identity in the Late Prehispanic Andes," *Craft and Social Identity*, ed. Cathy Lynne Costin and Rita P. Wright (Washington, DC: American Anthropological Association, 1998), 123–41.

87. Broad agricultural tracts were opened up to grow crops for Inca army, and storehouses housed food for the army's consumption: Nathan Wachtel, "The Mitmaes of the Cochabamba Valley: The Colonization Policy of Huayna Capac," in *The Inca and Aztec States, 1400–1800: Anthropology and History*, ed. George A. Collier, Renato I. Rosaldo, and John D. Wirth (New York: Academic Press, 1982), 199–235; Timothy K. Earle and Terrence N. D'Altroy, "Storage Facilities and State Finance in the Upper Mantaro Valley, Peru," in *Contexts for Prehistoric Exchange*, ed. Jonathan E. Ericson and Timothy K. Earle (New York: Academic Press, 1982), 265–90; Nathan

Wachtel, "The Mitmaes of the Cochabamba Valley: The Colonization Policy of Huayna Capac," in *The Inca and Aztec States 1400–1800*, 199–235.

88. Margarita E. Gentile, "Tocapu: unidad de sentido en el lenguaje gráfico andino," paper delivered at the Museo de Arqueología y Antropología de la Universidad Nacional Mayor de San Marcos, Lima, 2009: "A comienzos del siglo XVII se sabía que tocapu era una calidad de tela, y así pasó a los diccionarios de época y alguna crónica."

89. John V. Murra, "Cloth and Its Function in the Inca State," *American Anthropologist* 64:4 (1962): 710–24.

90. Jean Berthelot, "The Extraction of Precious Metals at the Time of the Inca," in *Anthropological History of Andean Polities*, ed. John. V. Murra, Nathan Wachtel, and Jacques Revel (Cambridge: Cambridge University Press, 1986), 69–88.

91. John H. Rowe, "The Chronology of Inca Wooden Cups," in *Essays in Pre-Columbian Art and Archaeology*, ed. Samuel Lothrop (Boston: Harvard University Press, 1961), 317–41 (327): "*This type of design was called toqapu in Classic Inca; it was used most commonly on tapestry garments, and it served as a badge of rank. Toqapu designs are both more varied and more common on cups of later date.*" Other important early arguments concerning the t'oqapu as design unit include Thomas S. Barthel, "Erste Schritte zur Entzifferung der Inkaschrift," *Tribus* 19 (1970): 91–96; Victoria de la Jara, "Vers le déchiffrement des écritures anciennes du Pérou," *La Nature* (Paris) 3387 (1967): 241–47.

92. Rodolfo Cerrón-Palomino, "Tocapu (Etimologías)," *Boletín de la Academia Peruana de la Lengua* 40 (2005): 137–52.

93. For a recent insightful discussion of Wari tapestry-woven tunics, see Susan E. Bergh, "Tapestry-woven Tunics," in *Wari: Lords of the Ancient Andes*, ed. Susan E. Bergh (New York/Cleveland: Thames and Hudson/Cleveland Museum of Art, 2012), 159–92.

94. Alan Sawyer, "Tiahuanaco Tapestry Design," *Textile Museum Journal* 1:2 (1963): 27–38; William Conklin, "The Mythic Geometry of the Southern Sierra," in *The Junius B. Bird Conference on Andean Textiles*, ed. Ann Pollard Rowe (Washington, DC: The Textile Museum, 1986), 123–35.

95. George Kubler, *The Art and Architecture of Ancient America: The Mexican, Maya and Andean Peoples* (New Haven, CT: Yale University Press, 1962; 3rd ed. 1990), 309.

96. Mary Frame, "The Visual Images of Fabric Structures in Ancient Peruvian Art," in Ann Pollard Rowe, ed., *The Junius B. Bird Andean Textile Conference*, 1984 (Washington, DC: The Textile Museum, 1986), 47–80. Frame, "Beyond the Image: Dimensions of Pattern in Andean Textiles," in *Abstraction: The Amerindian Paradigm*, ed. César Paternosto (Brussels: Palais des Beaux-Arts de Bruxelles/Institut Valencià d'Art Modern, 2001), 113–36. See also the classic article by Anna H. Gayton, "The Cultural Significance of Peruvian Textiles: Production, Function, Aesthetics," in *Kroeber Anthropological Society Papers* 25 (1961): 111–28.

97. This paragraph borrows language from Charles Sanders Peirce, *Charles Sanders Peirce, Collected Writings* (8 Vols.), ed. Charles Hartshorne, Paul Weiss, and Arthur W. Burks (Cambridge, MA: Harvard University Press, 1931–58): esp. Vol. 2: 292, Vol. 4: 447.

98. It is certain that this garment pattern identified its wearers as soldiers in the Inca leadership's service. Though the question arises as to the military tunic's identification: ethnicity or specialized occupation? It is not certain whether this costume was identified exclusively with ethnic-Inca warriors drawn from the old Cuzco hinterland, or if it was worn by a particular class of military specialists closely identified with the Inca state. Either way, it was high-status military livery worn by the state's honor guard.

99. "Seeing-in" from Richard Wollheim, *Painting as an Art* (Princeton, NJ: Princeton University Press, 1987). Amy Oakland Rodman and Vicky Cassman, "Andean Tapestry: Structure Informs the Surface," *Art Journal* 54 (1995): 33–39.

100. The terms "surface color" and "field color" are drawn from David Katz, *The World of Colour* (London: Keegan, Paul, Trench, Trubner, 1935).

101. Marshall Sahlins, "Colors and Cultures," *Semiotica* 16 (1976), 16.

102. On the rainbow as a supernatural luminance, and on the relationship of perceptions of light to Andean notions of the sacred in general, see Rebecca R. Stone, *The Jaguar Within:*

Shamanic Trance in Ancient Central and South American Art (Austin: University of Texas Press, 2011), esp. 34–48.

103. The color of natural wool is referred to as *k'ura* by Aymara-speakers of Isluga; these colors are distinguished from the brighter, more pure colors of the rainbow. See Verónica Cereceda, "A Partir de los Colores de un Pajaro," 65. On color and materiality in the Andean tradition see also the important work by Gabriela Siracusano, *El Poder de los Colores: De lo Material a lo Simbólico en las Prácticas Culturales Andinas* (Buenos Aires: Fondo de Cultura Económica de Argentina, 2005).

104. Marianne Hogue, "Cosmology in Inka Tunics and Tectonics," in *Andean Textile Traditions: Papers from the 2001 Mayer Center Symposium at the Denver Art Museum*, ed. Margaret Young-Sánchez and Fronia W. Simpson (Denver: Denver Art Museum, 2006), 110–14.

105. Dean, *Culture of Stone*, 55–61.

106. See Maarten Van de Guchte, "'Carving the World': Inca Monumental Sculpture and Landscape" (Ph.D. dissertation. Department of Anthropology, University of Illinois Urbana/Champaign, 1992); Carolyn Dean, "The Inka Married the Earth: Integrated Outcrops and the Making of Place," *The Art Bulletin* 89:3 (2007): 502–18.

107. Marianne Hogue, "Cosmology in Inka Tunics and Tectonics," 110–114. On the larger problem of contiguity and pattern-relation, see George F. Lau, "The work of surfaces: object worlds and techniques of enhancement in the ancient Andes," *Journal of Material Culture* 15:3 (2010): 259–86.

108. Smith, "The Generative Landscape," 1–69.

109. Altar-like architectural compositions at the early coastal site of El Cardal (1150–800 BCE) suggest rudimentary forms of the step-mountain motif. See Richard Burger and Lucy Salazar-Burger, "Second Season of Investigations at the Initial Period Center of Cardal, Peru," *Journal of Field Archaeology* 18:3 (1991): 275–96.

110. Pedro Pizarro, *Relación* 181.

111. Cieza de León, *Descubrimiento*, Chapter 45, 156.

112. Felipe Guaman Poma de Ayala, *El primer nueva corónica y buen gobierno* (1615/1616), (Copenhagen, Royal Danish Library, GKS 2232 4°: facsimile at http://www.kb.dk), 254v.

113. Arnold van Gennep, *The Rites of Passage* [1909], trans. M. B. Vizedom and G. L. Caffee (Chicago: University of Chicago Press, 1960).

114. Paul A. Scolieri, *Dancing the New World: Aztecs, Spaniards, and the Choreography of Conquest* (Austin: University of Texas Press, 2013).

CHAPTER 4

1. Pedro Pizarro, *Relación del Descubrimiento y Conquista del Peru*, ed. Guillermo Lohmann Villena (Lima: Pontifica Universidad Católica del Peru, 1978), 37.

2. R. Hopkins, "Painting, Sculpture, Sight, and Touch," *British Journal of Aesthetics* 44:2 (2004): 149–66.

3. *Estraño . . . Lat. Extraneus, alienus, Loque es singular . . . Singular . . . del que no tiene otro á quien le comparemos.* Sebastián de Covarrubias, *Tesoro de la Lengua Castellana* (Madrid: 1611), 273: 176.

4. *Cadauno de los christianos dezia que haria mas que Roldan: porque no esperauamos otro Socorro, sino el de Dios.* Cristóbal de Mena, in Alexander Pogo, "The Anonymous *La Conquista Del Peru* [Seville, April 1534] and the *Libro Vltimo Del Svmmario Delle Indie Occidentali* [Venice, October 1534]," *Proceedings of the American Academy of Arts and Sciences* 64:8 (1930), 234.

5. Nicholas A. Saunders, "Stealers of Light, Traders in Brilliance: Amerindian Metaphysics in the Mirror of Conquest," *RES: Anthropology and Aesthetics* 33:1 (1998): 226–30.

6. Nicholas J. Saunders, "'Catching the Light': Technologies of Power and Enchantment in Pre-Columbian Goldworking," in *Gold and Power in Ancient Costa Rica, Panama, and Colombia*, ed. Jeffrey Quilter and John W. Hoopes (Washington, DC: Dumbarton Oaks, 2003), 15.

7. Gonzálo Lamana, "Beyond Exotization and Likeness: Alterity and the Production of Sense in a Colonial Encounter," in *Comparative Studies in Society and History* 47:1 (2005), 4.

8. *Traían grandes atambores, muchas bocinas, con sus banderas tendidas, que cierto era hermosa cosa ver tal junta de gente movida para tan poquitos.* Pedro de Cieza de León, *El Descubrimiento y Conquista del Perú* (1553), ed. Carmelo Sáenz de Santa Maria (Madrid: Historia 1984), Chapter 45, 156.

9. *No hazian sino venir yndios en tanta manera que jamas se quebro el hilo de la calçada . . . con mucha musica e ansi entro en la plaça.* Juan Ruiz de Arce, *La Memoria de Juan Ruiz de Arce (1543): Conquista del Perú, saberes secretos de caballería y defense del mayorazgo,* ed. Eva Stoll (Frankfurt and Madrid: Vervuert Verlag/Iberoamericana, 2002), 84.

10. *Tras esto venian otras tres escuadras vestidos de otra manera, todos cantando y bailando . . . luego venía mucha gente en escuadrones con coronas de oro y plata.* Mena, in Alexander Pogo, "The Anonymous *La Conquista,*" 89.

11. *Enpeçaron a entrar los esquadrones con grandes cantares, y así entrando ocuparon toda la plaça por todas partes.* Pedro Pizarro, *Relación,* 37.

12. *En llegando Atabalipa en medio de la plaza, hizo que todos estuviesen quedos, y la litera en que él venia y las otras en alto: no cesaba de entrar gente en la plaza.* Xerez, *Verdadera Relación de la Conquista del Perú* (1534; Madrid: Tip. de J. C. Garcia, 1891), 89.

13. *Comenzaron de entrar en la plaza: los escuadrones, como llegaron en medio de ella, hicieron de sí una muy grande muela; entró Atabalipa después de haberlo hecho muchos capitanes de los suyos con sus gentes; pasó por todos hasta ponerse en sus andas como iba en medio de la gente; púsose en pie en medio del estrado; habló en voz alta . . .* Cieza de León, *Descubrimiento,* Chapter 45, 142–44.

14. Pedro Cataño's record of 1543 is cited in Gonzálo Lamana, "Beyond Exotization and Likeness: Alterity and the Production of Sense in a Colonial Encounter," in *Comparative Studies in Society and History* 47:1 (2005), 32–33.

15. Don Diego Inca Mocha, Pobranza . . . [1573], in Edmundo Guillén Guillén, ed. *Versión Inca de la conquista* (Lima: Milla Batres, 1974), 96; also cited in Lamana, "Beyond Exotization and Likeness," 33.

16. George Kubler, "The Behavior of Atahualpa, 1531–33," *The Hispanic American Historical Review* 25:4 (1945), 413.

17. Frank Salomon and George L. Urioste, in *The Huarochirí Manuscript: A Testament of Ancient and Colonial Andean Religion,* trans. Frank Salomon and George L. Urioste (Austin: University of Texas Press, 1991), 115.

18. Johannes Fabian, *Time and the Other: How Anthropology Makes Its Object* (New York: Columbia University Press, 1983); Adam T. Smith, *The Political Landscape: Constellations of Authority in Early Complex Polities* (Berkeley: University of California Press, 2003).

19. Ruiz de Arce, cited in Carolyn Dean, *Culture of Stone: Inka Perspectives on Rock* (Durham, NC: Duke University Press, 2010), 129–30.

20. *Las casas della son de más de doscientos pasos en largo, son muy bien hechas, cercadas de tapias Fuertes, de altura de tres estados; las paredes y el techo cubierto de paja y madera asentada sobre las paredes; están dentro destas casas unos aposentos repartidos en ocho cuartos muy major hechos que ninguno de los otros. Las parades dellos son de piedra de cantería muy bien labradas, y cercados estos aposentos por sí con su cerca de cantería y sus puertas, y dentro en los patio sus pilas de agua traida de otra parte por caños para el servicio destas casas; por la delantera desta plaza, á la parte del campo, está encorporade den la plaza una fortaleza de piedra con una escalera de cantería, por donde suben de la plaza a la fortaleza; por la delantera della, a la parte del campo, est otra puerta falsa pequeña, con otra escalera angosta, sin salir de la plaza.* Xerez, *Verdadera Relación,* 78–79.

21. *Heran tres aposentos cada aposento seria de duzientos pasos. Estauan en tiangolo entr aposento y aposento abaxaua vna calle del pueblo para entra en la plaça la plaça estaua entre estos aposentos las esquinas que salian de los do aposentos que salian al campo yua vna muralla hecha de pared esquina de esquina. En el comedio de esta muralla estaua vna torre maçica.* Ruiz de Arce, *La Memoria,* 84–85.

22. *En Caxamalca había diez calles, que salían de la plaza. Y en cada bocacalle puso el Gobernador ocho hombres . . .* : Diego de Trujillo, *Relación del Descubrimiento del Reino del Perú* [1571], in *Tres testigos de la conquista,* ed. Conde de Carnilleros (3rd ed., Madrid, 1954), 133.

23. Graziano Gasparini and Louise Margolies, *Inca Architecture* (Patricia J. Lyons, trans.) (Bloomington: Indiana University Press, 1980), 67–68, 196–219. A recent discussion of a kallanka type is found in Susan A. Niles, *The Shape of Inca History: Narrative and Architecture in an Andean Empire* (Iowa City: University of Iowa Press, 1999), 274; for a recent detailed consideration of the structural details of an Inca kallanka, see also María de los Angeles Vargas, "The Kallanka at Samaipata, Bolivia: An Example of Inca Monumental Architecture," in *Variations in the Expression of Inka Power: A Symposium at Dumbarton Oaks,* ed. Richard L. Burger, Craig Morris, and Ramiro Matos Mendieta (Washington, DC: Dumbarton Oaks, 2007), 255–65.

24. For an introduction to Huánuco Viejo, now one of the best-studied provincial Inca centers, see Craig Morris and Donald Thompson, "Huanuco Viejo: An Inca Administrative Center," *American Antiquity* 35:3 (1970): 344–62.

25. Rogger Ravines, "El Cuarto de Rescate de Atahualpa," *Revista del Museo Nacional* 62 (1976): 114–43; Idilio Santillana Valencia, "El Cuarto de Rescate de Atahualpa: Aprocimaciones arqueológicas," *Boletín de Lima* 5:27 (1983): 13–22; Ravines, *Cajamarca Prehispanica: Inventario de monumentos arqueológicos* (Cajamarca: Instituto Nacional de Cultura de Cajamarca, 1985), 59–71.

26. The most impressive stone structure along Cajamarca's central square was described by the scribe Xerez as *una casa que se dice de la Sierpe*, "the so-called house of the snake." Xerez, *Verdadera Relación*, 86.

27. Pedro Pizarro, *Relación*, 175.

28. For an introduction to "Chosen Women," see Pilar Alberti Manzanares, "La Influencia económica y política de las Acllacuna en el Incanato," *Revista de Indias* 45 (1985): 557–85; Alberti Manzanares, "Una institución exclusivamente feminine en la época incaica: las acllacuna," *Revista Española de Antropología Americana* 16 (1986): 153–90; Silverblatt, *Sun, Moon, and Witches*, 81–108; Peter Gose, "The State as a Chosen Woman: Brideservice and the Feeding of Tributaries in the Inca Empire," *American Anthropologist* (n.s.) 102:1 (2000): 84–97; Anne Tiballi, "Imperial Subjectivities: The Archaeological Materials from the Cemetary of the Sacrificed Women, Pachacamac, Peru" (Ph.D. dissertation, SUNY Binghamton, 2010).

29. *Una fortalecilla que está en la plaça de Caxamarca.* Pedro Pizarro, *Relación*, 35. On the Inca architectural type of the Usnu, see the important piece by R. T. Zuidema, "El Ushnu," *Revista de la Universidad Complutense* (Madrid) 28 (1980): 317–62. Zuidema pursues the interpretation of ancient Inca social structure, where Rowe's concerns were more culture-evolutionary. See also F. M. Meddens, "Function and Meaning of the Usnu in Late Horizon Peru," *Tawantinsuyu* 3 (1997): 5–14; see also Brian S. Bauer, *The Sacred Landscape of the Inca: The Cusco Ceque System* (Austin: University of Texas Press, 1998), and Bauer, *Ancient Cusco*; Jessica Joyce Christie, "Did the Inka Copy Cusco? An Answer Derived from an Architectural-Sculptural Model," *Journal of Latin American and Caribbean Anthropology* 12:1 (2007): 164–99; John Hyslop, *Inca Settlement Planning*, 37–40, 69–101. Jorge Cornejo Bouroncle, "Huakaypata: La Plaza Mayor del Viejo Cusco," 86–116; Graziano Gasparini and Luise Margolies, *Inca Architecture* (Bloomington: Indiana University Press, 1980), 264–80. See also José Luis Pino Matos, "El *Ushnu* Inka y la Organización del Espacio en los Principales *Tampus* de los Wamani de la Sierra Central del Chinchaysuyu," *Chungará: Revista de Antropología Chilena* 36:2 (2004): 303–11; Dean, *Culture of Stone*, 137–41.

30. Emiliano Harth Terré's rendering of Cajamarca was tipped as a bookplate into Horacio H. Urteaga, *El fin de un imperio; obra escrita en conmemoración del 4° centenario de la muerte de Atahuallpa* (Lima: Librería e Imprenta Gil, 1933).

31. Susan Niles, *The Shape of Inca History*, 154–207.

32. This pattern is typical of Inca roads approaching/departing Inca administrative centers: John Hyslop, *The Inca Road System* (London: Academic Press, 1984); Hyslop, *Inca Settlement Planning* (Austin: University of Texas Press, 1990).

33. Betanzos, *Suma y narración* (Madrid: Ediciones Atlas, 1987), Chapter 25, 125. On the history of the Inca annexation of the Cajamarca region, see Maria Rostworowski de Diez Canseco, "Patronyms with the Consonant F in the Guarangas of Cajamarca," in *Andean Ecology and Civilization: An Interdisciplinary Perspective on Andean Ecological Complementarity*, ed. S. Masuda, I. Shimada, and C. Morris (Tokyo: University of Tokyo Press, 1985), 401–21; M. Remy Simatovic, "Organización y cambios del reino de Cuismancu 1540–1540," in *Historia de Cajamarca: Vol. II, Etnohistoria y Lingüística*, ed. F. Silva Santisteban, W. Espinoza Soriano, and Rogger Ravines (Cajamarca: Instituto Nacional de Cultura/Cajamarca and Corporación de Desarrollo de Cajamarca, 1985), 35–68.

34. Terence N. D'Altroy, *Provincial Power in the Inka Empire* (Washington, DC: Smithsonian, 1992), 77; D'Altroy, *The Incas* (Oxford: Blackwell, 2002), 67–68. On Inca provincial centers replicating the plan and component structures of Cuzco, see Christie, "Did the Inca Copy Cusco? An Answer Derived from an Architectural-Sculptural Model," 164–199,

and Lawrence Coben, "Other Cuscos: Replicated Theaters of Inca Power," in *Archaeologies of Performance: Theaters of Power, Community, and Politics*, ed. Takeshi Inomata (Lanham, MD: Altamira Press, 2006), 223–59.

35. Ryozo Matsumoto, "Dos Modos de proceso socio-cultural: El Horizonte temprano y el period intermedio temprano en el valle de Cajamarca," *Senri Ethnological Studies* 37 (1993): 169–202; Yasutake Kato, "Resultados de las excavaciones en Kuntur Wasi, Cajamarca," *Senri Ethnological Studies* 37 (1993): 203–28; Rogger Ravines, "Calles de Cajamarca: Historia de su crecimiento urbano," *Boletín de Lima* 82 (1992): 55–74; Rogger Ravines and Jorge Sachún C., "Monumentos arqueológicos tempranos de la region cisandina de Cajamarca," *Boletín de Lima* 87 (1993): 8–14; Rogger Ravines, "Los Incas en Cajamarca," *Boletín de Lima* 74 (1991): 5–10; Julio C. Tello, "La Ciudad Incaica de Cajamarca," *Chaski* 3 (1941): I; Shinya Watanabe, "Provincial Rule in the Inca State: A Case Study in the Cajamarca Region, Northern Highlands of Peru," *Kokuritsu Minzokugaku Hakubutsukan* 32:1 (2007): 87–144; Rainer Huhle, "Terremoto de Cajamarca: la derrota del Inca en la memoria colectiva, elementos para un análisis de la resistencia cultural de los pueblos andinos," *Ibero-Amerikanisches Archiv* 18:3–4 (1992): 387–426.

36. Mena, in Pogo, "The Anonymous *La Conquista*," 234.

37. F. Silva Santisteban, "Cajamarca en la historia del Perú," in *Historia de Cajamarca I: Arqueología*, ed. Wlademir Espinosa Soriano and Rogger Ravines (Cajamarca: Instituto Nacional de Cultura/Cajamarca and Corporación de Desarrollo de Cajamarca, 1985), 21; Jorge Sachún Cedeño, *Patrones de asentamiento en el proceso cultural prehispánico del valle de Cajamarca (primera aproximación)* (Trujillo: Editorial Sudamérica, 1985); Daniel G. Julien, "Late Pre-Incaic Ethnic Groups in Highland Peru: An Archaeological-Ethnohistorical Model of the Political Geography of the Cajamarca Region," *Latin American Antiquity* 4:3 (1993), 251.

38. Waldemar Espinoza Soriano, "El primer informe etnológico sobre Cajamarca. Año de 1540," *Revista Peruana de Cultura* 11–12 (1967): 5–41; "Los mitmas yungas de Collique en Cajamarca, siglos XV, XVI, XVII," *Revista del Museo Nacional* 37 (1969–70): 9–57.

39. Resident Inca administrator: Betanzos, *Suma y narración*, Chapter 19, 97. Yearly inspection: Betanzos, *Suma y narración*, Chapter 22, 116.

40. See R. T. Zuidema on Tanta Carhua, a provincial woman sacrificed by the Inca leadership: "Shaft Tombs and the Inca Empire." *Journal of the Steward Anthropological Society* 9 (1977): 133–78.

41. Shinya Watanabe, "Provincial Rule in the Inca State: A Case Study in the Cajamarca Region, Northern Highlands of Peru," *Bulletin of the National Museum of Ethnology (Osaka)* 32:1 (2007): 87–144; Watanabe, "Wari y Cajamarca," in *Huari y Tiwanaku: Modelos vs. evidencias* (Segunda parte), *Boletín de Arqueología PUCP* 5 (2001): 531–41; Carlos Williams and José Pineda, "Desde Ayacucho hasta Cajamarca: formas arquitectónicas con filiación wari," *Boletín de Lima* 40 (1985): 55–61.

42. George F. Lau, "Northern Exposures: Recuay-Cajamarca Boundaries and Interaction," in *Andean Archaeology III: North and South*, ed. William H. Isbell and Helaine Silverman (New York: Plenum/Kluwer, 2006), 143–70.

43. Willem F. Adelaar, "Cajamarca Quechua and the Expansion of the Huari State," in *Archaeology and Language in the Andes: A Cross-Disciplinary Exploration of History*, ed. Paul Heggarty and David Beresford-Jones (Oxford: British Academy/oxford university Press, 2012), 197–217.

44. On local Cajamarquino communities and Inca military expansion into the Cajamarca region, see the valuable recent work of J. Toohey, "Community Organization, Militarism, and Ethnogenesis in the Late Prehistoric Northern Highlands of Peru" (Ph.D. dissertation, Department of Anthropology, University of California, Santa Barbara, 2009).

45. Julien, "Late Pre-Incaic Ethnic Groups in Highland Peru," 250.

46. Rogger Ravines, "Los Incas en Cajamarca," *Boletín de Lima* 74 (1991): 5–10; Julien, "Late Pre-Incaic Ethnic Groups in Highland Peru," 246–73. See also the essays in *Provincial Inca: Archaeological and Ethnohistorical Assessment of the Impact of the Inca State*, ed. Michael Malpass (Iowa City: University of Iowa Press, 1993).

47. This is extrapolated from the example of Inca administration of the Vilcanota River Valley, cited in R. Alan Covey, *How the Incas Built Their Heartland: State Formation and the Innovation of Imperial Strategies in the Sacred Valley, Peru*

(Ann Arbor: University of Michigan Press), 174.

48. Julien, "Political Geography of the Cajamarca Region," 252; cites C. de Barrientos "Visita de las siete guarangas de la provincial de Caxamarca" [1540], in Waldemar Espinoza Soriano, *El Primer informe etnológico sobre Cajamarca. Año de 1540: Revista Peruana de Cultura* 11–12 (1967), 5–41.

49. Espinoza Soriano, "Los mitmaes yungas"; Daniel Julien, "Political Geography," 253.

50. John H. Rowe, "The Kingdom of Chimor," *Acta Americana* 6 (1948): 26–59.

51. The classic study of ethnic resettlement under the Inca regime is Waldemar Espinoza Soriano's "Los mitmas huayacuntu en Quito o guarniciones para la represión armada, siglos XV y XVI," *Revista del Museo Nacional* (Lima) 41 (1975): 351–94.

52. Terence N. D'Altroy and Timothy K. Earle, "Storage Facilities and State Finance in the Upper Mantaro River Valley, Peru," in *Contexts for Prehistoric Exchange*, ed. Jonathan E. Ericson and Timothy K. Earle (New York: Academic Press, 1982), 265–90; Terence N. D'Altroy and Christine A. Hastorf, "The Distribution and Contents of Inca State Storehouses in the Xauxa Region of Peru," *American Antiquity* 49:2 (1984): 334–49; D'Altroy and Earle, "Staple Finance," 193.

53. Watson Smith, *When is a Kiva? And Other Questions about Southwestern Archaeology*, ed. Raymond H. Thompson (Tucson: University of Arizona Press, 1990).

54. Craig Morris, "The Infrastructure of Inca Control in the Peruvian Central Highlands," in *The Inca and Aztec States 1400–1800 Anthropology and History*, ed. George A. Collier, Renato I. Rosaldo, and John D. Wirth (New York: Academic Press, 1982), 153–71.

55. On the Inca leadership's shifting of local feasts and rituals from the traditional Cajamaquino of Guzmango to the Inca settlement of Cajamarca, see Martti Pärssinen, *Tawantinsuyu: The Inca State and Its Political Organization* (Helsinki: Societas Historica Finlandiae, 1992), 318.

56. María Rostworowski de Diez Canseco, *History of the Inca Realm*, trans. Harry B. Iceland (Cambridge: Cambridge University Press, 1999), 222.

57. Craig Morris and Donald E. Thompson, *Húanuco Pampa: An Inca City and Its Hinterland* (London: Thames and Hudson, 1985), 165.

58. For general observations of the Inca plaza within the deeper Andean cultural tradition, see Jerry D. Moore, "The Archaeology of Plazas and the Proxemics of Ritual: Three Andean Traditions," *American Anthropologist* 98:4 (1996): 789–802.

59. The flexibility of Inca administrative processes across the Andes is the basis of much current archaeological inquiry and debate in Andean Studies. For case studies and bibliography, see the essays in *Variations in the Expression of Inka Power: A Symposium at Dumbarton Oaks*, ed. Richard L. Burger, Craig Morris, and Ramiro Matos Mendieta (Washington, DC: Dumbarton Oaks, 2007).

60. Craig Morris, R. Alan Covey, Pat H. Stein, *The Húanuco Pampa Archaeological Project. Volume 1: The Plaza and Palace Complex* (Anthropological Papers of the American Museum of Natural History, no. 96).

61. See Geoffrey Conrad, "Inca Imperialism: The Great Simplification and the Accident of Empire," in *Ideology and Pre-Columbian Civilizations*, ed. Arthur Demarest and Geoffrey Conrad (Santa Fe: School of American Research, 1992), 159–74. See also Elizabeth DeMarrais, Luis Jaime Castillo, and Timothy Earle, "Ideology, Materialization, and Power Strategies," *Current Anthropology*, 37:1 (1996):15–31, esp. 27–30: "The Inca case suggests that expansionist empires may simplify ideology into critical elements that are 'transportable' across cultural boundaries, among them representations of military power, state insignia, and massive ceremonialism" (20).

62. William H. Isbell, "Cosmological Order Expressed in Prehistoric Ceremonial Centers," in *Actes du XLIIe Congrès International des Américanistes*, vol. IV (Paris: Congrès du Centenaire and Fondation Singer-Polignac, 2–9 September 1976), 269–97.

63. Craig Morris and R. Alan Covey, "La Plaza Central de Húanuco Pampa: Espacio y Trasformación," *Boletín Aqueologia de la Pontífica Universidad Católica del Perú* 7 (2003), 134–37; Morris and Covey, "The Management of Scale or the Creation of Scale: Administrative Processes in Two Inca Provinces," in *Intermediate Elites in Pre-Columbian States and Empires*, ed. Christina M. Elson and R. Alan Covey (Tucson: University of Arizona Press, 2006), 137–46. On violence in Andean centers, see E. R. Swenson, "Cities of Violence: Sacrifice, Power, and

Urbanization in the Andes," *Journal of Social Archaeology* 3(2): 256–96.

64. Christine A. Hastorf, "Andean Luxury Foods: Special Food for the Ancestors, Deities, and the Elite," *Antiquity* 77 (2003): 545–54.

65. Christine A. Hastorf and Sissel Johannessen, "Pre-Hispanic Political Change and the Role of Maize in the Central Andes of Peru," *American Anthropologist* (n.s.) 95:1 (1993): 115–38. See also Justin Jennings, "La Chichera y El Patrón: Chicha and the Energetics of Feasting in the Prehistoric Andes," *Archeological Papers of the American Anthropological Association* 14:1 (2004): 241–59; Tamara L. Bray, "To Dine Splendidly: Imperial Pottery, Commensal Politics, and the Inca State," in *The Archaeology and Politics of Food and Feasting in Early States and Empires*, ed. Tamara. L. Bray (New York: Kluwer/Plenum, 2003), 93–142; also Paul S. Goldstein, "From Stew-Eaters to Maize-Drinkers: The Chicha Economy and the Tiwanaku Expansion," in *The Archaeology and Politics of Food and Feasting in Early States and Empires*, 143–72; Timothy Earle and Cathy Lynne Costin, "Status Distinction and Legitimation of Power as Reflected in Changing Patterns of Consumption in Late Prehispanic Peru," *American Antiquity* 54:4 (1989): 691–714. M. J. Weismantel, "Maize Beer and Andean Social Transformations: Drunken Indians, Bread Babies, and Chosen Women," *Modern Language Notes* 106: 4 (1991), 875–76: "Much of the significance of maize beer rested on its power to symbolize the agricultural economy upon which society depended . . . the Inca strove to make maize itself a royal food . . . making chicha into a symbol of empire." See also Thomas B. F. Cummins, *Toasts with the Inca: Andean Abstraction and Colonial Images on Quero Vessels* (Ann Arbor: University of Michigan Press, 2002), 39–58.

66. Gose, "The State as a Chosen Woman." On the Inca state's efforts to bind its subject peoples in reciprocal obligation, see Rostworowski de Diez Canseco, *History of the Inca Realm*, 42–47.

67. Cristóbal de Molina, *Fábulas y Mitos de los Incas* [1585], ed. Henrique Urbano and Pierre Duviols (Madrid: Historia, 1988), 49. Molina's comments concern the Quilla Raymi rituals of December.

68. Felipe Guaman Poma de Ayala, *El primer nueva corónica y buen gobierno* (1615/1616) (Copenhagen, Royal Danish Library, GKS 2232 4°: facsimile at http://www.kb.dk), 31v.

69. Thomas B. F. Cummins, *Toasts with the Inca*, 39–58. See also Tamara L. Bray, "To Dine Splendidly," 93–142. See also Susan Elizabeth Ramírez, *To Feed and Be Fed: The Cosmological Bases of Authority and Identity in the Andes* (Stanford, CA: Stanford University Press, 2005), 113–56.

70. Peter Gose, "The State as a Chosen Woman: Brideservice and the Feeding of Tributaries in the Inca Empire," *American Anthropologist* (n.s.) 102:1 (2000): 84–97.

71. José Luis Martínez Cereceda, "El 'personage sentado' en los keru: Hacia una identificación de los kuraka Andinos," *Boletín del Museo Chileño de Arte precolombino* 1 (1986): 108–11. Cited in Susan Elizabeth Ramírez, *To Feed and Be Fed*, 179–91, esp. 184. On Inca processionals, see Carolyn Dean, *Inka Bodies and the Body of Christ: Corpus Christi in Colonial Cusco* (Austin: University of Texas Press, 1999).

72. William Conklin, "A Khipu Information String Theory," in *Narrative Threads: Accounting and Recounting in Andean Khipu*, ed. Jeffrey Quiter and Gary Urton (Austin: University of Texas Press, 2002), 53–86.

73. R. T. Zuidema, "La Quadrature du cercle dans l'ancien Pérou," *Recherches amérindiennes au Quebec* III: 1–2 (1973): 147–65.

74. María Rostorowski de Diez Canseco, *History of the Inca Realm*, 224–25.

75. Susan Elizabeth Ramírez, *To Feed and Be Fed*, 180.

76. Pedro Pizarro, *Relación*, 181. On the Chincha capital of Centinela and historical evidence of relations between Inca and Chincha, see María Rostworowski de Diez Canseco, "Mercaderes del valle de Chincha en la época prehispánica: Un document y uno comentarios," in *Etnía y sociedad* (Lima: Instituto de Estudios Peruanos, 1977), 97–140; see also the perspectives based on archaeological evidence offered by Craig Morris and Julián Idilio Santillana, "The Inca Transformation of the Chincha Capital," in *Variations in the Expression of Inka Power*, ed. Richard R. Burger, Craig Morris, and Ramiro Matos Mendieta (Washington, DC: Dumbarton Oaks, 2007), 135–64.

77. Mena, in Pogo, "The Anonymous *La Conquista*," 236.

78. Katharina J. Schreiber, "Conquest and Consolidation: A Comparison of the Wari and Inca Occupations of a Highland Peruvian Valley," *American Antiquity* 52:2 (1987) 278; cites

Felípe Guaman Poma de Ayala, *Nueva Corónica*, 338 [340]; Luis de Monzón, "Descripción de la Tiera del Repartimiento de los Rucanas Antamarcas de la Corona Real, Jurisdición de la Ciudad de Guamanga, 1586," *Relaciones Geográficas de Indias*, Vol. I, ed. M. Jiménez de la Espada (Madrid: Ministerio de Fomento, 1881), 204.

79. Lucy C. Salazar, "Machu Picchu's Silent Majority: A Consideration of the Inca Cemeteries," in *Variations in the Expression of Inka Power*, 165–83.

80. Horacio Villanueva Urteaga, *Cajamarca: apuntes para su historia* (Cuzco: Editorial Garcilaso, 1975), 10–11.

81. Cummins, *Toasts with the Inca*, 78.

82. *Los caciques de todo el distrito de aquella gran ciudad venían a ella a solemnizar la fiesta, acompañados de sus parientes y de toda la gnte noble de sus provincias. Traían todas las galas, ornaentos e invenciones que en tiempos de sus reyes Inca usaban en la celebración de sus mayores fiestas . . . unos venían (como pintan a Hércules) vestidos con la piel de león ys sus cabezas encajadas en las del animal, porque se preciaban descender de un león. Otros traían las alas de un ave muy grande que llaman cuntur puestas a las espaldas, como las que pintan a los ángeles, porque se precian descender de aquella ave. Y así venían otros con otras divisas pintadas, como fuentes, ríos, lagos, sierras, montes, cuevas porque decían que sus primeros padres salieron de aquellas cosas. Traían otras divisas extrañas con los vestidos chapados de oro y plata. Otros con guirnaldas de oro y plata; otros venían hechos monstruos, con mascaras feísimas y en las manos pellejinas de diversos animals comos les hubiesent cazado hacienda grandes ademanes fingiendo locos y tontos para agradar a sus reyes de todas maneras, unos con grandezas y riquezas, otros con locuras y miserias . . . Llevaban sus atambores, flautas, caracoles, y otros instrumentos musicales. Muchas provincias llevaban sus mujeres en pos de los varones, que les ayudaban a tañer y cantar . . . Entraba cada nación por su antigüedad (como fueron conquistados por los Incas) . . .* Garcilaso de la Vega, *Comentarios Reales* (1609), Part II, Book VI, Chapter I. Cited in and discussed in Craig Morris and R. Alan Covey, "La Plaza Central de Huánuco Pampa: Espacio y Trasformación," *Boletín Aqueologia de la Pontífica Universidad Católica del Perú* 7 (2003), 136.

83. Regina Harrison, "Modes of Discourse: The Relación de Antigüedades deste Reyno del Pirú by Joan de Santacruz Pachacuti Yamqui Salcamaygua," in *From Oral to Written Expression: Native Andean Chronicles of the Early Colonial Period*, ed. Rolena Adorno (Syracuse, NY: Syracuse University, 1982), 62; Harrison translates Santacruz Pachacuti Yamqui [1613] 1927: 145 Relación de antiguedades deste Reyno del Piru: Estudio Ethnothistórico de Pierre Duviols y César Itier *1613* (Lima/Cusco: Institut Francais d'Etudes Andines/Centro de Estudios Regionales Andinds "Bartolomé de las Casas," 1993). Commenting on the passage, Harrison notes, "Knowledge, then, was conveyed through visual signs, and this cultural mapping was so complete that one could identify at a glance the participants at a ceremonial gathering" (62).

84. Gary Urton, "Andean Social Organization and the Maintenance of the Nazca Lines: Anthropological and Archaeological Perspectives," in *The Lines of Nazca*, ed. Anthony F. Aveni (Philadelphia: American Philosophical Society, 1990), 173–206.

85. See Thomas B. F. Cummins, "The Images in in Murúa's *Historia General del Piru*: An Art Historical Study," in *The Getty Murúa: Essays on the Making of Martín de Murúa's "Historia general del Piru," 1616, Ms. Ludwig XIII 16*, ed. Thomas B. F. Cummins and Barbara Anderson (Los Angeles: J. Paul Getty Trust, 2008), 147–74. On this image as a statement of Inca universality, see Thomas B. F. Cummins and Stephen Houston, "Body, Presence and Space in Andean and Mesoamerican Rulership," in *Palaces of the Ancient New World*, ed. Susan Tobey Evans and Joanne Pillsbury (Washington, DC: Dumbarton Oaks, 2005), 359–98. See also Susan Elizabeth Ramírez, *To Feed and Be Fed: The Cosmological Bases of Authority and Identity in the Andes* (Stanford, CA: Stanford University Press, 2005), 74–80.

86. Eric Boman, *Antiquités de region andine de la République argentine et du desert d'Atacama* (Paris: Imprinte Nationale, 1908), fig. 147 and pl. LXI. See also Marta Ruiz, "Unkus, caminos, y encuentros," *Revista Andina* 34 (2005): 199–215.

87. Pedro Cieza de León, *The Discovery and Conquest of Perú* (Durham, NC: Duke University Press, 1998), 209; Cobo, *History of the Inca Empire*, 246, cited in Jerry D. Moore, *Cultural Landscapes in the Ancient Andes: Archaeologies of Place* (Gainesville: University of Florida Press, 2005), 151–52; Christoph Cox, "Beyond Representation and Signification: Toward a Sonic

Materialism," *Journal of Visual Culture* 10 (Aug. 2011): 145–61.

88. *Entrasen in la ciudad cantando . . . cada uno dellos las cosas que les habían acaecido en las jornadas que anis había hecho todo.* Betanzos, *Suma y narración de los Incas* (Madrid: Editorial Atlas, 1987), Chapter 19, 95.

89. Jan Szeminski, *Wira Quchan y sus obras: teleología andina y lenguaje, 1550–1662* (Lima: Instituto de Estudios Peruanos, 1997), 92–93, 195–97; Alfred A. Torero, "Entre Roma y Lima: El Lexicón quichua de fray Domingo de Santo Tomás [1560]," in *La descripción de las lenguas amerindias en la época colonial*, ed. Klaus Zimmermann (Frankfurt: Vervuert-Iberoamericana, 1997), 271–90; Rodolfo Cerrón Palomino, "El Cantar del Inka Yupanqui y la lengua secreta de los Incas," *Revista Andina* 32 (1998): 417–52.

90. Peggy Phelan, *Unmarked: The Politics of Performance* (New York: Routledge, 1993); André Lepecki, *Exhausting Dance: Performance and the Politics of Movement* (New York: Routledge, 2006).

91. *The Huarochirí Manuscript*, ed. Salomon and Urioste, 38.

92. María Rostworowski de Diez Canseco, "Mercaderes del valle de Chincha en la época prehispánica: Un document y uno comentarios," in Rostworowski de Diez Canseco, *Etnía y sociedad* (Lima: Instituto de Estudios Peruanos, 1977), 97–104.

93. Gerald Taylor, "Camac, Camay y Camasca Camac en el manuscrito de Huarochiri," in *Camay y Camasca y Otros Ensayos Sobre Huarochiri y Yauyos* (Lima: Institut francais d'etudes Andines, 2000), 1–17; John V. Murra, "El 'control vertical' de un Maximo de Pesos Econologicos en la Economica de las Sociedades Andianas," in *Formaciones economicas y politicas del Mundo Andino* (Lima: Instituto de Estudios Peruanos, 1972), 59–116; R. Tom Zuidema, "Bureaucracy and Systematic Knowledge in Andean Civilization," in *The Inca and Aztec States, 1400–1800: Anthropology and History*, ed. George A. Collier, Renato I. Rosaldo, and John D. Wirth (New York: Academic Press, 1982), 419–58; Cathy Lynne Costin, "Craft Production and Mobilization Strategies in the Inca Empire," in *Craft Specialization and Social Evolution: In Memory of V. Gordon Childe*, ed. Bernard Wailes (Philadelphia: University Museum of Archaeology and Anthropology University of Pennsylvania, 1996), 213; Costin, "Housewives,

Chosen Women, Skilled Men: Cloth Production and Social Identity in the Late Prehispanic Andes," in *Craft and Social Identity*, ed. Cathy Lynne Costin and Ria P. Wright (Northridge: California State University, 1998), 123–40.

94. Jan Szeminski, *Léxico de Fray Domingo de Santo Tomás, 1560* (Lima: Convento de Santo-Domingo-Qorikancha/Sociedad Polaca de Estudios Latinoamericanos/Universidad Hebrea de Jerusalén, 2006), 60, 61.

95. "Place of crying" (Awkaypata): Víctor Angles Vargas, *Historia del Cusco*, vol. I (Cusco: Industrial Gráfica, 1988), 81–82.

96. Bruce Mannheim and M. Newfield describe "sound suggestiveness" and "constellations of word affinities" in their article "Iconicity in Phonological Change," in *Papers from the 5th International Conference on Historical Linguistics* (Amsterdam: Benjamins, 1982), 211–22; 215: "Metaphoric iconicity brings together etymologically unrelated lexemes based on an association of meaning correlated with some element(s) of phonological similarity across the set." See also Frank Salomon, "How the Huacas Were: The Language of Substance and Transformation in the Huarochirí Quechua Manuscript," *RES: Anthropology and Aesthetics* 33 (1998), 10.

97. Jean-Pierre Protzen and John H. Rowe, "Hawkaypata: the Terrace of Leisure," in *Streets: Critical Perspectives on Public Space*, ed. Zeynep Celik, Diane Favro, and Richard Ingersoll (Berkeley: University of California Press, 1994), 235–246. Rodolfo Cerrón-Palomino implicitly challenges Rowe's reading, pointing to the Aucaypata's derivation from an Aymara term *hauquipatha*, "plaça grande": Cerrón-Palomino, "El Aimara como lengua official de los Incas," *Boletín de Arqueología de la Pontífica Universidad Católica del Perú* 8 (2004): 14 (9–21).

98. Szemiñski, *Léxico*, 137.

99. Here I draw my understanding of the term soundscape from the work of R. Murray Schafer, *The Soundscape: Our Sonic Environment and the Tuning of the World* (Rochester, VT: Destiny, 1993), and Brandon LaBelle, *Background Noise: Perspectives on Sound Art* (London: Continuum, 2006). I am also indebted to the important article by Claudette Kemper Columbus, "Soundscapes in Andean Contexts," History of Religions 44:2 (2004): 153–68.

100. Jerry D. Moore, *Architecture and Power in the Andes: The Archaeology of Public Buildings* (New York: Cambridge University Press, 1996), esp. 220–28.

101. Lawrence E. Sullivan, *Icanchu's Drum: Meaning in South American Religions* (New York: Macmillan, 1988), 284.

102. Christoph Cox, "Beyond Representation and Signification: Toward a Sonic Materialism," *Journal of Visual Culture* 10 (Aug. 2011): 145–61.

103. Eric Shouse, "Feeling, Emotion, Affect," *M/C Journal* 8 (Dec. 2005): journal.media-culture.org.au/0512/03-shouse.php, 1, 5; Joseph LeDoux, *The Emotional Brain: The Mysterious Underpinnings of Emotional Life* (New York: Touchstone, 1996); *Brian Massumi, Parables for the Virtual: Movement, Affect, Sensation* (Durham, NC: Duke University Press, 2002); Nigel Thrift, "Intensities of Feeling: Towards a Spatial Politics of Affect," *Geografiska Annaler* 86 (2004): 57–78; Daniel Lord Smail, *On Deep History and the Brain* (Berkeley: University of California Press, 2008). For a detailed critique of "the affective turn," see Ruth Leys, "The Affective Turn: A Critique," *Critical Inquiry* 37: 3 (Spring 2011): 434–72.

104. Brian Massumi, *Parables for the Virtual*, 27.

105. "Chemical messenger": Daniel Lord Smail, *On Deep History and the Brain* (Berkeley: University of California Press, 2008), 176.

106. Zuidema: sun "sits still" in his solstitial seat "The Inca Calendar," in *Native American Astronomy*, ed. Anthony F. Aveni (Austin: University of Texas Press, 1977), 246. Felípe Guaman Poma de Ayala describes the Solstice ceremony in *El primer nueva corónica y buen gobierno* (1615/1616), (Copenhagen, Royal Danish Library, GKS 2232 4°: facsimile at http://www.kb.dk), 258 [260].

107. This ritual was described as *Camay* ("Creator Rite"), by Juan de Betanzos; or *Hatumpo Coiquis* ("Great Rite") by Polo de Ondegardo: see Brian S. Bauer and David S. P. Dearborn, *Astronomy and Empire in the Ancient Andes* (Austin: University of Texas, 1995), Table 2; Gary Tomlinson, *The Singing of the New World: Indigenous Voice in the Era of European Contact* (New York: Cambridge University Press, 2007), 124–67.

108. Golden drums were pounded to announce victories; see R. T. Zuidema, "La Imagen del sol y la huaca de Susurpuquio en el sistema astronómico de los Incas en el Cusco," *Journal de la Société des Américanistes* 63 (1974–6): 206–07.

109. This is the celebration of Capac Raymi; for an introduction to this complex ritual cycle, see Zuidema, "The Lion in the City: Royal Symbols of Transition in Cusco," in *Animal Myths and Metaphors in South America*, ed. Gary Urton (Salt Lake City: University of Utah Press, 1985), 183–96.

110. Cobo, *History of the Inca Empire An Account of the Indians' Customs and Their Origin, Together with a Treatise on Inca Legends, History, and Social Institutions* (1653), ed. and trans. Roland Hamilton (Austin: University of Texas Press, 1983), 27–29; Garcilaso, *Comentarios*, 118–19.

111. Frank Salomon, "How the Huacas Were," 10.

112. R. T. Zuidema, "Inca Cosmos in Andean Context: From the Perspective of the Capac Raymi Camay Quilla Feast Celebrating the December Solstice in Cusco," in *Andean Cosmologies through Time: Persistence and Emergence*, ed. Robert V. H. Dover, Katherine E. Seibold, and John H. McDowell (Bloomington: Indiana University Press, 1992), 23.

113. R. Tom Zuidema, "The Lion in the City," 195: *choque cumya*, golden thunderclap of puma skins, 195; Whip: Szemiñiski, *Léxico de Fray Domingo de Santo Tomás*, 117; Arquebus, Ludovico Bertonio *Arte y gramática muy copiosa de la lengua Aymara*, vol. 1 (Paris: Institut d'Ethnologie, 1956), 66 (cited in Tristan Platt, "The Sound of Light: Emergent Communication through Quechua Shamanic Dialogue," in *Creating Context in Andean Cultures*, ed. Rosaleen Howard Malverde (New York: Oxford University Press, 1997), 225 n. 6). Drums: "drums of the sun" at December Solstice ritual, cited by Zuidema, "Lion in the City," 183; on Inca drums and drumming, see also Jerry D. Moore, "'The Indians Were Much Given to Their Taquis': Drumming and Generative Categories in Ancient Andean Funerary Processions," in *Archaeology of Performance: Theaters of Power, Community, and Politics*, ed. Takeshi Inomata and Lawrence S. Coben (Lanham, MD: Altamira Press/Rowman and Littlefield, 2006), 47–69.

114. These translations are given for the expressions *Huacchini* and *Huachiscca* in González Holguín, *Vocabulario*, 168–69.

115. *Ñispa qori pachanta*: The Huarochirí Manuscript, sect. 17 and n. 47. The hair of a supernatural being is described as "curly gold" in *The Huarochirí Manuscript*, sect. 194.

116. *The Huarochirí Manuscript*, sect. 112 (283) and n. 563. On Aymara, see Gerald Taylor, "Lengua general y lenguas particulares en la antigua provincia de Yauyos (Peru)," *Revista de Indias* 171 (1983): 265–89.

117. Verónica Cereceda, "A Partir de los Colores de un Pajaro," *Boletín del Museo Chileno de Arte Precolombino* 4 (1990), 80.

118. Interchangeable usage, eg. *Huarochirí Manuscript*, sections 307–08, where *quri* ("*curri*") and *chuqui* substitute for one another in the description of a golden headdress.

119. Mary W. Helms, "Precious Metals and Politics: Style and Ideology in the Intermediate Area and Peru," *Journal of Latin American Lore* 7 (1984): 215–37.

120. For an overview to Inca gold production, see Heather Lechtman, "The Inca and Andean Metallurgical Tradition," in *Variations in the Expression of Inka Power*, ed. Richard Burger, Craig Morris, and Ramón Matos Mendieta (Washington, DC: Dumbarton Oaks, 2007), 313–55. For a recent discussion of Inca mining, see Gabriel E. Cantarutti, "Mining Under Inca Rule in North-Central Chile: The Los Infieles Mining Complex," in *Mining and Quarrying in the Ancient Andes: Sociopolitical, Economic, and Symbolic Dimensions*, ed. Nicholas Tripcevich and Kevin J. Vaughn (New York: Springer, 2013), 185–212.

121. Maurice Merleau-Ponty, *The Phenomenology of Perception* (New York: Humanities Press, 1962); Merleau-Ponty, "The Intertwining – The Chiasm," in *The Visible and the Invisible*, ed. Claude Lefort (4th ed., Evanston, IL: Northwestern University Press, 1992), 248.

122. Martin Heidegger, "Building, Dwelling, Thinking," in *Poetry, Language, Thought*, trans. Alfred Hofstadter (New York: Harper & Row, 1971), 154–53.

123. David Abram, *The Spell of the Sensuous: Perception and Language in a More-Than-Human World* (New York: Pantheon, 1996), 65.

124. Maurice Blanchot, *The Writing of the Disaster* (1980), new ed. trans. Ann Smock (Lincoln: University of Nebraska Press, 1995): "Light breaks forth: the burst of light, the dispersion that resonates or vibrates dazzlingly – and in clarity clamors but does not clarify. The breaking forth of light, the shattering reverberation of a language to which no hearing can be given" (39).

125. Crary discusses seventeenth- and eighteenth-century efforts to curb this capacity of daylight in scientific observation: Jonathan Crary, *Techniques of the Observer: On Vision and Modernity in the Nineteenth Century* (Cambridge, MA: MIT Press, 1992), 43.

126. Here I borrow "the sound of light" from Tristan Platt, "The Sound of Light: Emergent Communication through Quechua Shamanic Dialogue," in *Creating Context in Andean Cultures*, ed. Rosaleen Howard Malverde (New York: Oxford University Press, 1997).

127. Arthur A. Demarest, *Viracocha: The Nature and Antiquity of the Andean High God* (Cambridge, MA: Peabody Museum, Harvard University, 1981), 22–31.

128. Juan de Betanzos, *Narrative of the Incas* [1557], trans. Roland Hamilton and Dana Buchanan (Austin: University of Texas Press, 1996), Chapter XI, 44.

129. Franklin Pease G. Y., *El Dios creador andino* (Lima: Mosca Azul, 1973); Demarest, *Viracocha*, 39–41.

130. Shadow of *upani* or *camaquen*: Pierre Duviols, "'Camaquen, upani': Un Concept animiste des anciens Péruviens," in *Amerikanische Studien: Festschrift für Hermann Trimborn*, ed. R. Hartmann and U. Oberem (Collectanea Instituti Anthropos 20/1978), St. Augustin, Switzerland, 32–144. *Cultura andina y repression: Proceso y visitas del idolatries y hechicerías, Cajatambo, siglo XVII* (Centro de Investigaciones Rurales Andinos, Archivos de Historia Andina 5 [1986]1986a) 67, 92; Gerald Taylor, "Supay," *Amerindia* 5 (1980): 47–63; Frank Salomon, "The Beautiful Grandparents," 329.

131. Mariusz S. Ziólkowski, "El Sapan Inka y el Sumo Sacerdote: Acerca de la Legitimización del Poder in el Tawantinsuyu," in *El Culto Estatal del Imperio Inka: Memorias del 46th Congreso Internacional de Americanistas, Amsterdam, 1988*, ed. Mariusz S. Ziólkowski (Warsaw: University of Warsaw, 1991), 59–74.

132. Szemiñski, *Léxico*, 119–120.

133. On the Inca ruler, see Susan Elizabeth Ramírez, *To Feed and Be Fed*, 74–80; see also Thomas B. F. Cummins and Stephen Houston "Body, Presence and Space in Andean and Mesoamerican Rulership," in *Palaces of the*

Ancient New World, ed. Susan Tobey Evans and Joanne Pillsbury (Washington, DC: Dumbarton Oaks, 2005), 359–98.

134. On the "court in motion" in the Inca realm, see Dennis Ogburn, "Dynamic Display, Propaganda, and the Reinforcement of Provincial Power in the Inca Empire," *Archaeological Papers of the American Anthropological Association* 14 (2005): 225–39.

135. Feathers: Cristóbal de Molina, *Fábulas y Mitos de los Incas* [1585], ed. Henrique Urbano and Pierre Duviols (Madrid: Historia, 1988) on May ceremonies in Aucay Pata. Ground shells: extrapolated from Chimu royal practice, cited in Miguel Cabello de Valboa, *Miscelánea antartica del Perú antiguo* (1586; reprint L. E. Valcárcel, ed., Lima: Universidad Nacional Mayor de San Marcos, 1951). The trade of spondylus shells "in a very fragmentary form" – i.e., powdered – is archaeologically attested by the high frequency of small-balance scales in excavations in the Inca-period Chincha region, Craig Morris and Julián Idilio Santillana, "The Inca Transformation of the Chincha Capital," in *Variations in the Expression of Inka Power: A Symposium at Dumbarton Oaks*, ed. Richard L. Burger, Craig Morris, and Ramiro Matos Mendieta (Washington, DC: Dumbarton Oaks, 2007), 157.

136. "Luck" (well-being, contentment), or *Sami*: see Enrique Urbano, "Sami y Ecaco: Introducción a la noción de 'fortuna' en los Andes," in *Religions des andes et langues indigenes: Équateur-Pérou-Bolivie avant et après le conquete espagnole*, ed. Pierre Duviols (Aix-en-Provence: University of Provence, 1993) 235–43. On the circulation of cosmic energies, see Daisy Nuñez Prado Béjar, "La Reciprocidad como ethos de la cultura quechua," *Allpanchis* 4 (1972): 135–65; John Earls and Irene Silverblatt, "La Realidad Física y Social en la Cosmología Andina," *Actes du XLIIᵉ Congrès International des Américanistes*, Vol. IV (Paris: Congrès du Centenaire and Fondation Singer-Polignac, 2–9 September 1976): 299–325; Bruce Mannheim, "The Language of Reciprocity in Southern Peruvian Quechua," *Anthropological Linguistics* 28 (1986): 267–73.

137. R. Tom Zuidema, "Guaman Poma and the Art of Empire: Toward an Iconography of Inca Royal Dress," in *Transatlantic Encounters: Europeans and Andeans in the Sixteenth Century*, ed. Kenneth J. Andrien and Rolena Adorno (Berkeley: University of California Press, 1991), 174; also Zuidema, "The Lion in the City"; *Lirpu* and *Kuychi*: Guaman Poma, *Corónica*, 119–20.

138. *Cittuy*, "to shine/sparkle" was generally ascribed to shining things such as the sun at midday; the term also seems to register the synaesthetic quality of sunlight, as something that "reverberates": see González Holguín, *Vocabulario*, 85.

139. R. Alan Covey, "Intermediate Elites in the Inca Heartland, A.D. 1000–1500," in *Intermediate Elites in Pre-Columbian States and Empires*, ed. Christina M. Elson and R. Alan Covey (Tucson: University of Arizona Press, 2006), 120–21.

140. Cited in Martín de Murua, *Historia general del Perú* (1609; reprint Madrid, 1962), 115, 123 (cited in Maarten Van de Guchte, "'Carving the World': Inca Monumental Sculpture and Landscape" [Ph.D. dissertation, Department of Anthropology, University of Illinois Urbana/Champaign, 1992], 32; Ann Kendall, *Aspects of Inca Architecture: Description, Function, Chronology* [Oxford: BAR International, 1985], 62). Blue and yellow panels from Huari Pampa Ocoña, ca. 700–850 C.E., including examples in the collections of Dumbarton Oaks (B-522), the Metropolitan Museum of Art, the University Museum of the University of Pennsylvania, the St. Louis Art Museum, the Dallas Museum of Art, and the Musées Royaux d'Art de d'Histoire, Brussels; see *Andean Art at Dumbarton Oaks*, vol. 2, ed. Elizabeth Hill Boone (Washington, DC: Dumbarton Oaks, 1996), pl. 120, 417–18. Roof thatched with feather is cited in a mythological account: *The Huarochirí Manuscript: A Testament of Ancient and Colonial Andean Religion*, trans. Frank Salomon and George L. Urioste (Austin: University of Texas Press, 1991), section 39, 55. Huayna Capac's marriage to Cusi Rimay: "roofs of city were covered for the occasion with the finest cloths woven with brilliant feathers of tropical birds... [couple] toured Cuzco in separate litters" (Rostworowski de Diez Canseco, *History of the Inca Realm*, 105, cites Cabello de Valboa, Cobo, and Santa Cruz Pachacuti); Wayna Qhapaq's corpse returned from Tomebamba, the streets and standing architecture of Cuzco were covered in cumbi

and silverwork and gold (Martín de Murua, *Historia general del Perú, origen y descendencia de los Incas* [1609]; cited in Van de Guchte, 32); at Washkar's marriage, towers created, covered in metal and cloth (Murua; cited by Ann Kendall, Aspects of Inca Arch.), 62; Sabine MacCormack, *Religion in the Andes: Vision and Imagination in Early Colonial Peru* (Princeton, NJ: Princeton University Press, 1991), 320.

141. Covey, "Intermediate Elites," 123, 133 n. 6. Captains: Felipe Guaman Poma de Ayala, *El primer nueva corónica y buen gobierno* (1615/1616) (Copenhagen, Royal Danish Library, GKS 2232 4°: facsimile at http://www.kb.dk), 65.

142. Cummins, *Toasts with the Inca*, 107–8.

143. R. T. Zuidema, "The Royal Whip in Cusco: Art, Social Structure, and Cosmology," in *The Language of Things: Studies in Ethnocommunication*, ed. Pieter ter Keurs and Dirk Smidt (Leiden: Rijksmuseum voor Volkenkunde, 1990), 169; Zuidema, "Myth and History in Perú," in *The Logic of Culture: Advances in Structural Theory and Methods*, ed. Ino Rossi (London: Tavistock 1982), 150–75.

144. This is the period of *huañoc* ("die-er"), which brackets those soon to expire with those recently expired. See George Urioste, "Sickness and Death in Preconquest Andean Cosmology: The Huarochirí Oral Tradition," in *Health in the Andes*, ed. Joseph W. Bastien and John M. Donahue (Washington, DC: American Anthropological Association, 1981), 9–18. Dimming fires: Salomon, "The Beautiful Grandparents," 331, cites Juan de Betanzos, *Suma y Narración de los Incas*, ed. María del Carmen Martín Rubio (Madrid: Ediciones Atlas, 1987), 141–50.

145. Jean Berthelot, "The Extraction of Precious Metals at the Time of the Inca," in *Anthropological History of Andean Polities*, ed. John V. Murra, Nathan Wachtel, and Jacques Revel (Cambridge: Cambridge University Press, 1986), 69–88.

146. Heather Lechtman, "Arsenic Bronze: Dirty Copper or Chosen Alloy? A View from the Americas," *Journal of Field Archaeology* 23:3 (1996): 477–514.

147. Heather Lechtman, "Technologies of Power: The Andean Case," in *Configurations of Power: Holistic Anthropology in Theory and Practice*, ed. John S. Henderson and Patricia J. Netherly

(Ithaca, NY: Cornell University Press, 1993), 263.

148. Provincial leaders given shirts inlaid with metal, gold, silver, stone: John V. Murra, "On Inca Political Structure," in *Systems of Political Control and Bureaucracies in Human Societies*, ed. Verne F. Ray (Seattle: University of Washington Press, 1958), 30–41.

149. E.g. Juan de Betanzos, *Narrative of the Incas*, trans. Roland Hamilton and Dana Buchanan (Austin: University of Texas Press, 1996), Part I, Chapter 3: 13; Cristóbal de Molina, *An Account of the Fables and Rites of the Incas (Fábulas y Ritos de los Incas*, 1575); trans. Clements R. Markham (London: Hakluyt Society, 1873), 6.

150. This tendency may be related to contemporary Quechua-speaking communities' recognition of the quality of *llunko* or *llanka* in all-black animals: see Penelope Y. Dransart, *Earth, Water, Fleece, and Fabric: An Ethnography and Archaeology of Andean Camelid Herding* (London: Routledge, 2002), 138–39.

151. *Que no tuvieron senal* [sic] *ni mancha ni lunar y fuesen hermosos*. Felipe Guaman Poma de Ayala, *El primer nueva corónica y buen gobierno* (1615/1616) (Copenhagen, Royal Danish Library, GKS 2232 4°: facsimile at http://www.kb.dk), 261–64. This quality of surface perfection is also alluded to by Molina, writing in Cuzco in 1585: *Sin fealdad ninguna ni mancha y lanudo* (Cristóbal de Molina, *Fábulas y Mitos de los Incas* [1585], ed. Henrique Urbano and Pierre Duviols [Madrid: Historia, 1988], 79). On this form of Inca sacrifice (*Capac Hucha*), see Colin McEwan and Maarten van de Guchte, "Ancestral Time and Sacred Space in Inca State Ritual," in *Ancient Americas: Art from Sacred Landscapes*, ed. Richard Townsend (Chicago: Art Institute of Chicago, 1992), 359–71; Johan Rienhart, *The Ice Maiden: Inca Mummies, Mountain Gods, and Sacred Sites in the Andes* (Washington, DC: National Geographic Society, 2005); Johan Rienhart and Maria Constanza Ceruti, *Inca Rituals and Sacred Mountains: A Study of the World's Highest Archaeological Sites* (Los Angeles: Cotsen Institute of Archaeology Press, 2010); Valeria A. Andrushko, Michele R. Buzon, Arminda M. Gibaja, Gordon F. McEwan, Antonio Simonetti, and Robert A. Creaser, "Investigating a Child Sacrifice Event from the Inca Heartland,"

Journal of Archaeological Science 38 (2011): 323–33; Thomas Besom, *Inca Human Sacrifice and Mountain Worship: Strategies for Empire Unification* (Albuquerque: University of New Mexico Press, 2013).

152. Cummins has likened certain designs on incised Inca keros to teeth, allying them with a larger iconography of skulls: Cummins, *Toasts with the Inca*, 14–38. Colin McEwan identifies incised devices of concentric squares as motifs relating to the Inca *usnu* and the ideology of ritual libation: McEwan, "Cognising and Marking the Andean Landscape: Radial, Concentric, and Hierarchical Perspectives," in *Inca Sacred Space: Landscape, Site and Symbol in the Andes*, ed. Frank Meddens, Katie Willis, Colin McEwan, and Nicholas Branch (London: Archetype, 2014), 29–47. All these readings are complementary.

153. *Plumes d'éternité: Parures funéraires de l'Ancien Pérou* (Paris: Somogy, 2003), James W. Reid, *Magic Feathers: Textile Art from Ancient Peru* (London: Textile and Art Publications, 2003); Heidi King, ed. *Peruvian Featherworks: Art of the Precolumbian Era*, ex. cat. Metropolitan Museum of Art (New York: Metropolitan Museum of Art, 2012).

154. Victor Turner, "Liminality and Communitas," in *The Ritual Process: Structure and Anti-Structure* (Chicago: Aldine, 1969), 94–113; see also the classic work of Arnold van Gennep, *The Rites of Passage* [1909], trans. M. B. Vizedom and G. L. Caffee (Chicago: University of Chicago Press, 1960).

155. Turner, "Liminality and Communitas," 94–113.

156. On earthquakes and the Inca dynastic principle of Pachakuti, see Rebecca R. Stone, "'And All Theirs Different from His': The Dumbarton Oaks Royal Inka Tunic in Context," in *Variations in the Expression of Inka Power*, Richard R. Burger, Craig Morris, and Ramiro Matos Mendieta, eds. (Washington, DC: Dumbarton Oaks, 2007), 406. See also López-Baralt, Mercedes, "The *Yana K'uychi* or Black Rainbow in Atawallpa's Elegy: A Look at the Andean Metaphor of Liminality in a Cultural Context," *Myth and the Imaginary in the New World* (1986): 261–303; Sabine MacCormack, "Pachacuti: Miracles, Punishments, and Last Judgment: Visionary Past and Prophetic Future in Early Colonial Peru," *The American Historical Review* 93

(1988): 960–1006; Constance Classen, "Sweet Colors, Fragrant Songs: Sensory Models of the Andes and the Amazon," *American Ethnologist* 17 (1990): 722–35; and "Creation by Sound/Creation by Light: A Sensory Analysis of Two South American Cosmologies" in David Howes, ed., *The Varieties of Sensory Experience: A Sourcebook in the Anthropology of the Senses* (Toronto: University of Toronto Press, 1991), 238–55.

157. Felipe Guaman Poma de Ayala, *El primer nueva corónica y buen gobierno* (1615/1616) (Copenhagen, Royal Danish Library, GKS 2232 4°: facsimile at http://www.kb.dk), notes Laws of Inca 185[187], Decía ací: "*Ama nacaconquicho yntiman quillaman chuqui ylla uaca uillcaconaman noca yncayquitapas coyatauanpas. Uanochiquimanmi, tucochiquimanmi.*" Translated in footnote as: "No deberéis maldecir contra el sol, la luna, las divinidades resplandecientes como objetos de oro, ni contra mí, vuestro Inca, ni contra la reina. Los haría matar ciertamente, los exterminaría sin duda."

158. Irene Silverblatt, *Sun, Moon, and Witches: Gender Ideologies and Class in Inca and Colonial Peru* (Princeton, NJ: Princeton University Press, 1987), 20–66.

159. An Inca prayer to the sun recorded by Cristóbal de Molina set elemental *punchao . . . tuta* (day-night/life-death) against more "domestic" forms of illumination. *Killariy . . . K'anchariy* (daylight/candlelight): see John H. Rowe, "Eleven Inca Prayers from the Zithuwa Ritual," *Kroeber Anthropological Society Papers* 8/9 (1953), 90–91. See also Regina Harrison, "The Language and Rhetoric of Conversion in the Viceroyalty of Peru," *Poetics Today* 16:1 (1995), 13–20.

160. Bruce Mannheim and Krista van Vleet, "The Dialogics of Southern Quechua Narrative," *American Anthropologist* 100:2 (1998): 326–46; see also essays in Mannheim and Bruce Tedlock, eds. *The Dialogic Emergence of Culture* (Urbana: University of Illinois Press, 1995).

161. Felipe Guaman Poma de Ayala, *El primer nueva corónica y buen gobierno* (1615/1616) (Copenhagen, Royal Danish Library, GKS 2232 4°: facsimile at http://www.kb.dk), 31.

162. Szemiñiski, *Léxico*, 155, 245–6; Jorge A. Lira, *Diccionario kkechuwa-español* (Bogotá, Colombia: Secretaría Ejecutiva del Convenio "Andrés Bello", 1982), 245–6.

163. Cristóbal de Molina, *Fábulas*, 77, 100, and n. 75.

164. Ahmed Achrati, "Body and Embodiment: A Sensible Approach to Rock Art," *Rock Art Research* 24:1 (2007): 47–57 (48).

165. Szemiñiski, *Léxico*, 155, 245–46; Lira, *Diccionario kkechuwa-español*, 273–74.

166. Dean, *Culture of Stone*, 63; Salomon and Urioste, *The Huarochirí Manuscript*, 74 n. 257. See also Frank Salomon, "Andean Opulence: Indigenous Ideas about Wealth in Colonial Peru," in *The Colonial Andes: Tapestry and Silverwork, 1530–1830*, ed. Elena Phipps, Johanna Hecht, and Cristina Esteras Martín (New York: The Metropolitan Museum of Art, 2004), 114–24.

167. *Illa* has come to signify shining, spiritually charged objects: see Salomon, "Andean Opulence," 114–17; for an instance of *illa* in the ritual practice of Quechua speakers, see Catherine J. Allen, *The Hold Life Has: Coca and Cultural Identity in an Andean Community* (Washington, DC: Smithsonian University Press, 1988), 63; O. Harris, "The Earth and State: the Sources and Meanings of Money in Northern Potosí, Bolivia," in *Money and the Morality of Exchange*, ed. J. Parry and M. Bloch (Cambridge: Cambridge University Press, 1989), 258–60; Sarah Lind Skar, Lives Together – Worlds Apart: Quechua Colonization in Jungle and City (Oslo: Scandinavian University Press, 1994), 67–70.

168. Diego de González Holguín, *Vocabulario de la lengua general de todo el Perú llamada lengua qquichua o del Inca* (1608; reprint Lima: Universidad Nacional Mayor de San Marcos, 1989), 569.

169. I borrow the terms "cold" and "hot culture" from Marshall Sahlins, *Culture and Practical Reason* (Chicago: University of Chicago Press, 1976).

170. On this miracle of Santa María de Peña de Francia, see Felipe Guaman Poma de Ayala, *El primer nueva corónica y buen gobierno* (1615/ 1616) (Copenhagen, Royal Danish Library, GKS 2232 4°: facsimile at http://www.kb .dk), 404v. On this trope of the Virgin Mary in the late medieval and early modern Iberian world, see Amy G. Remensnyder, *Virgin Mary at War and Peace in the Old and New Worlds* (Oxford: Oxford University Press, 2014), 198–200; on the European understandings of the Virgin's role in the siege of Cuzco, see Thomas Flickema, "The Siege of Cuzco," *Revista de Historia de América* 92 (1981): 17–47.

171. Guaman Poma, ibid., 403: "*hizo otro milagro muy grande, milagro de la Madre de Dios en este rreyno, que lo uieron a uista de ojos los yndios deste rreyno y lo declaran y dan fe de ello, como en aquel tienpo no auía nenguna señora en todo el rreyno ni jamás lo auían uisto ni conocido, cino primera señora le conoció a la Uirgen María.*"

172. Willem F. Adelaar, "Cajamarca Quechua and the Expansion of the Huari State," in *Archaeology and Language in the Andes: A Cross-Disciplinary Exploration of History*, ed. Paul Heggarty and David Beresford-Jones (Oxford: British Academy/Oxford University Press, 2012), 197–217 (211). Cites Alfredo A. Torero, "Procedencia geográfica de los dialectors quechuas de Ferrañafe y Cajamarca," *Anales Científicos de la Universidad Agraria* 6:3–4 (1968): 308.

CONCLUSION

1. Juan Ruiz de Arce, *La Memoria de Juan Ruiz de Arce (1543): Conquista del Perú, saberes secretos de caballería y defense del mayorazgo*, ed. Eva Stoll (Frankfurt and Madrid: Vervuert Verlag/ Iberoamericana, 2002), 83.

2. Janis B. Nuckolls, *Sounds Like Life: Sound-Symbolic Grammar, Performance, and Cognition in Pastaza Quechua* (New York: Oxford University Press, 1996), 167–70. See also Bruce Mannheim, "The Sound Must Seem an Echo to the Sense: Some Cultural Determinants of Language Change in Southern Peruvian Quechua," *Michigan Discussions in Anthropology* 8 (1988): 175–95.

3. Nuckolls, *Sounds Like Life*, 169.

4. Kroeber, "Great Art Styles of Ancient South America," in Kroeber, *The Nature of Culture* (Chicago: University of Chicago Press, 1952), 293 (reprinted from Sol Tax, ed., *The Civilizations of Ancient America: Selected Papers for the XXIXth International Congress of Americanists* [1951], 207–15). See Meyer Schapiro's critique of Kroeber's "exaggerated holism," in Meyer Schapiro, review of A. L. Kroeber, *Style and Civilizations, American Anthropologist* 61 (1959): 304–05; George Kubler, *Cuzco: Reconstruction of the Town and Restoration of Its Monuments (Report of the Unesco Mission of 1951)* (Paris: UNESCO, 1952), 32.

5. Pedro Cieza de León offers the most extended account of Atawallpa's interaction with the breviary: Cieza de León, *El Descubrimiento y Conquista del Perú* (1553), ed. Carmelo Sáenz de Santa Maria (Madrid: Historia 1984), Chapt. 45, 156–7. On this episode, see Sabine MacCormack, "Atahualpa and the Book," *Dispositio* XIV; Patricia Seed, "'Failing to Marvel': Atahualpa's Encounter with the Word," *Latin American Research Review* 26: (1991): 7–32; Tom Cummins, "'Let Me See! Reading is for them' Colonial Andean Images and Objects 'como es Costumbre tener los Caciques Señores'" *Native Traditions in the Postconquest World*, ed. Elizabeth Boone and Tom Cummins (Washington, DC: Dumbarton Oaks, 1998), 91–148; Gonzalo Lamana, "Beyond Exotization and Likeness: Alterity and the Production of Sense in a Colonial Encounter," in *Comparative Studies in Society and History* 47:1 (2005): 32–33; Lamana, *Domination without Dominance: Inca-Spanish Encounters in Early Colonial Peru* (Durham and London: Duke University Press, 2008).

6. On the idol lost at cards, see Pierre Duviols, "'Punchao': Idolo Mayor del Coricancha, Historia y Tipologia," *Antropolgía Andina* 1–2 (1976): 156–83; John H. Rowe, "El Arte Religioso del Cusco en el Horizonte Temprano," *Ñawpa Pacha* 14 (1976), 1–20. On the soldier who claimed to have lost the idol, Mansio Serra de Leguizamón, see James Lockhart, *The Men of Cajamarca: A Social and Biographical Study of the First Conquerors of Peru* (Austin: University of Texas Press, 1972), 469; Stuart Sterling, *The Last Conquistador: Mansio Serra de Leguizamón and the Conquest of the Incas* (Phoenix Mill, England: Sutton Publishing, 1999). On those portraits, see Catherine Julien, "History and Art in Translation: The *Paños* and Other Objects Collected by Francisco Toledo," *Colonial Latin American Review* 8:1 (1999): 61–89. For a rebuttal of the pre-contact origin of these images, see Thomas B. F. Cummins, "The Images in in Murúa's *Historia General del Piru*: An Art Historical Study," in *The Getty Murúa: Essays on the Making of Martín de Murúa's "Historia general del Piru," 1616, Ms. Ludwig XIII 16*, ed. Thomas B. F. Cummins and Barbara Anderson (Los Angeles: J. Paul Getty Trust, 2008), 147–74.

7. Gonzálo Lamana, *Domination without Dominance: Inca-Spanish Encounters in Early Colonial Peru* (Durham: Duke University Press, 2008), 79.

8. Titu Cusi Yupanqui, *History of How the Spaniards Arrived in Peru: Dual Language Edition*, trans. Catherine Julien (Indianapolis/Cambridge: Hackett Publishing, 2006), 13–16; Juan de Betanzos, *Suma y narración de los Incas*, ed. Maria del Carmen Martín Rubio (Madrid: Atlas, 1987), 267–69. See Cummins, *Toasts with the Inca*, 14–38.

9. Joan de Santa Cruz Pachacuti Yamqui Salcamaygua, *Relación de antiguedades deste Reyno del Piru: Estudio Ethnothistórico de Pierre Duviols y César Itier* (Lima/Cusco: Institut Francais d'Etudes Andines/Centro de Estudios Regionales Andinds "Bartolomé de las Casas," 1993), 266–68 (42v–43r); eating own dead: 222(20v).

10. Sabine MacCormack, *On the Wings of Time: Rome, the Incas, Spain, and Peru* (Princeton, NJ: Princeton University Press, 2007), 66–100.

11. On Ruiz's career after Cajamarca, see Lockhart, *The Men of Cajamarca*, 54–57.

12. Francisco de Xerez, *Verdadera Relación de la Conquista del Perú* [1534] (Madrid: Tip. J. C. Garcia, 1891), 82.

13. See Thomas B. F. Cummins, *Toasts with the Inca*, 14–38.

14. Cummins, *Toasts with the Inca*, 39–58. See also Susan Elizabeth Ramírez, *To Feed and Be Fed: The Cosmological Bases of Authority and Identity in the Andes* (Stanford, CA: Stanford University Press, 2005).

15. Peter Gose, "The State as a Chosen Woman: Brideservice and the Feeding of Tributaries in the Inca Empire," *American Anthropologist* (ns) 102:1 (2000), 86–89.

16. Cecelia F. Klein, "Wild Woman in Colonial Mexico: An Encounter of European and Aztec Concepts of the Other," in *Reframing the Renaissance: Studies in the Migration of Visual Culture*, ed. Claire Farago (London: Yale University Press, 1995), 244–63. See also Irene Silverblatt, *Sun, Moon, and Witches: Gender Ideologies and Class in Inca and Colonial Peru* (Princeton, NJ: Princeton University Press, 1987), 159–96.

17. On Inca "chosen women," see Chapter 4, note 28.

18. This is the woman Qispi Sisa, who bore her first child in 1534: on this and other histories of native Andean and European unions and their offspring, see Stuart B. Schwartz and Frank

Salomon, "New Peoples and New Kinds of People: Adaptation, Readjustment, and Ethnogenesis in South American Indigenous Societies (Colonial Era)," in *The Cambridge History of the Native Peoples of the Americas*, ed. Stuart B. Schwartz and Frank Salomon, Vol. III, part 2 (Cambridge: Cambridge University Press, 1999), 443–501; Qispi Sisa is cited on 479.

19. Mary J. Weismantel, "Moche Sex Pots: Reproduction and Temporality in Ancient South America," *American Anthropologist*, New Series 106:3 (Sep. 2004), 495–505; Weismantel, "Maize Beer and Andean Social Transformations: Drunken Indians, Bread Babies, and Chosen Women," *Modern Language Notes* 104:4 (1991): 861–79.

20. Denise Y. Arnold, "Convertirse en persona': el tejido: La Terminología de un cuerpo textile," in *Actas de la 1 jornada Internacional sobre Textiles Precolombinos*, ed. Victória Solanilla Demestre (Barcelona: Servei de Publicacions de la UAB, 2000), 11, 17–19.

21. Denise Y. Arnold and Christine Hastorf, *Heads of State: Icons, Power, and Politics in the Ancient and Modern Andes* (Walnut Creek, CA: Left Coast Press, 2008), 66–67.

22. See, e.g., Anne Paul, "Paracas Necrópolis Bundle 89: A Description of its Contents," in *Paracas Art and Architecture: Object and Context in South Coastal Peru*, ed. Anne Paul (Iowa City: University of Iowa Press, 1991), 172–221.

23. Denise Y. Arnold and Juan de Dios Yapita, *River of Fleece, River of Song: Singing to the Animals, an Andean Poetics of Creation* (Markt Schwaben: Anton Saurwein, 2001), 64–67.

24. Dennis E. Ogburn, "Human Trophies in the Late Pre-Hispanic Andes: Striving for Status and Maintaining Power among the Inkas and Other Societies," in *The Taking and Displaying of Human Body Parts as Trophies by Amerindians*, ed. Richard Chacon and David H. Dye (New York: Springer, 2007), 505–21. See also Denise Y. Arnold, *The Metamorphosis of Heads: Textual Struggles, Education, and Land in the Andes* (Pittsburgh: University of Pittsburgh Press, 2006); Arnold and Hastorf, *Heads of State*.

25. On the hair of high-status Inca males, see John H. Rowe, "Inca Culture at the Time of the Spanish Conquest," *Handbook of South American Indians, Bureau of American Ethnology Bulletin* 143:2, ed. Julian H. Steward (Washington, DC: Smithsonian Institution, 1946), 236; on practices of tonsure, see Mariusz S. Ziółkowski, *La Guerra de los Wawqis: Los Objectivos y los mechanismos de la rivaldad dentro de la élite Inka, siglos XV y XVI* (Quito: Biblioteca Abya-Yala, 1997), 65–71.

26. Van de Guchte, "Sculpture and the concept of the double meaning among the Inca Kings." *RES: Anthropology and Aesthetics* 29/30 (1996): 256–69; Peter Gose, "Oracles, Divine Kingship, and Political Representation in the Inca State," *Ethnohistory* 43:1 (1996): 19–20; Carolyn Dean, *Culture of Stone*, 41–45.

27. Cobo, *History of the Inca Empire: An Account of the Indians' Customs and Their Origin, Together with a Treatise on Inca Legends, History, and Social Institutions* (1653), ed. and trans. Roland Hamilton (Austin: University of Texas Press, 1983), 177; Franklin Pease G. Y., *Los Ultimos Incas del Cusco* (Lima: Taller Gráfica Villanueva, 1972), 45.

28. Catherine J. Allen, "'Let's Drink Together, My Dear': Persistent Ceremonies in a Changing Community," in *Drink, Power, and Society in the Andes*, ed. Justin Jennings and Brenda J. Bowser (Gainesville: Press of the University of Florida, 2008), 38; Joseph W. Bastien, "Qollahuaya-Andean Body Concepts: A Topographical-Hydraulic Model of Physiology," *American Anthropologist* (n.s.) 87:3 (1985), 597.

29. Susan A. Niles, "*Moya* Place or Yours? Inca Private Ownership of Pleasant Places," *Ñawpa Pacha* 25–27 (1987–89): 189–206.

30. Ruiz de Arce, *Memoria*, 80–81.

31. Pedro Pizarro, *Relacion*, 32.

32. Describing the April rites of Raymi Qilla, Guaman Poma related how the Inca emperor would perform a song, "singing of the rivers in that sound they make." Felipe Guaman Poma de Ayala, *El primer nueva corónica y buen gobierno* (1615/1616) (Copenhagen, Royal Danish Library, GKS 2232 4°: facsimile at http://www.kb.dk), 244v.

33. Brian S. Bauer, *The Sacred Landscape of the Inca* (Austin: University of Texas Press, 1998), 53.

34. *Ñispa qori pachanta: The Huarochirí Manuscript*, sect. 17 and n. 47. The hair of a supernatural being is described as "curly gold" in *The Huarochirí Manuscript* sect. 194.

35. R. Tom Zuidema, "El Primer nueva corónica y buen gobierno," *Latin American Indian Literatures* 6:2 (1982), 131, 126–32. On love songs in a landscape, see Antoinette Molinié, "The Spell of Yucay: A Symbolic Structure in Incaic Terraces," *Journal of the Steward Anthropological*

Society 24:1–2 (1996): 203–30; Henry Stobart, *Music and the Poetics of Production in the Bolivian Andes* (Aldershot, England: Ashgate, 2006), esp. 102–32, on "Marrying the Mountain and the Production of People."

36. Jean-Philippe Husson, *La Poesie Quechua dans la chronique de Felipe Waman Puma de Ayala* (Paris: L'Harmattan, 1985), 131–36.

37. Veronica Cereceda, "Aproximaciones a una estética andina: de la belleza al tinku," in Thérése Bouysse-Cassagne, ed. *Tres reflexiones sobre el pensamiento andino* (La Paz: Hisbol, 1987), 133–231.

38. For instance, the important oracle of Ancocagua, set on the high ground above the confluence of the Apurímac and Totorani rivers (María Fortoleza); see Johan Reinhard, "The Temple of Blindness: An Investigation into the Inca Shrine of Ancocagua," *Andean Past* 5 (1998): 89–108.

39. Scott C. Smith, "The Generative Landscape: The Step Mountain Motif in Tiwanaku Iconography," *Ancient America* 12 (2012), 23, cites Joseph Bastien, *Mountain of the Condor: Metaphor and Ritual in an Andean Allyu* (St. Paul, MN: American Ethnological Society/ West Publishing, 1978), 195–96.

40. *Phichiw*: Jan Szemiñski, *Léxico de Fray Domingo de Santo Tomás, 1560* (Lima: Convento de Santo-Domingo-Qorikancha/Sociedad Polaca de Estudios Latinoamericanos/Universidad Hebrea de Jerusalén, 2006). 402: "Ppichiu. Todo Pajaro y la niña del ojo."

41. Smith, "The Generative Landscape," 12.

42. Catherine J. Allen, "When Pebbles Move Mountains," in *Creating Context in Andean Cultures*, ed. Rosaleen Howard-Malverde (Oxford Studies in Anthropological Linguistics, Oxford University Press, 1997), 80; Allen, *The Hold Life Has: Coca and Cultural Identity in an Andean Community* (Washington, DC: Smithsonian Institution, 2002), 36.

43. Enrique Urbano, "Sami y Ecaco: Introducción a la noción de 'fortuna' en los Andes," in Pierre Duviols, ed., *Religions des andes et langues indigenes: Équateur-Pérou-Bolivie avant et après le conquete espagnole* (Aix-en-Provence: University of Provence, 1993), 235–243.

44. Inca Garcilaso de la Vega, *Historia General del Perú* [1617] (Lima: Libreria Internacional del Peru, SA, 1959), Book II, Chapter I, 114–15.

45. The phrase *casas de plazer* was widely employed by early Spanish soldiers and settlers in Peru: it is found in administrative documents as early as 1534. Frank Salomon, *Native Lords of Quito in the Age of the Incas: The Political Economy of North Andean Chiefdoms* (Cambridge: Cambridge University Press, 1986), 147. The phrase is now employed to refer to country houses, "houses of rest and distraction" (*Diccionario de la lengua española*, 23rd ed. (Madrid: Real Academia Española, 2010).

46. Cervantes, *Don Quijote* (1605), Vol. II, Chapter 30: *que venga mucho en hora Buena a servirse de mí y del duque mi marido, en una casa de placer que aquí tenemos*. Cervantes's passage participates in the early modern period's deep literature of secular pleasure and the country retreat: see David R. Coffin, *The Villa in the Life of Renaissance Rome* (Princeton, NJ: Princeton University Press, 1979), 9–22.

47. On erotic images of bathing in early-sixteenth-century Europe, see Anne Röver Kann, *Albrecht Dürer: Das Frauenbad von 1496* (Bremen, 2001). Erwin Panofsky, "Homage to Fracastoro in a Germano-Flemish Composition of about 1590?" *Nederlands kunsthistorisch jaarboek*, XII (1961): 1–33. See also Michael Camille, *The Medieval Art of Love: Objects and Subjects of Desire* (New York: Harry N. Abrams, 1998), and Anne Dunlop, *Painted Palaces: The Rise of Secular Art in Early Renaissance Italy* (State College: Pennsylvania State University Press, 2009), esp. 1–5, 137–142; Diane Wolfthal, *In and Out the Marital Bed: Seeing Sex in Renaissance Europe* (New Haven, CT: Yale University Press, 2010), 187.

BIBLIOGRAPHY

Abercrombie, Thomas A. *Pathways of Memory and Power: Ethnography and History among an Andean People* (Madison: University of Wisconsin Press, 1998).

Abram, David. *The Spell of the Sensuous: Perception and Language in a More-Than-Human World* (New York: Pantheon, 1996).

Achrati, Ahmed. "Body and Embodiment: A Sensible Approach to Rock Art." *Rock Art Research* 24:1 (2007): 47–57.

Acuto, F. A. "Paisaje y dominación: La constitución del espacio social en el Imperio Inka." In *Sed Non Satiata: Teoría social en la arqueología latino-americana contemporánea* (Buenos Aires: Ediciones El Tridente, 1999), 33–75.

Adelaar, Willem F. H. *Tarma Quechua: Grammar, Texts, Dictionary* (Lisse: Peter de Ridder, 1977).

Adelaar, Willem F. "Cajamarca Quechua and the Expansion of the Huari State." In *Archaeology and Language in the Andes: A Cross-Disciplinary Exploration of History*, ed. Paul Heggarty and David Beresford-Jones (Oxford: British Academy/Oxford University Press, 2012), 197–217.

Adorno, Rolena. *Guaman Poma: Writing and Resistence in Colonial Peru* (Austin: University of Texas Press, 1988).

Adorno, Rolena. "Sur y Norte: El Diálogo crítico literario latinoamericanista en la segunda mitad del siglo veinte," *Hofstra Hispanic Review* 1:1 (2005): 5–14.

Aimi, Antonio. *Perú: Tremila Anni di Capolavori* (Milan: Electa, 2003).

Alberti Manzanares, Pilar. "La Influencia económica y política de las Acllacuna en el Incanato." *Revista de Indias* 45 (1985): 557–85.

Alberti Manzanares, Pilar. "Una institución exclusivamente feminine en la época incaica:

las acllacuna." *Revista Española de Antropología Americana* 16 (1986): 153–90.

Allen, Catherine J. *The Hold Life Has: Coca and Cultural Identity in an Andean Community* (Washington, DC: Smithsonian University Press, 1988).

Allen, Catherine J. "When Pebbles Move Mountains." In *Creating Context in Andean Cultures*, Rosaleen Howard-Malverde, ed., Oxford Studies in Anthropological Linguistics (Oxford: Oxford University Press, 1997), 73–83.

Allen, Catherine J. "'Let's Drink Together, My Dear': Persistent Ceremonies in a Changing Community." In *Drink, Power, and Society in the Andes*, ed. Justin Jennings and Brenda J. Bowser (Gainesville: Press of the University of Florida, 2008), 28–48.

Andaluz Westreicher, Carlos, Juan Luis Mérega, Gabriel Palmili. "The Economics of Pastoralism: Study on Current Practices in South America." *Nomadic Peoples* 11:2 (2007): 87–105.

Anderson, Virginia DeJohn. *Creatures of Empire: How Domestic Animals Transformed Early America* (Oxford: Oxford University Press, 2002).

Andrushko, Valeria A., Michele R. Buzon, Arminda M. Gibaja, Gordon F. McEwan, Antonio Simonetti, and Robert A. Creaser. "Investigating a Child Sacrifice Event from the Inca Heartland." *Journal of Archaeological Science* 38 (2011): 323–33.

Angulo-Cano, Yaniro. "The Modern Autobiographical 'I' in Bernal Díaz del Castillo." *MLN: Modern Language Notes* 125:2 (2010): 287–304.

Alonso, A. "Las Momias de los Incas: su función y realidad social." *Revista Española*

de Antropología Americana 19 (1989): 109–35.

Arce, Juan Ruiz de. *La Memoria de Juan Ruiz de Arce (1543): Conquista del Perú, saberes secretos de caballería y defense del mayorazgo,* ed. Eva Stoll (Frankfurt and Madrid: Vervuert Verlag/Iberoamericana, 2002).

Arellano, Carmen, and Ramiro Matos Mendieta. "Variations between Inka Installations in the Puna of Chinchayqocha and the Drainage of Tarma." In *Variations in the Expression of Inka Power,* ed. In *Variations in the Expression of Inka Power,* ed. Richard L. Burger, Craig Morris, Ramiro Matos, et al. (Washington, DC: Dumbarton Oaks, 2007), 11–44.

Argyle, Michael, and Janet Dean, "Eye-Contact, Distance and Affiliation," *Sociometry* 28:3 (1965): 289–304.

Arnold, Denise Y. "Convertirse en persona': el tejido: La Terminología de un cuerpo textile." In *Actas de la 1 jornada Internacional sobre Textiles Precolombinos,* ed. Victória Solanilla Demestre (Barcelona: Servei de Publicacions de la UAB, 2000), 9–28.

Arnold, Denise Y. *The Metamorphosis of Heads: Textual Struggles, Education, and Land in the Andes* (Pittsburgh: University of Pittsburgh Press, 2006).

Arnold, Denise Y., and Juan de Dios Yapita, *River of Fleece, River of Song: Singing to the Animals, an Andean Poetics of Creation* (Markt Schwaben: Anton Saurwein, 2001).

Arnold, Denise Y., and Christine Hastorf, *Heads of State: Icons, Power, and Politics in the Ancient and Modern Andes* (Walnut Creek: Left Coast Press, 2008).

Aschero, C. A. "Figuras humanas, camelidos y espacio en la interacción circumpeneña," in *Arte en las rocas: arte repustre, menhires y piedras de colores en Argentina,* eds. M. Podestá and M. de Hoyos (Buenos Aires: Sociedad Argentina de Antropología, 2000), 15–44.

Avila, Francisco de. *Dioses y hombres de Huarochiri* (1608), trans. J. M. Arguedas, Lima 1966.

Bal, Mieke. "Visual Essentialism and the Object of Visual Culture," *Journal of Visual Culture* 2:1 (2003): 5–32.

Barrenechea, Raúl Porras. *Pizarro* (Lima: Editorial Pizarro, 1978).

Barrientos, Cristóbal de. "Visita de las siete guarangas de la provincial de Caxamarca" [1540], in Waldemar Espinoza Soriano, *El Primer informe etnológico sobre Cajamarca. Año de 1540: Revista Peruana de Cultura* 11–12 (1967): 5–41.

Barthel, Thomas S. "Erste Schritte zur Entzifferung der Inkaschrift." *Tribus* 19 (1970): 91–96.

Basso, Ellen. *A Musical View of the Universe* (Philadelphia: University of Pennsylvania Press, 1985).

Bastien, Joseph W. *Mountain of the Condor: Metaphor and Ritual in an Andean Allyu* (St. Paul, MN; American Ethnological Society/West Publishing, 1978).

Bastien, Joseph W. "Qollahuaya-Andean Body Concepts: A Topographical-Hydraulic Model of Physiology." *American Anthropologist* (n.s.) 87:3 (1985): 595–611.

Baudin, Louis. *A Socialist Empire: The Incas of Peru* (Paris, 1928), trans. Katherine Woods (Princeton, NJ: D. van Nostrand, 1961).

Bauer, Brian S. "Pacariqtambo and the Mythical Origins of the Inca." *Latin American Antiquity* 2:1 (Mar., 1991): 7–26.

Bauer, Brian S. *The Sacred Landscape of the Inca* (Austin: University of Texas Press, 1998).

Bauer, Brian S. *Ancient Cuzco: Heartland of the Inca* (Austin: University of Texas Press, 2004).

Bauer, Brian S., and David S. P. Dearborn, *Astronomy and Empire in the Ancient Andes* (Austin: University of Texas, 1995).

Bauer, Brian S., and Charles Stanish, *Ritual and Pilgrimage in the Ancient Andes: The Islands of the Sun and the Moon* (Austin: University of Texas Press, 2001).

Baxandall, Michael. *The Limewood Sculptors of Renaissance Germany* (New Haven: Yale University Press, 1980).

Berenguer, J. *Caravanas, interacción y cambio en el desierto de Atacama* (Santiago, Chile: Sirawi Ediciones, 2004).

Berg, Susan E., ed. *Wari: Lords of the Ancient Andes.* (New York/Cleveland: Thames and Hudson/Cleveland Museum of Art, 2012).

Berthelot, Jean. "The Extraction of Precious Metals at the Time of the Inca." In *Anthropological History of Andean Polities,* ed. John. V. Murra, Nathan Wachtel, and Jacques Revel

(Cambridge: Cambridge University Press, 1986), 69–88.

Bertonio, Ludovico. *Arte y gramática muy copiosa de la lengua Aymara*, vol. 1 (Paris: Institut d'Ethnologie, 1956).

Besom, Thomas. *Of Summits and Sacrifice: An Ethnohistoric Study of Inka Religious Practices* (Austin: University of Texas Press, 2009).

Besom, Thomas. *Inca Human Sacrifice and Mountain Worship: Strategies for Empire Unification* (Albuquerque: University of New Mexico Press, 2013).

Betanzos, Juan de. *Suma y Narración de los Incas* [1557], ed. María del Carmen and Martín Rubio (Madrid: Ediciones Atlas, 1987).

Bhabha, Homi K. "Of Mimicry and Man: The Ambivalence of Colonial Discourse," *October* 28 (Spring 1984): 125–33, reprinted in *The Location of Culture* (London: Routledge, 1994).

Blanchot, Maurice. *The Writing of the Disaster* (1980), new ed. trans. Ann Smock (Lincoln: University of Nebraska Press, 1995).

Bolton, Charlene. "Pastoralism and Personality: An Andean Reliction." *Ethos* 4:4 (1976): 463–81.

Boman, Eric. *Antiquités de region andine de la République argentine et du desert d'Atacama* (Paris: Imprinte Nationale, 1908).

Bonavia, Duccio. *Los camélidos sudamericanos. Una introducción a su estudio* (La Paz: IFEA, UPCH, Conservación Internacional, 1996).

Bonavia, Duccio. *Maize: Origin, Domestication, and Role in the Development of Culture* (New York: Cambridge University Press, 2012).

Bouchard, Jean-François. *Contribution à l'étude de l'architecture Inca: Etablissement de la vallée du Rio Vilcanota -Urubamba (Cahiers d'archéologie et d'ethnologie d'Amérique du Sud* (Paris: Editions de la Maison des Science de l'Homme, 1983).

Bouysse-Cassagne, Thérèse. "Urco and Uma: Aymara Concepts of Space." In *Anthropological History of Andean Polities*, ed. John V. Murra, Nathan Wachtel, and Jacques Revel (London: Cambridge University Press, 1986), 201–27.

Bradley, Peter T., and David Cahill, *Habsburg Peru: Images, Imagination and Memory* (Liverpool: Liverpool University Press, 2000).

Bram, Joseph. *An Analysis of Inca Militarism* (New York: Augustin, 1941).

Bradley, R. *The Significance of Monuments: On the Shaping of Human Experience in Neolithic and Bronze Age Europe* (London: Routledge, 1998).

Bray, Tamara L. "An Archaeological Perspective on the Andean Concept of Camaquen: Thinking through Late Pre-Columbian Ofrendas and Huacas," *Anthropology Faculty Research Publications Paper* 1 (Digital Commons@Wayne State University, 1999).

Bray, Tamara L. "To Dine Splendidly: Imperial Pottery, Commensal Politics, and the Inca State." In *The Archaeology and Politics of Food and Feasting in Early States and Empires*, ed. Tamara. L. Bray (New York: Kluwer/Plenum, 2003), 93–142.

Briones, Luis, Lautaro Núñez, and Vivien G. Standen, "Geoglyphs and Prehispanic Llama Caravan Traffic in the Atacama Desert (Northern Chile)." *Chungará* 37:2 (2005): 195–223.

Browman, David L. "Pastoral Nomadism in the Andes." *Current Anthropology* 15:2 (1974): 188–96.

Browman, David L. "Origins and Development of Andean Pastoralism: An Overview of the Past 6000 Years." In *The Walking Larder*, ed. Juliet Clutton-Brock (London: Unwin-Hyman, 1989), 256–68.

Brown, David O. "Administration and Settlement Planning in the Provinces of the Inca Empire: A Perspective from the Inca Provincial Capital of Pumpu on the Junín Plain of Highland Perú," Ph.D. dissertation, University of Michigan, Ann Arbor, 1991.

Burger, Richard and Lucy Salazar-Burger. "Second Season of Investigations at the Initial Period Center of Cardal, Peru." *Journal of Field Archaeology* 18:3 (1991): 275–96.

Butler, Barbara Y. *Holy Intoxication to Drunken Dissipation: Alcohol among Quichua Speakers in Otavalo, Ecuador* (Albuquerque: University of New Mexico Press, 2006).

Cabello de Valboa, Miguel. *Miscelánea antartica del Perú antiguo* (1586; reprint L. E. Valcárcel, ed., Lima: Universidad Nacional Mayor de San Marcos, 1951).

Cabrera, Angel. *Caballos de América* (Buenos Aires: Editorial Sudamericana, 1945).

Cadena, Marisol de la. *Indigenous Mestizos: The Politics of Race and Culture in Cuzco, Peru 1919–1991* (Durham: Duke University Press, 2000).

Camargo Mareovich, Cecilia and Wilder Javier León Ascurra, "Caminos Inca Cajamarca-Baños del Inca," *Qhapaq Ñan: El Gran Camino Inca*: http://www.qhapaqnan.gob.pe.

Camille, Michael. *The Medieval Art of Love: Objects and Subjects of Desire* (New York: Harry N. Abrams, 1998).

Camino, Alejandro, Jorge Recharte, Pedro Bidegaray, "Flexibilidad calendarica en la agricultura tradicional de las vertientes orientales de los Andes." In Heather Lechtman, ed., *La Tecnología en el mundo andino*, vol. I (Mexico City: Universidad Autónoma de México, 1981), 169–94.

Cantarutti, Gabriel E. "Mining under Inca Rule in North-Central Chile: The Los Infieles Mining Complex." In *Mining and Quarrying in the Ancient Andes: Sociopolitical, Economic, and Symbolic Dimensions*, ed. Nicholas Tripcevich and Kevin J. Vaughn (New York: Springer, 2013), 185–212.

Cañizares-Esguerra, Jorge. *How to Write the History of the New World: Histories, Epistemologies, and Identities in the Eighteenth-Century Atlantic World* (Stanford: Stanford University Press, 2001).

Caprara, Andrea and Alejandro Isla. "Il rito del llama tink'a presso le comunità quechua delle Ande peruviane." *Thule* 5:18/19 (2005): 237–50.

Carrasco, Davíd. *To Change Place: Aztec Ceremonial Landscapes* (Boulder: University of Colorado Press, 1991).

Carrión Cachot, Rebecca. *El Culto al agua en el antiguo Peru: La Pacha element cultural pan-andino: Separata de la Revista del Museo Nacional de Antropología y Arqueología* II:2 (Lima: Museo Nacional de Antropología y Arqueología 1955).

Cereceda, Verónica. "Aproximaciones a una estética andina: de la belleza al tinku." In Thèrése Bouysse-Cassagne, ed. *Tres reflexiones sobre el pensamiento andino* (La Paz: Hisbol, 1987), 133–231.

Cereceda, Verónica. "A Partir de los Colores de un Pajaro," *Boletín del Museo Chileno de Arte Precolombino* 4 (1990): 57–104.

Cerrón Palomino, Rodolfo. "El Cantar del Inca Yupanqui y la lengua secreta de los incas." *Revista Andina* 32 (1998): 417–452.

Cerrón-Palomino, Rodolfo. "El aymara como lengua oficial de los Incas." *Boletín de Arqueología Pontífica Universidad Católica del Perú* 8 (2004): 9–21.

Cerrón-Palomino, Rodolfo. "Tocapu (Etimologías)," *Boletín de la Academia Peruana de la Lengua* 40 (2005): 137–52.

Cerrón-Palomino, Rodolfo. "Cuzco: la piedra donde se posó la lechuza. Historia de un nombre." *Revista Andina* 44 (2007): 143–74.

Cerrón-Palomino, Rodolfo. "Unraveling the Enigma of the 'Particular Language' of the Incas." In *Archaeology and Language in the Andes: A Cross-Disciplinary Exploration of History*, ed. Paul Heggarty and David Beresford-Jones (Oxford: British Academy/Oxford University Press, 2012), 265–94.

Certeau, Michel de. *The Practice of Everyday Life (Arts de faire vol. I: L'Invention du Quotidien*, 1980), trans. Steven Rendall (Berkeley: University of California Press, 1984).

Certeau, Michel de. *Heterologies: Discourse on the Other*, trans. Brian Massumi (Minneapolis: University of Minnesota Press, 1986).

Chakrabarty, Dipesh. *Provincializing Europe: Postcolonial Thought and Historical Difference* (Princeton: Princeton University Press, 2000).

Chardon, Roland. "The Elusive Spanish League: A Problem of Measurement in Sixteenth-Century New Spain," *The Hispanic American Historical Review* 60:2 (1980): 294–302.

Chávez, Sergio Jorge. "Funerary Offerings from a Middle Horizon Context in Pomacanchi, Cuzco." *Ñawpa Pacha* 22–23 (1984–85): 1–48.

Chepstow-Lusty, Alex J., Michael R. Frogley, Brian S. Bauer, Melanie J. Leng, Andy B. Cundy, Karin P. Boessenkool, and Alain Gioda. "Evaluating Socio-economic Change in the Andes Using Oribatid Mite Abundances as Indicators of Domestic Animal Densities."

Journal of Archaeological Science 34:7 (2007): 1178–86.

Childe, V. Gordon. *Man Makes Himself* (London: Watts, 1951).

Christie, Jessica Joyce. "Houses of Political Power among the Ancient Maya and Inca." In *Palaces and Power in the Americas: From Peru to the Northwest Coast*, ed. Jessica Joyce Christie and Patricia Joan Sarro (Austin: University of Texas Press, 2010), 354–96.

Christie, Jessica Joyce. "Did the Inca Copy Cusco? An Answer Derived from an Architectural-Sculptural Model." *Journal of Latin American and Caribbean Anthropology* 12:1 (2007): 164–99.

Cieza de León, Pedro. *El Descubrimiento y Conquista del Perú (1553)*, ed. Carmelo Sáenz de Santa Maria (Madrid: Historia 1984).

Clarkson, Persis, and Luis Briones. "Geoglifos, senderos y etnoarqueología de caravanas en el desierto chileno." *Boletín del Museo chileno de Arte precolombino* 8 (2001): 35–45.

Classen, Constance. "Sweet Colors, Fragrant Songs: Sensory Models of the Andes and the Amazon." *American Ethnologist* 17 (1990): 722–35.

Classen, Constance. "Creation by Sound/Creation by Light: A Sensory Analysis of Two South American Cosmologies." In *The Varieties of Sensory Experience: A Sourcebook in the Anthropology of the Senses*, ed. David Howes (Toronto: University of Toronto Press, 1991), 238–55.

Classen, Constance. "Foundations for an Anthropology of the Senses." *International Social Science Journal* 153 (1997): 401–12.

Classen, Constance. *Inca Cosmology and the Human Body* (Salt Lake City: University of Utah Press, 1997).

Clendinnen, Inga. *Ambivalent Conquests: Maya and Spaniards in Yucatán, 1517–1570* (New York: Cambridge University Press, 1987).

Clendinnen, Inga. "'Fierce and Unnatural Cruelty': Cortés and the Conquest of Mexico," *Representations* 33 (Winter 1991): 65–100.

Coben, Lawrence. "Other Cuzcos: Replicated Theaters of Inka Power." In *Archaeologies of Performance: Theaters of Power, Community, and Politics*, ed. Takeshi Inomata (Lanham, MD: Altamira Press, 2006), 223–59.

Cobo, Bernabé. *History of the Inca Empire: An Account of the Indians' Customs and Their Origin, Together with a Treatise on Inca Legends, History, and Social Institutions (1653)*, ed. and trans. Roland Hamilton (Austin: University of Texas Press, 1983).

Cobo, Bernabé. *Inca Religions and Customs (1653)*, ed. and trans. Roland Hamilton (Austin: University of Texas Press, 1990).

Columbus, Claudette Kemper. "Soundscapes in Andean Contexts." *History of Religions* 44:2 (2004): 153–168.

Conklin, William. "The Mythic Geometry of the Southern Sierra." In *The Junius B. Bird Conference on Andean Textiles*, ed. Ann Pollard Rowe (Washington, DC: The Textile Museum, 1986), 123–35.

Conklin, William. "Structure as Meaning in Ancient Andean Textiles." In *Andean Art at Dumbarton Oak*, Vol. 2, ed. Elizabeth Hill Boone (Washington, DC: Dumbarton Oaks Research Library and Collection, 1996), 321–28.

Conklin, William. "A Khipu Information String Theory." In *Narrative Threads: Accounting and Recounting in Andean Khipu*, ed. Jeffrey Quiter and Gary Urton (Austin: University of Texas Press, 2002), 53–86.

Conrad, Geoffrey. "Inca Imperialism: The Great Simplification and the Accident of Empire." In *Ideology and Pre-Columbian Civilizations*, ed. Arthur Demarest and Geoffrey Conrad, (Santa Fe: School of American Research, 1992), 159–74.

Constable, Olivia Remie. "Chess and Courtly Culture in Medieval Castile: The Libros del Ajadrez of Alfonso X, El Sabio." *Speculum* 82 (2007): 301–47.

Cook, Anita G. "The Middle Horizon Ceramic Offerings from Conchopata." *Ñawpa Pacha* 22–23 (1984–85): 49–90.

Cook, Anita G. *Wari y Tiwanaku: Entre el estilo y la imagen* (Lima: Pontifica Universidad Catolica del Peru, 1994).

Cornejo Bouroncle, Jorge. *Huakaypata: La Plaza Mayor del Viejo Cuzco* (Cuzco: n.p., 1946).

Costin, Cathy L. "Craft Production and Mobilization Strategies in the Inca Empire." In *Craft Specialization and Social Evolution: In Memory of V. Gordon Childe*, ed. Bernard Wailes (University Museum of Archaeology and Anthropology University of Pennsylvania, Philadelphia, 1996), 177–224.

Costin, Cathy Lynne. "Housewives, Chosen Women, Skilled Men: Cloth Production and Social Identity in the Late Prehispanic Andes." In *Craft and social identity*, ed. Cathy Lynne Costin and Rita P. Wright (Washington, DC: American Anthropological Association: 1998), 123–41.

Covarrubias, Sebastián de. *Tesoro de la Lengua Castellana* (Madrid: 1611).

Covey, R. Alan. "A Processual Study of Inca State Formation." *Journal of Anthropological Archaeology* 22 (2003): 333–57.

Covey, R. Alan. *How the Incas Built their Heartland: State Formation and the Innovation of Imperial Strategies in the Sacred Valley, Peru* (Ann Arbor: University of Michigan Press, 2006).

Covey, R. Alan. "The Inca Empire." In *Handbook of South American Archaeology*, ed. Helaine Silverman and William H. Isbell (New York: Springer, 2008), 809–30.

Cox, Christoph. "Beyond Representation and Signification: Toward a Sonic Materialism." *Journal of Visual Culture* 10 (Aug. 2011): 145–61.

Crary, Jonathan. *Techniques of the Observer: On Vision and Modernity in the Nineteenth Century* (Cambridge: MIT Press, 1992).

Crickmay, Lindsey. "Stone: Spanish 'mojon' as a translation of Quechua and Aymara terms for 'limit.'" In *Kay Pacha: Cultivating Earth and Water in the Andes*, ed. Penelope Dransart (Oxford: BAR International, 2006), 71–76.

Cristina, Alcalde. "Leaders, Healers, Laborers, and Lovers: Reinterpreting Women's Roles in Moche Society." In *Ungendering Civilization*, ed. K. Anne Pyburn (New York: Routledge, 2004), 136–55.

Cummins, Tom. "The Madonna and the Horse: Becoming Colonial in New Spain and Peru." In *Native Artists and Patrons in Colonial Latin America*, ed. Emily Umberger and Tom Cummins (Tempe: Arizona State University Press, 1995), 52–83.

Cummins, Tom. "'Let Me See! Reading is for them' Colonial Andean Images and Objects 'como es Costumbre tener los Caciques Señores'." In *Native Traditions in the Postconquest World*, ed. Elizabeth Boone and Tom Cummins (Washington, DC: Dumbarton Oaks, 1998), 91–148.

Cummins, Thomas B. F. *Toasts with the Inca: Andean Abstraction and Colonial Images on Quero Vessels* (Ann Arbor: University of Michigan Press, 2002).

Cummins, Thomas B. F., and Stephen Houston. "Body, Presence and Space in Andean and Mesoamerican Rulership." In *Palaces of the Ancient New World*, ed. Susan Tobey Evans and Joanne Pillsbury (Washington, DC: Dumbarton Oaks, 2005), 359–98.

Cummins, Thomas B. F. "The Images in Murúa's Historia General del Piru: An Art Historical Study." In *The Getty Murúa: Essays on the Making of Martín de Murúa's "Historia general del Piru," 1616, Ms. Ludwig XIII 16*, ed. Thomas B. F. Cummins and Barbara Anderson (Los Angeles: J. Paul Getty Trust, 2008), 147–74.

Cummins, Tom. "The Felicitous Legacy of the Lanzón." In *Chavín: Art, Architecture, and Culture*, ed. William J. Conklin and Jeffrey Quilter (Los Angeles: Cotsen Institute of Archaeology 2008), 279–304.

Cúneo-Vidal, Rómulo. *Vida del conquistador del Perú, don Francisco Pizarro, y de sus hermanos Hernando, Juan y Gonzalo Pizarro y Francisco Martín de Alcántara* (Barcelona: Maucci, 1925).

Cunnighame Graham, R. B. *The Horses of the Conquest*, ed. Robert Moorman Denhardt (Norman: University of Oklahoma Press, 1949).

Curtius, Ernst Robert. *European Literature and the Latin Middle Ages* (new ed. Princeton, NJ: Princeton University Press, 2013).

D'Altroy, Terence N. *Provincial Power in the Inka Empire* (Washington, DC: Smithsonian, 1992).

D'Altroy, Terence N. *The Incas* (Oxford: Blackwell, 2002).

D'Altroy, Terence N., and Christine A. Hastorf. "The Distribution and Contents of Inca State Storehouses in the Xauxa Region of Peru." *American Antiquity* 49:2 (1984): 334–49.

D'Altroy, Terence N., and Timothy K. Earle. "Storage Facilities and State Finance in the Upper Mantaro River Valley, Peru." In *Contexts for Prehistoric Exchange*, ed. Jonathan E. Ericson and Timothy K. Earle (New York: Academic Press, 1982), 265–90.

D'Altroy, Terence N., and Timothy K. Earle. "Staple Finance, Wealth Finance, and Storage in the Inca Political Economy." *Current Anthropology* 26:2 (1985): 187–206.

D'Altroy, Terence N., Ana María Lorandi, Verónica I. Williams, Milena Calderari, Christine A. Hastorf, Elizabeth DeMarrais, and Melissa B. Hagstrum. "Inka Rule in the Northern Calchaquí Valley, Argentina." *Journal of Field Archaeology* 27:1 (2000): 1–26.

Davis, Whitney. "Writing Culture in Prehistoric Central America." In *Reinterpreting the Prehistory of Central America*, ed. Mark Miller Graham (Boulder: University of Colorado Press, 1993), 253–76.

Davis, Whitney. *A General Theory of Visual Culture* (Princeton: Princeton University Press, 2011).

Dean, Carolyn. *Inka Bodies and the Body of Christ: Corpus Christi in Colonial Cusco* (Austin: University of Texas Press, 1999).

Dean, Carolyn. "Rethinking Apacheta." *Ñawpa Pacha* 28 (2006): 93–108.

Dean, Carolyn. "The Trouble with (the Term) Art." *Art Journal* 65:2 (Summer 2006): 24–32.

Dean, Carolyn. "The Inka Married the Earth: Integrated Outcrops and the Making of Place." *The Art Bulletin* 89:3 (2007): 502–18.

Dean, Carolyn. *A Culture of Stone: Inka Perspectives on Rock* (Durham: Duke University Press, 2010).

Dean, Carolyn. "War Games: Indigenous Militaristic Theater in Colonial Peru," In *Contested Vision of the Spanish Colonial World*, ed. Ilona Katzew (Los Angeles: LACMA, 2011), 132–49.

Dean, Carolyn and Dana Leibsohn. "Hybridity and Its Discontents: Considering Visual Culture in Colonial Spanish America." *Colonial Latin American Review* 12:1 (2003): 5–35.

Dearborn, David S. P., and Raymond E. White. "The 'Torreón' at Machu Picchu as an Observatory." *Archaeoastronomy* 5 (1983): S37–49.

Dedenbach-Salazar Sáenz, Sabine. *Inka Pachaq Llamanpa Willaynin: Uso y Crianza de los Camélidos en la Epoca Incaica. Estudio Lingüístico y Etnohistórico basado en las Fuentes Lexicográficas y Textuale del Primer Siglo después de la Conquista* BAS 16 (Bonn: Bonner Amerikanische Studien 1990).

Demarest, Arthur A. *Viracocha: The Nature and Antiquity of the Andean High God* (Cambridge: Peabody Museum, Harvard University, 1981).

DeMarrais, Elizabeth, Luis Jaime Castillo, and Timothy Earle. "Ideology, Materialization, and Power Strategies." *Current Anthropology*, 37:1 (1996): 15–31.

Denhardt, Robert Moorman. "The Truth about Cortés's Horses." *Hispanic American Historical Review* 17 (1937): 525–35.

Denhardt, Robert Moorman. "The Equine Strategy of Cortés," *Hispanic American Historical Review* 18 (1938): 500–55.

Derrida, Jacques. *The Beast and the Sovereign, Volume 1*, trans. Geoffrey Bennington (Chicago: University of Chicago Press, 2009).

D'Harcourt, Raoul. *Textiles of Ancient Peru and Their Techniques* (Paris, 1934; trans. reprint Seattle: University of Washington Press, 1962).

Diamond, Jared. *Guns, Germs and Steel: The Fates of Human Societies* (New York: Norton, 1997).

Dietler, Michael. "Alcohol: Anthropological/Archaeological Perspectives." *Annual Review of Anthropology* 35:1 (2006): 229–49.

Dillehay, Tom D., and L. Nuñez. "Camelids, Caravans, and Complex Societies." In *Recent Studies in Precolumbian Archaeology*, ed. Nicholas J. Saunders and Olivier de Montmollin (Oxford: BAR International, 1988), 603–33.

Donnan, Christopher B. "An Ancient Peruvian Architectural Model." *The Masterkey* (Southwest Museum, Los Angeles) 49:1 (1975): 20–29.

Dransart, Penny. "Llamas, herders and the exploitation of raw materials in the Atacama desert." *World Archaeology* 22:3 (1991): 304–19.

Dransart, Penelope Y. *Earth, Water, Fleece, and Fabric: An Ethnography and Archaeology of Andean Camelid Herding* (London: Routledge, 2002).

Dunlop, Anne. *Painted Palaces: The Rise of Secular Art in Early Renaissance Italy* (State College: Pennsylvania State University Press, 2009).

Duranti, Alessandro. "Husserl, Intersubjectivity, and Anthropology." *Anthropological Theory* 10 (2010): 16–35.

Duranti, Alessandro, and Charles Goodwin. "Rethinking Context: An Introduction." In *Rethinking Context: Language as an Interactive Phenomenon*, ed. Alessandro Duranti and Charles Goodwin (New York: Cambridge University Press, 1992), 1–42.

Duviols, Pierre. "Huari y Llacuaz: Agricultores y pastores, un dualismo prehispánico de oposición y complementaridad." *Revista del Museo Nacional* 39 (1973): 153–91.

Duviols, Pierre. "Sumaq T'ika: La Princesse du village sans eau." *Journal de la Société des Américanistes* 63 (1974–76): 153–98.

Duviols, Pierre. "'Punchao': Idolo Mayor del Coricancha, Historia y Tipologia." *Antropolgía Andina* 1–2 (1976): 156–83.

Duviols, Pierre. "'Camaquen, upani': Un Concept animiste des anciens Péruviens." In *Amerikanische Studien: Festschrift für Hermann Trimborn*, ed. R. Hartmann and U. Oberem (St. Augustin, Switzerland: Collectanea Instituti Anthropos 1978), 32–144.

Duviols, Pierre. "Un Symbolisme de l'occupation, de l'aménagement et de l'exploitation de l'espace: Le Monolithe 'huanca' et sa fonction dans les Andes préhispaniques." *L'Homme* 19:2 (1979): 7–31.

Duviols, Pierre. *Cultura andina y repression: Proceso y visitas del idolatries y hechicerías, Cajatambo, siglo XVII* (Centro de Investigaciones Rurales Andinos, Archivos de Historia Andina 5, 1986).

Duviols, Pierre. "El Inca, Rey Solar responsable y garante de la fertilidad, de la armonía cósmica, social y política: El Ejemplo de la guerras rituals de sucesión." *Journal of the Steward Anthropological Society* 25:1/2 (1997): 312–46.

Earle, Timothy. "Routes through the Landscape: A Comparative Perspective." In *Landscapes of Movement: Trails, Paths, and Roads in Anthropological Perspective*, ed. James E. Snead, Clark L. Erickson, and J. Andrew Darling (Philadelphia: University of Pennsylvania, 2009), 253–309.

Earle, Timothy K. "Wealth Finance in the Inka Empire: Evidence from the Calchaquí Valley, Argentina." *American Antiquity* 59:3 (1994): 443–60.

Earle, Timothy K., and Terrence N. D'Altroy. "Storage Facilities and State Finance in the Upper Mantaro Valley, Peru." In *Contexts for Prehistoric Exchange*, ed. Jonathan E. Ericson and Timothy K. Earle (New York: Academic Press, 1982), 265–90.

Earle, Timothy, and Cathy Lynne Costin. "Status Distinction and Legitimation of Power as Reflected in Changing Patterns of Consumption in Late Prehispanic Peru." *American Antiquity* 54:4 (1989): 691–714.

Earls, John, and Irene Silverblatt. "La Realidad Física y Social en la Cosmología Andina," *Actes du XLIIe Congrès International des Américanistes*, Vol. IV (Paris: Congrès du Centenaire and Fondation Singer-Polignac, 2–9 September 1976): 299–325.

Emery, Irene. *The Primary Structure of Fabrics: An Illustrated Classification*, 2nd ed. (Washington, DC: Textile Museum, 1980).

Erickson, Clark. "The Lake Titicaca Basin: A Pre-Columbian Built Landscape." In *Imperfect Balance: Landscape Transformations in the Precolumbian Americas*, ed. David Lentz (New York: Columbia University Press, 2000), 311–56.

Espinoza Soriano, Waldemar. "El primer informe etnológico sobre Cajamarca. Año de 1540." *Revista Peruana de Cultura* 11–12 (1967): 5–41.

Espinoza Soriano, Waldemar. "Los mitmas yungas de Collique en Cajamarca, siglos XV, XVI, XVII." *Revista del Museo Nacional* 37 (1969–70): 9–57.

Espinoza Soriano, Waldemar. "Los mitmaes huayacuntu en Quito o guarniciones para la represión armada, siglos XV y XVI." *Revista del Museo Nacional* (Lima) 41 (1975): 351–94.

Fabian, Johannes. *Time and the Other: How Anthropology Makes Its Object* (New York: Columbia University Press, 1983).

Farrington, Ian S. "The Concept of Cusco," *Tawantinsuyu* 5 (1998): 53–59.

Feld, Steven. *Sound and Sentiment* (Philadelphia: University of Pennsylvania Press, 1982).

Flannery, Kent, Joyce Marcus, and Robert G. Reynolds. *The Flocks of the Wamani: A Study of Llama Herders on the Punas of Ayacucho, Peru* (New York: Academic Press, 1989).

Flickema, Thomas. "The Siege of Cuzco," *Revista de Historia de América* 92 (1981): 17–47.

Flores Hernández, Benjamín. "La jineta indiana en los textos de Juan Suárez de Peralta y Bernardo de Vargas Machuca." *Estudios Americanos* 54:2 (1997): 639–64.

Flores Ochoa, Jorge A. "Pastores de Paratía: Una introduction a su estudio." *Serie Antropología Social* (Mexico City: IEP, 1968), 5–159.

Flores Ochoa, Jorge A. "Enqa, enqaychu, illa y khuya rumi: Aspectos magico-religiosos entre pastores." *Journal de la Société des Américainistes (Paris)* 63 (1974–76): 245–62.

Flores Ochoa, Jorge. "Aspectos mágicos del pastoreo: Enqa, enqaychu, illa y khyua rumi." In *Pastores de la Puna: uywmichiq punarunakuna*, ed. Jorge Flores Ochoa (Lima: Instituto de Estudios Peruanos, 1977), 211–37.

Foucault, Michel. "Des Espaces Autres," 1967: trans. "Of Other Spaces," *Diacritics* 16 (Spring 1986): 22–27.

Foucault, Michel. *"Society Must Be Defended": Lectures at the Collège de France 1975–1976*, vol. III, trans. David Macey (New York: Macmillan, 2003).

Frame, Mary. "The Visual Images of Fabric Structures in Ancient Peruvian Art." In *The Junius B. Bird Andean Textile Conference*, 1984, ed. Anne Pollard Rowe (Washington, DC: The Textile Museum, 1986), 47–80.

Frame, Mary. "Beyond the Image: Dimensions of Pattern in Andean Textiles." In *Abstraction:*

The Amerindian Paradigm, ed. César Paternosto (Brussels: Palais des Beaux-Arts de Bruxelles/Institut Valencià d'Art Modern, 2001) 113–36.

Frame, Mary. "What Guaman Poma Shows Us, but Does Not Tell Us, about Tukapu." *Ñawpa Pacha* 30:1 (2010): 25–52.

Frame, Mary. "Los vestidos del Sapa Inka, la Coya, y los nobles del imperio." In *Señores de los Imperios del Sol*, ed. Krysztof Makowski (Lima: Banco de Crédito, 2010), 261–81.

Franklin, William L. "Biology, Ecology, and Relationship to Man of the South American Camelids." In *Mammalian Biology in South America*, ed. Michale A. Mares and Hugh H. Geoways (Linesville: University of Pittsburgh Pymatuning Laboratory of Ecology, 1982), 457–89.

Fried, M. H. *The Evolution of Political Society* (New York: Random House, 1967).

Garcia, J. Uriel. *Cuzco: Capital arqueológico de Sud America* (Buenos Aires: Editorial Pampa, 1951).

Garland-Thomson, Rosemarie "Ways of Staring," *Journal of Visual Culture* 5 (2006), 173–92.

Gasparini, Graziano, and Louise Margolies. *Inca Architecture*, trans. Patricia J. Lyons (Bloomington: Indiana University Press, 1980).

Gayton, Anna H. "The Cultural Significance of Peruvian Textiles: Production, Function, Aesthetics," in *Kroeber Anthropological Society Papers* 25 (1961): 111–28.

Gell, Alfred. "Vogel's Net: Traps as Artworks and Artworks as Traps." *Journal of Material Culture* 1:1 (1996): 15–38.

Gelles, Paul H. *Water and Power in Highland Peru* (New Brunswick, NJ: Rutgers University Press, 2000).

Gennep, Arnold van. *The Rites of Passage* [1909]. Trans. M. B. Vizedom and G. L. Caffee (Chicago: University of Chicago Press, 1960).

Gentile, Margarita E. "Tocapu: unidad de sentido en el lenguaje gráfico andino." Paper delivered at the Museo de Arqueología y Antropología de la Universidad Nacional Mayor de San Marcos, Lima, 2009.

Gero, Joan M. "Stone Knots and Ceramic Beaus: Interpreting Gender in the Peruvian Early Intermediate Period." In *Gender in Pre-Hispanic America*, ed. Cecelia F. Klein (Washington, DC: Dumbarton Oaks, 2001), 15–55.

Gilmore, Raymond M. "Fauna and Ethnozoology of South America." In *Handbook of South American Indians: Bureau of American Ethnology Bulletin 143*, ed. Julian H. Steward (Washington, DC: Smithsonian Institution, 1950), 345–464.

Ginzburg, Carlo. *The Cheese and the Worms: The Cosmos of a Sixteenth-Century Miller*, trans. John Tedeschi and Anne Tedeschi (Baltimore: Johns Hopkins Press, 1980).

Goepfert, Nicolas. "Lama et le cerf: dualisme alimentaire et symbolique dans les Andes centrales." *Anthropozoologica* 45:1 (2010): 25–45.

Goffman, Erving. "Footing," *Semiotica* 25:1/2 (1979): 1–29.

Goldstein, Paul S. "From Stew-Eaters to Maize-Drinkers: The Chicha Economy and the Tiwanaku Expansion." In *The Archaeology and Politics of Food and Feasting in Early States and Empires*, ed. Tamara. L. Bray, (New York: Kluwer/Plenum, 2003), 143–72.

Golte, Jürgen. "El Concepto de sonqo en el runa simi del siglo XVI." *Indiana* 1 (1973): 213–18.

González Holguín, Diego de. *Vocabulario de la lengua general de todo el Perú llamada lengua qquichua o del Inca* (1608, reprint Lima: Universidad Nacional Mayor de San Marcos, 1989).

González, L. R. *Bronces sin nombre: La metalurgia prehispánica en el noroeste de argentina* (Buenos Aires: Ediciones Fundación CEPPA, 2004).

González, L. R., and M. Tarragó. "Dominación, resistencia, y tecnología: La ocupación incaica en el noroeste argentine." *Chungará: Revista de Antropología Chilena* 36:2 (2004): 393–406.

Gose, Peter. "Oracles, Divine Kingship, and Political Representation in the Inca State." *Ethnohistory* 43:1 (1996): 1–32.

Gose, Peter. "The State as a Chosen Woman: Brideservice and the Feeding of Tributaries in the Inca Empire," *American Anthropologist* (n.s.) 102:1 (2000): 84–97.

Gose, Peter. "Mountains Historicized: Ancestors and Landscape in the Colonial Andes." In Kay Pacha: *Cultivating Earth and Water in the Andes*, ed. Penelope Dransart (Oxford: BAR International, 2006), 29–38.

Gose, Peter. *Invaders as Ancestors: On the Intercultural Making and Unmaking of Spanish Colonialism in the Andes* (Toronto: University of Toronto Press, 2008).

Gründler, Hana. "'A Labyrinth of Paths': Ludwig Wittgenstein on Seeing, Drawing, and Thinking," in *Linea II: Giochi, Metamorfosi, Seduzioni della Linea*, ed. Marzia Faietti and Gerhard Wolf (Florence: Giunti Editori, 2012), 223–35.

Guaman Poma de Ayala, Felípe. *El primer nueva corónica y buen gobierno* (1615/1616) (Copenhagen, Royal Danish Library, GKS 2232 4°: facsimile at http://www.kb.dk).

Guchte, Maarten van de. "El ciclo mítico andino de la piedra cansada." *Revista Andina* 2:2 (1984): 539–56.

Guchte, Maarten Van de. "'Carving the World': Inca Monumental Sculpture and Landscape," Ph.D. dissertation, Department of Anthropology, University of Illinois Urbana/Champaign, 1992.

Guchte, Maarten Van de. "Sculpture and the Concept of the Double Meaning among the Inca Kings." *RES: Anthropology and Aesthetics* 29/30 (1996): 256–69.

Guchte, Maarten van de. "The Inca Cognition of Landscape: Archaeology, Ethnohistory, and the Aesthetic of Alterity." In *Archaeologies of Landscape*, ed. Wendy Ashmore and Bernhard Knapp (Malden: Blackwell, 1999), 149–68.

Hagen, Victor Wolfgang von. *Highway of the Sun* (New York: Duell, Sloan, and Pearce, 1955).

Hammond, Norman. "Inside the Black Box: Reconstructing the Maya Polity." In *Classic Maya Political History: Hieroglyphic and Archaeological Evidence*, ed. T. Patrick Culbert (New York: Cambridge University Press, 1991), 253–84.

Hanks, William F. "Explorations in the Deictic Field," *Current Anthropology* 46:2 (2005): 191–221.

Harris, O. "The Earth and State: the Sources and Meanings of Money in Northern Potosí, Bolivia." In *Money and the Morality of Exchange*, ed. J. Parry and M. Bloch (Cambridge: Cambridge University Press, 1989), 258–60.

Harrison, Regina. "Modes of Discourse: The Relación de Antigüedades deste Reyno del Pirú by Joan de Santacruz Pachacuti Yamqui Salcamaygua." In *From Oral to Written Expression: Native Andean Chronicles of the Early Colonial Period* (Syracuse: Syracuse University, 1982), 65–99.

Harrison, Regina. *Signs, Songs and Memory in the Andes: Translating Quechua Language and Culture* (Austin: University of Texas Press, 1989).

Harrison, Regina. "The Language and Rhetoric of Conversion in the Viceroyalty of Peru," *Poetics Today* 16:1 (1995): 1–27.

Hastorf, Christine A. "Andean Luxury Foods: Special Food for the Ancestors, Deities, and the Elite." *Antiquity* 77 (2003): 545–54.

Hastorf, Christine A., Elsie Sandefur, Timothy K. Earle, H. E. Wright Jr., Lisa LeCount, and Glenn Russell. "Settlement archaeology in the Jauja region of Peru: evidence from the Early Intermediate Period through the Late Intermediate Period: A Report on the 1986 Field Season." *Andean Past* 2 (1989): 81–129.

Hastorf, Christine A., and Sissel Johannessen. "Pre-Hispanic Political Change and the Role of Maize in the Central Andes of Peru." *American Anthropologist* (ns) 95:1 (1993): 115–38.

Heidegger, Martin. "Building, Dwelling, Thinking." In *Poetry, Language, Thought*, trans. Alfred Hofstadter (New York: Harper & Row, 1971), 344–63.

Helms, Mary W. "Precious Metals and Politics: Style and Ideology in the Intermediate Area and Peru." *Journal of Latin American Lore* 7 (1984): 215–37.

Hemming, John. *The Conquest of the Incas* (New York: Harcourt, 1970).

Hemming, John, and Edward Ranney. *Monuments of the Incas* (New York: New York Graphic Society, 1982).

Herring, Adam. "'Shimmering Foundation': The Twelve-Angled Stone of Inca Cusco." *Critical Inquiry* 37:1 (2010): 60–105.

Herring, Adam. "An Archaeology of Abstraction: Ollantaytambo." *World Art* 3:1 (2013): 41–65.

Herring, Adam. "Caught Looking: Under the Gaze of Inka Atawallpa, 15 November 1532."

Journal of Medieval and Early Modern Studies 44:2 (Spring 2014): 373–406.

Hiltunen, J. J. *Ancient Kings of Peru: The Reliability of the Chronicle of Fernando de Montesinos: Correlating the Dynasty Lists with Current Prehistoric Periodization in the Andes* (Helsinki: Suomen Historiallinen Seura, 1999).

Hogue, Marianne. "Cosmology in Inca Tunics and Tectonics." In *Andean Textile Traditions: Papers from the 2001 Mayer Center Symposium at the Denver Art Museum*, ed. Margaret Young-Sánchez and Fronia W. Simpson (Denver: Denver Art Museum, 2006), 99–119.

Hopkins, R. "Painting, Sculpture, Sight, and Touch." *British Journal of Aesthetics* 44:2 (2004): 149–66.

Hornberger, Esteban, and Nancy Hornberger. *Diccionario tri-lingue quechua de Cusco* (Lima: Centro de Estudios Andinos Bartolome de Las Casas: 2008).

Howard, Rosaleen. "Rumi: An Ethnolinguistic Approach to the Symbolism of Stone(s) in the Andes." In Kay Pacha: *Cultivating Earth and Water in the Andes*, ed. Penelope Dransart (Oxford: BAR International, 2006), 233–45

Howes, David, ed. *The Sixth Sense Reader* (Oxford: Berg, 2009).

Hughes, Lauren. "Weaving Inca Imperial Ideas: Iconography and Ideology of the Inca Coca Bag," *Textile: The Journal of Cloth and Culture* 8:2 (2010): 148–79.

Huhle, Rainer. "Terremoto de Cajamarca: la derrota del Inca en la memoria colectiva, elementos para un análisis de la resistencia cultural de los pueblos andinos." *Ibero-Amerikanisches Archiv* 18:3–4 (1992): 387–426.

Hulme, Peter. *Colonial Encounters* (New York: Methuen, 1986).

Humboldt, Alexander von. *Vues de Cordillères, et monuments des peoples indigenes de l'Amerique* (Paris, 1812).

Husson, Jean-Philippe. *La Poesie Quechua dans la chronique de Felipe Waman Puma de Ayala* (Paris: L'Harmattan, 1985).

Hyslop, John. *The Inka Road System* (London: Academic Press, 1984).

Hyslop, John. *Inka Settlement Planning* (Austin: University of Texas Press, 1990).

Inca Mocha, Don Diego. "Testimonio de Don Diego Inca Mocha" [1573], in *Versión inca de la conquista*, ed. Edmundo Guillén Guillén (Lima: Milla Batres, 1974), 95–100.

Ingold, Tim. Hunters, Pastoralists and Ranchers: Reindeer Economies and their Transformations (Cambridge: Cambridge University Press, 1980).

Ingold, Tim. *Making: Anthropology, Archaeology, Art, and Architecture* (London: Routledge, 2000).

Ingold, Tim. "Culture on the Ground: The World Perceived through the Feet." *Journal of Material Culture* 9:3 (2004), 326–79.

Isbell, William. *Mummies and Mortuary Monuments: A Postprocessual Prehistory of Central Andean Social Organization* (Austin: University of Texas Press, 1977).

Isbell, William H. "Conchopata, Ideological Innovator in Middle Horizon 1a," *Ñawpa Pacha* 22–23 (1984–85): 91–126.

Isbell, William H. *Of Mummies and Mortuary Monuments: A Postprocessual Prehistory of Andean Social Organization* (Austin: University of Texas Press, 1997).

Isbell, William H. "Landscape of Power: A Network of Palaces in Middle Horizon Peru." In Jessica Joyce Christie and Patricia Sarro, eds., *Palaces and Power in the Americas: From Perú to the Northwest Coast* (Austin: University of Texas Press, 2006), 44–98.

Isbell, William H., and Anita G. Cook. "A New Perspective on Conchopata and the Andean Middle Horizon." In William H. Isbell and Helaine Silverman, eds., *Andean Archaeology II: Art, Landscape, and Society* (New York and Boston: Kluwer Academic/Plenum Publishers, 2001), 249–305.

Isbell, William H., and Patricia J. Knobloch. "SAIS: The Origin, Development, and Dating of Tiwanaku-Huari Iconography." In *Tiwanaku: Essays from the 2005 Mayer Center Symposium at the Denver Art Museum*, ed. Margaret Young-Sánchez (Denver: Denver Art Museum, 2009), 165–210.

Isbell, William H., and Patricia J. Knoblauch. "Missing Links, Imaginary Links: Staff God Imagery in the South Andean Past." In *Andean Archaeology III*, eds. William H. Isbel and Helaine Silverman (New York: Springer, 2006), 307–51.

Jara, Victoria de la. "Vers le déchiffrement des écritures anciennes du Pérou," *La Nature (Paris)* 3387 (1967): 241–47.

Jay, Martin. "Scopic Regimes of Modernity." In *Vision and Visuality*, ed. Hal Foster (Seattle: Bay Press, 1988), 3–28.

Jed, Stephanie. "The Scene of Tyranny: Humanism and the History of Writing," in *The Violence of Representation* (London: Routledge, 1989), 29–44.

Jed, Stephanie H. "Relations of Prose: Knights Errant in the Archives of Early Modern Italy." In *The Project of Prose in the Early Modern West*, ed. Elizabeth Fowler and Roland Greene (Cambridge: Cambridge University Press, 1997), 48–65.

Jennings, Justin, Kathleen L. Antrobus, Sam J. Atencio, Erin Glavich, Rebecca Johnson, German Loffler, and Christine Luu. "'Drinking Beer in a Blissful Mood': Alcohol Production, Operational Chains, and Feasting in the Ancient World." *Current Anthropology* 46:2 (2005): 275–303.

Jennings, Justin. "La Chichera y El Patron: Chicha and the Energetics of Feasting in the Prehistoric Andes." In *Foundations of Power in the Prehispanic Andes: Archaeological Papers of the American Anthropological Association no. 14*, ed. Kevin Vaughn, Dennis Ogburn, and Christina Conlee (Washington, DC: American Anthropological Association, 2005), 241–59.

Jones, Julie. *Art of Empire: The Inca of Peru* (New York: Museum of Primitive Art, 1964).

Joralemon, Donald, and Douglas Sharon. *Sorcery and Shamanism: Curanderos and Clients in Northern Peru* (Salt Lake City: University of Utah Press, 1993).

Julien, Catherine. "History and Art in Translation: The Paños and Other Objects Collected by Francisco Toledo." *Colonial Latin American Review* 8:1 (1999): 61–89.

Julien, Catherine. "Punchao en España." In *El Hombre y los Andes: Homenaje a Franklin Pease G. Y.*, ed. Javier Flores Espinoza and Rafaél

Varón Gabai (Lima, Pontificia Universidad Católica del Perú, 2002), 709–15.

Julien, Daniel G. "Late pre-Inkaic ethnic groups in highland Peru: an archaeological-ethnohistorical model of the political geography of the Cajamarca region." *Latin American Antiquity* 4:3 (1993): 246–73.

Karsten, R. *A Totalitarian State of the Past: The Civilization of the Inca Empire in Ancient Peru: Commentationes Humanarum Litterarum* XVI:1 (Helsingfors: Societas Scientiarum Fennica, 1949).

Kato, Yasutake. "Resultados de las excavaciones en Kuntur Wasi, Cajamarca." *Senri Ethnological Studies* 37 (1993): 203–28.

Katterman, Grace. "Early Cotton Network Knotted in Colored Patterns." *Andean Past* 9 (2009): 249–75.

Katz, David. *The World of Colour* (London: Keegan, Paul, Trench, Trubner, 1935).

Kemper Columbus, Claudette. "Mountains That Move." *American Journal of Semiotics* 17:4 (2001): 175–99.

Kendall, Ann. *Aspects of Inca Architecture* (Oxford: British Archaeological Reports 1985).

Kent, Jonathan D. "The Domestication and Exploitation of the South American Camelids: Methods of Analysis and the Application to Circum-Lacustrine Archaeological Sites in Bolivia and Peru," Ph.D. dissertation, Washington University, Saint Louis, 1982.

King, Heidi. *Peruvian Featherworks: Art of the Precolumbian Era* (New York/New Haven: Metropolitan Museum of Art/Yale University Press, 2012).

Kiracofe, James B., and John S. Marr. "Marching to Disaster: The Catastrophic Convergence of Inca Imperial Policy, Sand Flies, and El Niño in the 1524 Andean Epidemic." In *El Niño: Catastrophism, and Culture Change in the Ancient Americas*, ed. Daniel H. Sandweiss and Jeffrey Quilter (Washington, DC: Dumbarton Oaks, 2008), 145–66.

Klein, Cecelia F. "Wild Woman in Colonial Mexico: An Encounter of European and Aztec Concepts of the Other." In Claire Farago, ed., *Reframing the Renaissance: Studies in the Migra-*tion of Visual Culture (New Haven: Yale University Press, 1995), 244–63.

Knudson, Kelly J., Kristin R. Gardella, and Jason Jaeger. "Provisioning Inka Feasts at Tiwanaku, Bolivia: The Geographic Origins of Camelids in the Pumapunku Complex." *Journal of Archaeological Science* 39 (2012): 479–91.

Kosok, Paul. *Transport in Peru* (London: W. Clowes and Sons, 1951).

Krickeberg, Walter. *Felsplastik und Felsbilder bei den Kulturvölkern Altamerikas* (Berlin, 1949).

Kroeber, Alfred. "Great Art Styles of Ancient South America," in The Nature of Culture, ed. A. L. Kroeber (Chicago: University of Chicago Press, 1952), 289–96.

Kroeber, A. L. *Anthropology: Culture Patterns and Processes* (New York: Harcourt Brace, 1963).

Kubler, George. "The Behavior of Atahualpa, 1531–33." *The Hispanic American Historical Review* 25:4 (1945): 413–27.

Kubler, George. *The Art and Architecture of Ancient America: The Mexican, Maya and Andean Peoples* (New Haven: Yale University Press, 1962).

Kubler, George. *The Shape of Time: Remarks on the History of Things* (New Haven: Yale University Press, 1962).

Kubler, George. "History – or Anthropology – of Art?" *Critical Inquiry* I:1 (1975): 127–44.

Kubler, George. "On the Colonial Extinction of the Motifs of Precolumbian Art," *Studies in Ancient American and European Art: The Collected Essays of George Kubler*, ed. Thomas Reese (New Haven: Yale University Press 1985), 66–74.

LaBelle, Brandon. *Background Noise: Perspectives on Sound Art* (London: Continuum, 2006).

Lacan, Jacques. "Of the Gaze as Objet Petit A," *The Seminar of Jacques Lacan, Book XI: The Four Fundamental Concepts of Psychoanalysis*, ed. Jacques-Alain Miller, trans. Alan Sheridan (first edition 1973; rev. ed. New York: W. W. Norton and Company 1998), 67–119.

Lamana, Gonzalo. "Beyond Exotization and Likeness: Alterity and the Production of Sense in a Colonial Encounter," in *Comparative Studies in Society and History* 47:1 (2005): 32–33.

Lamana, Gonzalo. *Domination without Dominance: Inca-Spanish Encounters in Early Colonial Peru* (Durham: Duke University Press, 2008).

Lane, Kevin. "Through the Looking Glass: Re-Assessing the Role of Agro-Pastoralism in the North-Central Andean Highlands." *World Archaeology* 38:3 (2006): 493–510.

Larrea, Juan. *Corona Incaica* (Córdoba, Spain: Facultad de Filosofía y Humanística 1960).

Lau, George F. "Northern Exposures: Recuay-Cajamarca boundaries and interaction." In *Andean Archaeology III: North and South*, ed. William H. Isbell and Helaine Silverman (New York: Plenum/Kluwer, 2006), 143–70.

Lau, George F. "Animal Resources and Recuay Cultural Transformations at Chinchawas, North Highlands, Peru." *Andean Past* 8 (2007): 449–76.

Lau, George F. "Ancestor Images in the Andes." *The Handbook of South American Archaeology* IX (2008): 1027–45.

Lau, George F. "The work of surfaces: object worlds and techniques of enhancement in the ancient Andes." *Journal of Material Culture* 15:3 (2010): 259–86.

Lau, George F. *Andean Expressions: Art and Archaeology of the Recuay Culture* (Iowa City: University of Iowa Press, 2011).

Lau, George F. "Intercultural Relations in Northern Peru: The North Central Highlands during the Middle Horizon." *Boletín Arqueológico PUCP* 16 (2012): 23–52.

Lechtman, Heather. "Andean Value Systems and the Development of Prehistoric Metallurgy." *Technology and Culture* 25 (1984):1–36.

Lechtman, Heather. "Technologies of Power: The Andean Case." In *Configurations of Power: Holistic Anthropology in Theory and Practice*, ed. John S. Henderson and Patricia J. Netherly (Ithaca: Cornell University Press, 1993), 244–80.

Lechtman, Heather. "Arsenic Bronze: Dirty Copper or Chosen Alloy? A View from the Americas." *Journal of Field Archaeology* 23:3 (1996): 477–514.

Lechtman, Heather. "The Inka and Andean Metallurgical Tradition." In *Variations in the Expression of Inka Power*, ed. Richard L. Burger, Craig Morris, Ramiro Matos, et al. (Washington, DC: Dumbarton Oaks, 2007), 313–55.

LeDoux, Joseph. *The Emotional Brain: The Mysterious Underpinnings of Emotional Life* (New York, 1996).

Lepecki, André. *Exhausting Dance: Performance and the Politics of Movement* (New York: Routledge, 2006).

Lévi-Strauss, Claude. *The Raw and the Cooked* (New York: Harper & Row, 1969).

Leys, Ruth. "The Affective Turn: A Critique," *Critical Inquiry* 37: 3 (Spring 2011): 434–72.

Lira, Jorge A. *Diccionario kkechuwa-español* (Bogotá, Colombia: Secretaría Ejecutiva del Convenio "Andrés Bello", 1982).

Llagostera, Augustín. "Contextualización e iconografía de las tabletas psicotrópicas Tiwanaku de San Pedro de Atacama," *Chungará: Revista de Antropología Chilena* 38:1 (2006): 83–112.

Llanos, Luis A. "Informe sobre Ollantaytambo: Trabajos arqueológicos en el Departamento del Cuzco bajo la Dirección del Dr. Luis E. Valcarcel." *Revista del Museo Nacional, II Semestre* 5:2 (1936): 123–56.

Lockhart, James. *The Men of Cajamarca: A Social and Biographical Study of the First Conquerors of Peru* (Austin: University of Texas Press, 1972).

Lopez Baralt, Mercedes. "The Quechua Elegy to the All-Powerful Inca Atawallpa." *Latin American Indian Literatures* 4 (1980): 79–86.

López-Baralt, Mercedes. "The Yana K'uychi or Black Rainbow in Atawallpa's Elegy: A Look at the Andean Metaphor of Liminality in a Cultural Context." In *Myth and the Imaginary in the New World*, ed. Edmundo Magaña and Peter Mason (Dordrecht: FORIS, 1986), 261–303.

MacCormack, Sabine. "Pachacuti: Miracles, Punishments, and Last Judgment: Visionary Past and Prophetic Future in Early Colonial Peru." *The American Historical Review* 93 (1988): 960–1006.

MacCormack, Sabine. "Atahualpa and the Book," *Dispositio* XIV (1989): 141–68.

MacCormack, Sabine. *Religion in the Andes: Vision and Imagination in Early Colonial*

Peru (Princeton: Princeton University Press, 1991).

MacCormack, Sabine. *On the Wings of Time: Rome, the Incas, Spain, and Peru* (Princeton: Princeton University Press, 2007).

Mackey, Carol. "Elite Residences at Farfán: A Comparison of the Chimú and Inca Occupations." In *Palaces and Power in the Americas: From Peru to the Northwest Coast*, ed. Jessica Joyce Christie and Patricia Joan Sarro (Austin: University of Texas Press, 2010), 313–52.

Makowski Hanula, Krzysztof. "¿Convención figurativa o personalidad?: Las deidades frontales de báculos en las iconografías Wari y Tiwanaku." In *Huari y Tiwanaku: Modelos vs. Evidencias, segunda parte*, ed. Peter Kaulicke and William H. Isbell; *Boletín de Arqueología PUCP* 5 (2001): 337–73.

Makowski Hanula, Krzysztof. "El Panteón Tiahuanaco y las deidades de báculos." In *Los Dioses de antiguo Perú*, ed. Krzysztof Makowski, vol. II (Lima: Banco de Crédito, 2001), 67–104.

Makowski Hanula, Krzysztof. "Cuando aún no llegaron los Incas: templos, rituals, y dioses de los Andes centrales (2700 a.C. – 1470 d.C.)." In *Y Llegaron los Incas*, ex. cat. (Madrid: Museo de América, 2006), 35–56.

Makowski Hanula, Krzyztof. "Royal Statues, Staff Gods, and the Religious Ideology of the Prehistoric State of Tiwanaku." In *Tiwanaku: Essays from the 2005 Mayer Center Symposium at the Denver Art Museum*, ed. Margaret Young-Sánchez (Denver: Denver Art Museum, 2009), 133–64.

Malpass, Michael, ed. *Provincial Inca: Archaeological and Ethnohistorical Assessment of the Impact of the Inca State* (Iowa City: University of Iowa Press, 1993).

Mamani Siñani, Roger Leonardo. "Carneros de la tierra, guanaco y vicuñas: La importancia del Ganado, una visión desde las crónicas." *Serie Anales de la Reunión Annual de Etnología* 18:1 (2004): 103–14.

Mannheim, Bruce. "The Language of Reciprocity in Southern Peruvian Quechua." *Anthropological Linguistics* 28 (1986): 267–73.

Mannheim, Bruce. "The Sound Must Seem an Echo to the Sense: Some Cultural Determinants of Language Change in Southern Peruvian Quechua," *Michigan Discussions in Anthropology* 8 (1988): 175–95.

Mannheim, Bruce, and Bruce Tedlock, eds. *The Dialogic Emergence of Culture* (Urbana: University of Illinois Press, 1995).

Mannheim, Bruce, and Krista van Vleet. "The Dialogics of Southern Quechua Narrative," *American Anthropologist* 100:2 (1998): 326–46.

Mannheim, Bruce, and M. Newfield. "Iconicity in Phonological Change." In *Papers from the 5th International Conference on Historical Linguistics* (Amsterdam: Benjamins, 1982), 211–22.

Manríquez S., Viviana. "El término Ylla y su potencial simbólico en el Tawantinsuyu: Una reflexión acerca de la presencia inca en Caspana (río Loa, desierto de Atacama)." *Estudios Atacameños* 18 (1999): 107–18.

Manuel Torres, Constantino. *The Iconography of South American Snuff Trays and Related Paraphernalia* (Göteborg: Etnografiska Museum, 1987).

Manuel Torres, Constantino. "Tiwanaku Snuffing Paraphernalia." In *Tiwanaku: Ancestors of the Inca*, ed. Margaret Young-Sánchez (Lincoln: Denver Art Museum/University of Nebraska Press, 2004), 114–20.

Marin, Louis. *Portrait du roi* (Paris: Éditions de Minuit, 1981).

Markham, Clements R. *Reports on the discovery of Peru*, vol. I (London: Hakluyt Society, 1872).

Martínez Cereceda, José Luis. "El 'personage sentado' en los keru: Hacia una identificación de los kuraka Andinos." *Boletín del Museo Chileno de Arte precolombino* 1 (1986): 108–11.

Martínez Cereceda, José Luis. *Autoridades en los Andes: Los Atributos del Señor* (Lima: Pontífica Universidad Católica del Perú, 1995).

Massumi, Brian. *Parables for the Virtual: Movement, Affect, Sensation* (Durham: Duke University Press, 2002).

Matos Mendieta, Ramiro. *Pumpu: Centro administrativo inka de la puna de Junín* (Lima: Editorial Horizonte, 1994).

Matsumoto, Ryozo. "Dos Modos de proceso socio-cultural: El Horizonte temprano y el period intermedio temprano en el valle

de Cajamarca." *Senri Ethnological Studies* 37 (1993): 169–202.

McClelland, Donna. *Moche fineline painting from San Jose de Moro* (Los Angeles: Cotsen Institute of Archaeology at UCLA, 2007).

McClelland, Donald. "Architectural Models in Late Moche Tombs." *Ñawpa Pacha* 30:2 (2010): 209–30.

McEwan, Colin. "Cognising and Marking the Andean Landscape: Radial, Concentric, and Hierarchical Perspectives." In *Inca Sacred Space: Landscape, Site and Symbol in the Andes*, ed. Frank Meddens, Katie Willis, Colin McEwan, and Nicholas Branch (London: Archetype, 2014), 29–47.

McEwan, Colin, and Maarten Van de Guchte. "Ancestral Time and Sacred Space in Inca State Ritual." In *The Ancient Americas: Art from Sacred Landscapes* (Chicago: Art Institute of Chicago, 1992), 359–371.

Meddens, Frank M. "Function and Meaning of the Usnu in Late Horizon Peru." *Tawantinsuyu* 3 (1997): 5–14.

Meddens, Frank M., Colin McEwan, and Cirilio Vivanco Pomacanchari. "Inca 'Stone Ancestors' in Context at a High-Altitude Usnu platform." *Latin American Antiquity* 21:2 (2010): 173–94.

Medinaceli, Ximena. "Andean pastoralists: a proposal for reading their history. A bibliographic essay of ethnography and history." *Bulletin de l'Institut Français d'Etudes andines* 34:3 (2005): 463–74.

Melville, Elinor G. K. *A Plague of Sheep: Environmental Consequences of the Conquest of Mexico* (Cambridge: Cambridge University Press, 1997).

Mena, Cristóbal. "The Anonymous La Conquista Del Peru [Seville, April 1534] and the Libro Vltimo Del Svmmario Delle Indie Occidentali [Venice, October 1534]," *Proceedings of the American Academy of Arts and Sciences* 64:8, ed. Alexander Pogo (Philadelphia: American Academy of Arts and Sciences, 1944).

Mengoni Goñalons, Guillermo L. "Gestion des camélidés pendant la période Inca au nord-ouest de l'Argentine: modèles et indicateurs archéozoologiques." *Anthropozoologica* 42:2 (2007): 129–41.

Menzel, Dorothy. "Style and Time in the Middle Horizon." *Ñawpa Pacha* 2 (1964): 1–106.

Merleau-Ponty, Maurice. *The Phenomenology of Perception* (New York: Humanities Press, 1962).

Merleau-Ponty, Maurice. "The Intertwining – The Chiasm." In *The Visible and the Invisible*, ed. Claude Lefort (4th ed., Evanston: Northwestern University Press, 1992), 130–55.

Methfessel, Carlos, and Lilo Methfessel. "Arte rupestre de la 'Rutas de la Sal' a lo largo del Rio San Juan del Oro," *Boletín de la Sociedad de Investigación del Arte Rupestre de Bolivia* 11 (1997): 76–84.

Metz, Christian. *The Imaginary Signifier* (1975; Bloomington: Indiana University Press, 1982).

Meyers, Albert. "Toward a Reconceptualization of the Late Horizon and the Inka Period," in *Variations in the Expression of Inka Power*, ed. Richard L. Burger, Craig Morris, Ramiro Matos, et al. (Washington, DC: Dumbarton Oaks, 2008), 223–54.

Mignolo, Walter. "Afterword: from Colonial Discourse to Colonial Semiosis," *Dispositio.* XIV: 36–38 (1989): 333–37.

Mignolo, Walter. "Crossing Gazes and the Silence of the 'Indians': Theodor De Bry and Guaman Poma de Ayala." *Journal of Medieval and Early Modern Studies* 41, no. 1 (2011): 173–223.

Miller, George. "An Introduction to the Ethnoarchaeology of the Andean Camelids," Ph.D. dissertation, University of California at Berkeley, 1974.

Mitchell, W. "Local Ecology and the State: Implications of Contemporary Quechua Land Use for the Inca Sequence of Agricultural Work." In *Beyond the Myths of Culture: Essays in Cultural Materialism*, ed. E. B. Ross (New York: Academic Press, 1980), 139–54.

Mitchell, W. T. "Showing Seeing: A Critique of Visual Culture," *Journal of Visual Culture* 1:2 (2002): 165–81.

Mitchell, W. J. T. *Landscape and Power*, new ed. (Chicago: University of Chicago Press, 2002).

Mitchell, W. J. T. "There Are No Visual Media," *Journal of Visual Culture* 4:2 (2005): 257–66.

Molina, Cristóbal de. *Fábulas y Mitos de los Incas* [1585], ed. Henrique Urbano and Pierre Duviols, (Madrid: Historia, 1988).

Molinié, Antoinette. "The Spell of Yucay: A Symbolic Structure in Incaic Terraces." *Journal of the Steward Anthropological Society* 24:1–2 (1996): 203–30.

Moore, Jerry D. "The Archaeology of Plazas and the Proxemics of Ritual: Three Andean Traditions." *American Anthropologist* 98:4 (1996): 789–802.

Moore, Jerry D. *Architecture and Power in the Andes: The Archaeology of Public Buildings* (New York: Cambridge University Press, 1996).

Moore, Jerry D. "Life Behind Walls: Patterns in the Urban Landscape on the Prehistoric North Coast of Peru." In *The Social Construction of Ancient Cities*, ed. Monica L. Smith (Washington: Smithsonian Books, 2003), 81–102.

Moore, Jerry D. "'The Indians Were Much Given to Their Taquis': Drumming and Generative Categories in Ancient Andean Funerary Processions." In *Archaeology of Performance: Theaters of Power, Community, and Politics*, ed. Takeshi Inomata and Lawrence S. Coben (Lanham: Altamira Press/Rowman and Littlefield, 2006), 47–69.

Moore, Jerry D. *Cultural Landscapes in the Ancient Andes: Archaeologies of Place* (Gainesville: University of Florida Press, 2005).

Morris, Craig. "Storage in Tawantinsuyu," Ph.D. dissertation, University of Chicago, 1967.

Morris, Craig. "The Infrastructure of Inca Control in the Peruvian Central Highlands." In *The Inca and Aztec states, 1400–1800: Anthropology and History*, ed. George A. Collier, Renato I. Rosaldo, and John D. Wirth (New York: Academic Press, 1982), 153–71.

Morris, Craig. "Enclosures of Power: The Multiple Spaces of Inca Administrative Palaces." In *Palaces of the Ancient World*, ed. Susan Toby Evans and Joanne Pillsbury (Washington, DC: Dumbarton Oaks, 2009), 299–323.

Morris, Craig, and R. Alan Covey. "La Plaza Central de Huánuco Pampa: Espacio y Trasformación." *Boletín Aqueologia de la Pontífica Universidad Católica del Perú* 7 (2003): 134–37.

Morris, Craig, and R. Alan Covey. "The Management of Scale or the Creation of Scale: Administrative Processes in Two Inca Provinces." In *Intermediate Elites in Pre-Columbian States and Empires*, ed. Christina M. Elson and R. Alan Covey (Tucson: University of Arizona Press, 2006), 137–46.

Morris, Craig, R. Alan Covey, and Pat H. Stein. *The Huánuco Pampa Archaeological Project. Volume 1, The plaza and palace complex: Anthropological Papers of the American Museum of Natural History 96* (New York: American Museum of Natural History, 2011).

Morris, Craig, and Julián Idilio Santillana. "The Inca Transformation of the Chincha Capital." In *Variations in the Expression of Inka Power*, ed. Richard L. Burger, Craig Morris, Ramiro Matos, et al. (Washington, DC: Dumbarton Oaks, 2007), 135–64.

Morris, Craig, and Donald E. Thompson. *Húanuco Pampa: An Inca City and Its Hinterland* (London: Thames and Hudson, 1985).

Mostny, Grete, and Hans Niemeyer. *Arte repustre chileno: Serie el Patrimonio Cultural Chileno, Colección Historia del Arte Chileno* (Santiago: Departamento de Extensión Cultural del Ministerio de Educación, 1983).

Murra, John V. "On Inca Political Structure." In *Systems of Political Control and Bureaucracies in Human Societies*, ed. Verne F. Ray (Seattle: University of Washington Press, 1958), 30–41.

Murra, John V. "Cloth and Its Function in the Inca State." *American Anthropologist* 64:4 (1962): 710–24.

Murra, John V. "Herds and Herders in the Inca State." In *Man, Culture and Animals: The Role of Animals in Human Ecological Adjustments*, ed. A. Leeds and A. Vayda (Washington, DC: American Association for the Advancement of Science, 1965), 185–216.

Murra, John V. "Current Research and Prospects in Andean Ethnohistory." *Latin American Research Review* 1970 5:1 (1970): 3–36.

Murra, John V. "El 'control vertical' de un Maximo de Pesos Econologicos en la Economica

de las Sociedades Andianas." In *Formaciones economicas y politicas del Mundo Andino* (Lima: Instituto de Estudios Peruanos, 1972), 59–116.

Murra, John V. "Rite and Crop in the Inca State." In *Peoples and Cultures of South America*, ed. Daniel Gross (New York: Doubleday/Museum of Natural History Press: 1973), 377–94. (Originally in *Culture in History*, ed. Stanley Diamond [New York: Academic Press, 1960], 393–407.)

Murra, John V. *Formaciones económicas y políticas del mundo andino* (Lima: Instituto de Estudios Andinos, 1975).

Murra, John V. "Los olleros del Inca: Hacia una historia y arqueología del Qollasuyu." In *Historia, problema y promesa: Homenaje a Jorge Basadre* (Lima: Universidad Católica, 1979), 415–23.

Murra, John V. *The Economic Organization of the Inca State* (1955; reprint Greenwich: Jai Press, 1980).

Murra, John V. "The Expansion of the Inca State: Armies, War, and Rebellions." In *Anthropological History of Andean Politics*, ed. John Murra, Nathan Wachtel, and Jacques Revel (Cambridge: Cambridge University Press, 1986), 49–58.

Murúa, Martín de. *Historia del orígen y genealogía real de los Reyes Incas del Perú* [1590], ed. Constantino Bayle (Madrid, 1946).

Murua, Martín de. *Historia general del Perú, origen y descendencia de los incas* [1609], ed. Manuel Ballesteros Gaibrois. 2 vols. (Madrid: Instituto "Gonzalo Fernández de Oviedo," 1962–64.

Nair, Stella. "Localizing Sacredness, Difference, and Yachacuscamcani in a Colonial Andean Painting" *The Art Bulletin* 89:2 (2007): 211–38.

Nielsen, A. E. *Andean Caravans: An Ethnoarchaeology* (Tucson: University of Arizona, 2000).

Nielsen, Axel E. "Pastoralism and the Non-Pastoral World of the Late Pre-Columbian History of the Southern Andes (1000–1535)." *Nomadic Peoples* 13:2 (2009): 17–35.

Niemeyer, Hermann M. "On the Provenience of Wood Used in the Manufacture of Snuff Trays from San Pedro de Atacama (Northern Chile)." *Journal of Archaeological Science* 40:1 (2013): 398–404.

Nieves Zedeño, María. "Animating by Association: Index Objects and Relational Taxonomies." In *Cambridge Archaeological Journal* 19:3 (2009): 407–17.

Niles, Susan A. "Moya Place or Yours? Inca Private Ownership of Pleasant Places." *Ñawpa Pacha* 25–27 (1987–89): 189–206.

Niles, Susan A. *Callachaca: Style and Status in an Inca Community* (Iowa City: University of Iowa Press, 1987).

Niles, Susan A. *The Shape of Inca History: Narrative and Architecture in an Andean Empire* (Iowa City: University of Iowa Press, 1999).

Nuckolls, Janis B. *Sounds like Life: Sound-Symbolic Grammar, Performance, and Cognition in Pastaza Quechua* (New York: Oxford University Press, 1996).

Nuñez Prado Béjar, Daisy. "La Reciprocidad como ethos de la cultura quechua," *Allpanchis* 4 (1972): 135–65.

Nuñez, L., and T. S. Dillehay. *Movilidad giratoria, armonía social y desarrollo en los Andes Meridionales: patrones de tráfico e interacción económica* (Antofagasta: Universidad Católica del Norte, 1995).

Oesterreicher, Wulf. "Kein sprachlicher Alltag – der Konquistador Alonso Borregán schreibt eine Chronik." In Annette Sabban and Christian Schmitt, eds., *Sprachlicher Alltag – Linguistik, Rhetorik, Literatur: Festschrift für Wolf-Dieter Stempel* (Tübingen: Niemeyer, 1994), 379–418.

Oesterreicher, Wulf. "'Uno de Cajamarca,' Gaspar de Marquina schreibt an seinen Vater [20 Juli 1533]." In Sybille Große and Axel Schönberger, eds., *Dulce et decorum est philologiam colere: Festschrift für Dietrich Briesemeister zu seinem 65. Geburtstag* [Berlin: DEE, 1999], 37–81.

Ogburn, Dennis. "Dynamic Display, Propaganda, and the Reinforcement of Provincial Power in the Inca Empire," *Archaeological Papers of the American Anthropological Association* 14 (2005): 225–39.

Ogburn, Dennis E. "Human Trophies in the Late Pre-Hispanic Andes: Striving for Status

and Maintaining Power among the Incas and Other Societies." In *The Taking and Displaying of Human Body Parts as Trophies by Amerindians*, ed. Richard Chacon and David H. Dye (New York: Springer, 2007), 505–21.

Ong, Walter. "'I See What You Say': Sense Analogues of Intellect." In *Interfaces with the World: Studies in the Evolution of Consciousness and Culture*, ed. Walter Ong (Ithaca: Cornell University Press, 1977), 121–44.

Pachacuti Yamqui Salcamaygua, Joan de Santa Cruz. *Relación de antiguedades deste Reyno del Piru: Estudio Ethnothistórico de Pierre Duviols y César Itier* 1613 (Lima/Cusco: Institut Francais d'Etudes Andines/Centro de Estudios Regionales Andinds "Bartolomé de las Casas," 1993).

Palacios Rios, F. "Tecnología del Pastoreo." In *Tecnología en el Mundo Andino: Runakunap Kawasayninkupaq Rurasqankunaqa*, vol. I, ed. Heather Lechtman and A. M. Solis (Mexico City: UNAM, 1981), 217–32.

Panofsky, Erwin. "Homage to Fracastoro in a Germano-Flemish Composition of about 1590?" *Nederlands kunsthistorisch jaarboek* XII (1961): 1–33.

Pärssinen, Martti. *Tawantinsuyu: The Inca State and Its Political Organization* (Helsinki: Societas Historica Finlandiae, 1992).

Pärssinen, Marti. "Investigaciones arqueológicas con ayude de Fuentes históricas: experiencias en Cajamarca, Pacasa, y Yampara." In *Saberes y memorias en los Andes: In Memoriam Thierry Saignes*, ed. Bouysse-Cassagne (Paris-Lima: Credal-IFEA, 1997), 41–58.

Pasztory, Esther. *Inka Cubism: Reflections on Andean Art* (Columbia University web publication, 2010): http://www.columbia.edu/~ep9/Inka-Cubism.pdf.

Paternosto, César. *The Stone and the Thread: Andean Roots of Abstract Art*. trans. Esther Allen (Austin: University of Texas Press: 1996).

Paternosto, César, ed. *Abstraction: The Amerindian Paradigm* (Brussels: Palais des Beaux-Arts de Bruxelles/Institut Valencià d'Art Modern, 2001).

Paul, Anne. "Paracas Necrópolis Bundle 89: A Description of its Contents." In *Paracas Art and Architecture: Object and Context in South Coastal Peru*, ed. Anne Paul (Iowa City: University of Iowa Press, 1991), 172–221.

Pease G. Y., Franklin. *Los Ultimos Incas del Cusco* (Lima: Taller Gráfica Villanueva, 1972).

Pease G. Y., Franklin. *El Dios creador andino* (Lima: Mosca Azul, 1973).

Pease G. Y., Franklin. "Chronicles of the Andes in the Sixteenth and Seventeenth Centuries," in *Guide to Documentary Sources for Andean Studies, 1530–1900*, ed. Joanne Pillsbury (Norman: University of Oklahoma Press, 2009), 11–22.

Peirce, Charles Sanders. *Collected Writings* (8 Vols.), ed. Charles Hartshorne, Paul Weiss, and Arthur W. Burks (Cambridge: Harvard University Press, 1931–58).

Pelissero, Norberto. "Otra vez la plastica rupestre y su relacion con las estaciones de trashumancia." *Baessler-Archiv* (Neue Folge) 44:2 (1996): 401–06.

Phelan, Peggy. *Unmarked: The Politics of Performance* (New York: Routledge, 1993).

Phipps, Elena, Nancy Turner, and Karen Trentelman. "Colors, Textiles, and Artistic Production in Murúa's Historia General del Piru." In *The Getty Murúa: Essays on the Making of Martín de Murúa's "Historia general del Piru," 1616, Ms. Ludwig XIII 16*, ed. Thomas B. F. Cummins and Barbara Anderson (Los Angeles: J. Paul Getty Trust, 2008), 125–46.

Pillsbury, Joanne. "Inka Unku: Strategy and Design in Colonial Peru." In *Cleveland Studies in the History of Art* 7 (2002): 68–103.

Pillsbury, Joanne. "The Concept of the Palace in the Andes." In *Palaces of the Ancient New World*, ed. Susan Toby Evans and Joanne Pillsbury (Washington, DC: Dumbarton Oaks, 2005), 181–86.

Pillsbury, Joanne. "Inka-Colonial Tunics: A Case Study of the Bandelier Set." In *Andean Textile Traditions: Papers from the 2001 Mayer Center Symposium at the Denver Art Museum*, eds. Margaret Young-Sanchez and Fronia W. Simpson (Denver: Denver Art Museum, 2006), 120–68.

Pillsbury, Joanne. "Reading Art without Writing: Interpreting Chimú Architectural

Sculpture." In *Dialogues in Art History, from Mesopotamian to Modern: Readings for a New Century*. Studies in the History of Art, Vol. 74 (Washington, DC: Center for Advanced Study in the Visual Arts, 2009), 73–89.

Pino Matos, José Luis. "El Ushnu Inca y la Organización del Espacio en los Principales Tampus de los Wamani de la Sierra Central del Chinchaysuyu." *Chungara: Revista de Antropología Chilena* 36:2 (2004): 303–11.

Pizarro, Hernando. "A los Magníficos señores Oidores de la Audiencia Real de Su Majestad, que residen en la Ciudad de Santo Domingo." In J. Amador de los Ríos, ed., *Historia general y natural de las Indias de Gonzalo Fernández de Oviedo y Valdés*[1539–48] (Madrid 1851; repr. J. Pérez de Tudela Bueso, Madrid 1959), Book 46, Chapter 16, 84–90.

Pizarro, Pedro. *Relación del descubrimiento y conquista del Peru [1571]*, ed. Guillermo Lohmann Villena and Pierre Duviols (Lima: Pontífica Universidad Católica del Perú, 1978).

Platt, Tristan. "The Sound of Light: Emergent Communication through Quechua Shamanic Dialogue," in *Creating Context in Andean Cultures*, ed. Rosaleen Howard Malverde (New York: Oxford University Press, 1997), 196–226.

Protzen, Jean-Pierre. *Inca Architecture and Construction at Ollantaytambo* (Oxford: Oxford University Press, 1993).

Protzen, Jean-Pierre, and John H. Rowe. "Hawkaypata: the Terrace of Leisure." In *Streets: Critical Perspectives on Public Space*, ed. Zeynep Celik, Diane Favro, and Richard Ingersoll (Berkeley: University of California Press, 1994) 235–46.

Quilter, Jeffrey. "The Moche Revolt of the Objects." *Latin American Antiquity* 1:1 (1990): 42–65.

Rabasa, José. "Columbus and the New Scriptural Economy of the Renaissance," *Dispositio* XIV: 36–38 (1989): 271–301.

Ramírez, Susan Elizabeth. *To Feed and Be Fed: The Cosmological Bases of Authority and Identity in the Andes* (Stanford, CA: Stanford University Press, 2005).

Randall, Robert. "La Lengua Sagrada: El Juego del palabras en la cosmología andina." *Allpan-chis: Revista del Instituto Pastoral Andina* 29–30 (1987): 267–305.

Ravines, Rogger. "El Cuarto de Rescate de Atahualpa." *Revista del Museo Nacional* 62 (1976): 114–43.

Ravines, Rogger. *Cajamarca prehispanica: Inventario de monumentos arqueológicos* (Cajamarca, Perú: Instituto Nacional de Cultura de Cajamarca/Corporación de Desarrollo de Cajamarca, 1985).

Ravines, Rogger. "Los Incas en Cajamarca." *Boletín de Lima* 74 (1991): 5–10.

Ravines, Rogger. "Calles de Cajamarca: Historia de su crecimiento urbano." *Boletín de Lima* 82 (1992): 55–74.

Ravines, Rogger, and Jorge Sachún C. "Monumentos arqueológicos tempranos de la region cisandina de Cajamarca." *Boletín de Lima* 87 (1993): 8–14.

Regal, Alberto. *Los Caminos del Inca en el Antiguo Perú* (Lima: San Martí y cía., 1936).

Remensnyder, Amy G. *Virgin Mary at War and Peace in the Old and New Worlds* (Oxford: Oxford University Press, 2014).

Reinhard, Johan. "The Temple of Blindness: An Investigation into the Inca Shrine of Ancocagua." *Andean Past* 5 (1998): 89–108.

Rienhart, Johan. *The Ice Maiden: Inca Mummies, Mountain Gods, and Sacred Sites in the Andes* (Washington, DC: National Geographic Society, 2005).

Rienhart, Johan, and Maria Constanza Ceruti. *Inca Rituals and Sacred Mountains: A Study of the World's Highest Archaeological Sites* (Los Angeles: Cotsen Institute of Archaeology Press, 2010).

Roa-de-la-Carrera, Cristián A. *Histories of Infamy: Francisco López de Gómara and the Ethics of Spanish Imperialism*, trans. Scott Sessions (Boulder: University of Colorado Press, 2005).

Rodman, Amy Oakland, and Vicky Cassman. "Andean Tapestry: Structure Informs the Surface." *Art Journal* 54 (1995): 33–39.

Romero Bedregal, Hugo. "Llamas, mito y ciencia en el mundo andino." *Reunión Anual de Etnología* 17:1 (2003): 621–40.

Rostworowski de Diez Canseco, María. "Mercaderes del valle de Chincha en la época prehispánica: Un document y uno comentarios." In Rostworowski de Diez Canseco, *Etnía y*

sociedad (Lima: Instituto de Estudios Peruanos, 1977), 97–140.

Rostworowski de Diez Canseco, Maria. "Patronyms with the Consonant F in the Guarangas of Cajamarca." In *Andean Ecology and Civilization: An Interdisciplinary Perspective on Andean Ecological Complementarity*, ed. S. Masuda, I. Shimada, and C. Morris (Tokyo: University of Tokyo Press, 1985), 401–21.

Rostworowski de Diez Canseco, María. *History of the Inca Realm*, trans. Harry B. Iceland (Cambridge: Cambridge University Press, 1999).

Röver Kann, Anne. *Albrecht Dürer: Das Frauenbad von 1496* (Bremen, 2001).

Rowe, Anne Pollard. "Inca Weaving and Costume." *The Textile Museum Journal* 34:5 (1997): 5–54.

Rowe, John H. *An Introduction to the Archaeology of Cuzco. Papers of the Peabody Museum of American Archaeology and Ethnology*, Vol. XXVII, no. 2 (Cambridge: Peabody Museum of American Archaeology and Ethnology, Harvard University, 1944), 41–43.

Rowe, John H. "Inca Culture at the Time of the Spanish Conquest." *Handbook of South American Indians, Bureau of American Ethnology Bulletin* 143, Vol. 2, ed. Julian H. Steward (Washington, DC: Smithsonian Institution, 1946).

Rowe, John H. "The Kingdom of Chimor." *Acta Americana* 6 (1948): 26–59.

Rowe, John H. "Eleven Inca Prayers from the Zithuwa Ritual," *Kroeber Anthropological Society Papers* 8/9 (Berkeley: Dept. of Anthropology, University of California at Berkeley, 1953).

Rowe, John H. "The Chronology of Inca Wooden Cups." In *Essays in Pre-Columbian Art and Archaeology*, ed. Samuel Lothrop (Boston, Harvard University Press, 1961), 317–41.

Rowe, John H. "El Arte Religioso del Cuzco en el Horizonte Temprano." *Ñawpa Pacha* 14 (1976): 1–20.

Rowe, John Howland. "An Account of the Shrines of Ancient Cuzco." *Ñawpa Pacha* 17 (1979): 1–80.

Rowe, John H. "Standardization in Inca Tapestry Tunics." In *The Junius B. Bird Pre-Columbian Textile Conference*, 1973, ed. Ann

Pollard Rowe, Elizabeth P. Benson, and Anne-Louise Schaffer (Washington, DC: Textile Museum and Dumbarton Oaks, 1979), 239–64.

Rowe, John H., and Ann Pollard Rowe, "Inca Tunics." In *Andean Art at Dumbarton Oaks*, vol. 2 (Washington, DC: Dumbarton Oaks, 1996): 453–66.

Rubies, J. P. "Travel Writing as a Genre: Facts, Fictions and the Invention of a Scientific Discourse in Early Modern Europe," *Journeys* 1 (2000): 5–33.

Ruiz de Arce, Juan. *La Memoria de Juan Ruiz de Arce (1543): Conquista del Perú, saberes secretos de caballería y defense del mayorazgo*, ed. Eva Stoll (Frankfurt and Madrid: Vervuert Verlag/Iberoamericana, 2002).

Ruiz, Mara. "Unkus, caminos, y encuentros." *Revista Andina* 34 (2005): 199–215.

Schäpers, Joachim. "Francisco Pizarros Marsch von San Miguel nach Cajamarca." *Ibero-Amerikanisches Archiv Neue Folge* 9:2 (1983): 241–51.

Schivelbusch, Wolfgang. *The Railway Journey: Trains and Travel in the Nineteenth Century*, trans. Anselm Hollo (New York: Urizen Books, 1979).

Shimada, Melody. "Continuities and Changes in Patterns of Faunal Resource Utilization: Formative through Cajamarca Periods." In *The Formative Period in the Cajamarca Basin, Peru: Excavations at Huacaloma and Layzón, 1982*, ed. Kazuo Terada and Yoshio Onuki (Tokyo: University of Tokyo, 1985), 289–310.

Shimada, Melody, and Izumi Shimada. "Prehistoric Llama Breeding and Herding on the North Coast of Peru." *American Antiquity* 50 (1985): 3–26.

Silverman, Helaine. "The Early Nasca Pilgrimage Center of Cahuachi and the Nasca Lines: Anthropological and Archaeological Perspectives," in *The Lines of Nazca*, ed. Anthony Aveni (Philadelphia: American Philosophical Society, 1991), 207–44.

Skar, S. "The Role of Urine in Andean Notions of Health and the Cosmos." In *Native and Neighbors in Indigenous South America*, ed. H. Skar and F. Salomon (Gothenburg:

Etnografiske Studier/Gothenburg Ethnographic Museum, 1987), 267–94.

Sachún Cedeño, J. *Patrones de asentamiento en el proceso cultural prehispánico del valle de Cajamarca (primera aproximación)* (Trujillo, Peru: Editorial Sudamérica, 1986).

Sahlins, Marshall. "Colors and Cultures," *Semiotica* 16 (1976), 1–22.

Sahlins, Marshall. *Culture and Practical Reason* (Chicago: University of Chicago Press, 1976).

Sahlins, Marshall. *Islands of History* (Chicago: University of Chicago Press, 1985).

Sahlins, Marshall. "The Stranger-King or, Elementary Forms of the Politics of Life," *Indonesia and the Malay World* 36:105 (2008): 177–99.

Said, Edward *Beginnings: Intention and Method* (New York: Columbia University Press, 1976).

Salazar, Lucy C. "Machu Picchu's Silent Majority: A Consideration of the Inca Cemeteries." In *Variations in the Expression of Inka Power*, ed. Richard L. Burger, Craig Morris, Ramiro Matos, et al. (Washington, DC: Dumbarton Oaks, 2007), 165–83.

Salomon, Frank. *Native Lords of Quito in the Age of the Incas: The Political Economy of North Andean Chiefdoms* (Cambridge: Cambridge University Press, 1986).

Salomon, Frank. "Vertical Politics on the Inca Frontier." In *Anthropological History of Andean Polities*, ed. John. V. Murra, Nathan Wachtel, and Jacques Revel (Cambridge: Cambridge University Press, 1986), 89–118.

Salomon, Frank. "The Beautiful Grandparents: Andean Ancestor Shrines and Mortuary Ritual as seen through Colonial Records." In *Tombs for the Living: Andean Mortuary Practices*, ed. T. Dillehay (Washington, DC: Dumbarton Oaks, 1995), 331–53.

Salomon, Frank. "How the Huacas Were: The Language of Substance and Transfromation in the Huarochirí Quechua Manuscript." *RES: Anthropology and Aesthetics* 33 (1998): 7–17.

Salomon, Frank. "Andean Opulence: Indigenous Ideas about Wealth in Colonial Peru." In *The Colonial Andes: Tapestry and Silverwork, 1530–1830*, ed. Elena Phipps, Johanna Hecht, and Cristina Esteras Martín (New York: The Metropolitan Museum of Art, 2004), 114–24.

Salomon, Frank, and Sue Grosboll. "A Visit to the Children of Chaupi Ñamca: From Myth to History via Onomastics and Demography." In *History and Language in the Andes*, ed. Paul Heggarty and Adrian J. Pearce (London: Palgrave 2011), 39–62.

Salomon, Frank, and George L. Urioste. *The Huarochirí Manuscript: A Testament of Ancient and Colonial Andean Religion* (Austin: University of Texas Press, 1991).

Santillana Valencia, Idilio. "El Cuarto de Rescate de Atahualpa: Aprocimaciones arqueológicas." *Boletín de Lima* 5: 27 (1983): 13–22.

Santisteban, F. Silva. "Cajamarca en la historia del Perú," in *Historia de Cajamarca I: Arqueología*, ed. Wlademir Espinosa Soriano and Rogger Ravines (Cajamarca: Instituto Nacional de Cultura/Cajamarca and Corporación de Desarrollo de Cajamarca, 1985), 9–27.

Saunders, Nicholas J. "Stealers of Light, Traders in Brilliance: Amerindian Metaphysics in the Mirror of Conquest." *RES: Anthropology and Aesthetics* 33:1 (1998): 226–30.

Saunders, Nicholas J. "'Catching the Light': Technologies of Power and Enchantment in Pre-Columbian Goldworking." In *Gold and Power in Ancient Costa Rica, Panama, and Colombia*, ed. Jeffrey Quilter and John W. Hoopes (Washington, DC: Dumbarton Oaks, 2003), 15–48.

Sawyer, Alan. "Tiahuanaco Tapestry Design," *Textile Museum Journal* 1:2 (1963): 27–38.

Schaedel, Richard P. "Early State of the Incas." In *The Early State*, ed. Henri J. M. Claesson and Peter Skalník (The Hague: Mouton, 1978), 289–320.

Schafer, R. Murray. *The Soundscape: Our Sonic Environment and the Tuning of the World* (Rochester, VT: Destiny, 1993).

Schäpers, Joachim. "Francisco Pizarros Marsch von San Miguel nach Cajamarca." *Ibero-Amerikanisches Archiv Neue Folge* 9:2 (1983): 241–51.

Schapiro, Meyer. "Review of A. L. Kroeber, *Style and Civilizations*." American Anthropologist 61 (1959): 304.

Schreiber, Katharina J. "Conquest and Consolidation: A Comparison of the Wari and Inka

Occupations of a Highland Peruvian Valley."
American Antiquity 52:2 (1987): 266–84.

Schreiber, Katharina J., and Raymond E. White.
"Intimachay, a December Solstice Observatory." *American Antiquity* 52 (1987): 346–52.

Schwartz, Stuart B., and Frank Salomon. "New
Peoples and New Kinds of People: Adaptation, Readjustment, and Ethnogenesis in
South American Indigenous Societies (Colonial Era)." In *The Cambridge History of the
Native Peoples of the Americas*, ed. Stuart B.
Schwartz and Frank Salomon, Vol. III, part
2 (Cambridge: Cambridge University Press,
1999), 443–501.

Scolieri, Paul A. *Dancing the New World: Aztecs,
Spaniards, and the Choreography of Conquest*
(Austin: University of Texas Press, 2013).

Scott, Heidi V. *Contested Territory: Mapping Peru
in the Sixteenth and Seventeenth Centuries* (Notre
Dame: University of Notre Dame Press,
2009).

Seed, Patricia. "'Failing to Marvel': Atahualpa's
Encounter with the Word," *Latin American
Research Review* 26: (1991): 7–32.

Seed, Patricia. *Ceremonies of Possession: Europe's
Conquest of the New World, 1492–1640*
(Cambridge: Cambridge University Press,
1995).

Seligmann, Linda. "Systems of Knowledge and
Authority in the Huanoquite Landscape,"
Journal of the Steward Anthropological Society 25:2
(1999): 27–55.

Sherbondy, Jeanette. "The Canal Systems of
Hanan Cuzco." Ph.D. dissertation, Department of Anthropology, University of Illinois,
1982.

Sherbondy, Jeanette. "El Regadío, los Lagos, y
los Mitos de Origen." *Allpanchis* 20 (1982):
3–32.

Sherbondy, Jeanette. "Los Ceques: Codigo de
Canales en el Cusco Incaico." *Allpanchis*, 27
(1986): 39–74.

Sherbondy, Jeanette E. "Organización hidráulica
y poder en el Cuzco de los Incas." *Revista
Española de Antropología Americana (Madrid)* 17
(1987): 117–53.

Sherbondy, Jeanette. "Water Ideology in Inca
Ethnogenesis." In *Andean Cosmologies through
Time*, edited by K. Seibold and J. McDowell (Bloomington: Indiana University Press,
1992), 46–66.

Sherbondy, Jeanette. "Water and Power: The
Role of Irrigation Districts in the Transition
from Inca to Spanish Cuzco." In *Irrigation at
High Altitudes: The Social Organization of Water
Control Systems in the Andes*, ed. W. Mitchell
and D. Guillet (Washington, DC: American
Anthropological Association, 1994), 69–97.

Shouse, Eric. "Feeling, Emotion, Affect," *M/C
Journal* 8 (Dec. 2005): journal.media-culture
.org.au/0512/03-shouse.php, PP 1,5.

Sillar, William. "The Dead and the Drying;
techniques for transforming people and things
in the Andes." *Journal of Material Culture* 1:3
(1996): 259–89.

Silverblatt, Irene. *Sun, Moon, and Witches: Gender
Ideologies and Class in Inca and Colonial Peru*
(Princeton: Princeton University Press, 1987).

Simatovic, M. Remy. "Organización y cambios
del reino de Cuismancu 1540–1540." In
Historia de Cajamarca: Vol. II, Etnohistoria y Lingüistica, ed. F. Silva Santisteban,
W. Espinoza Soriano, and Rogger Ravines
(Cajamarca: Instituto Nacional de Cultura/
Cajamarca and Corporación de Desarrollo de
Cajamarca, 1985), 35–68.

Simmel, Georg. "Sociology of the Senses: Visual
Interaction." In *Introduction to the Science of
Sociology*, ed. R. E. Park and E. W. Burgess
(Chicago: University of Chicago Press, 1921).

Siracusano, Gabriela. *El Poder de los colores: de
lo material a lo simbólico en las prácticas culturales andinas* (Buenos Aires: Fondo de Cultura
Económica de Argentina, 2005).

Skar, Sarah Lind. *Lives Together – Worlds Apart:
Quechua Colonization in Jungle and City* (Oslo:
Scandinavian University Press, 1994).

Smail, Daniel Lord. *On Deep History and the
Brain* (Berkeley: University of California Press,
2008).

Smith, Adam T. *The Political Landscape: Constellations of Authority in Early Complex Polities* (Berkeley: University of California Press,
2003).

Smith, Scott C. "The Generative Landscape:
The Step Mountain Motif in Tiwanaku
Iconography." *Ancient America* 12 (2012): 1–
69.

Smith, Watson. *When is a Kiva? And Other Questions about Southwestern Archaeology*. Ed. Raymond H. Thompson (Tucson: University of Arizona Press, 1990).

Staller, John E., ed. *Precolumbian Landscapes of Creation and Origin* (Chicago: Springer, 2008).

Stempel, Wolf-Dieter, Annette Sabban, and Christian Schmitt, eds. *Sprachlicher Alltag: Linguistik, Rhetorik, Literaturwissenschaft: Festschrift für Wolf-Dieter Stempel 7. Juli 1994* (Tübingen: Niemeyer, 1994).

Sterling, Stuart. *The Last Conquistador: Mansio Serra de Leguizamón and the Conquest of the Incas* (Phoenix Mill, England: Sutton Publishing, 1999).

Steward, Julian. *Theory of Culture Change* (Urbana/Champaign: University of Illinois Press, 1960).

Stobart, Henry. *Music and the Poetics of Production in the Bolivian Andes* (Aldershot: Ashgate, 2006).

Stone-Miller, Rebecca. *To Weave for the Sun: Ancient Andean Textiles* (New York: Thames and Hudson, 1992).

Stone-Miller, Rebecca. *Seeing with New Eyes: Highlights of the Michael C. Carlos Museum Collection of the Ancient Americas* (Atlanta: Michael C. Carlos Museum, Emory University, 2002).

Stone-Miller, Rebecca. "Mimesis as Participation: Imagery, Style, and Function of the Michael C. Carlos Museum Pakcha, and Inca Ritual Watering Device." In Kay Pacha: *Cultivating Earth and Water in the Andes*, ed. Penny Dransart (Oxford: BAR International Series, 2006), 215–24.

Stone, Rebecca R. "'And All Theirs Different from His': The Dumbarton Oaks Royal Inka Tunic in Context." In *Variations in the Expression of Inka Power*, ed. Richard L. Burger, Craig Morris, Ramiro Matos, et al. (Washington, DC: Dumbarton Oaks, 2007), 385–422.

Stone, Rebecca R. *The Jaguar Within: Shamanic Trance in Ancient Central and South American Art* (Austin: University of Texas Press, 2011).

Strube Erdmann, León. *Vialidad imperial de los incas: desde Colombia hasta Chile central y sur de Mendoza (Argentina) con inclusión de sus proyecciones orientales* (Córdoba: Dirección General de Publicaciones, 1963).

Sullivan, Lawrence E. *Icanchu's Drum: Meaning in South American Religions* (New York: Macmillan, 1988).

Summers, David. *Real Spaces: World Art History and the Rise of Western Modernism* (London: Phaidon, 2003).

Swenson, E. R. "Cities of Violence: Sacrifice, Power, and Urbanization in the Andes." *Journal of Social Archaeology* 3(2): 256–96.

Szeminski, Jan. *Wira Quchan y sus obras: teleología andina y lenguaje, 1550–1662* (Lima: Instituto de Estudios Peruanos, 1997).

Szeminski, Jan. "Wana Kawri Waka." In *El Culto Estatal del Imperio Inka: Memorias del 46th Congreso Internacional de Americanistas, Amsterdam, 1988*, ed. Mariusz S. Ziólkowski (Warsaw: University of Warsaw, 1991), 35–53.

Szeminski, Jan. *Wira Quchan y sus obras: teología andina y lenguaje, 1550–1662* (Lima: Instituto de Estudios Peruanos, 1997).

Szemiñski, Jan. *Léxico de Fray Domingo de Santo Tomás, 1560* (Lima: Convento de Santo-Domingo-Qorikancha/Sociedad Polaca de Estudios Latinoamericanos/Universidad Hebrea de Jerusalén, 2006).

Taylor, Gerald. "Supay." *Amerindia* 5 (1980): 47–63.

Taylor, Gerald. *Camac, Camay y Camasca y Otros Ensayos Sobre Huarochiri y Yauyos* (Lima: Institut francais d'etudes Andines, 2000).

Tello, Julio C. "La Ciudad Incaica de Cajamarca." *Chaski* 3 (1941): i.

Thomas, Hugh. *Who's Who of the Conquistadors* (London: Cassell and Co., 2000).

Thrift, Nigel. "Intensities of Feeling: Towards a Spatial Politics of Affect." *Geografiska Annaler* 86 (2004): 57–78.

Tiballi, Anne. "Imperial Subjectivities: The Archaeological Materials from the Cemetary of the Sacrificed Women, Pachacamac, Peru," Ph.D. dissertation, SUNY Binghamton, 2010.

Tilley, Christopher A. *A Phenomenology of Landscape* (Oxford: BAR International Series, 1994).

Tomlinson, Gary. *The Singing of the New World: Indigenous Voice in the Era of European Contact* (New York: Cambridge University Press, 2007).

Topic, John R., and Theresa L. Topic. "Coast-Highland Relations in Northern Peru: Some Observations on Routes, Networks, and Scales of Interaction." In *Civilization in the Ancient Americas: Essays in Honor of Gordon R. Willey*, ed. Richard M. Leventhal and Alan L. Kolata (Cambridge: Harvard University Press, 1983), 237–60.

Topic, John R., Theresa L. Topic, and Thomas H. McGreevy. "Comment on the Breeding and Herding of Llamas and Alpacas on the North Coast of Peru." *American Antiquity* 52:4 (1987): 832–35.

Toohey, J. "Community Organization, Militarism, and Ethnogenesis in the Lat Prehistoric Northern Highlands of Peru," Ph.D. dissertation, Department of Anthropology, University of California, Santa Barbara, 2009.

Torero, Alfredo A. "Procedencia geográfica de los dialectors quechuas de Ferrañafe y Cajamarca." *Anales Científicos de la Universidad Agraria* 6:3–4 (1968): 291–316.

Torero, Alfredo A. "Entre Roma y Lima: El Lexicón quichua de fray Domingo de Santo Tomás [1560]," in *La descripción de las lenguas amerindias en la época colonial*, ed. Klaus Zimmermann (Fankfurt: Vervuert-Iberoamericana, 1997), 271–290.

Treacy, John M. *Las Chacras de Coporaque: Andeneria y Riego en El Valle Del Colca* (Lima: Instituto de Estudios Peruanos, 1994).

Trujillo, Diego de. "Relación del Descubrimiento del Reino del Perú [1571]." In *Tres testigos de la conquista*, ed. Conde de Carnilleros (3rd ed. Madrid, 1954).

Tschudi, J. J. von. *Travels in Peru, During the Years 1838–1842 [1847]* (London: David Brogue, 1966).

Turner, Victor W. *The Forest of Symbols: Aspects of Ndemba Ritual* (Ithaca: Cornell University Press, 1967).

Turner, Victor. *The Ritual Process: Structure and Anti-Structure* (Chicago: Aldine, 1969).

Ubbelohde-Doering, Heinrich. *On the Royal Highway of the Inca* (Tübingen: Ernst Wasmuth, 1956).

Uceda, Santiago. "Esculuras en Miniatura y una Maqueta en Madera." In *Investigaciones en la Huaca de la Luna 1995*, ed. S. Uceda, E. Mujica,

and R. Morales (Trujillo, Peru: Universidad Nacional de la Libertad, 1997), 151–76.

Uhle, Max. "Explorations in Chincha." *University of California Publications in American Archaeology and Ethnology* (Berkeley: University of California)12:2 (1924): 55–94.

Urbano, Enrique. "Sami y Ecaco: Introducción a la noción de 'fortuna' en los Andes." In *Religions des andes et langues indigenes: Équateur-Pérou-Bolivie avant et après et conquete espagnole*, ed. Pierre Duviols (Aix-en-Provence: University of Provence, 1993) 235–43.

Uribe Rodríguez, Mauricio. "La arqueología del Inka en Chile." *Chungará: Revista de Antropología Chilena* 15 (1999–2000): 63–97.

Uribe Rodriguez, Mauricio, Viviana Marnríquez Soto, and Leonor Adán Alfaro. "El 'poder' del Inka en Chile: Aproximaciones a partir de la arqueoloía de Caspana (Río Loa, Desierto de Atacama)." In *Desafios para el tercer milenio: Actas de tercer congreso chileno de Antropología* (Santiago, Chile: Colegio de Antropolgos de Chile, 2000), 706–23.

Urioste, George. "Sickness and Death in Preconquest Andean Cosmology: The Huarochirí Oral Tradition." In *Health in the Andes*, ed. Joseph W. Bastien and John M. Donahue (Washington, DC: American Anthropological Association, 1981), 9–18.

Urteaga, Horacio H. *El fin de un imperio; obra escrita en conmemoración del 4 °centenario de la muerte de Atahuallpa* (Lima: Librería e Imprenta Gil, 1933).

Urton, Gary. "Animals and Astronomy in the Quechua Universe." *Proceedings of the American Philosophical Society* 125:2 (1981): 110–27.

Urton, Gary. *The History of a Myth: Pacariqtambo and the Origin of the Incas* (Austin: University of Texas Press, 1990).

Urton, Gary "Andean Social Organization and the Maintenance of the Nazca Lines: Anthropological and Archaeological Perspectives," in *The Lines of Nazca*, ed. Anthony Aveni (Philadelphia: American Philosophical Society, 1991), 173–206.

Urton, Gary. *Inca Myths* (London: British Museum Press, 1999).

Urton, Gary. "The Herder-Cultivator Relationship as a Paradigm for Archaeological Origins,

Linguistic Dispersals, and the Evolution of Record-Keeping in the Andes." In *Archaeology and Language in the Andes*, ed. Paul Heggarty and David Beresford-Jones (Oxford: British Academy/Oxford University Press, 2012), 321–43.

Valderrama, R., and C. Escalante, *Del Tata Mallku a la Mama Pacha: Riego, sociedad, y ritos en los Andes Peruanos* (Lima: DESCO, 1988).

Van Buren, M., and A. M. Presta. "The Organization of Inka Silver Production in Porco, Bolivia." In *Distant Provinces in the Inka Empire: Toward a Deeper Understanding of Inka Imperialism*, ed. Michael A. Malpass and Sandra Alconini (Iowa City: University of Iowa Press, 2010), 171–92.

Vargas, María de los Angeles. "The Kallanka at Samaipata, Bolivia: An Example of Inca Monumental Architecture." In *Variations in the Expression of Inka Power*, ed. Richard L. Burger, Craig Morris, Ramiro Matos, et al. (Washington, DC: Dumbarton Oaks, 2007), 255–65.

Vázquez Fuller, C. "Llamas y alpacas en la prehistoria ecuatoriana." *Sarance* 18 (1993): 129–33.

Vedesio, Gustavo. "Forgotten Territorialities: The Materiality of Indigenous Pasts," *Nepantla: Views from South* 2:1 (2001): 85–114.

Vilches V., Flora, and Mauricio Uribe R. "Grabados y pinturas del arte rupestre tardío de Caspana." *Estudios Atacameños* 18 (1999): 73–87.

Virilio, Paul. *Speed and Politics: An Essay on Dromology*, trans. Mark Polizzotti (New York: Semiotext(e), 1986).

Vitry, Christian. "Apachetas y mojones, marcadores espaciales del paisaje prehispánico." *Revista Escuela de Historia* 1:1 (2002): 179–91.

Wachtel, Nathan. "The Structure of the Inca State." In *The Vision of the Vanquished: The Spanish Conquest of Peru through Native Eyes, 1530–1570* (New York: Barnes and Noble, 1977), 61–84.

Wachtel, Nathan. "The Mitmaes of the Cochabamba Valley: The Colonization Policy of Huayna Capac." In *The Inca and Aztec States, 1400–1800: Anthropology and History*, ed. George A. Collier, Renato I. Rosaldo, and

John D. Wirth (New York: Academic Press, 1982), 199–235.

Wallace, Dwight T. "The Inca Compound at La Centinela." *Andean Past* 5 (1998): 9–34.

Watanabe, Shinya. "Wari y Cajamarca." In *Huari y Tiwanaku: Modelos vs. evidencias* (Segunda parte), *Boletín de Arqueología PUCP* 5 (2001): 531–41.

Watanabe, Shinya. "Provincial Rule in the Inca State: A Case Study in the Cajamarca Region, Northern Highlands of Peru." *Kokuritsu Minzokugaku Hakubutsukan* 32:1 (2007): 87–144.

West, T. L. "Sufriendo nos Vamos: From a Subsistence to a Market Economy in an Aymara Community of Bolivia," Ph.D. dissertation, New School of Social Research, 1982.

Westreicher, C. A., J. L. Mérega, and G. Palmili. "The Economics of Pastoralism: A Study of Current Practices in South America." *Nomadic Peoples* 11:2 (2007): 87–105.

Weismantel, Mary J. "Maize Beer and Andean Social Transformations: Drunken Indians, Bread Babies, and Chosen Women," *Modern Language Notes* 104:4 (1991): 861–79.

Weismantel, Mary J. "Moche Sex Pots: Reproduction and Temporality in Ancient South America," *American Anthropologist* (n.s.) 106:3 (Sep. 2004): 495–505.

Wheeler, Jane C. "On the Origin and Early Development of the Camelid Pastoralism in the Central Andes." In *Animals and Archaeology: Early Herders and their Flocks*, vol. 3, ed. Juliet Clutton-Brock and Caroline Grigson (Oxford: BAR International Series, 1984), 395–410.

Wheeler, Jane C., A. J. F. Russel, and Hilary Redden. "Llamas and Alpacas: Pre-conquest Breeds and Post-conquest Hybrids." *Journal of Archaeological Science* 22:6 (1995): 833–40.

Wheeler, Jane C., A. J. F. Russel, and H. F. Stanley. "A Measure of Loss: Prehispanic Llama and Alpaca Breeds." *Archivos de Zootécnica* (Córdoba, Spain) 41 (1992): 467–75.

White, Leslie. *The Evolution of Culture* (New York: McGraw-Hill, 1959).

Williams, Carlos, and José Pineda. "Desde Ayacucho hasta Cajamarca: formas arquitectónicas con filiación wari." *Boletín de Lima* 40 (1985): 55–61.

Williams, Raymond. "Culture." In *Keywords: A Vocabulary of Culture and Society* (New York: Oxford University Press, 1976), 76–82.

Wittgenstein, Ludwig. *Philosophical Investigations*, ed. P. M. S. Hacker and Joachim Schulte (Oxford: Blackwell, 2009).

Wolfe, Tom. *The Painted Word* (New York: Farrar, Straus and Giroux, 1975).

Wolfthal, Diane. *In and Out the Marital Bed: Seeing Sex in Renaissance Europe* (New Haven: Yale University Press, 2010).

Wolin, Richard. *Heidegger's Children: Hannah Arendt, Karl Löwith, Hans Jonas, and Herbert Marcuse* (Princeton, NJ: Princeton University Press, 2001).

Wollheim, Richard. *Painting as an Art* (Princeton, NJ: Princeton University Press, 1987).

Xerez, Francisco de. *Verdadera Relación de la Conquista del Perú* [1534] (Madrid: Tip. de J. C. Garcia, 1891).

Yacobaccio, Hugo D. "Social Dimensions of Camelid Domestication in the Southern Andes." *Anthropozoologica* 39:1 (2004): 237–47.

Yaeger, Jason, and J. M. Bejarano. "Reconfiguración de un espaio sagrado: Los inkas y la pirámide Pumapunku en Tiwanaku, Bolivia," *Chungará* 36:2 (2004): 337–50.

Yaya, Isabel. "The Importance of Initiatory Ideals: Kinship and Politics in an Inca Narrative." *Ethnohistory* 55:1 (2008): 52–85.

Young-Sánchez, Margaret. *Tiwanaku: Ancestors of the Inca* (Denver/Lincoln: Denver Art Museum/University of Nebraska Press, 2004).

Yupanqui, Titu Cusi. *History of How the Spaniards Arrived in Peru: Dual Language Edition*, trans. Catherine Julien (Indianapolis/Cambridge: Hackett, 2006).

Zárate, Augustín de. *Historia del descubrimiento y conquista de la provincia del Perú y de las guerras y cosas señaladas en ella [1555]* (Biblioteca de Autores Españoles XXVI: Historiadores Primitivos de Indias, Madrid: Ediciones Atlas, 1947).

Ziólkowski, Mariusz S. "Hanan Pachap Unancha: las 'señales del cielo' y su papel en la etnohistoria andina," *Revista Española de Antropología Americana* 15 (1985): 147–82.

Ziólkowski, Mariusz S. "El Sapan Inka y el Sumo Sacerdote: Acerca de la Legitimización del Poder in el Tawantinsuyu." In Mariusz S. Ziólkowski, ed., *El Culto Estatal del Imperio Inca: Memorias del 46th Congreso Internacional de Americanistas, Amsterdam, 1988* (Warsaw: University of Warsaw, 1991), 59–74.

Ziólkowski, Mariusz S. *La Guerra de los Wawqis: Los Objectivos y los mechanismos de la rivaldad dentro de la élite Inka, siglos XV y XVI* (Quito: Biblioteca Abya-Yala, 1997).

Ziólkowski, Mariusz S. "Los Wakakuna de los Cusqueños." In *Los Dioses Antiguos del Perú* (Lima: Banco de Crédito, 2000).

Ziólkowski, Mariusz S. "El Inka ye el breviario, o del arte de conversar con las Huacas." In *El Hombre y los Andes: Homenaje a Franklin Pease G. Y.*, ed. Javier Flores Espinoza and Rafaél Varón Gabai (Lima: Pontifica Universidad Católica del Perú, 2002), 597–610.

Zuidema, R. T. *Inca Civilization in Cuzco*, trans. Jean-Jacques Decoster (Austin: University of Texas Press, 1990).

Zuidema, R. T. "The Relationship between Mountains and Coast in Ancient Peru." In *The Wonder of Man's Ingenuity: Being a Series of Studies in Archaeology, Material Culture, and Social Anthropology* (Leiden: Rijksmuseum voor Volkenkunde/Brill, 1962), 156–62.

Zuidema, R. T. "La Quadrature du cercle dans l'ancien Pérou." *Recherches amérindiennes au Quebec* III:1–2 (1973): 147–65.

Zuidema, R. T. "La Imagen del sol y la huaca de Susurpuquio en el sistema astronómico de los Incas en el Cuzco." *Journal de la Société des Américanistes* 63 (1974–6): 199–230.

Zuidema, R. T. "Shaft Tombs and the Inca Empire." *Journal of the Steward Anthropological Society* 9 (1977): 133–78.

Zuidema, R. T. "The Inca Calendar." In *Native American Astronomy*, ed. Anthony Aveni (Austin: University of Texas Press, 1977), 219–59.

Zuidema, R. T. "El Ushnu." *Revista de la Universidad Complutense (Madrid)* 28 (1980): 317–62.

Zuidema, R. T. "Bureaucracy and Systematic Knowledge in Andean Civilization." In *The Inca and Aztec States, 1400–1800: Anthropology and History*, ed. George A. Collier, Renato

I. Rosaldo, and John D. Wirth (New York: Academic Press, 1982), 419–58.

Zuidema, R. T. "El Primer nueva corónica y buen gobierno," *Latin American Indian Literatures* 6:2 (1982), 126–32.

Zuidema, R. T. "Myth and History in Perú." In *The Logic of Culture: Advances in Structural Theory and Methods*, ed. Ino Rossi (London: Tavistock, 1982), 150–75.

Zuidema, R. T. "The Lion in the City: Royal Symbols of Transition in Cuzco." In *Animal Myths and Metaphors in South America*, ed. Gary Urton (Salt Lake City: University of Utah Press, 1985), 183–250.

Zuidema, R. T. "The Royal Whip in Cuzco: Art, Social Structure, and Cosmology." In *The Language of Things: Studies in Ethnocommunication*, ed. Pieter ter Keurs and Dirk Smidt (Lei-

den: Rijksmuseum voor Volkenkunde, 1990), 159–72.

Zuidema, R. T. "Guaman Poma and the Art of Empire: Toward an Iconography of Inca Royal Dress." In *Transatlantic Encounters: Europeans and Andeans in the Sixteenth Century*, ed. Kenneth J. Andrien and Rolena Adorno (Berkeley: University of California Press, 1991), 151–202.

Zuidema, R. T. "Inca Cosmos in Andean Context: From the Perspective of the Capac Raymi Camay Quilla Feast Celebrating the December Solstice in Cuzco." In *Andean Cosmologies through Time: Persistence and Emergence*, ed. Robert V. H. Dover, Katherine E. Seibold, and John H. McDowell (Bloomington: Indiana University Press, 1992), 17–45.

INDEX

Abram, David, 143
abstraction (as term of visual design and formal
 structure), 12, 154
 and Inca visual expression, 12–13, 154
accounts of action at Cajamarca, European, 173
affect (biological function of human response), 14, 28,
 29, 30, 119, 140
 biological definitions of, 140
Amazon, 39
anamorphosis (chiasmic structure of colonial
 subject-positions), 15
aqllawasi ("House of the Chosen Women"), 125
architecture, Inca, 46–48, 57, 121–127
Argentina, 1, 25, 135, **136**
Atacama Desert, 25, 26, **27**, **37**, 39, 56
Atawallpa (Inca ruler), 6–8
 and dynastic relics, 91
 as *intip churin* ("son of the sun"), 66, 144–145
 as understood within European notions of political
 leadership, 121
 Europeans' first encounter with, 42–44
 fighting tactics of, 99–100
 legitimacy as Inca ruler, 7–8
 name, meanings of, 6–7
 political career of, 7–8
 rationale for entering Cajamarca's plaza, 116, 120
 rationale in first meeting with Europeans, 44–45
 vision of, *See* vision and Inca constructs of leadership
aucay camayoc (soldier), Inca understandings of, 138–139

beer, Andean (*chicha, aqha*), 31, 38, 45, 56, 85, 113, 125,
 131, 135, 146, 156, 162, 196
Bhabha, Homi K., 15
biological reproduction, Inca understandings of, 163–164
Blanchot, Maurice, 143
Bolivia, 1, 25, 99, **111**

Cajamarca, **23**, **24**, 25, **124**
 as Inca administrative and military installation, 88
 physical setting of, 20–23, 24–25
 urban design and architecture of, 122–127
casa de plazer (pleasure house/country house), 169–170
Cataño, Pedro, 120
caves, 58, **60**, 64, 93, 107, 192
Cerro Sechín, 13, **65**, 67

Cerrón Palomino, Rodolfo, xi, 16, 102
Certeau, Michel de, 18
Chancay, 13, **40**, 46
Chavín, 164
chess, chessboards, 74, **77**, 80–81
Chile, 1, 25, **27**, 29
Chimor, kingdom of (Chimú; Andean polity of the
 north coast), 13, 53, **100**, 129, **147–148**, **151**
Choquequilla, **60**, 63, 64, 192
chuqi/choque (aspect of Inca sunlight/gold), 142
civility, Inca, 145, 155
cloth, 1, 5, **40**, 42, **43**, 45, 46, **51**, **52**, 53, 55, 57, **69**, 71,
 72, 78, 89, **96**, **101**, **104**, 105, 109, 110, 146, **149**,
 152
coca bags, Inca, **96**, 97
color, surface color vs. field color, 110
Covarrubias, Sebastián de, 118
Covey, Alan, 134
Cuzco, 3, 4, 6, 7, 8, 9, 16, 17, 18, 26, 28, 30, 31, 41, 47,
 52, 54, 58, 68, 70, 72, 86, 89, 90, 91, 92, 93, 94, 97,
 102, 108, 124, 127, 128, 129, 130, 131, 134, 137,
 141, 144, 145, 146, 155, 156, 160, 161, 167

Ecuador, 1, 7, 8, 21, **47**, 48, 68, 87, 128, 131
effigies, Inca, 34, 35, 49, 57, 58, 60, 63, 89, 90, 91, 92,
 96, 97, 125, 164, *See also* Punchao/Punchaw
encounter at Cajamarca, historical synopsis, 4–8
eyesight, 33, 68, *See also* vision

feasting, 38, 97, 116, 131, 139
feather, Andean objects of, **51**, **52**, 53, **101**, 146, **151**, 152

Garcilaso de la Vega, 18, 102, 134, 161, 169
Gennep, Arnold van, 154
geoglyphs and rock art, 25, **27**, **29**, **55**, 58, **59**, **60**, **61**, **62**,
 111, 135
Goffman, Erving, 53
gold, 4, 6, **31**, 34, 35, **36**, 57, 96, **97**, 99, **100**, 101, 118,
 119, 120, 121, 129, 132, 134, **137**, 141, 142, 143,
 146, **147**, **148**, **149**, 150, **151**, 152, 155, 156, 160
 and Western scholarly understandings of, 121
 Inca synaesthetic understandings of, 141–142, *See also*
 quri, *chuqi/choque*
Guaman Poma de Ayala, Felipe, **53**, **63**, 64, **67**, **91**, 94,
 97, 99, 100, 101, **113**, 141, **153**, **158**, 167

247